GRACE MACINNIS: A STORY OF LOVE AND INTEGRITY

*A Story of Love
and Integrity*
Presented through the
generosity of
Irene Dyck

GRACE MACINNIS: A STORY OF LOVE AND INTEGRITY

ANN FARRELL

PUBLISHED BY
FITZHENRY & WHITESIDE

Grace MacInnis
© Ann Farrell 1994

Fitzhenry & Whiteside
195 Allstate Parkway
Markham, Ontario L3R 4T8

Editor: Sarah Reid
Designer: Arne Roosman
Typesetting: Ivan Jesperson
Printed and bound in Canada

Canadian Cataloguing in Publication Data

Farrell, Ann, 1924–
Grace MacInnis: a story of love and integrity

Included bibliographical references and index.
ISBN 1–55041–167–5

1. MacInnis, Grace, 1905–1991. 2. Legislators – Canada – Biography.
3. Canada. Parliament. House of Commons. – Biography. 4. Social
reformers – Canada – Biography. I. Title.

FC626.M325F37 1994 328.71'092 C94–931218–5
F1034.3.M325F37 1994

Dedication

Dedicated to my sons David and Dominic
and daughters Mary Ann, Siobhan, and Judy.

Table of Contents

Introduction ... ix
Acknowledgements ... xi

Part I

Chapter 1 - Born to Socialism ... 1
 The First of Many Moves 8

Chapter 2 - Early Awakenings ... 17
 From Manitoba to a Place of Magic 22

Chapter 3 - Growing up in Gibson's Landing 27
 Hard Times .. 30
 The Winnipeg Strike .. 35

Chapter 4 - Vancouver and University 43
 Scholarship to the Sorbonne 49
 Ottawa and Angus MacInnis 53

Part II

Chapter 5 - Courtship by Mail 59

Chapter 6 - Building a Marriage, Building a Party 83
 The CCF Is Born ... 95

Chapter 7 - The Party Is Up and On Its Way 105
 Young Socialists Play Their Part 114

Chapter 8 - War on the Horizon, Struggles at Home 119
 War Is Declared, Grace Becomes an MLA 130

Chapter 9 - J.S. Woodsworth Dies – Political Life Goes On 143

Chapter 10 - The Japanese-Canadian Issue 157

Chapter 11 - A War Ends, Conflict Continues 181

Chapter 12 - Angus Retires ... 199

Part III

Chapter 13 - The First Woman M.P. from British Columbia 207

Chapter 14 - A Fair Deal for Consumers 219
 A Department of Consumer Affairs 221
 A Prices Review Board ... 224
 The Pharmaceutical Industry 229
 Packaging and Labelling Legislation 230
 Moral Suasion Alone Won't Protect Prices 231
 Federal Umbrella for the Co-operative Movement 233
 Re-elected With a Clean Sweep 235

Chapter 15 - The Issue of Birth Control 237
 The Issue of Abortion .. 243

Chapter 16 - Grace Goes to Bat for Mothers 257
 Tax Exemptions ... 260
 Freeing Women to Participate 262
 Maternity Leave ... 270
 A Tally on Day Care at the End of 1973 272

Chapter 17 - Housing and Other Issues 275
 Pensions and Allowances .. 288

Chapter 18 - An Early Defender of Many Causes 295
 A Broader Scope .. 300

Chapter 19 - A Woman to Remember 305

Backnotes .. 317
Bibliography .. 324
Index .. 328

Introduction

The Canadian Labour Congress Executive Council met in March this year in Winnipeg in honour of the 75th anniversary of the Winnipeg General Strike. Bill Blaikie, the NDP MP for Winnipeg-Transcona, attended the meeting as the NDP labour critic. His presence was doubly appropriate as before his election he had been the minister at the All Peoples Mission where J.S. Woodsworth, father of Grace Woodsworth MacInnis, had once served.

Although most of the time we are caught up in the demands of our daily lives, it is important to remember the efforts of those who went before us. Indeed, much of what we value about being Canadians resulted from the relentless struggles of people like J.S. Woodsworth, his daughter, and his son-in-law, all of whom served in the Canadian Parliament. Indeed, as we survey Canada today we find ourselves facing arguments and opponents similar to those that the original founders of the CCF faced in the 1930s.

Agnes Macphail can be considered the leading woman among the first generation of social reformers elected to Parliament. Grace MacInnis played that role in the second generation. And make her mark she did, even when she was the only woman elected to the House of Commons in 1968. When the Royal Commission on the Status of Women was doing its work, Grace had to make herself heard over the male prejudices of that time.

I was happy to be present at the 1982 CLC Convention when the labour movement honoured the two pillars of the second generation of CCF–NDP MPs, Stanley Knowles and Grace MacInnis. On the CLC Award for Outstanding Service to Humanity to Grace were inscribed the following words:

"What we desire for ourselves, we wish for all. To this end we may take our share of the world's work and the world's struggle" — J.S. Woodsworth.

Presented to Grace MacInnis by the Canadian Labour Congress as a tribute to her redoubtable energy and resolve, her unquestionable idealism and her buoyant, humane and uncompromising commitment to those social principles which have so enriched the lives of men and women throughout Canada.

On accepting the award, Grace did not allow her seventy-seven years or her arthritis to hold her back from giving us all some advice:

> I think you need allies, it is not enough to be allied with the NDP, to have the two together like we do now, you need allies in the hard-pressed taxpayers, you need them in the elderly and the sick and the handicapped and the poor people. Now, there is only one way you are going to get those allies. If you spend your whole time . . . fighting for wages and working conditions and fringe benefits and things like that, I doubt if you will raise an ally. While people are vaguely sympathetic, they also think as taxpayers and elderly and handicapped. . . . I would like to see this great big amalgam of the NDP and the trade union arm spend a lot more time on fighting for these things, these new rights, fighting for a chance for socially useful work . . . for low-income people, the right to good education and training, the right to unpolluted environment, the right to freedom from war and rumours of war, and the right to share in decisions about these matters, not only as NDP and trade unionists but as other people. If you show yourselves interested to the point of involvement in those matters, you will get allies and you will get enough allies that Ottawa will listen and they will give grudgingly.

In the light of the debates now taking place in the party, I believe Grace's words are even more valid today.

While we think of Grace primarily in her role as debater and defender of the rights of people, there was the human story of her life as well. Her marriage to Angus MacInnis was a union of ideas and hearts. The details of this marriage of minds comes forth in the private correspondence quoted by Ann Farrell as she brings to light the personal side of a very public life.

In all her efforts, Grace was never afraid to speak her mind. She did not hold back her views, even when speaking to allies with whom she disagreed. Throughout her life, she persevered in the good fight. It took a long time for her to gain the recognition she deserved, but in the end, thank goodness, she got it.

In today's world of the fifteen-second sound bite, it is a rare politician who can convey any depth to an argument. Grace certainly did that, and we are the richer for her efforts.

<div style="text-align: right;">
Robert White,

Ottawa, April, 1994
</div>

Acknowledgements

In July 1992, a year after Grace MacInnis died, a group that included her family, friends and colleagues, recognizing the importance of setting down her record while memories remained fresh and those who shared her life were still available, put in motion the Grace MacInnis Biography Project. This story would span more than fifty years in which she and her father J.S. Woodsworth, founder of the Co-operative Commonwealth Federation along with her husband Angus MacInnis, worked — sometimes together — in the House of Commons and throughout the country for the cause of social democracy.

This family dynasty shared a determination to motivate Canadians to create a better society at home and abroad. Grace, in particular, devoted much of her efforts to issues chiefly of concern to women. Although her work on their behalf as a Member of Parliament occurred at a time when the women's movement in Canada was growing rapidly, Grace always maintained that her aim was to remove obstacles impeding the full development of women *and men* — especially poverty. In her opinion, the application of sound socialist principles could achieve better results for *everyone* than could an approach limited by gender focus.

Although a single author's name appears on the cover of this book, its contents could never have been put together without the help and encouragement of a vast supporting cast. The writer was funded by groups and individuals who believe Grace's contribution to her times deserves recognition. Implicit in their support is the hope that her story will inspire others to continue along the same path.

The major contributors were: The Boag Foundation, Douglas-Coldwell Foundation, Japanese Canadian Redress Foundation, the national offices of the United Steelworkers of America and the Canadian Auto Workers, and the Ontario Federation of Labour. The New Democratic Party federal office, many constituency associations and individual members also provided financial assistance or services in kind; among the latter, Bernard Simpson, a Vancouver MLA, was particularly helpful.

I am indebted to members of the Woodsworth family for their interviews and wholehearted support: Grace's brothers — Bruce and his wife Sylvia, who put the author up in their home and provided a memoir of Grace's mother Lucy, as well as childhood photos of the family; Charles, who read some of the early chapters and provided a memoir of

his father; Ralph and his wife Vivian, who have followed the project through their son Glenn, Grace's nephew and executor of her estate. Glenn Woodsworth made an invaluable contribution to the project, allowing me access to thirty years of correspondence between Grace and Angus during their courtship and marriage.

The project committee, headed by the indefatigable eighty-one-year-old Eileen (Tallman) Sufrin, Kay Lackner, Donna Wilson, Jessie (Mendels) Winch, Ellen Woodsworth, and in Ontario, Gwen and Stewart Cooke, were able co-ordinators and fund-raisers, acting as a source of contacts as well as editorial counselling. Ellen, Grace's second cousin, drove the author to the Sunshine Coast. The grateful recognition this group has earned serves to illustrate one of Grace's favourite contentions, that nothing quite equals the fervor of volunteers.

A good number of the project's sponsors agreed to interviews and their observations are found elsewhere in this book. I am particularly grateful to June Callwood, Cliff Scotton, and Kalmen Kaplansky who read the original chapter outline; to Lorne Ingle and Donald and Simone MacDonald who read Parts I and II for historical accuracy; to Roy Miki who offered helpful comments on the chapter dealing with the Japanese Canadian issue; and to Doris Anderson for her pertinent comments on Grace's parliamentary years in Part III.

Among those long-standing CCF–NDP activists from B.C. who provided useful source material, Frank Snowsell and Bernard Webber (an MLA with Grace from 1941–45) deserve particular mention.

Special thanks go to George Brandak, Curator of Manuscripts, Special Collections Library, University of British Columbia, who, in addition to being helpful in the research stage, also read and commented on drafts and expedited obtaining photographs reproduced from the MacInnis files.

During one of Toronto's hottest summers on record in 1993 it was a great boon to have the assistance of researcher Mary Alton who undertook the task of referencing Grace's speeches as an MP over nine years in *Hansard* at the University of Toronto's Robarts Library. The national headquarters of the Canadian Abortion Rights Action League assisted me with research on the abortion issue.

Sarah Reid, the book's editor, allowed that arduous process to be as pleasant and constructive as possible, thereby making the book more readable without disturbing its flow, never an easy task. I also acknowledge with thanks the encouragement and support of the publisher, Robert I. Fitzhenry, whose humour and patience helped me over some of the rough spots.

My thanks too, to Bob White, president of the Canadian Labour Congress, for his foreword, an introduction to the life of Grace MacInnis from one who continues to share her dream for society.

It is impossible to include all those who kept me going along the way. Among those whose hospitality I enjoyed during my travels: Dorothy Dawson and Dinah Kowalczyk in B.C.; Joy Hodges, Peterborough; and Annaline Lubbe, Ottawa. There were others who simply listened, offering uncritical ears and TLC when required. Special thanks to my children and their families, David, Dominic, Judy, Mary Ann, and Siobhan, as well as my patient friend Maida George.

Ann Farrell, Toronto

Part I, Chapter 1

Born to Socialism

The family called her the Yeller Kid. Not exactly the sort of nickname one might expect for the daughter of a Methodist minister, but then this baby was born to parents who could be relied upon to do the unexpected.

Winona Grace Woodsworth was born in Winnipeg on July 25, 1905 – Winona after Longfellow's "Hiawatha" and Grace for the fashionable Methodist church of which her father, James Shaver Woodsworth, was minister.

As for the yelling, likely it was intended to distract her father as he tried to read to his wife Lucy over the breakfast table, a favourite pastime of his. It was perhaps the earliest hint Grace gave of her intention to raise her voice whenever she wished to draw attention to what she believed was right.

Less than forty years had passed since Confederation, the twentieth century was just beginning, and neither the howling infant nor her father were aware of what destiny had in store for them, or of the part they were to play in the rise of Canadian socialism. Woodsworth*, perhaps, already had an inkling. He could not put from his mind the poverty he had seen in London's slums as a student in England. Increasingly, he felt he had a responsibility to help the poor, although just how he might do so remained unclear. At the same time, he was finding it hard to ignore growing doubts about aspects of his church's dogma. The

* Woodsworth was popularly known as J.S. by many people, both inside and outside politics, after the formation of the CCF in 1933. To his wife Lucy he was always James; to his children to this day he remains Father.

result was increasing conflict in his mind between his commitment to continue in the Methodist tradition of his family, and his growing desire to work more directly with the disadvantaged in the community.

His ambivalence arose in part because he had been "born and brought up in the Methodist Church."[1] Son and grandson of Methodist ministers, Woodsworth had been born in 1874 on Applewood Farm, near Islington, Ontario, and had moved west with his father when he was eight years old. Like his daughter, he was the eldest of six children. Originally, the family had come across the border from Pennsylvania to escape the American Revolution. His mother's people were United Empire Loyalists with Dutch roots, and his father's family was of Yorkshire descent.

Grace's mother, Lucy Staples, was descended from Irish Protestant settlers who had fled County Wexford in southern Ireland to escape the persecution of Catholic neighbours. They came to Cavan, near Peterborough, Ontario, where they bought land to farm.

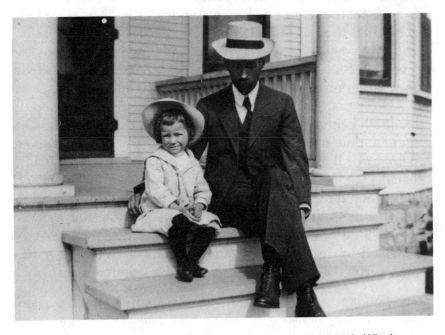

Young Grace, aged about three, sitting on the steps of their home in Winnipeg with her father, J.S. Woodsworth

When Grace was older, all those who knew her agreed that she was stubborn – even more stubborn than her father, it was said. Given her ancestry, perhaps this was not so surprising. In fact, father and daughter had more in common than the temperament of their forebears. Just as Woodsworth found himself strongly drawn to follow his father's calling in the Methodist church, so Grace, in her turn, followed in *her* father's footsteps, to work for the socialist movement he adopted when he left the church. The effect of these decisions early in their lives was to set them on a path they would ultimately travel together part of the way, one that led to the formation of a socialist family dynasty destined to last fifty years. Although it would be many years before she became aware of it, Grace inherited from her mother's side of the family something far less desirable – the genes that one day would force her into early retirement from the political life that meant so much to her by contributing to the development of the severe rheumatoid arthritis that crippled her in later life.

Winnipeg in 1905 was a fast-growing prairie city, the population a mix of Anglo-Saxon middle- and upper-class residents, and a veritable hodge-podge of nationalities from Europe. The latter, mostly impoverished immigrants, were often isolated by language and bigotry, and were frequently exploited by their employers. This burgeoning population lived in overcrowded, unpaved streets in squalid conditions, clustered – in the expression of the times – on the wrong side of the tracks.

The railway that ran on those tracks past the ramshackle homes of Winnipeg's immigrant population was very much a part of the lives of many early Canadians. Until air travel became commonplace, it also played an important role in the lives of Woodsworth, his daughter Grace, and later on, her husband Angus MacInnis. It was their lifeline as they traversed the country building a new socialist movement in Canada, the Co-operative Commonwealth Federation.

In contrast to the immigrants' depressing environment, the surroundings of Grace's childhood were comfortable. James and Lucy Woodsworth lived in the home of his parents, a home simply furnished in keeping with the family's Methodist values. They

lived as they believed Christ would want them to; nevertheless, the atmosphere was warm and gracious. Lucy and her mother-in-law got along well, and Woodsworth's parishioners warmed to the poise and charm of the young minister's wife. His father, already aware of his son's misgivings about the ministry, was sympathetic toward his search for another path to follow that would bring him closer to his new goal of meeting social, rather than strictly spiritual needs. The infant Grace must have enjoyed her first year surrounded by a loving family who gave her all the nurturing babies thrive on.

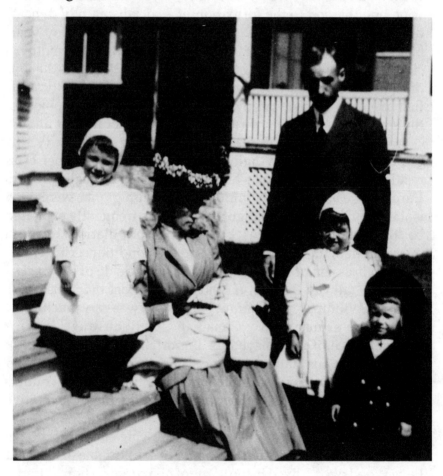

J.S Woodsworth and his wife Lucy with their young family on the steps of their home in Winnipeg. Grace is seen here with her younger sister Belva and their brother Charles. Baby Ralph is on his mother's knee.

Woodsworth enjoyed children's company, and they enjoyed his, recognizing in him a child-like enthusiasm for life, and for enjoying the inconsequential details many grown-ups ignore. His desk drawer yielded the kind of treasure trove more often associated with a small boy's pocket: shells, birds' eggs, pieces of amethyst and other precious stones. When they were older, his children loved these trinkets, not only for themselves, but because their father could tell them fascinating stories about them. His own enjoyment of them was infectious and captured their youthful imaginations.

Lucy Woodsworth was entirely different. Calm and serene whatever happened, she was always able to manage in a crisis and to act as mediator when her husband, who had a short fuse, lost his temper. Overwork, zeal for his causes, a stubborn nature and the pursuit of social justice simply wore him out until the kindly man his children loved would erupt alarmingly. Lucy understood him and made his home a haven where his energies could recuperate. She was able to make his children understand his need for peace and rest and to do their part towards providing it. Her Irish sense of fun and practical approach to life proved essential during her sometimes turbulent life with "him with a burning passion for social justice," as she once put it. Her surviving children remember her as loving, good-humoured, and spirited.

In those early days as a young mother in Winnipeg her role as buffer between her fiery husband and the rest of the world still lay ahead. Apart from his reservations about his future as a Methodist minister, at that time Woodsworth was at peace, at least in his home. He had a wife who was a true companion in every way and a new baby they both enjoyed and loved. That wife, however, already saw clearly, and accepted without reservation, that James, the life he chose to lead, and the consequences that followed, came first, and she would always back him wholeheartedly.

Lucy lived to be 102, and Grace always admired her, loved her deeply, and she recognized her gift of understanding in a special way when she dedicated her biography of her father, "To Mother, who understood."

An absent father, travelling the country on political business, was something the Woodsworth children had to get used to. Grace was hardly a year old when she had her first taste of separation from her father. It wasn't politics that took him away on this occasion but his need to make some decisions about his life. After a few years, there were too many young Woodsworths for them to feel truly lonely when their father was away. (In all, there were six Woodsworth children: Grace and Belva and four boys: Charles, Ralph, Bruce, and Howard.) They were also part of a large, extended family which cushioned them to some extent from feeling their father's absences too keenly. Nevertheless, throughout her life Grace would comment that children need two parents.

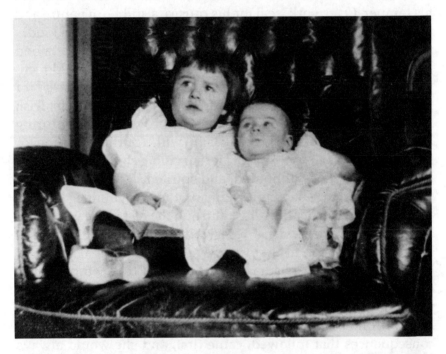

Two little Woodsworth girls, Grace and Belva, share a large armchair. Great playmates as children, Belva never shared her sister's passion for politics. She married Ralph Staples, an early leader in the co-operative movement and lived in Cavan, Ontario, where her mother came from.

Despite Woodsworth's enjoyment of home and family, his conscience continued to goad him. Because he could not accept his church's doctrine he felt a hypocrite in his role as minister at Grace Church. In addition, his health was not good, and so he asked the Methodist Conference if he might have a year without assignment in which to think things over. This being granted, he decided on a journey to England, Europe, and the Holy Land. Lucy accompanied him for the first few weeks, leaving the baby with her aunt on the Staples family farm in Cavan, Ontario. For a mother to leave an infant at such a young age was highly unusual at that time, although baby Grace was evidently happy enough in her new surroundings. From Cavan, Woodsworth wrote to his mother in Winnipeg:

> Grace sat up to the table for breakfast in her high chair. She had some of the yolk of my egg, and Lucy's too, and a crust. Then, as the bath was not quite ready I took her out for a walk. As we went through the grain to the far barn she had [her feet] washed with dew. Then we came back through the stables. She doesn't like the shiver the horses give when she gets up the courage to touch them. The chickens always delight her. The gobbler gobbled at her. She doesn't know what to make of him. And Towzer accompanies us on these expeditions. Her gaze follows him when there is nothing more exciting. So we had quite a bit of exercise.[2]

It was mid-July, just before Grace's first birthday, when the young parents and several other members of the Woodsworth family set sail. Safe in the country air of Ontario, no doubt more tolerable than the stifling summer heat of Winnipeg, little Grace could not have known that that summer in 1906 would seal her political destiny. Her father would return renewed, but before long would leave the pulpit to take up his life's work on behalf of the underprivileged, work that Grace would embrace as her own.

The First of Many Moves

James returned from abroad to a six-month assignment at a scandal-scarred parish at Revelstoke, in British Columbia's mountain country. He and Lucy had already spent time apart during his recent trip, nonetheless it was decided that, because the assignment was a short-term one, and because Lucy was pregnant, their separation should be extended a few more months. Lucy and Grace would remain on the farm in Cavan to await the birth of the new baby.

The situation in Revelstoke quickly improved under Woodsworth's enthusiastic and persistent direction, but his work wasn't helped by his own growing discomfort over preaching a doctrine he no longer believed in. He wrote to Lucy about the progress he was making and about his crisis of faith. His letters also showed how he missed his young family: "Sometimes I feel this is no life to be living at all. Married yet separated from home. . . ."[3] Lucy tried to reassure her husband with news of his little daughter and of their doings on the farm. She always seemed able to accept what couldn't be changed; a knack she had perhaps developed growing up in a farm family where daily decisions so often depended on the vagaries of the weather. All the same, she must have been concerned about having no prospects for a settled home in which to raise her young family, or even the assurance of a regular income. She supported James fully in his desire to live up to his highest principles, once writing, "Nothing takes precedence over the ought."[4] James dearly loved his wife for her loyalty, writing in reply: "Oh, my dear wife, it isn't one woman in a thousand who could say that – and mean it."[5] The lofty ideals and strong bonds of affection shared by her parents surely provided Grace with role models that would influence her life, although sometimes they must have seemed difficult to live up to. Many years later, Grace would comment: "It is overwhelming to be a Woodsworth."

James' and Lucy's second daughter, Belva, was born in May 1907, a month before James left Revelstoke to attend the Manitoba Conference of the Methodist Church in Carman, where he freely discussed his doctrinal doubts. Much to his surprise, a special committee of leading ministers, struck to consider his intention to resign, reported: "there is nothing in his doctrinal beliefs and adhesion to our discipline to warrant his separation from the ministry of the Methodist Church and [we] therefore recommend that his resignation be not accepted."[6] The church then made a

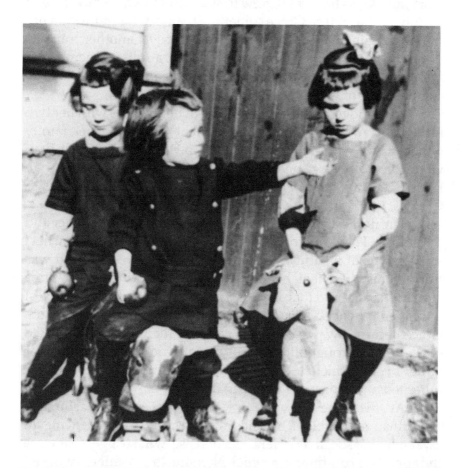

Playtime, and a ride for Charles with Belva on the pillion while Grace sits astride her own mount. Despite the family's frequent moves and lack of money, Grace recalled her childhood as happy, held together by her mother's even temperament and sense of fun.

wise move, one that ultimately was to put Woodsworth on the path to socialism: it appointed him to take charge of the All People's Mission, just being established in North Winnipeg.

Woodsworth's lifelong drive to take on the unexpected may have taught his children to adapt to change, but in Lucy's case, change carried an additional burden, that of packing and unpacking all the boxes the constant moves entailed. Again her own background likely stood her in good stead. Farm children had always been expected to take responsibility for some of the work, and so, as her brood grew in size, all of them learned to lend a hand. As the eldest, Grace sometimes came in for more than her share. Her siblings complain she was "bossy," another trait she came by honestly – even after they were adults, remembers a family friend, Woodsworth's five brothers and sisters tended to stand in awe of him.

Lucy moved back into the home of her in-laws with her two little girls, and it wasn't until 1909 that Grace and her family would move with her father deep into Winnipeg's North End, where he took charge of Maple Street Mission near the Canadian Pacific Railway station. Four-year-old Grace by then had a brother, Charles, just a tiny baby.

The next six years were a significant time for both father and daughter. They not only provided Grace with her earliest impressions of what it was like to be a Woodsworth, but it was during this time that her father's socialist principles became clearly defined, and that she experienced her own first stirrings of a social conscience. Through the pattern of daily life at the Mission, Grace became aware, even as a child, of the issues that were to concern her throughout her life. This period would cement her father's commitment to social activism, a commitment that Grace inherited and embraced with equal fervor.

At this same time, out in Vancouver, Angus MacInnis, a motorman for the city's transit system, was also experiencing an awakening of social conscience. In his case, what triggered it were the appalling conditions in which Nanaimo's coal miners worked on Vancouver Island. Angus, who was raised in poverty in a Gaelic-speaking family on Prince Edward Island, and Grace were

destined to meet, to fall in love and marry, and to join forces in the fight to help the disadvantaged.

After the middle-class comfort of her grandparents' home, the Mission was from the beginning an eye-opener for Grace. There were the cockroaches, an aspect of life that might have horrified many people, but which Grace saw as nothing more than an "exciting" introduction to her new home. She remembered the mission kindergarten as a "sunny, happy place where the mothers brought their children, struggling at the same time with winter wrappings and the English language. . . . There was a swimming-pool in the basement where the cement walls echoed the Tarzan-like yells of boys and girls for whom bathing was an amazing luxury. There was the library whose books had been donated by 'more fortunate' people in other parts of the city, that splendid room where I made the acquaintance of *Alice in Wonderland*, looking eagerly at the pictures and longing for the time when I could read the text."[7] There were cookery and sewing classes, "where they sometimes brought their embroidery from the Old Land, exquisite stitching in gorgeous reds and blues and purples. There were classes in English where my father often taught. I remember watching him as he said slowly to some shy and awkward man who followed his encouraging expression: 'I get out of bed . . . I put on my pants . . . I put on my shirt . . . I put on my socks . . . I put on my shoes . . .' He would accompany each sentence with appropriate gestures and wait for the learner to repeat it, often many times, until it became clear that he had grasped its meaning."[8]

The Mission was a seven-day-a-week operation, with services on Sunday, lantern-slide lectures, and a fresh air camp on Lake Winnipeg in the summer for these inner-city children. The All People's Mission was a place of amazing activity, and the dynamo driving it was Grace's father. One of his projects was a vegetable garden which in due course produced tender green lettuce and fat radishes. It wasn't long before the bigger boys began to raid this tempting source of food. Woodsworth would appear around the corner of the house to chase the youngsters away wearing a sailor hat that made him look as regal as the newly crowned King of England and that caused the boys to shout "King George!" as they ran away.

Woodsworth, ahead of his time as he so often was, believed in educating "the whole person." He took his children on walks around the neighbourhood where they could not but notice the differences between the immigrant community in which they now lived and the one they had left behind. "Here the sights and sounds and smells were colourful and vivid. We got used to the bright kerchiefs of the women, the rough sheepskin coats of the men, and everywhere the queer talk we couldn't understand. We got used to the unpaved streets of North Winnipeg, to the children playing about in the mud, and even to seeing chickens and pigs cluttering up the door yards. We even became accustomed to the flies that swarmed around the garbage heaps in the back lanes and settled on the meat in the crowded little corner stores. Those pigs and chickens and flies worried my father, he was always indignant that the city authorities did nothing about them."[9]

Reports about the living conditions of Winnipeg's immigrants that Woodsworth had given the local authorities, in the hope (futile as it turned out) that something would be done, were collected by the Mission workers. Four of the reports speak for themselves:

> Jacob Lalucki is employed in the CPR shops. He is a Ruthenian, his wife Polish. They are both Roman Catholics, but occasionally attend our Mission. They have two young children. They live in one room, and have nine boarders, and the wife goes out washing.

> Michael Yakoff and his wife are Russians. They have four children. He has only one leg and acts as caretaker in a hall for which he receives $12 a month. They live in three rented rooms for which they pay $8 a month. They keep some roomers, Pieter, the eldest boy, eight years old, has to go out along the streets and lanes where he can find sticks of wood, empty bottles, etc., for which he gets a few cents to help keep the family. Of course, he does not go to school. The family is Greek Orthodox, but attends the Mission.

> Peter Dagchook and his wife are Ruthenian. He is a labourer – works "steady," but drinks heavily. They have

eight children. The eldest daughter is married and doing well. One boy ran away from home. Another boy is in jail. A 13-year-old girl is at present in the hospital, and the four younger children are still at home.

John Luelbachyh and his wife Mary came out from Galicia last spring. When he reached Winnipeg, it was discovered he had "sore eyes" and he was deported. His wife remained in the Immigration Hall for several months. Then she had a bad ankle and had to be taken to the hospital. The three children were sent to the Children's Aid.[10]

Woodsworth's reports warned of the consequences of these conditions continuing without remedy. In the end, it took a city-wide outbreak of "summer complaint" to push the authorities into action. This was a type of summer influenza triggered by extreme heat, to which small children were susceptible. Many babies died during the heat of July and August. Although this was predominantly an illness of the poor, sometimes better-off families were affected. Ralph, the Woodsworth's second son, then two years old, was so ill during this outbreak that his recovery, in his sister's words, "seemed a miracle."

In a letter to the editor of the *Free Press*, Woodsworth wrote: "Yesterday I stood beside a child's grave. Away on each side of me stretched rows of tiny graves that tomorrow and the next day will be filled. The fearful expense and waste of all these lives, the trouble and heart-breaking grief of their parents could be, much of it, prevented. This is the plain, unvarnished fact."[11]

Woodsworth was among the first to press for a compulsory school attendance law in Manitoba, and he was also among those urging the establishment of a Juvenile Court in Winnipeg. As he also believed that prevention was better than cure, he pushed for playground facilities for poor children.

In 1909, the Ministerial Association appointed Woodsworth as its delegate to the Winnipeg Trades and Labour Council. This opened up new vistas for him as previously he had had little hands-on experience with non-professional working people. He was quick to take advantage of his new role, and in the spring of

that year he started writing a series of articles in a small Winnipeg labour paper, *The Voice*, under the pseudonym of Pastor Newbottle. His subjects included the conditions of immigrants and working conditions in industry.

For all the diverse influences that filled their every waking moment, Grace and her siblings always knew that their opinions, even if controversial, would receive a respectful hearing. In her formative years she probably saw more of poverty and its effects, Canada's multi-ethnic mix, and community living than many people see in a lifetime. It was only a beginning.

Years later, Grace's brother Bruce talked about the breadth of their education. "Father always had us sit up at the table when people visited us and there was discussion. We were to keep quiet until we knew enough to be able to contribute to the subject under discussion."[12] Woodsworth also left a wide variety of papers, books, and reports about the Mission, an invitation to read and become knowledgeable on a diversity of subjects. No Woodsworth child had to be afraid to disagree, but he or she was expected to have done his or her homework.

In the end Woodsworth came to the conclusion that his church could not be counted on to take a lead in dealing with the community's social ills. As a result he was on the move again, in search of an organization that would take effective action to improve social conditions for immigrants and other impoverished workers. He resigned from the Mission in June 1913 and was named secretary to a new venture to be known as the Canadian Welfare League. It was to be launched in the fall at the Canadian Conference of Charities and Corrections. Dr. J. Halpenny was named president of the League, and its purpose was to promote a general interest in all forms of social welfare. It was to make a practical study of emergent social problems caused by Canada's large and heterogeneous immigration, by the rapid growth of cities and the stagnation of some rural districts, and by the beginning of industrialism and "generally our entrance into a fuller national health." Woodsworth believed this was the route to go in search of the reforms he believed to be so necessary.

As secretary of the Canadian Welfare League, Woodsworth was on the road for long stretches at a time. Lucy, home alone again with the children, continued to give her husband every encouragement. She never let her mind rust and found time to keep up to date on many subjects and to take part in community endeavours. The family continued to grow and during this chapter of their lives two more sons were born: Bruce in 1914 and Howard, the baby, in 1916.

His move to a civil-service desk put some physical distance between Grace and the stark conditions that continued to be the focal point of her father's work. However, she was in elementary school, she could read, and the dramatic visual images already imprinted on her young mind were now being reinforced by the written word, often from her father's pen. She herself began keeping a diary to record their hectic lives at this time, in neat handwriting that changed very little until arthritis crippled her fingers many years later.

The distraction of television was still in the future and the Woodsworths were avid readers, so it is possible that Grace's social education at that point outdistanced her academic studies. In her case these early influences would eventually lead her on to the path her father trod. Yet where her siblings were concerned these same influences led to different career choices. Charles came nearest to public life when, following a career in journalism, he became a diplomat. Bruce, a teacher and geologist, once ran unsuccessfully for the NDP in Okanagan South, B.C.

Part I, Chapter 2

Early Awakenings

Grace and her siblings defied the contemporary wisdom that says children need a stable environment in order to enjoy a happy childhood. Life in the Woodsworth family was anything but settled, subject as it was to frequent moves, lack of money, and a father who constantly changed jobs, invariably as a result of some clash with the establishment. Yet the children looked back on their childhood as a positive experience, remembering it, for the most part, as loving and inspiring. They not only admired the strong principles by which their parents lived, they also drew strength from the abiding affection and respect their parents had for them, for each other, and, in fact for all who crossed their path.

Charles, the eldest son, in a written memoir about growing up, recalls: "It was a mixed blessing when, pyjama-clad, we tumbled romping into our parents' big bed in the early morning and father would playfully tickle us with [his beard] like a stiff scrubbing brush when he was supposed to be giving us an affectionate kiss."[13] Neighbourhood youngsters, to the chagrin of the Woodsworth children, would call out "Beaver!" as their father walked by. When Woodsworth was at home, the children often found him authoritarian. This, of course, wasn't particularly unusual at a time when the role of a father as a family's ultimate authority was undisputed. In fact, as the eldest of six children, Woodsworth brought some experience to the job of being in charge. Over the years Charles was amused to observe that "this early-inculcated respect" for his father's will had "a prolonged effect" as well upon his uncles and aunts. Even though they might differ widely with him on his political views, the fact remained

that they continued to look up to him. "With no reason in this world to fear his poor opinion" wrote Charles, "I have nevertheless seen them quail before his frown of irritation in some altogether trifling matter."[14]

Grace, who was fiercely loyal to her father, did not comment on her father's authoritarian nature, although her lifelong friend Kathleen Inglis Godwin recalls that she used to "work out" her feelings by scrubbing floors. However, Grace's surviving brothers recall their father's sharp temper well. In Charles's words, "he was frequently a stern parent. The rigorousness of our upbringing, tempered by Mother's loving solicitude and her brighter disposition, was based on deep affection and a fundamental sense of justice. His sternness could be excused . . . in some part by the inherent intensity of his nature. But it was at times nonetheless uncomfortable."[15] For example, Woodsworth continued his father's custom of reading aloud from the Bible after breakfast, following this up with long, drawn-out annotations on each passage, to the intense boredom of his young audience. Perhaps because Howard was the family's baby, he just couldn't contain his boredom in silence and would collapse into fits of nervous, helpless giggling. This, in turn, would set off his brother Bruce in similar fashion. Charles recalls that the sessions frequently ended in "extreme, if not physical, discomfort for all."[16]

According to Bruce Woodsworth, his father "was fiery, like a meteor going up and, if not watched very closely, it might burn itself out." In contrast, he described his mother as "very calm, cool and intellectual . . . she had a different way of dealing with things."[17] Indeed, in Charles's opinion, she was "a miracle," and very seldom does he recall seeing her fly off the handle.

It fell to Lucy to manage the often meagre amount of money available to pay the bills, something her family remembers she did very well. Nobody went hungry, and somehow the wherewithal was always found for education, whether it was music lessons, university, or a trip to Europe – which James and Lucy considered an equally viable avenue to learning. They weren't brought up to consume, a virtue surely honed of necessity in a family of such modest means. This early need for economy, however, led to a

lifetime habit of frugality on the part of some of the Woodsworth children. This was especially true in Grace's case, a habit reinforced later on as her husband Angus shared her prudence where spending money was concerned.

Even though the family was poor and Ralph wished sometimes he could have a new overcoat when the weather was cold, they all worked together and put up with things. Ralph pays tribute to his mother as "a very fine person who played as important a part in our lives as father. Our parents didn't worry about money, at least not openly, they didn't discuss it. But she was a very smart and wise woman, although she kept in the background. Yet she knew as much as father about Canadian politics, she always kept up. She also had a wonderful sense of humour and could see the joke, even if it was on her."[18]

The same didn't always hold true for his father. Although Woodsworth had a sense of humour, Ralph says, he could not be described as "a figure of fun." Lucy actually saw to it that no one *made* fun of him. Woodsworth sometimes wrote amusingly about his children in the Christmas Annual that was a feature of their life together. Each year all family members were expected to make a contribution to this record of the year's activities. Woodsworth set great store by this exercise; his children did not always share his enthusiasm. Nevertheless, some of the entries that remain are endearing, for instance, an entry headed "Our Chickens" lists the names of the family's hens: "Pet, Cupid, The Mother, Blackie, Head Shawl, Wiseman, Browneyes, Dickie, Grey Eyes, Bluett, and I forgot, Fluffy the Rooster."

As the eldest in the family, Grace was often responsible for taking care of her siblings, which led to her reputation for bossiness, particularly among her brothers. Many years later she confided to her husband that she believed this early responsibility put a distance between her and her siblings.

At the same time, her position in the family strengthened the close bond she felt with her mother. Later, she would write of her:

> Mother never sought security. The idea of settling down permanently in one dwelling – if she ever held such an

idea – must have been abandoned very early in her married life. We children grew up with the expectation that our lives would be spent moving about from house to house, from province to province, in accordance with the needs of father's work. We never thought in terms of any other arrangement – a sure indication of mother's attitudes.

Nor did she look for economic security. She knew that father must carry on his work through the best means available at any given time. Whether this meant the salary of a city pulpit, the uncertain income of a travelling lecturer, the casual earnings of a longshoreman, the fixed indemnity of a Member of Parliament, she accepted what came to the family as her farm forebears had accepted the sun and the rain, the hail and the frost. It never occurred to her to do otherwise.[19]

That Lucy was able to influence her children was partially due to the fact that the Woodsworths were distinctly different from most families of that time. The difference was in attitude. Long before such a concept became fashionable, James and Lucy observed equality in their dealing not only with people of different social standing, education, race, and religion, but also within the family regarding the roles of male and females. Never at any time did either of her parents give Grace the feeling she could not achieve whatever she wished because of her sex. Chores in the household were not divided between boys' and girls' tasks – in fact, there is the charming picture of James peacefully darning socks as Lucy reads to him by lamplight. Theirs was always a co-operative family, an early introduction to a co-operative movement which would become as much a part of Grace's life as it had her father's before her.

Grace was said to be the child most like her father temperamentally: serious, tense, obstinate, courageous, determined, innovative, loyal, passionate, and a perfectionist. The early influences in her life, coupled with her own temperament, do much to explain an attitude of Grace's that has often been misunderstood, that is, her attitude to feminism.

Her political championship of women's issues, especially those that affected poor women, and the fact her struggles in connection with such issues as abortion and pensions coincided with the awakening of the women's movement in Canada, led many people to call her a feminist, a label she resisted strenuously all her life. It is, of course, possible to argue that she herself didn't need feminism because she had the great good fortune – particularly in her era – to spend her life first with a father and later with a husband who treated her as an equal intellectually and politically. However, it was not until after the deaths of James and of Angus that she really did become her own person, freed from supporting the male politicians in her life.

Grace, of course, never experienced the discrimination faced by women less fortunately placed. She recognized this and maintained that all too often feminism tended to be white and middle class, whereas she believed the poor were the people who needed it most. In her opinion, education was more likely to help them get ahead than a declaration of their rights as women. The middle class already had access to education: the poor, on the other hand, even though some education was generally available to them, often received insufficient to give them a competitive edge. However, given that this sort of help was made available, it was Grace's firm opinion that people (including women) should compete on merit. Likely she would not have approved of current affirmative action legislation.

Towards the end of her life, pressed on the subject of feminism by Professor Veronica Strong-Boag of the University of British Columbia, Grace allowed that *perhaps* she was a feminist. In the final analysis, her legislative achievements in the area of women's issues far outweighed any potential importance her acceptance of a feminist label might have conferred on her. What really counted in Grace's estimation was that *all* men and women be guaranteed an opportunity to achieve their full potential as persons in their own right.

From Manitoba to a Place of Magic

The Canadian Welfare League had been open barely a year when, in the summer of 1914, Woodsworth set up a Short Training Class in Social Work with help from specialists; it was one of Canada's first training programs in this field. He was also appointed as an extension lecturer at McGill University in Montreal which gave him an opportunity to air his concerns about immigrant problems before a wider audience.

For two and a half years his work with the League took him across the country, and he enjoyed it, although, according to Grace, her father was "always conscious of the great burden thrown upon Mother by his long absences during which she had the full care of the home and children." It was a pain of separation he felt himself. In a letter to Lucy in November 1915, he wrote: "So when I get discouraged you'll have to keep me going. Mr. Dobson has two beautiful children. His little girl of nine is a very lovable child. I felt hungry for our own little ones."[20] During these years he constantly sought and Lucy constantly gave reassurances that she was with him heart and soul in his work.

Grace never had children of her own and, although she offered various responses to those who asked her why, it was not until nearly the end of her life, at a time when society had come to regard it as "acceptable" for a woman to make such an admission, that she gave what was perhaps the real answer: she had not really wanted them. Perhaps her early experiences contributed to her decision. Certainly, years later when she was an MP, Grace pointed out that a look at the lives of other women politicians at that time showed that most were single, divorced, or had no children.

Until 1916 the war did not intrude unduly on either the Canadian Welfare League or its pacifist secretary. Early that year, however, the needs of war dried up the League's funding sources and forced its closure. Fortunately, at this point the three prairie provinces stepped in and jointly established a Bureau of Research

whose mandate was similar to that of the Canadian Welfare League. Woodsworth continued his work with the new office until the end of that year when he wrote a report outlining plans for the coming year. None of these plans was to come to fruition because within a month the Bureau became history. The reason for this sudden turn of events was a letter Woodsworth wrote to *The Manitoba Free Press* (later *The Winnipeg Free Press*).

The letter was a public reply to a circular from the federal government seeking the Bureau's help in promoting the success of the National Service Registration scheme. Woodsworth rejected the government's request on grounds of his passionate commitment to pacifism. It brought his career as a civil servant to an abrupt end. Called on the mat by the cabinet minister in charge of the Bureau, he refused to back down or to give an undertaking that he would desist in the future.

Lucy, loyal as always, stood by his action. It was a courageous moment for them both. "They had decided," wrote Grace, "that, come what might, the price of cowardly silence was too great to pay. Father must speak out against war or everlastingly forfeit his self-respect. Love of Father and love of Truth were always the greatest things in Mother's life. He knew that she could never bear to think of him being less than the truth that was in him."[21]

Woodsworth's pacifism dated back to the Boer War, to shortly before Christmas 1899, during his stay at Mansfield House, the East London Social Settlement. Woodsworth wrote to his mother at that time:

> Here I am in the "Common Room" at Mansfield House . . . now I hear the talk around me is about the war . . . most of the [poor] men in the House are much opposed to the war. They think the English are wrong. The other day I heard a large audience of working men oppose the war . . . now I know Harold [his brother] will object to this. Let him remember that the Boers are his cousins [a reference to their mother's Dutch ancestry] and that they are fighting for their liberty. Why should England be supreme in South Africa? Our losses have been dreadful. Then here in England we have the widows and children.[22]

Later, a visit to the Army and Navy Museum in London deepened his anti-war feelings significantly. Many years later he recalled the reactions evoked by that visit:

> On my return to London I visited the Army and Navy Museum – a vast collection of British War flags, war-trophies, the torn and blood-stained flags and tattered uniforms taken from defeated armies, the wretched rags torn from the corpses of natives from almost every part of the world. I left the Museum sick at heart and almost sick at my stomach. So this is Empire! Subsequent studies only confirmed the impressions of that day.[23]

At the time of Woodsworth's dismissal from the Bureau he was forty-four years old. The youngest of his and Lucy's six children was only three months old. Grace, not yet eleven, faced yet another move with her family, and an approaching adolescence of great uncertainty. As their days in Winnipeg drew to a close, Grace's mother took the two youngest children on a visit to the farm in Ontario while her husband stayed home, winding up the affairs of the Bureau and packing up the family's belongings. It had been decided to move to the west coast and to take time to regain their strength and reflect on their future. The move was a speculative one. James and Lucy had decided to take their small savings and spend a little time in Victoria where they would regain their strength and decide on their next step.

With Lucy in Cavan, the remaining four youngsters chose this inopportune moment to go down with mumps. However, James proved equal to the emergency, and eventually, in April 1917, all eight of them set out for the west coast. Not one person came to the station to see the family off; people they had thought of as neighbours and friends had deserted them. The elder Woodsworths were terribly hurt by this, a hurt only slightly eased by the arrival, over time, of letters of apology; the writers were ashamed they had not supported Woodsworth's stand for pacifism, and regretted their faint-heartedness.

British Columbia turned out to be an immediate love affair for all of the Woodsworths, one that would last, in some measure, for

the rest of their lives. The family settled in Gibson's Landing (now called Gibsons) on the Sunshine Coast of B.C.'s lower mainland, where her father ministered to a small parish. It was, Grace wrote, their "magical place." It was also the place where she would experience at first hand some of the poverty that had surrounded her at the Mission.

Before she was much older, another defiant political action of her father's would give Grace her first personal taste of politics and introduce her to that rush of adrenaline that accompanies a clandestine operation. It fact, it was in this peaceful ocean backwater that the family's life would change forever when Woodsworth finally severed his connection with the Methodist church and embarked on the road that would lead him and Grace into politics.

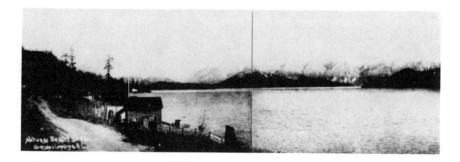

A view of Gibson's Landing on the Sunshine Coast of British Columbia. The Woodsworth family came here after their father was dismissed from his post in Winnipeg. Grace and her siblings called it their "magical place," and it was here that Grace helped hide her father's books from a potential search by the RCMP following his arrest during the Winnipeg Strike.

Part I, Chapter 3

Growing up in Gibson's Landing

Beneath Grace's matter-of-fact exterior beat a romantic heart. She wasn't demonstrative, but the poetry she wrote when she was a girl and letters to her husband through the years revealed a romanticism that might well have surprised parliamentary colleagues who saw only her more feisty side. She was also deeply moved by the beauty of nature, and her lyrical description of Gibsons as she first saw it as an adolescent girl is evocative not only of its beauty but also of the intrinsic romance this place held for her.

> Gibson's Landing was... an enchanted clearing surrounded by deep forests, dark with rain and luminous with the sunshine sifting through the heavy layers of green; of trails that wound from the familiar stony roads of the shorefront up through the mossy forest until they lost themselves in the mystery of the mountain. It was the wonder of sea lapping against the islands or stretching itself in a path of gold beneath the moon, lashing the Point in white-capped fury or veiling itself in the driving mists of the rain. It was the majesty of the Britannia Range, its snow-covered peaks high and straight above the waters like a great wall between us and the world we had known, a great wall coloured by the gold of morning sunshine, the rose of sunset, and the shifting blues of every hour and season.[24]

The family needed the peace of their new surroundings after the emotional turmoil of the final months in Winnipeg. At the time, Grace would write: "Perhaps it was a bit more difficult for

[Lucy] to accept social insecurity. She had grown up in an atmosphere untroubled by the conflict of ideas. Among the neighbours there was a friendly interest, and differences in politics and religion had come to be accepted as inherited qualities like the colour of one's hair . . . she knew that Father's action in opposing the First World War would not be popular, but it must have startled her to see the way in which friends of long standing fell away from them."[25]

During their early days at Gibsons their father was with them, and this made it all the easier to enjoy their new home in the local Methodist Mission, comprising some 140 families. They discovered Dragon Castle, a blackened tree stump near the parsonage. Called "a stick" by the local people, Dragon Castle was thirty feet high, and what made it such fun was that it was large enough for all of them to squeeze into it together. After so many absences, they enjoyed their father's presence, especially as he was such a lively companion.

Although Lucy no doubt also enjoyed having her husband home for a change, by this time she likely knew for sure that wealth and stability would never be theirs. However, Lucy's Irish farm heritage and temperament were something to be reckoned with. Beneath her cheerful exterior there was a fighting spirit that was to stand her in good stead as the wife of a man who was forever battling the odds. She had a practical brand of courage that her daughter Grace inherited. Grace's nephew, Peter Staples, who still lives near the family farm in Cavan, tells the story of the time when some of the Catholic neighbours of his protestant predecessors followed them across the ocean from Ireland and settled nearby. The old harassment started all over again, and the persecution that had caused them to leave Ireland was rekindled. This was too much for the protestants and a number of them banded together to form a group that came to be known as the Cavan Blazers. It wasn't long before they took action by torching their tormentors' barns. It was a drastic move, but it was successful, and the newcomers were driven out. Although this sort of behaviour went against all that Grace and her family believed in, this was the determination that they would show whenever it was a case of standing up for people's rights.

Grace's three surviving brothers, Charles, Ralph, and Bruce, all recall their lives at Gibsons with nostalgia, despite the family's straitened circumstances. They taught themselves to swim, and Nora Hill, a friend from those days, laughs to remember how Howard, the baby, would sit by the pool in a suitcase, wedged in with towels, while his brothers and sisters were in the water.

Not all their memories are as pleasant. Upon occasion, Woodsworth's wrath could spill over, turning him from an exciting companion into an angry parent bent on punishment. Corporal punishment as a form of discipline was accepted by society at that time, and given Woodsworth's strong Methodist background, the occasional spankings he administered to his lively sons were perhaps not surprising, lifelong dedication to the cause of pacifism or no. Later, Grace's husband Angus, despite his admiration and affection for his father-in-law, would more than once make critical comments about his short temper.

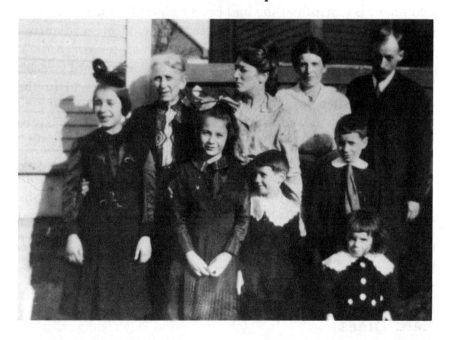

James and Lucy Woodsworth's family around 1916. Back, left to right: James's mother Esther (née Shaver); Lucy; Edith Rose (née Woodsworth), James's youngest sister; James. Front, left to right: Grace, Belva, Ralph, Charles, and Bruce. Howard had not yet been born.

Looking back to those years during the First World War, Grace's brothers do not dwell on minor blemishes in a man sorely tried by his circumstances, a man whose character and political courage they respect almost to the point of reverence. However Grace's sister Belva was less able to deal with conflict. She shrank from unpleasantness, even in family discussions, recalled Grace, and later, she became upset when she saw her father being "pounded by the members of the establishment in the House of Commons. She was uncomfortable and a little fearful of what might happen."[26]

For a while in Gibsons, for reasons of economy, the Woodsworths shared the home of the local doctor's family, the Inglises. They had a large apartment in the basement, and Kathleen Inglis (later Godwin) became Grace's great girlhood friend. She remembers Woodsworth's outbursts, and how the shouting always disturbed her. "Grace would argue with her father a lot, but she accepted his discipline; she had been trained that way from the beginning." Lucy always tried to act as mediator on these stormy occasions.

Kathleen's and Grace's close friendship lasted until Grace's death. It began soon after the Woodsworths' arrival in the community when Kathleen's mother sent her over to the new neighbours' house with a batch of biscuits. "There was Grace baby-sitting her little brother, Howard. He was nine months old," Kathleen recalled. "I had just had a little brother myself, who was only a couple of weeks old, so we had much in common right from the start . . . she was a wonderful person, although later on she didn't have many interests outside politics. At that time we loved to read books together, books like *Lorna Doone* and *Little Women*. We memorized the whole of Sir Walter Scott's *Lady of the Lake*."[27] Kathleen and Grace, together with Grace's sister Belva, formed a trio of close friends.

Hard Times

At Gibson's Landing the children were free to enjoy pursuits new to them, fresh as they were from city living. As minister, their

father had the use of an old gas-powered boat that he re-named the *Goodwill*. The whole family would joyously clamber aboard and set sail on sometimes choppy water, at some peril according to Charles, who looks back on these voyages with misgiving. His father had little mechanical skill, and was no more competent in marine matters, so it appears the family's safety was often more a matter of good luck than good judgement.

During the great influenza epidemic of that period all twelve children in the combined Woodsworth and Inglis households fell ill. James and Lucy remained healthy and were, naturally, overwhelmingly busy attending to their sick brood. Nevertheless when either found a spare moment, they visited their neighbours' homes to give what help they could.

The Anglo-Saxon influence dominated Gibson's Landing when Woodsworth went there as a minister. As a result, his predecessors at the Mission had not felt it necessary to pay much attention to the large number of families of Finnish descent within its boundaries who, in any case, rarely attended church. Nevertheless their numbers were significant in so small a community. Woodsworth was unconcerned about their church attendance record, and he and Lucy soon set about getting to know them, a practice in keeping with the custom he followed throughout his life with all who crossed his path. Woodsworth's wider purpose was always to help people in every way, especially newcomers, so they might establish themselves as worthwhile, self-respecting citizens. Not surprisingly, his actions found little favour with his Anglo-Saxon parishioners, several of whom were influential in the community. Later, in fact, when once again Woodsworth disobeyed orders, his friendship with the Finns was just another bone of contention with his Anglo-Saxon superiors.

Indeed, the family's halcyon days were soon to end. Once again, Woodsworth was in hot water, this time with Gibsons' moneyed citizens. The seeds were sown when Woodsworth bought a small amount of stock in the local co-operative store, a move which aroused the displeasure of the town's leading merchant who happened also to be the most prominent lay Methodist. The crunch came when Woodsworth refused to display recruiting

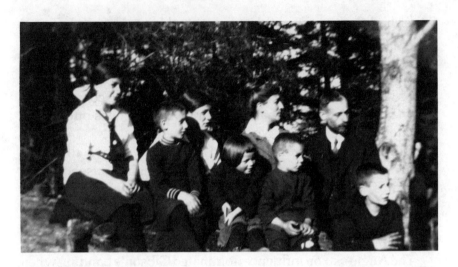

The Woodsworth family is seen here in 1918 resting on a fir log. Left to right: Belva, Ralph, Grace, Howard, Bruce, and Charles. James and Lucy are behind.

posters in the church. A chorus of dissent, led by this merchant, arose. A letter addressed to the British Columbia Conference, giving the misleading impression that it represented a majority view, demanded Woodsworth's resignation. At the spring meeting of the Conference in 1918, his mission was not renewed.

Following discussion with Lucy, Woodsworth sent a letter of resignation to the Manitoba Conference of the Methodist Church. This latest experience simply brought to a head the difficulties over dogma and other aspects of his ministry Woodsworth had been facing for years. His conscience, he finally realized, dictated that he move on.

As it turned out, however, the parishioners responsible for his departure were by no means representative of the majority. Writing to his mother shortly after his official letter of resignation was sent, Woodsworth told her that others of the congregation had subscribed a sum of money that exceeded the amount outstanding on his salary. The gift was accompanied by a testimonial that read: "We the people of Gibson's Landing and Robert's Creek wish to show our grateful appreciation to you for all your labours, and to show the high esteem in which you have been held by us since coming into our midst."[28]

So it was that in the summer of 1918, Woodsworth, a small, slightly built man, unused to manual work, became a longshoreman on the docks of Vancouver in order to feed his family. Because of his views, jobs were unavailable to him, and his job as a longshoreman came only after he had spent days on the docks, often in the rain, seeking membership in the union. The union's secretary, E. E. Winch, admired his persistence and, his own family being away, took Woodsworth into his home, since Gibsons was too far to travel to every night. Ultimately this would lead him into the political career that made him famous as it was Ernie Winch – later MLA for Burnaby, B.C., and president of the Vancouver Trades and Labour Council – who later put Woodsworth on the road that led him to found the CCF.

That all lay ahead, however, and it was actually the flu epidemic that opened the door to the union for Woodsworth. It happened that the union's business agent was among those who fell sick during the epidemic. His exhausted wife was unable to find a nurse to look after him, and Woodsworth offered to do the job. Although the man died, the union, in appreciation, finally agreed to take him on as a full member.

After he began working as a longshoreman, James wrote to Lucy: "I'll have to get a freight hook, emblem of my new profession! There's no doubt about this being the way to get an insight into labour conditions. But to think of you as the wife of a common labourer – a casual labourer at that! – a docker."[29]

Lucy's reaction was simple and to the point: "I am proud to be your wife and the mother of the children of a docker (when the docker is your own dear self). But oh! I just ache to think of how your poor back must ache. I am half-expecting to have you home tonight."[30]

As far as Grace was concerned she admitted her father's new job was something of an emotional shock, testing attitudes she had been brought up to accept in theory. Despite the influence of parents who believed all work should be accorded a common dignity, the reality of her father's new role in society was something she was not immediately prepared for. She was still, after all, only thirteen, an impressionable and emotional age.

It was time again to make adjustments, some of a more practical nature. Lucy managed to get a job at the school in Gibsons, and a housekeeper was hired to took after the younger children while she taught. The position was not secured without difficulty: the same people who had recommended James's dismissal had tried, unsuccessfully, to prevent her appointment.

Grace's admiration for her mother grew in this period: she has recorded seeing her late at night patching worn pants by lamplight. The family fortunately received gifts such as clothing at that time, and it was fortunate that the pressure in those days to be stylish and keep up with one's peers was less overwhelming than it is for today's young people. Grace's own self-image, even then, was so strong that she cheerfully joked at school that her boots had been handed down to her by Harold Winch. (Harold, like his father Ernie, later became an MLA, then an MP, and was leader of British Columbia's CCF Party.) Gifts of money from well-wishers were sometimes received by Woodsworth, and on one memorable occasion the family in Ontario sent them a chicken. Unfortunately, thought had not been given to preventing its going bad *en route* and the result was a foul-smelling – and inedible – parcel at the post office.

The First World War dragged on, and Woodsworth's pacifism remained a constant factor in his thinking. It surfaced when out of twelve hundred longshoremen employed on Vancouver's docks he was the only one to refuse to load munitions destined for use by the allied force sent to crush Russia's new regime – in spite of the double pay the job entailed and his own desperate financial circumstances. Family records show that between mid-August and the end of 1918, longshoring brought in only $491.50 (at 65 cents an hour for an eight-hour day). Lucy, working at the school in Gibsons, earned just $177.

Yet Grace's brothers today don't look back on the period when their father was a longshoreman as one of deprivation. Pocket money may have been a little short, clothes old and darned, but there was always enough to eat, and life in the village with their friends – and with their mother's good management – was never without laughter.

The Winnipeg Strike

In the spring of 1919 Woodsworth embarked on a series of actions that would profoundly affect not only the course of his own life but that of the entire family, especially fourteen-year-old Grace who, at this time, became caught up in the politics that would hold her almost until the end of her life.

With the war over, Woodsworth was able to devote more time to the cause of social democracy. In January 1919 he wrote in the *B.C. Federationist:* "Revolution may appear to come more slowly [in Britain than in Russia] but there will be no counter-revolution . . . It may take a few years to work out, but when it's done it's done for good."[31] A few months later, at the invitation of Rev. William Ivens of Winnipeg, Woodsworth set out across the prairies on a speaking tour, leaving his family behind at Gibsons. Ivens, like Woodsworth, had been removed the year before from his pastorate, in his case at McDougall Church in Winnipeg, by the same Manitoba Methodist Conference that had received his colleague's resignation.

It was as Woodsworth was travelling by train to Winnipeg that he first got the news of the Winnipeg general strike that had started on May 15. His subsequent involvement in the strike was coincidental with his visit there, and was not planned ahead. By the time Woodsworth arrived in Winnipeg, a city of two hundred thousand at the time, some thirty thousand workers, twelve thousand of whom were not union members, were on strike. The effect was to bring the city to a virtual halt. Contrary to the rumours, however, the strikers from the beginning were counselled against violence by their leaders who urged them instead to stay peacefully at home.

By this time Woodsworth's experience as a working man on the docks and his involvement with the Federated Labour Party had crystallized his position on social democracy. He immediately sided with the strikers and, as scheduled, spoke to a crowd of ten thousand at Winnipeg's Labour Church on June 8. He said that

rather than blaming the workers, blame should be placed on the employers whose "arrogant determination" had provoked the strike in the first place.

Woodsworth was outraged to hear of two pieces of legislation which had been rushed through Parliament with indecent haste shortly before his arrival in Winnipeg. The first was an amendment to the Immigration Act permitting the deportation as an undesirable of any immigrant, British- or foreign-born, regardless of how long he had lived in Canada, and without trial by jury. The second was an amendment to the Criminal Code, later known as Section 98. It reversed the tradition of British law, allowing a person's arrest on suspicion and placing the burden of proving innocence on the accused. It was to take Woodsworth until 1927 to have the amendment to the Immigration Act repealed, and until 1936 to have Section 98 removed.

Different interpretations exist as to the real cause of the strike. According to the report of the Robson Commission, appointed by the Manitoba government to conduct an investigation, the strikers' objectives were to improve wages, working conditions, and labour's bargaining position. A more inflammatory view was promoted during the strike by the opponents of the Central Strike Committee. Named the Citizens' Committee of One Thousand, this *ad hoc* group of the city's prominent business leaders and lawyers perceived the event as further evidence of the "Red Menace," an hysteria which surfaced in North America following the Russian Revolution and which continued to pervade some sections of society for years to come. The result of the Committee's "Red" rumour-mongering was panic in certain quarters, the apprehensions being heightened by the fact that most of the city's returned soldiers sided with the strikers.

In addition to issues such as wages and working conditions, another important factor aggravated the strike in its initial stages and contributed to its becoming generalized. It concerned a move by union leaders in western Canada towards what can best be described as industrial unionism. Many of these union leaders were recent immigrants from Britain, who believed that units such as existed in eastern Canada for individual crafts and trades

were too small for effective action against employers. Hence they pushed for the establishment of industry-wide unions. For example, when the workers in the building and metal trades had gone on strike on May 1, they had insisted that their Metal Trades Council be recognized as the bargaining authority, a demand that was rejected by their employers along with demands for wage increases to keep pace with the escalating cost of living during the post-war period.

The climate of the strike had heated up when service workers – telephone, post office, street railway, and waterworks – joined in. The strike leaders believed, however, that they could win by purely economic action – the withdrawal of their labour. "There is," the strike bulletin affirmed: "great cause for congratulation in this struggle, in that until the present moment the participants are more orderly than a crowd of spectators at a baseball game. . . . There has been evolved a weapon of great power – orderliness." [32]

At this point the city government further inflamed the situation by firing the entire municipal police force on the grounds that the policemen would not sign a yellow-dog contract – one that prohibited them from being members of a union – despite the fact that the policemen had decided to remain on duty in the interest of order during the strike. The folly of this decision was demonstrated almost immediately when a peaceful demonstration at Portage and Main - the junction of Winnipeg's two principal streets – turned into a riot in the hands of an untrained constabulary recruited by the Citizens' Committee.

On June 17, in the strike's fourth week, the ...
arrested ten of the leaders. Among them was Rev. William Ivens, Woodsworth's recruiter and editor of the strike bulletin, the *Western Labour News*. Woodsworth and his friend Fred Dixon, a Manitoba MLA, took over the strike bulletin, Woodsworth acting as editor and Dixon as reporter. In doing so both of them realized that at some point they would likely face arrest.

Despite the recently announced ban on public gatherings the returned, demobbed soldiers who supported the strike organized a parade on June 21. That day would be referred to from that time on as Bloody Saturday. The parade was to form up near City Hall

and march to the Royal Alexandria Hotel. The police, actually specially recruited constabulary, wielding horse collars sawn in two as weapons, broke up the parade in front of City Hall where soldiers appeared with rifles and machine guns. Before order was restored a boy had been killed, a man injured so badly that he later died, and injuries inflicted on a hundred others.

Woodsworth saw to it that the strike bulletin carried a full report of Bloody Saturday plus an editorial cautioning strikers not to retaliate with violence. The bulletin also accused the government of introducing "Kaiserism" to Canada.

Three days before the strike's collapse on June 26, Woodsworth's support of it led to his being arrested on charges of seditious libel. Part of the indictment surprisingly included his use of the quotation from the Bible: Isaiah 10:1-2, "Woe unto them that decree unrighteous decrees, and that write grievousness which they have prescribed; to turn aside the needy from judgement, and to take away the right from the poor of my people, that widows may be their prey, and that they may rob the fatherless." In a letter from jail he airily wrote to Lucy: "You have told me I would not be happy until I got into trouble." Although his friend Dixon managed to carry on the newspaper after Woodsworth's detention, three days later he himself was arrested and placed in the next cell. Their efforts had been in vain: the strike was called off on that day.

Woodsworth was both disappointed and angry - angry because of the violent outcome of events despite the strikers' non-violent behaviour throughout. In fact, no firearms were ever discovered in any striker's belongings in the subsequent investigations.

Woodsworth and Dixon were released from jail on June 28 on two sureties of $1,500 each. Six months later, they pleaded not guilty before the assize court, and the trial was postponed until January 1920. The charge of speaking seditious words remained unaltered until March 7, 1920, when the Crown entered a "stay of proceedings."

Naturally, news of Woodsworth's arrest caused consternation at Gibsons. Lucy, as might be expected, fully supported her

husband's stand. In a letter to Mary Woodsworth (James's sister) dated June 30, 1919, she wrote:

> I am sure there is no need to go into our position. With James, I have entirely ceased to wish for luxury, ease, comfort, or advantage for us, yes, or for our children, while countless thousands never do or never will, under the present system, get a chance for ordinary, decent living. You see, since James has been a longshoreman, I have seen that those who work with him can never get enough money to clothe and nourish their children and to provide for dentistry, surgery, high school or university education, music, travel, or indeed, the delights of a few hours every day of care-free leisure. We like all these things intensely. The only reason we have not been actively in the conflict to help make them general for the human race is because others have never had them. It has taken us this long time to realize how clear-cut is the issue as to whether or not they shall get them.[33]

The children's reactions to news of the arrest were less altruistic. Describing her five-year-old's concern, Lucy recollected: "Bruce said to me one night at bed-time: 'Father might get hurt.' After I had tucked him in, I was standing by the window when he groaned out: 'I *wish* Father had Charles' .22 with him!'" When he first heard about his father's arrest, he had asked his mother "with great earnestness: 'Was Father put in jail, Mother, just because he speaked a little on the Gov'ment?'"[34]

Charles took it more or less in his stride, mostly displaying interest in the turn of events. Ralph was upset, his eyes filling up with tears as he asked what it all meant.

What a day it must have been for Lucy. Somehow she taught French, British, and Canadian history and drawing in the afternoon before having to break the news to her children that their father was in jail. As she wrote to her mother-in-law in Winnipeg, "my thoughts were far away in Winnipeg with you all."

In Grace's opinion, her mother during this period "rose to full moral stature." After news of the riot reached Gibsons, Lucy had

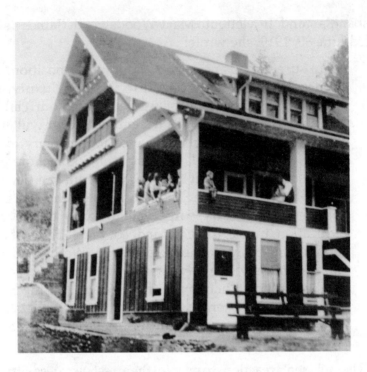

This large house belonging to Gibson's Landing local physician was also home
to the Woodsworth family after their father left the local Methodist Mission.

feared that there might be real trouble for James. She had asked
Mrs. Inglis to send word to her in school should she learn of
anything happening that might pose a real threat. As soon as news
of her husband's arrest reached her, Lucy's immediate fear was
that the RCMP might arrive on the next boat to search their home
for evidence that could back up the charge of seditious libel.

She called Grace and her friend Kathleen Inglis out of class and
told them to clear the house of anything they thought would look
"seditious" to the police. The two girls headed for home where
they took an old bread box, lined it with oilcloth, and searched the
house for anything that could possibly be construed as dangerous.
They pulled out books on socialism, those on war and peace, even
a few containing sermons, and those with red covers if they
seemed at all controversial. They carried the box into the woods
and hid it under a log, taking care to cover their traces with
bracken and leaves.

Gibson's Landing, 1918. Grace Woodsworth and her chum Kathleen Inglis (Godwin). According to her brother Bruce, it is probable that Grace is seen wearing Harold Winch's cast-off boots, an incident described in this book.

This was the girls' secret. Even Lucy was kept ignorant as to the whereabouts of the box. From that moment the conspirators referred to it by the letters "S.V." – secret vault – enjoying their role in the political action that had put Woodsworth's name on the front pages of the country's newspapers.

When Woodsworth returned to Gibson's Landing, his eldest son, Charles, greeted him on the dock to the tune of "God Save the King" played on his violin. It was not, perhaps, the most apt selection in the circumstances, but it was the only one he had learned on his recently acquired instrument. Eventually Woodsworth and his loyal accomplice headed into the woods to retrieve his "illicit" library. The bread box was unearthed and returned to its rightful place, the books restored to the family bookshelves. It must have been a proud moment for both of them.

Part I, Chapter 4

Vancouver and University

Following his troubles in Winnipeg and a speaking tour which enabled him to visit his family in Gibsons, Woodsworth took part in the 1920 provincial election campaign in Manitoba. But his heart yearned for his family and in consultation with Lucy it was decided he would join her and the family would settle in B.C. Not only was its milder climate more attractive, but they preferred life on the coast and the beauty of the scenery. The children were getting older so, despite the family's love of Gibsons, it was decided to move to Vancouver in order to be nearer to high schools and university.

That fall the family moved to the Kitsilano district of Vancouver and bought an old frame home near the beach. It was the only home they ever owned. (Throughout his life J.S. Woodsworth never earned more than $5,000 a year.) As usual, funds were low, and to raise the down payment he had to borrow on a life insurance policy.

The house was badly in need of painting, and, to economise, Woodsworth took advantage of a sale of war-surplus paint. Its dismal colour – battleship grey – is still clear in Charles's memory along with the apprehension he felt as he mounted the rickety ladders his father borrowed for the job. As Charles recalls: "he tied two or three ladders end to end with rope and sent me aloft to paint under the high eaves. I don't say that Father was afraid to mount these swaying, broken-backed creations himself. But I was considerably lighter in weight and was obviously the one for the top-storey job."[35]

The family struggled with their few belongings to put a home together, bringing from Winnipeg some of the furniture that had been stored there when they had moved to the coast. They had grown accustomed to using anything that came to hand for bedding during the tough times at Gibsons: for example, they slept between sheets painted with maps and statistics that had previously been used by their father to illustrate his lectures. Their new neighbours seemed to take an unusual interest in their lines of washing. It wasn't until weeks later, when they became better acquainted, that those neighbours told them: "We thought you were undertakers. One of those sheets said 'Last year we buried 500 babies.'"[36]

Grace and her sister Belva continued their education at Kitsilano High School. Grace was one of the school's first graduating class. Following her graduation, Grace enrolled in a general arts program at the University of British Columbia. Her friend from Gibsons, Kathleen Inglis, joined her at university and boarded with the family. The two girls explored the city together and Kathleen's presence helped Grace to put up with some of the torments of first-year initiation rites.

Meanwhile, Woodsworth had become a political candidate for the first time, running for the Federated Labour Party in B.C.'s provincial election. Although unsuccessful, he won 7,500 votes on a socialist program. He spent the winter doing educational work for the labour movement and the family continued to survive on minimal funds. By the following spring it was obvious that something had to be done to improve the family's finances and, reluctantly, Woodsworth left home again. As he was still black-listed in some quarters he had to take what was available to him. He returned to Winnipeg to act as secretary for the Labour Church. This had been established by William Ivens following his expulsion from McDougall Church in 1918. Without a creed, it was "founded on the Fatherhood of God and the Brotherhood of man."

His affiliation with this church was in keeping with his and his family's break from Methodism. The children had stopped attending Sunday school after Woodsworth's resignation from

Convocation Day, May 17, 1928, at the University of Manitoba. James Woodsworth's sister Mary attended lectures with Grace for three years, and they graduated together.

the Methodist Conference of Manitoba, and from that time on, they followed their individual spiritual paths. About this time Woodsworth created a family grace before meals that they used for many years. It ran: "We are thankful for these and all the good things of life. We recognize that they are a part of our common heritage and come to us through the efforts of our brothers and sisters the world over. What we desire for ourselves, we wish for all. To this end, may we take our share in the world's work and the world's struggles."

Now that the children were older Lucy was free to take a more active role in the community. Her activities often complemented her husband's, and during this period she was a leader in the newly organized Women's International League for Peace and Freedom, and also sometimes spoke at political meetings.

In the fall of 1921 Woodsworth finally won a seat in the House of Commons. Campaigning in Winnipeg Centre as a socialist for the Independent Labour Party of Manitoba (ILP) against three opponents – Conservative, Liberal, and Independent Liberal – he was the first socialist to win a seat in Parliament. When he went to Ottawa to take that seat, the Liberal government was led by William Lyon Mackenzie King and the Opposition by Arthur Meighen. Woodsworth joined a labour colleague, William Irvine from the riding of Calgary. A native of the Shetland Isles and an editor and preacher with the Unitarian Church, Irvine shared with Woodsworth the co-operation of both workers and farmers, an alliance that was to work to their advantage.

Also taking a seat in Parliament for the first time that March 1922, was an Ontario school teacher, Agnes Macphail, elected by a group of farmers whose sixty-five members called themselves Progressives, and who sought a better deal for the agricultural community. She was the first woman MP to be elected to the Canadian Parliament. Fourteen more women members from all of Canada's mainstream parties would sit in the House before Grace would be elected in 1965 to represent the New Democratic Party for Vancouver Kingsway.

Grace was sixteen when her father went to Ottawa, and an enthusiastic diarist. She recorded at this period some observations about herself which, allowing for their youthful introspection, give an indication of the person she was to become later on.

> Sometimes, in order to provide future amusement for myself, I write down in this book little incidents about myself and side-lights which appear humourous even at the time. Then, too, one must have a safety valve; egotism demands it. Therefore, being in a somewhat quizzical and cynical mood I am about to try to catch this tormenting "self" and dissect it at leisure.
>
> First to observe its exterior features – easy enough! It is of medium height, broad-shouldered and of a well-nourished appearance – a particularly irritating feature. Short, straight hair, ordinary hazel eyes, a snub nose and

a wide grin set in a cheerful-looking round face all add to my annoyance.... Its mental content causes me a great deal of trouble. Here are its chief features:

1) The Scotsman's prayer "Lord gie us a good conceit in ourselves," applies poorly in comparison with the Pharisees' petition: "Lord, I thank thee that I am not as other men (and particularly women) are." There, the skeleton's out of the cupboard.

2) Conceit is generally mixed with some timidity called awkwardness. This horrid creature plagues me from daylight 'til dusk with its queer mixtures and bull-in-a-china shop performances.

3) Traceable to No. 1 is its excessive independence. Indeed, I have seen the poor thing weep with vexation when its will is crossed.

4) Dreaming is one of its favourite occupations and it doesn't wait 'til bed-time either. No fancy is too wild to be entered into by this will o' the wisp and it carries on the oddest dialogues between one person called Grace and another termed Winona. . . .

5) Another of my grievances is the way the flighty creature keeps bouncing up and down from the lowest depths to the highest peaks. Never can I have a bit of peace. Most often I boil in the infernal regions but at any moment I am likely to soar to a distinctly chilly mountain peak. . . .

6) Often the poor illogical self tries to convince me it possesses *some* virtues: truthfulness, order, honesty – I believe it mentions most often. But the silly thing says it hates people one moment and goes among them the next. It that truthful? Its disordered brain alone would be enough to disprove the second and as for the third it violates it every second breath.

Come to think of it – it seems rather unfair for a serious individual like myself to be tied down to *such* a headpiece and *such* an exterior appearance. They are really *so* misleading.[37]

For the next twelve months the family was separated again from their father while he adapted to his new environment. Thought was given to the problem of transferring six young people from the coast, whose stages of learning ranged from kindergarten to university. It was eventually decided that Grace, a keen French scholar, should take classes at a Roman Catholic, French-speaking convent in Ottawa, La Congrégation de Notre Dame. While there, of course, she visited the House of Commons for the first time. The pomp left her as indifferent as it had her father, however, if she didn't fall for the glitter, the process of debate held her enthralled, and she returned several times to the House to listen to it. She was a member of a debating team during her university years; this early apprenticeship served her well and, as time passed, she became a skilled and forceful debater both in and out of Parliament.

Grace also attended Ottawa Normal School. With two parents who were gifted teachers it was not surprising that she believed she might follow in their footsteps. However, time would show that teaching was not for her professionally, although in politics she proved herself adept in teaching party workers how to campaign effectively.

In the end, the family moved back to Winnipeg in the summer of 1924, taking a house on Chestnut Street, in the riding of Winnipeg South Centre. There Grace went on to complete her degree at the University of Manitoba. Charles also attended the University of Manitoba and later obtained a doctorate at the London School of Economics. On the whole, Woodsworth gave free rein to his children in choosing their courses, however, he remained adamant on one point, none of them was permitted to undergo cadet training. Not all of them, though, were to follow his pacifist example: Howard, the youngest, served with the Canadian army in Europe during the Second World War. But this was never a matter of conflict with his father, as Woodsworth always respected other people's points of view, including his family's.

It must have pleased Lucy and James, believing so strongly in education as they did, that all their children graduated from university. Belva studied Home Economics and later took post-

graduate studies at Columbia University in New York. She and Grace waitressed together one summer at Lake Louise. Ralph, who started university in Winnipeg, studied medicine at Edinburgh University, and Bruce took geology at the University of British Columbia. Howard attended Wesley College, then part of the University of Manitoba.

During Grace's university years, she had her first taste of teaching in the village of Dunrobin, north-west of Ottawa. This introduction to the classroom was a reasonably positive experience for her. Later on, placed in a far more demanding teaching position for which she lacked adequate experience, Grace found the situation extremely stressful. As a result, she decided to look elsewhere for a career.

Scholarship to the Sorbonne

Following graduation with a BA from the University of Manitoba in 1929, another academic opportunity presented itself to Grace: she won a French government scholarship for one year at the Sorbonne in Paris. It didn't provide much in the way of money, but added to some of her own savings there was enough, and she was overjoyed for a chance to further her knowledge of the French language and, for the first time in her life, to live independently. Lucy received some critical comments about allowing her young daughter to live alone in Paris, however, with her wise approach to parenting, she replied that her daughter was a grown woman who could conduct her own life perfectly well. Indeed, Lucy was a remarkable parent for her times, having acquainted Grace with "the facts of life" at the age of six. Grace was to say that her mother was the wisest person she had ever known "for the business of living and relations with people."

Her son Bruce once wrote of Lucy in her role as a wife: "With the exception of close family friends, few people across this country realize the tremendous influence Mrs. Woodsworth had upon her husband. One is fairly safe in saying that to whatever extent J.S. Woodsworth influenced the social, economic and

political thought of Canada from the beginning of the century – thirty years before there was any thought of founding a Co-operative Commonwealth Federation – until the beginning of this [Second World] war, then to just that extent was she equally responsible."

At twenty-four, Grace had eased up a little from the extremely serious youngster who, at age eleven, had recorded in her diary that she was going to undertake the reform of "the young rapscallions at school." In fact, another diary entry from college days gives a humorous self-evaluation of her social progress from the days of that solemn little reformer: "on the nights I danced I began to realize that after all it is rather restful to talk about hikes and music and moonlight and clothes – just for a change . . . back in college I felt melancholy. Yes, there was no help for it – I was becoming lowbrow . . . I had begun to use powder, I had learned to dance. I had actually put on some articles of modern clothing . . . every day, in every way I was getting younger and younger. I would become standardized in my ideas and lose all my boasted puritanical independence. And oh horror of horrors! I already liked the university girls and worse still I had a sneaking suspicion that in time I might come to tolerate the boys." [38]

Once in Paris she found a place to stay which, although it suited her purse, did not always satisfy her appetite – she grew fond of the couple whose home she shared but she found their fare a little meagre. Meanwhile, even though classes kept her busy she found time to be an enthusiastic tourist, visiting the art galleries and museums and also dating some of her fellow students. In particular, she formed a friendship with a Dutch South African, and the two of them contemplated becoming lovers – as Grace confided to her diary in an entry written in English, a departure from her usual custom of recording entries of a romantic nature in French, "What would Mother and Father say?"

However, Grace came down to earth sufficiently to decide that her friend's commitment to the relationship was not deep enough for her to – in the vernacular of the times – throw her bonnet over the windmill. Nevertheless, the pair travelled together to Germany where they met up with Charles and Belva.

Grace in her Paris flat in the winter of 1928–29. She had won a French government Scholarship to the Sorbonne during her final year of University.

Many years later Charles commented that it was a good thing nothing came of the liaison, "or they would have killed each other."[39] In Charles's opinion, the young man was very domineering.

Grace was back in Canada by late summer in 1931 to find her father ill with high blood pressure. Increasing ill health would plague Woodsworth for much of his life; overwork was partly to blame, as was his tense nature – indeed he had all the "Type A" characteristics that appear in today's medical journals and that lead to heart attacks and strokes. In addition, according to family members, not only did Woodsworth eat poorly from the standpoint of nutrition, but during the many years he travelled the country he tried to save money by eating in the cheapest restaurants and selecting the least costly items on the menu.

By September Grace had embarked on her only real teaching job, one that severely taxed her own emotional health and that proved to her that she must set herself new career goals.

On the face of it, the position of French teacher in Winnipeg initially seemed an obvious choice, a natural outcome of her recent studies at the Sorbonne. Her mandate was to teach French to local high school and elementary students, however, it wasn't long before she ran into difficulties with discipline. As Grace soon discovered, few of her students were in her class by choice, and stimulating and maintaining their interest in the French language often developed into a battle of wits that left her tired and dispirited. Her frustrations were increased because the classes were large. In the end she resigned, and such was her sense of failure that she had what family members describe as a nervous breakdown, but which was more likely a severe bout of depression. She soon recovered, but it would be many years before she "forgave" herself for falling short on a job for which, at the time, she lacked the classroom experience.

Grace's brother Bruce felt that her approach was "too intensive ... she would do her best to let [the students] know how important it was for them to learn French. They would cause trouble and Grace would probably blow her fuse and have a terrible time with herself afterwards, accusing herself. ... Grace and Mother would have long discussions ... my Mother would be philosophical and very calm. ... 'Well, Grace, try and get a little humour into it, don't try to get the whole French vocabulary learned in one day.' Her standards were too high, she expected too much of average students. Grace did a tremendous job of teaching when she got into the correct milieu for doing it, which was politics, for educating people to the line they should be taking, the same line as the CCF/NDP."[40]

Eventually her father came up with a practical solution to Grace's employment situation. He suggested that she learn to type and join him in Ottawa as his (unpaid) secretary. As she banged away in Winnipeg on the keys of a standard typewriter of that era she must have wondered when, and if, her superior education was ever going to pay off. To date, she seemed stuck in

a familiar pattern for the women of her day, teaching and office work. Granted being secretary to a Member of Parliament was a good beginning. In fact, it turned out to be like a university course in the political process and Grace's apprenticeship for her real life's work.

But she didn't know that at the time. Neither did she know that a man she had met casually the year before when she had visited her father in his office in Ottawa would become her husband before another year had passed.

Ottawa and Angus MacInnis

At the time Grace first knew Angus, he had just completed his first year in Ottawa following his election as the Independent Labour Party member of Vancouver South – later the riding was split and Angus spent his last years as an MP representing Vancouver Kingsway. He held that seat continuously for twenty-seven years, until ill health forced his retirement. One year after his death in 1964, Grace "inherited" this riding and held the seat for nine years, in the end defeated by ill health as were her husband and father before her. (A look at the lives of early CCF/NDP politicians shows only too clearly how overwork and stress shortened both their careers and their lives.)

Angus was born into a Conservative Presbyterian family on Prince Edward Island. The family had originally emigrated from the Isle of Skye off the coast of Scotland. As a child, he spoke only Gaelic until he went to school. At fourteen he had lost his father and had had to take a seven-day-a-week job driving a milk wagon to help support his family. This brought an abrupt end to his formal education, although he was always a prodigious reader and noted for his clear thinking and fiery oratory.

He moved west and arrived in B.C. in 1908. He worked as a motorman on the city's transit system, and became active in Division 101 of the Street Railwaymen's Union, at one time acting as its business agent. He retained his membership all his life.

Prior to his election to Parliament Angus was also active in civic politics in Vancouver, serving two years on the school board and four years as a councillor. He ran twice unsuccessfully for the provincial legislature before becoming a federal member. The Depression raged in North America, and in Germany Hitler was about to cast his shadow over the western world. Almost ten years had passed since J.S. had arrived on Parliament Hill, and he had finally been successful, by means of a Private Member's bill, in his bid to transfer jurisdiction over the granting of divorce from Parliament to the courts following a long and bitter parliamentary fight.

An alliance of Labour, Progressive, and farm organization members known as the Ginger Group was working to increase political pressure on the parliamentary establishment of Conservatives and Liberals to recognize the need for reform in many areas affecting ordinary people. At the same time, a number of members of the Group were working towards the formation of a new party, which would eventually become known as the Co-operative Commonwealth Federation (CCF), with a program they believed would offer voters a fairer deal along socialist lines. The term *Ginger Group* began as a nickname to designate a group of those members elected to Parliament in 1921. Although the name did not appear in the press until July 1924, it is possible and likely that it was used conversationally before that time. Members of the Ginger Group apparently showed reluctance in using the name initially. As some wags would have it, the reason for their reluctance may have stemmed from a suspicion that some people, rather than linking ginger with its natural place on the spice rack, instead chose to associate it with the rather unpleasant con-temporary practice of inducing high action in a laggardly horse by inserting ginger or a similar substance under its tail. [41]

It was not only an exciting time for Grace to join her father in his crusade for a brighter future, it was also a particularly opportune moment for her, allowing her to leave behind for good the emotional problems brought on by her experiences as a classroom teacher. Grace no doubt looked forward to her job and the possibility that she might have a role to play in planning the

new party. At the same time, it is likely that to some extent she was still emotionally vulnerable – in fact, Angus made reference to this in letters. His offer of friendship as an older man of position may well have provided her with the sense of security she needed at that time.

Given the heavy workload of the Woodsworths, father and daughter, there was little time for Grace to have a social life. As a consequence, it was perhaps not surprising that a man close at hand engaged her attention. Her serious nature and political maturity beyond her years were also in Angus's favour.

Many years later Grace talked about her initial attraction to Angus. His humble beginnings held particular appeal for her. As she explained it:

> From the very first I was taken with Angus as being one of the few original minds that I had ever encountered ... my whole life up till then had been with professional people and I was used to their "Perhapses" and "Maybes" and their fence-sitting generally ... and here was someone who knew where he stood on things and it might be wrong but at least he had the right to be wrong.
>
> I was very much aware of this and I was also very much aware of the fact that he was going through a lot of torment down there on the floor of the House because practically everybody else there had some kind of academic background ... there weren't many trade unionists or labour people in there at that time ... and all this new LSR [League for Social Reconstruction] crowd was coming along composed of Rhodes scholars or university professors ... I know that Angus suffered because he had trouble with getting grammatical English ... Angus was going through a great deal of misery and I recognized this and I recognized also that I wouldn't trade his original mind ... for any of this stuff.
>
> It was a real great enlightenment to me because I hadn't met anybody of that stripe so I guess from that point of view I was completely attracted to him.

He considered his second speech [in the House] a terrible flop and he was on the point of quitting . . . well, by that time I knew him and I guess I was pretty well hooked by that time, anyway. And so I told him that this was nonsense, that he, in my view, was very much better equipped to be in the House than most of those people were, and that practice would be all he'd need before he would be as good a speaker as any of them . . . all he needed to do was to work and have a bit of patience . . . he would ask my advice on grammatical construction . . . and procedure. He wouldn't be scared to ask me, you see, when he wouldn't want to do it with his peers.

As I came to know him I was greatly impressed with his judgement. [Over the years this became a joke between them] I may have said to him 'Angus, you are hardly ever wrong.' 'No,' he said, 'never.' I would say 'Hardly ever.' But he knew his judgement was good, like his ability to go to the heart of the matter, and his impatience with any fudging, he didn't believe in fudging.[42]

She liked his sincerity, his simplicity and his rough edges. Grace was always fond of lending a helping hand, and, in the early days, Angus was someone she could take under her wing.

As Grace "tidied up" Angus's speeches, sometimes she trod on his toes in the process, much to her chagrin. Those who knew her as a young woman commented that tact was not always Grace's strong point. Over the years she learned to be more diplomatic, but she knew that sometimes she had hurt Angus while trying to help him, and this caused her distress. Later on someone was to say of Angus that he was spare of frame and spare of words, but the words he knew, he did know how to use.

It has been said of Grace that she "married her father," but it seems more likely that she married a man she could respect as highly as her father, but who possessed special qualities of his own that she admired and loved. Her devotion and admiration survived their years together, and near the end of her life, she remarked: "One of these days Angus will be recognized. He is

much undervalued up to this point but he will be recognized one of these days as being the first person here on the [west] coast who combined representation of labour and union representation with political representation. You see, his union, like so many others, had a clause in it forbidding political action. Angus ignored that clause . . . he was a pioneer."

Grace and Angus tried to keep their growing affection a secret, although Grace was of the opinion that she didn't fool her father. They both loved walking and had their special places for secret trysts when they were in Ottawa. All year the pair exchanged numerous letters that switched easily from lover's talk to political comment. Angus liked to make a joke; both were sentimental.

Part II, Chapter 5

Courtship by Mail

Some four hundred letters exchanged between Grace and Angus MacInnis during their courtship and marriage have been made available by the family for this biography. Wherever possible throughout this section of the book, portions of these letters are quoted. The portrait of a marriage they depict unfortunately is often incomplete because many of the replies to specific letters by one partner or the other are missing. However, despite the gaps, the letters not only recount vividly the story of a political marriage that united two great friends and lovers, but also serve as links in the chain that stretched across the years between the birth of the CCF and its emergence as the mainstream political party known as the NDP.

Ninety-eight often lengthy letters trace the courtship of a couple whose love and commitment grew with a dignity that reflected morés that today seem almost forgotten. For several months during 1931 Grace took care of her brothers in the family's Winnipeg home while James and Lucy were vacationing in Europe. In fact, the couple saw little of each other during the period in which they became engaged and planned their marriage.

A July letter bearing the address of her mother's family farm in Cavan, Ontario seems to be the first "love letter" Grace ever wrote to Angus. Written before she went to Ottawa to become her father's secretary, it seems possible that what her parents saw as a solution to an employment problem happened to fit neatly into Grace's wish to see more of Angus. She wrote:

Dearest:

Here I am in Peterborough at 8 a.m. My cousin Ralph – a rather handsome young giant – has driven in with a load of veal and was good enough to invite me. And I want to send you just one word – just to say I missed you last night. It was so cool and fragrant – clover and hay and a new moon and darkness and everything that heart could wish except you, Mac.

The trip down was fine... off at Port Hope in the dawn. I walked down to the shore of Lake Ontario and watched a little fishing boat bobbing up and down on the waves while I ate that lovely big orange you gave me. Everything was so fresh and free – and I wanted you – just you – to make it perfect.

Dear, as a first love letter this can scarcely be called a success. But farms and writing don't do well together... what is there to say except that I'm thinking of you always. Good-bye, dear,

<div align="right">Your Grace</div>

The letters spoke touchingly of a growing love that gradually reached deeper levels of understanding of each other's needs and personalities. Although the proprieties were observed as was commonplace at that time, their exchanges were never prim. Their leisurely exploration of shared intellectual and political interests, written in days before the telephone and the fax machine took over our lives, were not only interesting, but were also remarkable in light of the couple's twenty-one-year age difference and their freedom from gender bias.

Shortly after her birthday on July 25, 1931, Grace, acknowledging a card from Angus wrote:

Of course I'm wishing you were here – especially a night like this when a glorious full moon is silvering the trees and making shadows along the road. Just the odd mosquito serves to remind one of Ottawa and the driveway where we spent many a happy hour....

Of course there are many people who must suspect us. . . . Father wrote a great, long letter saying he missed me, and it didn't seem nice to be alone. He too told me of going out to lunch with you – with "Mac" as he rather significantly said. Love may be blind but Father isn't.

Just imagine being loved by a famous man who is hero-worshipped by all sorts of people. It's nearly enough to ruin one!

Angus wrote the second week in August from Kamloops, B.C. He was travelling by train to Vancouver and, en route, had stopped off briefly to see Grace in Winnipeg. She was back in her parents' home after her visit in Cavan. Among other things he commented on the unemployed in Kamloops:

Angus MacInnis in 1938 when he was CCF MP for Vancouver Kingsway, a riding he represented for twenty-seven years.

Although this is a town of only 5,000 - 6,000 people they have about 500 unemployed. They have the "Jungle" [relief camps] here also. I saw some of the unemployed in the park, and they were real fine young fellows for the most part. . . .

Dear, I miss you. Everything almost reminds me of you. If there is anything nice I like to share it with you. If it is pretty I would like you to see it.

Within hours Angus was writing to Grace again:

I told you I would write when I arrived home, but while telling you that, here I am a little more than twelve hours later wishing I were talking to you again rather than writing, and that I could feel your little hand on my arm, that little hand that was hardly ever still, but kept feeling its way like a little blind thing for a more intimate resting place. I loved it.

Last night did, however, tell me one thing which I was never sure of before, that is, that you love me. I feel sure now, and I also feel sure that I love you. I never loved you so much, or wanted you so much as I did last night. . . . Oh you looked so nice! There now, that is more love by ninety-nine per cent than I ever put in a letter before. I am almost afraid to drop it in the letter box.

All my love is yours till we meet again,

Mac

Grace appears to have replied by return and, as was often the case in their letters, romance and politics followed one after the other, with hardly a pause:

How lovely it would be to see you opening the gate . . . I can shut my eyes and see you as you were at the meeting – strong and sincere. And no-one there but me knew how human and lovable the speaker could be. . . .

It's amazing to think of all these cities with growing "Jungles." We're really watching the beginnings of the

underworld in Canada. A friend of ours – a social service worker – was around today. Always an optimist, she nevertheless is full of forebodings for next winter. Yesterday three bank bandits were given heavy sentences here. . . .

Please be reserved and dignified with anyone you like but me. Mostly when you are about with me I forget about being grown-up. Tonight I would certainly muss your hair if you were here

In September Grace wrote to Angus of how the Depression was affecting Winnipeg:

The CPR shops have closed indefinitely . . . the relief work commenced is only a drop in the bucket and things look serious. Only today a little Roumanian was around here to see Father (who was away). He told me Father had married him in 1906. He fixed roofs but had no work now. He was a nice, open sort of chap and said cheerfully: "I no want relief. Relief no good. I can work. I want job." Really you could imagine so easily how a winter of unemployment will break him – make him shiftless and bitter. Talk about our having regard for human life! One could laugh if it weren't so terrible.

Another month would pass before Angus would read Grace's commentary about conditions in Winnipeg. This was only August and Angus wrote from Vancouver:

What a pleasure it was to read of all the love for me and so prettily expressed . . . but you are such a little flatterer. However, you seem so – and I am sure are – frank, and so truthful, that I even like the flattering.

After breakfast I unpacked and put Grace's photo on my dresser. Mother asked me who the lady was. I said "Someone you have not met yet." She said that she looked nice. Christine [his sister] knew she was one of the Woodsworth girls. . . .

Angus, perhaps because of shyness, sometimes referred to Grace in the third person in his letters to her. He had "introduced"

Grace by mail to his family in Vancouver. Their possible reaction to the couple's intended marriage was of particular concern to him because of his role as head of the family since his father's death. It was a closeness and responsibility that was to extend through much of his married life, and a role that Grace took over after his death. It was a responsibility that Grace willingly shared, and eventually she and Angus would come to enjoy the younger members of his family as they might have grandchildren. The previous letter continued:

> We had a wonderful good meeting Sunday night. I do not know where all the people came from but one man told me he drove 50 miles to attend the meeting.
>
> We also had a good meeting at Kelowna. We had a lot of questions at both meetings and they were very well pleased with the way I answered them. . . .
>
> I feel sometimes that I was not as kind as I might or should have been with you, but you are kind and I know you will make allowances. You are my greatest inspiration, and I am so glad you are not going to worry till we meet. . . .

Angus, who, after all, had been a single man for more than forty years when he met Grace, had a number of women friends. He did not give them up for Grace either then or later on. They became something of a joke between them – in later years Grace, who was always mindful of where their money went, sometimes encouraged Angus to seek out a woman friend in the hopes she might give him a meal – although it isn't clear whether her motivation was in seeing that her husband got a good meal when he was away from home, or to save pennies.

> [Angus] I can see you coming along Broadway [in Winnipeg] to meet me. How nice it was to meet you and how nice you were to me after we met. Then the restaurant. You were set on making sure that I would not eat too much.
>
> I was never sure whether you were afraid I would spend too much on the meal or you thought a hearty meal

might interfere with my talk. In any case your interest was appreciated. You were a comfortable person to be with on almost all occasions. . . .

[Grace] When will you learn that I cannot be jealous when I'm so happy. It would make me quite miserable if you became any less friendly with the women friends you have. But then I know you're poking gentle fun at me anyway. . . .

What prompted this response from Angus isn't clear, but the question of his lady friends evidently did occasionally arouse some misgivings on Grace's part:

I was not thinking altogether of you when I mentioned other lady friends. You would be sensible I know. But then there is me and also the others. You are not the only one who likes to be petted but you are the only one I want to pet at the moment.

For many reasons I like to be friendly, for many or one good reason I do not wish to be intimate. I know you won't be jealous dear, but do you remember I told you when walking with Miss Morrison on the Driveway that I was particular not to sit on the seat you and I used to sit on. . . .

While their letters switched easily between romance and politics, in Grace's case her letters seemed to combine two separate styles – her youth betrayed her when it came to writing of love, but, where politics were concerned, her writing displayed unusual maturity. Angus found this combination was part of Grace's appeal for him. It aroused a simultaneous reaction of tenderness and respect: tenderness in the romantic sense, and respect for both her natural talents and her superior education.

Yesterday morning I attended a convention of sorts and after listening to the confusion of tongues in connection with the most simple things I am driven reluctantly but irresistibly to the conclusion that a dictatorship will be

necessary to bring order out of the chaos which is upon us now, and almost inevitably will become worse. . . .

There was a little incident which reminded me of you – not that it was necessary for anything to remind me of you as I am thinking of you almost always. In fact, . . . when the organizer was giving his report he said he would like to have a French speaker for a district near Vancouver where there are a number of French-speaking people. Would you not fit in there nicely? And how proud I would feel about you. . . .

With love, Mac

[Later on, from Ottawa.] I miss you so much. For the last few days I have been thinking for some reason of the days after you left Ottawa. How mournful the chimes of the Tower clock sounded. I did not seem to notice them before, but after you left I heard them so distinctly, and they positively made my angry.

I remember walking home with Miss [Agnes] Macphail and Mr. [Robert] Coote one night earlier in the session and we were discussing our reactions to the chimes. Mr. Coote said they annoyed him. I said that when I was working I did not hear them and when I wanted to listen I liked them. Miss Macphail liked the way I put it and said it was just the way it affected her. . . .

[Back in Vancouver.] I have just come in from a lovely walk . . . Clinker [his dog] and I went up Little Mountain. . . . We walked, I mean Clinker and me, rather smartly all the time . . . it is the highest point in Vancouver and when one gets to the top one can look all over the City. It looked very nice tonight, although it is a little smoky on account of forest fires. . . . I think Clinker would like you too. . . .

Goodnight my love, Mac

[Two days later from Vancouver.] I have just had a call from the secretary of the Friends of the Soviet Union asking me to speak at their next meeting. This is supposed

to be a non-partisan organization, but I know it was formed by the Communist Party. I had a mind to decline at first, but I thought that would not be showing much courage. They love me about as well as a cat likes soap, so it will be interesting to see what their reaction will be to my appearing there. . . .

[On September 1.] I almost feel afraid of you now. How competent one must feel to be able to mop floors, mend stockings, make pies, roast meat, prepare and cook vegetables, review books, write articles in at least two languages, make speeches also in two languages, teach French, play the piano, enjoy music and literature and I don't know how many other things. The more I think of it the more nervous I become. . . .

[and from Grace, also dated September 1.] Could you offer any suggestions as to a discussion on tariffs? The Winnipeg WIL has asked me to be responsible for an evening on the subject. I thought of having three or four young people talk on the subject . . . should one confine it to Canadian tariffs, or would it be well to discuss the subject from the international angle?

[Angus, in reply.] The tariff question, I think Grace, should be discussed from the international point of view. Tariffs have very definite international implications. It seems to me that a good way to approach the subject would be to begin with Great Britain as the world's foremost free trade country. The reason being, of course, that when this free trade policy was adopted Great Britain had an advantage in manufacturing because of the advanced state of her industries at that time.

She also had markets in all parts of the world for her manufactured products. She also had to get her raw materials from other countries . . . At the moment, I do not think it is possible to take the position that tariffs are wholly unnecessary. However, rather than having each nation raising its tariff to protect its industry from

> competition from outside – like, shall I say, the United
> States, who feel they can do without the rest of the world,
> or like Canada raising her customs duties to some extent in
> reprisal, it would be better to arrange tariffs by mutual
> agreement. The worst features of tariffs, in my opinion, are
> not economic but political. . . .

During this period Grace made her debut as a public speaker
and soon gained recognition and a position on the political ladder.
The *Vancouver Sun* of September 11, under a Winnipeg dateline,
reported: "Miss Grace Woodsworth, daughter of J.S. Woodsworth,
Labour Member of Parliament for Winnipeg North Centre, made
her debut last night as a political speaker at a branch meeting of
the Independent Labour Party. . . . Speaking briskly and eloquently,
Miss Woodsworth reviewed the proceedings of the Ottawa House
and roused her audience with sallies at several prominent
parliamentarians: 'When Premier [R.B.] Bennett talked glibly
before his election about there being no occasion for
unemployment,' she said, 'he did not know what he was saying.
He did not know his economics.'"

Grace also confided to Angus about her relationship with
her brothers. She felt her position as eldest in the family, and the
attendant responsibility it had placed upon her in the past to take
charge, had led to some hostility on their part. Now her brothers
were older she believed a closer relationship was possible. Angus
encouraged her in this and to overcome her tendency to be overly
self-critical. He wrote:

> Oh, it is nice to know you are getting on so well with the
> boys. Perhaps they have always liked you, only very
> young people cannot show their likes and dislikes without
> being demonstrative. Then, again, you are growing older –
> you have changed in the short time I have known
> you – and women acquire a sort of gentleness of approach
> as they grow older (men do, too) and I think if environment
> is favourable to its growth it becomes a lovable characteristic
> of our lives. You must remember also that the boys are very
> dependent on you now and that you take the place of

mother, and what is more natural than that they should assume towards you that attitude they would naturally take with their mother. I envy the boys seeing so much of you.

> With love to my Grace, yours Angus

Because of their age difference, Angus sometimes worried about their prospects:

> To be quite frank, I, too, am almost unnerved at times by the immensity of the prospect before us. I think mostly of you. You are yet so young and have a right to demand so much of life. You have not got into the "what does it matter?" attitude that men sometimes get into but, possibly, never women. For me it is "never kick about what fate brings, it might be worse." Do not think I have any misgivings as to your worth. If anything I might wish it was not so great. . . .

Another topic that surfaced during this period was Japanese Canadians, a subject for which the couple would become well-known when they championed their cause during the Second World War.

> [Grace] It was good to hear about your Japanese meeting. Father will be so pleased to hear about it. It is great when Japanese people can tell you that you make them feel you are one of them. If some of the labour members like yourself could really get across to the foreign nationalities in Canada, we could use this as an entirely new source of support. For, as yet, the old parties have not taken the trouble to even pretend to be interested in them for their own sake. . . .

The Woodsworth shamrock plant was first mentioned in one of Grace's letters at this time. The plant was a symbol of this close-knit family. Originally given to Lucy by James during their courtship at the turn of the century, it had weathered the moves and continued to flourish in the family home in Winnipeg in 1931. Twelve years later some of it was to be scattered with Woodsworth's

ashes on the Gulf of Georgia. Many years later, a shoot from it flourished on Grace's desk in Parliament, and, to this day, three "descendants" continue to grow: one in Ottawa in the home of Kalmen Kaplansky, later International Affairs Director of the Canadian Labour Congress; another in Peterborough in the apartment of Maureen Staples, Ralph and Belva's daughter; and a third belongs to Margaret Mitchell, former MP for Vancouver East. The plant serves as a charming reminder of the party's will to survive, a permanent reminder of Canadian socialism's beginnings, and of its indomitable founder and his Irish partner.

As summer turned to fall, Grace continued her romantic dreams:

> You say you indulged in folly when you kissed my picture before going out to visit your farm. Of course it was foolish! Just as foolish as when I took your letter with me for company yesterday afternoon when I was out walking in the rain. It was a walk with nothing more romantic in view than to buy a couple of tins of salmon and some raisin bread for tea.

Grace and Angus discussed in their letters the possibility of her seeking a nomination. Grace's thoughts about public life – her desire to become part of it and what she would do about it – were in the distant future. It was the Depression, and, after discussion, the pair decided it was inappropriate for two members of the same family to be paid as politicians.

> [Grace] Your remarks about nominations may not be so far-fetched after all. Mr. Heaps and Mr. Ivens were, to my amazement, talking quite seriously of the possibility of having me run for a provincial seat. Of course I have not said a word to anyone but you, for to me the whole idea is far-fetched. To consider running, one ought, in my opinion, to have had considerable experience in a very small field – and, of course, to have a good working knowledge of economics. But the question again comes up as to what sort of life I ought to plan to lead with you. Do you think I should plan to go into politics in a public way (always

supposing I had the ability)? Or do you think I should write or do organizational work in a small way? Or should I continue with the secretarial line? Or should I go in for something entirely different like tutoring? We have never really discussed this problem seriously.

What would make me happiest would be to feel that I was making the fullest and best possible contribution to our partnership – whatever that happened to be.

Angus replied:

With the standing that would naturally come to you as the daughter of J.S. Woodsworth and improved by your own personality and talents there is nothing in the form of public preferment that you could not reasonably hope for from the people of Winnipeg, and possibly from the people of Vancouver. We cannot very well discuss your future in letters.

In retrospect, it's a wonder he and Grace managed to claim this year for themselves, albeit by correspondence for the most part, and somehow fitted into Angus's tours and Grace's domestic responsibilities. They were just in time because, by the following year, their lives were swallowed up forever by their political destinies. However, it wasn't romance that engaged Grace's attention in a letter she wrote on the last day of September:

Charles was hoping to be sent up to report the Estevan [Saskatchewan] situation, [coal miners seeking unionization] but the paper evidently decided to wait for further developments. It is a shocking situation – two miners dead [three, it was eventually reported] and two more dying after being fired upon by the police who said, or are reported to have said, that they had fired when all other means of obtaining law and order had failed. It would seem as if there were other means – such as improving conditions of work and wages, for example. If this is a sample of how the Bennett Relief Act is going to work out – well, they cannot call the next session too quickly for

you and Father and the rest to give publicity to the facts. . . . Having made this fine, impersonal start, you cannot accuse me of letting my Irish blarney offend your noble Scottish pride. I cannot promise that the reformation will be permanent. . . .

She continues with a paragraph that trips cheerfully from politics to domesticity, and finishes in romantic vein:

If you were here with me in the kitchen this afternoon you would find several things in progress. From time to time I rise to stir a kettle of what I hope is to be grape jelly. I did it this morning and had it all in the jars before I found it had decided not to jell. So, after mumbling several rather uncomplimentary things to the world in general, and myself in particular, I thought it wise to start all over again. . . . Then there is a pan of baked apples beside it on the stove, cooling for supper.

Beside me is the stocking basket, for I have just finished darning this week's supplies. . . . This is the night I speak at the Fort Rouge Labour Hall. . . . Do you remember once you led me into asking you if this love was a sort of Indian Summer for you? You said yes, but I know you will not feel that way about it now. It made me feel as if there were all sorts of very sad experiences behind your reply. Perhaps some day you will manage to change the sadness into a sort of misty regret that is really not sad at all, but only a remembered sadness, which is rather pleasant when one is happy at the time of remembering. . . .

By early October Angus was on a visit to Seattle, Washington, where he had two sisters. In reply to Grace's comments on the situation in Estevan he wrote:

I spoke to a meeting last Monday night in Malliardville, that is a village near New Westminster. The population is mostly workers in the sawmills there. At the present time the workers are on strike. They have been organized by communists. We had a well attended meeting. The

communists were out in force . . . we got a good hearing while we were talking but when the questions began it would make your heart sick to hear the silly questions and assertions. These people lie as a matter of considered policy. . . .

Grace, for her part, at times liked to air her literary knowledge:

As a role model I feel that I shall have to take Disraeli's wife. She was a sort of simple creature who kept most of the society women amused by her social errors and her ability to do some naïve thing when she was supposed to be dignified. But she had enough intelligence to know that she had a brilliant husband, and she made it her chief business in life to look after his comfort. When he was late at the House of Commons she always waited for him, and he knew enough about psychology not to send her home early. And, strangely enough, he was quite upset when she died, for he found her more amusing and more satisfyingly human than most of the great with whom he was daily thrown into contact. . . .

Grace finally gave her talk on tariffs and trade and wrote to share her experience:

It was very well received and provoked discussion. If I do say it, we had spent a lot of time on it – an examination of Free Trade, its causes, history, and decline with the reasons, tariffs, with a discussion of how the manufacturers are the only ones to benefit, and of how the dislocation causes world depression, etc., and finally the socialist solution of trade by international agreements. It seemed to me to be quite well worked out and as radical as I could make it. Well, some of the labour people got up when I had finished and pointed out that by studying the capitalist solutions for trade, I was bolstering up the system, and seeking to help get rid of the trouble for "our masters" . . . they got quite worked up, and I sat and tried not to look as irritated as I felt.

But a few days later, politics were put aside and Grace was enjoying the lighter side of life:

Our Sundays are the queerest things. It's the one day in the week when our individualities seem to come out in strong relief. Just now it's three o'clock on a grey, rainy afternoon. Charles is up in his room doing some constitutional history and, no doubt, wishing the exams were further away. Out in the kitchen are the other three boys. Ralph is sitting on the kitchen cabinet, doing some wood-carving. Bruce, with text-book and hunting-knife, is skinning a grouse that Howard found in the woods the other day. Howard is, of course, offering all kinds of advice as the work proceeds. . . .

Last night we gave quite a party. There were nearly thirty people here, counting ourselves. It was a successful evening, and the proof is that we did not get to bed till nearly four o'clock this morning. For me the highlight of the evening was a few moments' conversation I had with a Jewish reporter who works on the same paper as Charles. Our talk turned on philosophy, and there was that electric current that comes when two minds find that they understand each other. To me that is almost the most thrilling experience. (I say "almost" for there is one greater experience. That is when two personalities find they understand each other, not only mentally, but physically and morally as well.)

In a letter written in mid-November, Angus touched on Grace's need for equality in a relationship:

My first impression of you was very favourable, I mean the first time we had dinner together I felt that here was a woman who, if she wanted the company of men at all, wanted it on an equality basis. And if there is any quality I like in a person more than any other is that of insistence in taking a full share of all obligations. For such a person

I would do anything within reason ... after that it was easy to like you ... from liking you to loving you was only a step. I am also sure that if we are happy it will not be any half-hearted happiness. I think we are both capable of giving all or none.

Their wedding day was set for January 23, 1932, but her parents' extended stay in Europe kept Grace in Winnipeg looking after the boys and unable to visit Angus on the coast as she had hoped. Meanwhile, looking beyond herself and her own happiness, Grace became more aware than ever of how the Depression was affecting some of her neighbours. She resolved that she and Angus would act to improve conditions and to adopt a lifestyle that would keep them in touch with those who needed help:

The world is wrapped in a blanket of white this morning and the north wind is whirling the snow flakes around, as if it were trying to start up a blizzard to frighten us. Instead the white curtain seems the coziest sort of thing, shutting us off from the rest of the city, and making this house into a sort of warm little refuge. And then one thinks of all the miserable houses in the city where people are cold and hungry today. Dear, there is nothing in the whole world that I want you to do except to try all you life to do away with the cruel ignorance and indifference which make life into such a hideous thing for so many people. Pioneer conditions on the prairies were hard, but there was always the knowledge that given time and strength one could conquer even the climate and the soil of the bare plains. But here today the people have had their tools taken from them and have nothing to do except to huddle together miserably or else accept some degree of food and shelter from people who regard it as a sort of disease to ask for these things. Dear, we must always live as simply as possible so that we may always remain keenly alive to the suffering around us.

Like many people on the point of marriage, Grace was on edge and wondered if Angus was truly committed – the fact that

Angus still hadn't told his family of their intentions may have contributed to those feelings. In fact, Angus waited until Christmas Day to tell them.

> If you feel, even now, that marriage is an unwise step for you, you must tell me. It would be so easy to postpone it indefinitely, and gradually let it slide. And, in the meantime, I think I have developed to the point of being able to consider another possible relationship with you. I cannot say that I would prefer it – yet, but in time it might be so. You have always treated me on such a perfect basis of equality, that I feel I must be equally frank with you. The last thing I want to do is to take away that freedom which is one of the things I have most loved about you. At a distance you are possibly more able to form a reasoned decision. Certainly I am. As to the possibility of carrying out the alternative proposition – perhaps you could leave the ways and means to me. . . . I know you just well enough, Dear, to feel sure that you will take this in the spirit in which it is meant, and will feel how sincerely I mean every word of it. I think I love you enough to mean it.

Angus replied four days later, with quiet eloquence, and the moment he received Grace's letter of December 3:

> I would be proud to have you as a friend let alone to have your love. May I repeat a sentence of your letter of this morning: "This morning I love you more than ever – almost enough to be unselfish about it myself." That expresses my feeling exactly. However, love, my dear, is never unselfish, and that is the reason I cannot be absolutely unselfish now. I have said so often to you that, as far as I am concerned, I feel I am making no sacrifice. I wish I could feel so easy in my mind about you.
>
> If ever I think our marriage would be an unwise thing to do it is always because of you and never of myself. I mean by that I am old enough not to expect too much of life; and man anyway is more philosophical than woman. Romance does not mean so much to us, and when

realization does not come up to our anticipations we console ourselves with the attitude that we did not expect anything otherwise. I have no fear that I would have any disillusionment as far as you are concerned. . . . Now, as to the alternative relationship. At one time that would have been possible. That was before I knew you well enough to appreciate what a lovely nature yours is. Now I do not wish it, although I forget myself when I am with you.

It is not the morality of the situation that would prevent me, but my love for you, strange as that may seem. I am not unmindful of the physical basis of love, and I know that attracts me to you. I love you so that to accept you on any other basis than that of permanence I would consider quite unworthy. With a relationship of that kind one is never the same again.

Lovingly, Your Angus

In Grace's reply she quoted from Browning's "Rabbi Ben Ezra," noting that she copied it from her mother's book of poems: "On looking over Mother's copy of Browning," wrote Grace, "I find a number of passages sidelined 'J.' I've seen it before but never realized that years ago she found that Browning expressed best of all what she and Father thought."

Not for such hopes and fears
Annulling youth's brief years,
Do I remonstrate: folly wide the mark!
Rather I prize the doubt
Low kinds exist without,
Finished and finite clods, untroubled by a spark.

Angus recommended a book to Grace on women and equality. His views on this subject were, of course, remarkable for a man of his times. Grace shared them absolutely as time would show when she became a parliamentarian:

Did you ever read Oliver Schreiner's book *Woman and Labour?* If not you must read it . . . the book was published in 1911, but the point of view is new and it is unusual. Her

logic has compelled me to modify some of my views. Her chief point is that all civilizations perish when the women of that civilization degenerate from living without working. After stating a number of things that women do not ask for she put the demands for "Woman's Rights" better than I have heard them put before. It is short and I will quote it for you: "We demand that, in that strange and new world that is rising alike upon the man and the woman, where nothing is as it was, and all things are assuming new shapes and relations, that in this new world we also shall have our share of honoured and socially useful human toil, our full half of the labour of the Children of Woman. We demand nothing more than this, and we will take nothing less. *This is our 'WOMAN'S RIGHTS.'*"

A more profound reason for Grace's edginess emerged in a letter she wrote shortly before her parents' return just before Christmas. Its contents reveal the depth of her trust in Angus, especially in view of society's inhibitions about discussing such personal matters as birth control* with anyone, let alone a fiancé, in those days. It seems that despite her mother's frankness with her as a child about "the facts of life," and after having read, at Angus's suggestion, Dr. Marie Stopes's book on the subject, she remained deeply concerned. The reason dated back to two incidents that had occurred in her youth.

Unmarried but pregnant girls who had occasionally helped her mother at Gibson's had – as Grace put it – made her "rather morbidly interested in the question and quite resolved to avoid the misfortune at all costs." Next, she had read Upton Sinclair's *The Jungle*, which, she wrote:

> has a realistic description of a poor European woman who gives birth to a child amid scenes of extreme sordidness and poverty. Both she and the child die – the woman after

* At that time dissemination of birth control information and contraceptives was still illegal in Canada and could lead to a prison sentence.

intense and horrible suffering. No book that I have ever read has made a deeper impression on me. For years the fear of having a child was the greatest of all my fears – so great that I never spoke of it to a soul. It had underlaid the greater part of what the boys call my "Puritanism." And it is still there.

The current problem for Grace, as she saw it , was her ignorance about having "a satisfying sex life without the constant risk of conception." Such was her anxiety that she felt unable to wait for the imminent return of her mother, whom she knew she could rely on for frank advice. She wanted more immediate reassurance. Her sense of isolation was likely heightened by living in a household of brothers.

I know perfectly well that women simply do not discuss this question ahead of time, and I can only conclude that it is because such frankness is distasteful to either them or their husband-to-be. But you, Angus, seem to have more understanding than a man – to have a compound of both man's and woman's understanding. I am not afraid of you and mostly I am not afraid of what you will think of me for being so frank and bothersome.

Grace displayed great courage as well as trust in this letter. Later on, in Parliament, it became a matter of course for her to "bother" her fellow MPs, generally all men, about issues such as dissemination of birth control information, and removing abortion from the criminal code. She empathized all too well with what women suffered in this connection.

Her trust was justified, and Angus replied by return the same day as her parents arrived home.

Any man would indeed be proud to receive such a letter as I received from you this morning. I am replying to your letter without delay, although I have other important things to do. First because I would rather write to you than do anything else. . . . I can well realize how excited you must be with the homecoming of your father and mother

and then our approaching affair, too. You must not allow
yourself to become unduly excited. However, with your
mother home now she will take care of you . . . the matter
you referred to in your letter need not be discussed now.
I appreciated so much your confiding in me – but whatever
you do, do not worry over it. I shall understand.

Angus went on to say he did not want Grace to keep house
for him: "we shall keep house together. I want us to be partners in
what we do to the utmost limit." He also wanted to know if he
should order a suit for the wedding – neither he nor Grace was
overly concerned about fashion, and a family friend made Grace's
wedding dress. As to Grace's choice of a civil wedding presided
over by family friend Judge Lewis St. George Stubbs, he was
delighted.

Bless your dear heart, Grace! I am glad you have decided
on a civil ceremony. Stick to it whatever happens. Preachers
and doctors in their official capacity I despise, or maybe,
abhor and detest would be a better word.

When her parents arrived home, Grace's father lost no time
in getting down to business. By five o'clock on the day of his
arrival, she wrote to Angus, he already had her dealing with
outstanding correspondence and straightening out the family
accounts. "This morning I typed out a list of his engagements for
the month of January – far, far too many. He seems to be taking on
so much work that he will lose the benefit of the holiday."

As the wedding day approached, it was decided that, since
the next parliamentary session was slated for February 4, the
couple would head for Ottawa by train straight from a reception
of some fifty friends and relatives to be held at the Woodsworth
family home on Maryland Street in Winnipeg. Before that, each
of them spent Christmas with their respective families. Angus
reported that his news about his forthcoming marriage aroused
little comment except from his sister Christine, who "smiled
broadly and said 'Thank God! I won't have to go to places now'"
– presumably in the role of an escort.

Angus sent Grace a jade pendant for Christmas. This followed his asking her what she wanted as a gift. Grace had replied that she would like a ring, and this may well have confused Angus as she had scoffed at his previous offer of an engagement ring. As she had pointed out at the time, what would she have done with such a ring if she had had it, since they had kept their engagement secret for such a long time? It is not clear why Grace now wanted a ring; in any case, a pendant was what she received and no record exists as to whether she ever received an engagement ring.

The final letter of the year came from Angus, and it included a copy of one mailed to Judge Stubbs seeking his assistance at the wedding. The couple could hardly wait for the New Year – 1932 and a home together in Ottawa. Their permanent address would, of course, be in Augus's home riding of Vancouver.

Part II, Chapter 6

Building a Marriage, Building a Party

Had Grace's parents opposed the marriage she probably would have gone ahead anyway, given her independent nature. All the same, she was likely happy to receive the blessing from her mother which came in the mail shortly before her parents' return from abroad. The matter of the couple's age difference didn't arise, but her father, although pleased about the forthcoming union and despite his admiration for his future son-in-law's character and intelligence, did wonder whether the relationship might suffer because of Angus's lack of formal education. As it turned out, "suffer" was too strong a word; however it was a sensitive area between them, especially in the early days of their marriage.

Her mother's letter, incidentally, showed that Grace was not the only romantic in the family:

> There's nothing in the world to take the place of love and Belva's letter to you . . . made me realize how happy you are during these happy months. Perhaps I should be subdued over the thought that I shall not be able to have you with me in the home . . . how I have enjoyed your companionship. I was going to say, though, that I could not feel other than happy to think that to you has come the highest that life can offer in the way of happiness. You know that subconsciously I have developed this feeling – when I meet a woman who is alone. I always wish that she had a husband, a real husband, of course, because it is such

a pleasure to enjoy everything together. Oh now, I am not thinking in the romantic vein. I am thinking of 27 years of companionship with a man, a gentleman. So if you are really lovers – I can only say as you think of faring forth together into life – you ought to be happy in each other. Of course, marriage is no place for *laissez faire*. It requires determination on the part of each to let nothing mar the comradeship. If anything does then it is the first duty of each to make everything right again. Do you know the little verse from Elizabeth Barrett Browning? I sent it to Father before we were married but I cannot quote it exactly today . . . [43]

Beloved let us love so well
Our work shall still be better for our love
And still our love be sweeter for our work
And each commended for the sake of each
To all true workers and true lovers born . . .

A little over three weeks before their wedding day, Grace and Angus celebrated New Year's Day 1932 as they had Christmas, by mail. Despite their excitement over the coming wedding their joy must have been tempered by signs of the Depression that were all around them. Angus, for example, rented out a little farm he had in Burquitlam (New Westminster, B.C.) to a young couple who were destitute because of the economy – years passed before these tenants were able to pay rent. He had acquired the farm to indulge his fondness for chickens, a hobby that was not shared by his bride-to-be, who detested the noisy creatures.

More immediately, the year 1932 signified for Grace and Angus the formal beginning of their political partnership. Their marriage early in the year established them as a team, and, before summer was over, they were caught up in the first stirrings of a new Canadian political party. On August 1 Angus attended a meeting in Calgary with other independent and socialist members of the League for Social Reconstruction (LSR). The largest of the other groups present was the United Farmers of Alberta (UFA) which dominated the Ginger Group in Parliament. Others

included: the United Farmers of Canada (Saskatchewan section); the Socialist Party of Canada, with four members in the B.C. Legislature and Angus in Parliament; the Canadian Labour Party; the Dominion Labour Party, the Independent Labour Party; and the Canadian Brotherhood of Railway Employees (CBRE). Together, the people in this loose federation of socialist and farm groups created a new political party, the Co-operative Commonwealth Federation – the CCF. Grace's father was voted in as its first president, and Angus was named as one of the provisional officers.

The Calgary Conference, a precursor to the CCF's founding convention the following year, issued a one-page, eight-point statement, and afterwards the executive, chaired by Woodsworth, and including Angus, set to work on the follow-up conference in 1933 when the objectives of the CCF would be spelled out in the Regina Manifesto.

The Calgary program, as it came to be known, called for "evolutionary and peaceful means to guide society toward an

Grace and Angus revive fond memories of their courting days sitting together on the bench they often shared when they were still trying to keep their romance secret.

emphasis on human needs instead of the making of profit, and to limit the action of speculators." Reflecting a collective critique of an excessively individualistic society, it urged the establishment of a state-sponsored welfare program to aid less affluent Canadians, proposing the extension of social legislation to provide "public insurance against the hardships of unemployment, old age, accident, illness and crop failures." It called for "an active and interventionist state that would replace the present economic chaos with a planned system of social economy for the production, distribution and exchange of all goods and services."

International relations and federal-provincial relations were not covered at all, and, just as was the Regina Manifesto the following year, it was an expression "of a moderate form of socialism with emphasis on a greater use of government planning, increasing social ownership within the confines of a mixed economy, balancing public and private ownership and, above all, willingness to pursue a peaceful and evolutionary path."

Grace was not among the 131 people who attended this conference; she was home in Vancouver recovering from a tour during which she had visited forty-five places in as many days. Nonetheless, she shared Angus's pleasure about the new organization. He had told her "they wouldn't get any place until they got some kind of amalgamation . . ." and he felt the country "was ripe for some kind of socialist party" as had become evident in western Canada following the Winnipeg Strike years before.

Grace later pointed out that at the time of the Calgary Conference "there were a lot of experienced Britishers and they could, and probably did help with the organization . . . what we got were the convinced socialists and the people that were Christians and wanted to see Christianity put into practice . . . and the kind that had shown on the Prairies that they were capable of building a life for themselves with very little but their own hands to go on with."

Describing the somewhat confusing events that had led up to the Calgary Conference (which was really a western conference) Angus once wrote:

In the federal election of 1921 the farmers of Canada, organized as a progressive party, sent 65 members to Ottawa. Labour parties elected two members – J.S. Woodsworth from Winnipeg and William Irvine from Calgary. It soon became apparent that most of the Progressives did not know what they wanted or how to go about getting it. The result was that the great majority of them drifted back to the Liberals and Conservatives from whence they came. A few – 15 or so – most from Western Canada, felt that their difficulties were closely associated with the operation of the capitalist system. These members formed a loose alliance with the two Labour members and they worked together in the House of Commons for many years.[44]

However, at the time of Grace and Angus's wedding in January 1932, the Calgary Conference was six months away, and letters between the couple as the new year dawned were far more concerned with the approaching ceremony than with the historic events of which they were soon to be such an important part. Grace wrote:

> Sometimes the whole thing seems like a dream. At other times I feel such a throbbing, real sense of wanting you. I went to bed just before midnight and heard the New Year come in. How I should have loved to penetrate for one moment the secrets of what this year holds for us! But no, it is better this way. . . . How much more wonderful this experience of love is than I could have possibly imagined. I thought before I knew what it was, but never was it like this.

> [from Angus, also on January 1] I do not know if it is good form for a Member of Parliament to write his love letters on House of Commons stationery, but I am going to risk it this time. [Angus was a particularly scrupulous politician where expenses were concerned and throughout his life

In 1935 Grace and Angus visited the farm where he was born. Grace is seen here enjoying a walk in the woods.

was among the few who regularly tithed, that is, gave 10 per cent of his income to his party's coffers.] Did you go out on New Year's Eve? I went to bed about eleven and if there was any racket I didn't hear it ... seems strange to be going away [from his Vancouver home]. Next time I come back the old place will be home no longer. I shall come only as a visitor.

On January 12 the engagement notice appeared, with pictures, on the front page of *The Vancouver Sun* and also in the Winnipeg papers. The announcement brought him into the spotlight his shy nature had sought for so long to avoid; as he readily admitted, this was the main reason he had put off telling even his family about a love that plainly meant everything to him.

So now you have done it. I was in hope that I would be safely out of Vancouver before it [the news of the engagement] broke, but it was surely broadcast last night. You remember me speaking of Miss Moren. She gave me a nice little picture for Christmas. With that, and also on account of our being close friends for a number of years, I thought it would be nice to tell her before I left.

So last evening we made an appointment to have dinner together. We were sitting at the table in the restaurant talking about your father and his articles on Russia when the radio, which had been going on all the time, blared out the announcement of our engagement. I blushed most profusely, but Miss Moren, who was not particularly listening to the radio, did not get the purport of what was said, only having caught your father's name and mine.

She wanted to know what it was about but I would not tell her until I had finished dinner. She was pleased and is looking forward to meeting you when you come to Vancouver.

Evidently Angus was once engaged to Miss Moren, but, in the end, she turned him down. It is said she rejected him because she didn't feel comfortable with his working-class background, a

facet of Angus which attracted Grace, who enjoyed his directness compared with the "professional" men she had mostly known.

Angus's last letter, one week before the wedding, revealed a rare moment of vulnerability:

> This will be the last love letter from you, that is, the last love letter from Grace Woodsworth, but I hope not the last from my Grace. What a joy I have had in reading them, and how I enjoyed writing to you. I have enjoyed love before, but it was usually moments of pleasure followed by days of pain . . . I often felt I had no-one to love me, so you can imagine what it meant to me to have your love so true and kind, and also if I may say without giving offence, it came as it were "like Diana's kiss unasked, unsought," and how I have appreciated it, and Oh my God, Grace, how I hope I can keep it.

On the same day Grace wrote:

> A marriage in winter may seem dreary to some, but to us it will mean coziness and warmth. For the first time I love the cold purity of the snow, for by contrast our love seems richer and warmer. On a chair beside me is a gift from an old family friend, a pair of dainty white silk bloomers.

At last January 23 came for tall, rangy Angus and his petite bride, both dressed for the occasion with unaccustomed elegance – an elegance that in Grace at least, encouraged by Angus, would become very much part of her public persona. (Until that time not only had little money been available for elegance, but Grace's personal commitment to a modest lifestyle likely inhibited her from being fashion-conscious, at least compared with today's young women.) A family friend had made her wedding dress – in fact, a white two-piece that she wore for the ceremony and later as her "going-away" outfit. She also wore the pendant Angus had given her for Christmas and carried a bouquet of golden roses. These would become to them a symbol of their love, and would mark anniversaries from that time on.

They smiled broadly at the fifty or so guests assembled in the Woodsworth family home in Winnipeg where they exchanged their vows before Judge Lewis St. George Stubbs, himself a well-known socialist. Grace's brother Charles acted as best man. Another young guest was Bernard Webber who later would sit with Grace in the B.C. Legislature when she became an MLA. As arranged, following the wedding Grace and Angus left by train for Ottawa and a short honeymoon at the Bytown Inn. They then set up house in furnished rooms, and Grace continued to act as secretary for her father while Angus set out once more on his interminable travels by train across the country, drumming up support for his personal view of socialism as an Independent Labour Party MP.

If Grace wrote many letters to Angus immediately following her marriage, few have survived. Those that have indicate that she quickly settled down to her new life, undertaking some speaking engagements at political meetings. She would speak at hundreds of meetings over the years, building support for the CCF and, later on, the NDP. While she continued to be distressed by the effects of the Depression on the people she travelled amongst, she also marvelled at the courage and tenacity with which they faced their daily lives.

Grace ventured into Quebec that year, to Verdun, speaking in French, about which she confessed she felt nervous. However, her speech was well received, even if it would take a much more determined foray into Quebec to establish any significant voting interest in the socialist cause amongst French-speaking Canadians.

While she missed the companionship of her new husband – who continued to write to her faithfully – her family background turned out to have been a good preparation for her current situation, one that was to be her lot (as it had been her mother's) until Angus retired from public life. Once she had written to Angus that her life as a child had seemed to be one long move, losing old friends and having to make new ones, experience she immediately fell back on in Ottawa; it wasn't long before she was visiting back and forth with her new friends. Perhaps having experienced her father's absences during her childhood even helped her put up with Angus's with less resentment than was felt

by the other parliamentary wives. Most of these either came to Ottawa cut off from the support of the communities they left behind or remained behind lonely, just waiting for Parliament to recess and their husbands to return.

Grace enjoyed such diversions as lunching with her father in the dining room of the House of Commons and entertaining him with modest suppers in her small home. The meals she offered were simple, with an emphasis on vegetables, fruit, and rice. She had readily adopted her husband's views on diet, developed as a result of his fragile digestion. Angus was sometimes ridiculed as a food faddist, but, in fact, his dietary habits were very much in line with ours today, cutting back on meat and replacing fatty foods with the more beneficial nutrients contained in fruit, fibre, and vegetables

Late in 1932, Angus, accompanied by E.J. (Ted) Garland, an MP from Alberta, toured Nova Scotia and New Brunswick. They faced physical challenges many present-day parliamentarians (or political organizers) would likely not put up with. On and off trains at all hours of the day and night, sliding around in snowdrifts, staying where they could and eating what was offered, these soon-to-be CCFers were ice-bound disciples with hearts of fire.

Angus's letters gave a dramatic and humorous account of those early days. Speaking often to tiny audiences, unpaid and frequently spending money out of their own pockets, Angus and others like him built a solid, grass-roots loyalty and learned first-hand what living conditions were like across the country and what needed to be done to improve them. As he wrote to Grace, quoting his favourite Robert Burns: "That man to man the world o'er, shall brothers be for a' that."

[on Norfolk House notepaper, from New Glasgow, N.S., November 29.] When we left Inverness there was a blinding snowstorm. The man who was to take us to the next meeting place decided to start immediately, as he was afraid we might be held up for some time if the storm continued. I can assure you that Ted and I were not all that anxious to travel on such a night . . . the driver thought we should get some chains on his car before we left, so we

looked up a garage. There was a bunch of young fellows around the garage, more or less drunk. They worked for an hour or more trying, it seemed to me, to put No. 2 chains on No. 3 tire. However, shortly after eleven we got started and it was surely a wild night, a regular blizzard. Wind blowing, snow falling fast and drifting. I could not see how we could keep the car on the road. After we had gone about seven or eight miles, we did slide into the ditch. We could not get the car out, so we left it and went to look for a farm house. Fortunately, our driver knew the locality well and knew in which direction to turn.

After about a mile we came to the house. I was about all-in, and could not have gone another quarter of a mile without stopping for a rest. I believe Ted felt about the same. The people had gone to bed, but after some knocking on the door and yelling, we woke them up.

Our driver knew them. Their name MacLellan, Gaelic-speaking people as most of the people in this section are. Of course, they also spoke English, but Gaelic is the mother tongue. The whole family got up, that is the adult members of the family. The man of the house, his wife, a very fine-looking woman, a little inclined to stoutness, but must have been very beautiful when a girl. A hired man and a hired girl. The driver, Mr. MacLellan and the hired man went with a team of horses to get the car. Ted and I toasted our feet in the oven, and told yarns. They made tea for us. In about an hour the men returned with the car. We then sat up talking to about four o'clock. The bedroom was awful cold, but we had a lot of bedding. I was telling Ted that the pair of us had about as much heat as a carving set. By the way, Ted says that I am an altogether different person to what he thought I was. He said he thought I was a dour Scotchman without a bit of humour. We kid each other all the time, which helps make things pleasant.

[November 30, still amidst the snowdrifts]: In about two hours our driver had got men and horses and dug the car out and we were off again, but not for long. We soon came

to another drift, but we had kept the horses and we hitched them on to the car and detoured through some fields. I was saying to Ted we were like an invading army, tearing down fences, making our own roads through the farms, conscripting the population to dig us out and billeting ourselves on the inhabitants. Ted said we must be two d-—fools to go to all the trouble without getting anything for it. I said it was worse than that . . . we were not only doing it for nothing, but we were paying to be allowed to do it. . . . However, after taking about seven hours to go twenty miles we arrived at the home of our driver. The good thing which I think will come out of our visit down here is that the people will get to know us.

By December 7, Angus was speeding home on the train, longing to be reunited with Grace, looking forward to Christmas and a rest. One can only admire his comment in a final letter home: "The trip was very pleasant to me. Every minute of it was a happy one. I never wish to travel with a better and livelier companion than E.J. Garland. I think our trip was also of much good for the cause we have at heart and for which we are working."

Back in Ottawa Grace was full of good resolutions for their future together:

1. We must begin our day earlier, even if I have to have a nap in the afternoon.
2. We must make more contacts. It is so good for developing our thoughts and for putting them into words.
3. We must try (and I especially) to do more reading.

With the Calgary Conference behind them and the founding convention of the CCF ahead of them, Grace and Angus were already deeply involved in their life's work. Grace may have had a long way to go to catch up with her husband as an elected politician, but her own political contacts and her growing experience in the field augured well for the future she would one day make her own.

The CCF Is Born

Judging by the dearth of mail between Grace and Angus from the beginning of the year 1933 until well after the end of the CCF founding convention in Regina in July, it seems probable that the heavy burden of political action dried up even their fertile pens for a while.

In letters prior to their marriage, it had been agreed that consideration would be given to Grace's future career once she and Angus settled down in Ottawa together. Whether such discussions took place is not recorded, but it wasn't long before each day Grace could be found working alongside her husband in his office on the Hill – without being paid for the privilege. In fairness, it is highly unlikely there was any money available for a salary for her, and anyway, as Grace was fond of pointing out years later, in her opinion, some of the best work ever carried out by party supporters was done in the days when they acted as volunteers.

Asked once why she had been "content to be a housewife" in the early days of her marriage, Grace laughed heartily and replied that Angus's opinion on the subject was that any such description of her status "was a severe exaggeration." As she put it: "I think one rather misjudges women who may decide on a role that's a little different from either the housewife or 'women's lib.' You may have other roles besides that."[45]

In addition to Grace's duties as caucus secretary, she and Angus undertook speaking engagements, at first sharing the same platform. Before long the party had her doubling up in the afternoons talking to women's meetings, until, finally, she was sent out solo to undertake speaking tours.

It wasn't easy for Grace to build a career, and it must have been frustrating given her intelligence and ambitious nature, although her loyalty to and love for Angus prevented any outright rebellion on her part. However, it is little wonder that women's issues were the ones on which she focused when she became an

elected member, even if she did continue to deny being a feminist. It was, of course, not something many women cared to admit to during most of her lifetime, although it would be surprising if Grace had let public opinion stand in her way had she wanted to declare herself a feminist.

Meanwhile, not only did she have to assert her worth as a woman in politics, but she also had the problem of asserting herself as an individual. Despite Angus's insistence that he wanted her "to be a person in her own right," Grace later admitted: "I used to begin my speeches years ago, when I was starting out, that I laboured under two disabilities, my father and my husband."[46] In fact, many years later, towards the end of her career in federal politics, she claimed that, for her, one of the outstanding achievements of her life was "to have lived long enough to be standing on my own feet, in my own mind as well as in the public's mind, and to have emerged from under the shadow of my relatives."[47]

The year 1933 was indeed a momentous year for the newlyweds, and for the socialist movement in Canada as it struggled to bring together its disparate elements to form the CCF. When the time came for the national convention, Angus attended both as a B.C. delegate and MP, and as a member of the temporary executive that had been set up the previous year in Calgary. Grace, however, experienced some difficulty in achieving delegate status. Sixteen delegates were to be nominated, representing the sixteen federal ridings in British Columbia. She asked whether she could go along as a delegate as a member of the Socialist Party. She was turned down by its leader Ernie Winch as being "far too close to parsons [her father] and other professional people to be a safe delegate." Winch's socialism at that time was decidedly Marxian, and, in his opinion, Grace would be unreliable because her background was, as he put it, too "bourgeois." Determined to go, Grace then offered herself to the newly formed CCF clubs and was accepted.

According to Grace, the formation of these clubs had given rise to

a lot of soul searching and heart burning because the organizations were already in place, formed by the labour and farm parties who wanted to have a monopoly of people who could join the CCF through them. So the Socialist Party [of B.C.] was particularly keen [on the monopoly] because they were the guardians of the purity of doctrine of socialism and they didn't want weak sisters getting in.

. . . my father, and the people around him, tried hard to hold back the formation of these clubs and let the existing organizations have the recruiting. But people just wouldn't hear of it at all. You see the people out here [in B.C.] who would join the club section wouldn't be caught dead belonging to the Socialist Party . . . but they wanted to join the CCF and so they went ahead and formed the clubs, anyway. That is what happened and it happened . with mushroom swiftness.[48]

Grace later described socialist thinking in British Columbia at the time of the founding of the CCF; "British Columbia has been more militant than other provinces – probably in every way – and certainly in social thinking." There was, she said, a mixture of two strains; one strain of people who came from Britain,

some people would say they weren't militant at all but they were British labour people; they may not have been militant but they believed in getting things done gradually, step by step . . . they were a very persistent, steady act. The Marxian socialists always referred to them very scornfully as Utopians. The other strain was people who came from Europe, and also the people from north of the Clyde [Scotland], and some very militant types from Britain [Marxists]. They prided themselves on being atheists and believed that we had to have violence – certainly they believed that things had to get a whole lot worse before they got better. They were the ones that if you talked about improving anything said: 'Oh! Why patch up a rotten old

sinking ship of capitalism, let her go down' – without any raft in sight, of course.

So the two strains grew up side by side. If they had been allowed to continue I don't suppose there would ever have been a [CCF] party [in B.C.]. Angus was crucial because he came to terms with both strains and had a foot, probably, in both camps. At one meeting we invited the leaders of both groups within the party to our apartment in Vancouver and there was an evening of confrontation, and I thought we would be put out that night. It was a good, hard, stiff fight in which a lot of plain talk went on, pointing out what would happen if they couldn't get together.[49]

In fact, these divisions wouldn't be resolved until 1935 when an·amalgamation took place at the annual convention. In the meantime, undercurrents of animosity continued to flare up, accompanied by accusations and counter-accusations between factions.

A problem at this time, and one which was to continue for years, was the presence of and infiltration into the CCF of Communists, a presence regarded with mixed feelings at all levels of the party. J.S. and Angus, however, vigorously and unfailingly opposed the element.

British Columbia's factions were not the only divisive element among the two-hundred-odd delegates attending the first national convention. For instance, at that time labour groups were organized in individual cities without any binding superstructure. The individual groups each "wanted to swallow the other up whole."

It was British Columbia's socialists and their left-wing language that caused a communications problem at the CCF's first national convention at Regina in 1933. For instance, its Marxian flavour upset Agnes Macphail. She feared their rhetoric could frighten her farmers off the convention floor and keep them from joining the CCF. As Grace commented: "She was just on pins, she was trying to get the farmers kept in there and trying to hide from them the nasty kind of thinking of the B.C. socialists."

When Angus saw Agnes's distress, he didn't help matters by deciding to make mischief, something quite out of character with his usual behaviour. "He kept addressing her as 'Comrade Macphail,'" Grace said, "which just infuriated her because it meant she couldn't hold the farmers. She said she was going to leave the convention if this sort of thing went on, and she was going to take the farmers of Ontario with her."[50]

Angus exacerbated the situation by telling Agnes he had a suspicion that the convention could get along without the member from Southeast Grey. According to Grace, he made her so mad that for some time she wouldn't speak to him, although Angus eventually made up with her by passing along health hints for her great friend Bob Gardiner who was very sick at that time. Gardiner had wanted to marry her, but Macphail had always vowed to remain single to devote herself to politics.

Not many of those who attended the founding convention came from east of Ottawa. Delegates arrived by every conceivable means: Angus and Grace went from Ottawa by train, others drove, some even "rode the rods" – hopping a freight train as many destitute people were forced to do during the Depression.

The official name for the party – the Co-operative Commonwealth Federation – was decided, put forward by Walter Mentz of Edmonton and John Fenstein of Regina, and, not surprisingly, J.S. was named president of the temporary executive. Others on the executive were: Norman Priestly, Vice President of the United Farmers of Alberta; George H. Williams, Past President of the United Farmers of Canada, Saskatchewan section; John Queen, Member of the Legislative Assembly, Manitoba; Mrs. G. Latham, Edmonton; A.R. Mosher, Ottawa; William Irvine, Member of Parliament, Alberta; Angus MacInnis, Member of Parliament, Vancouver; and Mrs. Louise Lucas, President, Women's Section, United Farmers of Canada, Saskatchewan section.

The convention accepted the Regina Manifesto, written by Frank Underhill of the University of Toronto and Frank Scott of Montreal's McGill University, with help from members of the League for Social Reconstruction (LSR), the CCF's research arm. Throughout the political lives of J.S., Grace, and Angus, the

Manifesto was criticized in the belief that it was against any reconciliation with capitalism.

What the Manifesto aimed at was a political system in which economic equality would be possible. It advocated the elimination of the "glaring inequalities of wealth and opportunity [and] chaotic waste and instability." It went on to proclaim "We believe that these evils can be removed in a planned socialized economy in which our natural resources and principal means of production and distribution are owned, controlled and operated by the people."

In his autobiography, *The Good Fight*, David Lewis wrote: "From the day that the Regina Manifesto was promulgated, Woodsworth, [M.J.] Coldwell, [Tommy] Douglas, and the rest had to proclaim time and again, in and out of Parliament, that the CCF did not intend to nationalize everything. The words of the Regina document derive from the despair of the Depression; in 1944 they were already too sweeping."[51]

At the Dominion CCF convention held in Winnipeg 1934. Fifth from left at the back is Angus MacInnis. M.J. Coldwell is ninth from the left. In front, at far left is Robert Gardiner and third from left is J.S. Woodsworth. S.J. Farmer, prominent in the Winnipeg Strike and later an MLA, is sixth from left.

A 1992 book by Alan Whitehorn, *Canadian Socialism*, comments: "A certain mythology has arisen about the 1933 Regina Manifesto. Because of a few provocative passages, it has acquired an image somewhat more radical than the text as a whole merits. In fact, content analysis reveals that it does not dwell on the terms *socialism* or *socialist* . . . the 1933 document chose terms such as *socialization* or *social ownership*, hoping that these would be less intimidating to potential supporters. While the party's language became even more moderate in the 1950s and early 1960s (in what was referred to as the New Party Declaration), the 1983 revised document is emphatic in its use of the term *socialism*."[52] Grace herself accepted that the original Manifesto required updating with the changing times. She worked on one revised edition and favoured wording that would more correctly reflect the party's evolution from its beginnings.

After the dust had settled on the founding convention, Angus left for Saskatchewan on a western tour while Grace was touring in B.C. Evidently Angus had left in a huff, as an October letter carried an apology to Grace for this outburst of temper.

> My own dear Grace:
> I am so sorry that I was so cross and nasty with you before I left on Monday. I knew I was doing wrong all the time I was that way. All the time I loved you and my heart wanted to go out to you. Oh! I do love you, my dear. You are such a lovely soul and so lovely with me. It worries me. It seems I am getting worse all the time. I misunderstood what you suggested about the key, but there was no reason to act as I did.

The organization of the young CCF was less than adequate in those days, often due to lack of funds, and the continuing problem of factions. For example, some groups continued to work under their old titles instead of adopting the new CCF identity. In addition, few workers in a party that was so young were yet sufficiently knowledgeable to be of much help, especially as organizers. However, what they lacked in training they made up for in enthusiasm.

In May 1985 Angus and Grace vacationed in the maritimes, visiting friends in Amherst.

Grace herself continued to gain experience over the next few years by working at a variety of tasks necessary during this developmental phase of the party. On May 30, 1934, she wrote to Angus:

> We had a fairly good meeting at Kirkland Lake and Timmins . . . we had between 200-250 present . . . and if I say it myself I gave a good talk. I do not think much of the candidate and they do not seem to have any organization worth mentioning, and without organization we cannot win elections.

> [February 20, 1935, from Toronto] Boy [a family nickname], when you get away from Parliament and into groups of men and women you begin to get new angles on our work. I wish you and Father could get right down into some of these little study groups – I'm learning lots and lots of things which I never knew before and which one never learns at big public meetings.

The 1935 election was the first contest by the CCF, which for the economic reasons already outlined, was unable to field a full slate of candidates; in fact, it contested only 48 per cent of the ridings. All but three of the 118 who ran came from the western provinces. The new party came in third with 8.8 per cent of the national vote. In terms of seats, the party came in fourth with seven, behind the largely Alberta-based Social Credit Party. Those elected numbered among them some of socialism's most famous names: J.S. Woodsworth, T.C. Douglas, M.J. Coldwell, and Angus MacInnis.

Meanwhile Grace continued to be involved with the CCF clubs. Sometimes she found herself attending three meetings a day, but no matter how busy she was Grace always found time to appreciate her surroundings.

> Last night for some reason or other I was so sleepy that I went to bed about nine o'clock. Result: I woke up about four this morning . . . I got up before 4:30 and was soon dressed and eating oranges and drinking coffee . . . then about 5:35 I left the apartment . . . milkmen's horses came clip-clopping along . . . when I came to Dalhousie I followed it down to the National Research building. Then I wandered through the grounds overlooking the foam-flecked Ottawa along which a man was drifting in a flat-bottomed boat. The Gatineau Hills are very lovely in the early morning – low-lying, blue-grey masses, with here and there the delicate spire of a church silhouetted against the sky above them. Everything was in greys this morning – sky, buildings, water and even the far-off distance.

However, it was Angus who enjoyed *living* in the country, Grace was much more a city dweller.

> Well, dear . . . when you're away I realize just how much we live wrapped up in each other. I've got to get busy now and dig up some lady friends as substitutes. No hope for gentlemen in Ottawa.

At this time Grace and Angus voiced their strong support for the franchise of Japanese Canadians. In company with the Native population, Japanese Canadians were denied the vote. In B.C. this lack of franchise kept Japanese Canadians from professions such as medicine and the law, as enfranchisement was a prerequisite for entry into university programs in these disciplines. It would not be until after the end of the Second World War that this franchise would be granted, and during the war, both Grace and Angus would have more to say about Canada's treatment of Japanese Canadians.

Part II, Chapter Seven

The Party Is Up and On Its Way

On July 1, 1936 – Dominion Day – Grace was visiting her mother in Winnipeg while Angus was in British Columbia attending the provincial convention. Back in the home from which she was married in 1932 and evidently feeling a little nostalgic, she sat down to write to her husband:

> It seems strange to be sitting here in the old home writing to you as though the years between 1931 and 1936 had been wiped out. What happy, full years they have been.

Romance had by no means faded from their marriage, but during the intervening years the focus had shifted to the political partnership which bound them inseparably as long as Angus lived. As her brother Bruce sees it: "I don't like separating Grace from Angus because of the many things that I can recall – they worked together as a team. So many of the things Angus was trying to do, Grace was trying to do as well. They would help each other all the time. One thing I'd stress is what a wonderful pair they made together in a very complicated and different sphere of action."[53]

This close and successful co-operation wasn't achieved without learning some of the painful lessons of compromise. Those close to them recall that occasionally there were loud and angry disagreements – sometimes followed by sulking on Angus's part. But they talked about their differences and the relationship was strong enough to accommodate them.

One colleague who knew them well – in Grace's case for almost forty years – was Cliff Scotton, actively involved in every

federal election from 1953 on, the NDP's national campaign director in four, and the chair of the task force on restructuring the party. Over the years he came to understand how the partnership worked, and some of the stresses it underwent. While he described Grace as "determined, with strong opinions which were forcefully expressed," overall he saw the couple as "very equal." However, he said, "on occasion, she would have to jerk herself back when by inference she ever demonstrated that she had a better education than Angus. Being a street motorman was not thought to be at the top even of the working class ... and, from what I knew of Grace's affection for him, it would have hurt her if she thought that, even by inference, she was putting him down in some way.

"He was an orator when he got going – he was not a magical, lyrical speaker but his sincerity came across. Grace was influenced by him – later on, in *her* period [when she became a politician] she was reminiscent of Angus rather than her father. Angus sort of rolled along, she went in little tripping steps."[54]

During that summer of 1936 the country was enduring a terrible heat wave, especially in southern Ontario where

Early leaders in the CCF movement got together in 1976 in Nanaimo for a testimonial dinner for Irma and Tommy Douglas, seen here at the right. The others are Stanley Knowles, Grace, and Harold Winch.

temperatures ranged from 33 °C to over 40 °C, causing the deaths of 230 people. It wasn't much better for Grace in Winnipeg. As she wrote on July 7:

> The [provincial] campaign is *terribly* slow in getting started ... of course the heat is making meetings of any kind almost impossible. I cannot remember ever having experienced such steady perspiration day and night ... while I was waiting on the steps of the [swimming] baths I fell into conversation with a little girl about seven or eight years old. She was a cute little thing with a very ragged dress. She told me she was waiting for her three friends to come out from swimming. Her mother couldn't give her any money to go. I learned she lived close by and told her to get her mother's permission and a bathing suit and I would get her a ticket. She was off like a shot and back in a few moments. That was the best 15 cents' worth of anything I've bought for many a day! It surely was good to see how that little girl splashed and laughed in the cool water.
>
> Last night I addressed a branch of the CCYM [Co-operative Commonwealth Youth Movement]. They stuck it out valiantly in spite of the heat and so did I.

Also in 1936, David Lewis, who was destined to have a life-long impact on the social democratic movement in Canada, was elected as secretary to the National Council during the CCF convention in Regina. He had approached his law-firm employer, Russel Smart, and got them kindly to donate to the party its first official "quarters" in Ottawa; the quotes denote the humble nature of the accommodation, a lean-to with a dirt floor at 124 Wellington Street, opposite the Parliament Buildings, previously used as a storeroom for a restaurant. Inauspicious as the party's new "office" was, the address looked good – despite unpainted walls, washroom facilities in the building to which the lean-to was attached, and an open-to-the-elements window overlooking a parking lot. However, the price was right.

Norman Bethune was in Spain serving as a medical officer for the Republican forces in the Spanish Civil War; Edward VIII would shortly inform the world of his intention to abdicate from the British throne; and at the 1936 national convention in Regina, Grace was endeavouring to bridge Canada's two solitudes from the socialist perspective. She won unanimous support for her resolution to approach French Canadians in the hopes of forming a Quebec base for the CCF. It was to be an uphill struggle.

This convention attracted a better showing than did the founding convention in Calgary three years earlier, but it took years to build up attendance. More often than not it was the cost of travel that kept delegates away, not any lack of desire to be there. Even by the 1950s, registration figures reached no more that two hundred, although eventually annual conventions would attract a healthy crowd. There were 2,400 delegates on hand for the NDP's 1989 convention in Winnipeg.

The following year, Grace and her brother Charles co-authored a pamphlet, *Jungle Tales Retold*. It was an innovative CCF reaction to a report tabled by Tory Minister of Trade and Commerce H.H. Stevens in 1934, known as *Price Spreads and Mass Buying*. The report outlined inequities and focused on the profits accrued by industry leaders at the expense of the workers they employed for a pittance, under intolerable working conditions. Opening with a quotation from the nursery rhyme *"The House That Jack Built,"* and using reports from a number of industries and companies, the authors expanded on the findings of the Royal Commission. Regarding the Imperial Tobacco Company of Canada Ltd., for example, which at that time controlled 70 per cent of the production of the 127 tobacco companies in Canada, the Commission said:

> The exorbitant profits which this company has been able to make, even in a period of general economic distress, are proof that a dominating position can be used to avoid the necessity of sharing in that distress.

After outlining exactly how monopolies worked in the country's major industries – manufacturing, food, housing – and their domino effect at the expense of the economy and the

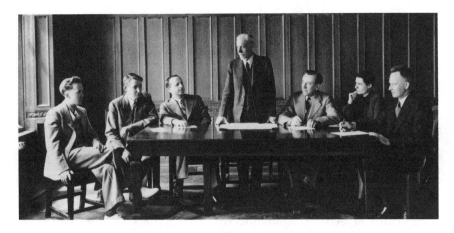

The CCF caucus meets following the 1935 election. Left to right: Tommy Douglas, Angus, A.A. Heaps, J.S. Woodsworth, M.J. Coldwell, Grace, and Grant MacNeil. (Photo by Karsh)

consumer, the authors suggested ways out, namely, social ownership. They quoted from Marquis Childs' *The Middle Way*, which described a co-operative experiment that was successful for a number of years in Sweden, and which Grace and Angus greatly admired.

This was followed up by an equally successful pamphlet, *Canada Through CCF Glasses* which outlined and explained the objectives of the Regina Manifesto, a document that, according to Scotton, represented for Grace "the importance of the [party's] ideology and [its] doctrinal aspects." The pamphlet also addressed the party's stand on such major issues as capitalism and co-operatives.

In Scotton's option, the "strength" Grace brought to the CCF in its early years stemmed particularly from her clearly defined beliefs about issues such as communism. For example, it so happened that the Cold War era which followed the end of the Second World War coincided with the period when the party was going through great difficulties establishing itself. It was also the time when the CCF's major ideological adversary was on the left, the Communist Party. Therefore, it was important that party members – such as Grace – were able to define the differences between their beliefs and those of these ideologues of the far left.



In fact, a resolution was passed at the 1935 national convention against building a united front with the Communists. It was part of a continuing battle which Grace and Angus in their home province of British Columbia would wage against the far left element of the CCF.

In the summer of 1937, Rod Young, leader of the Socialist Fellowship, was suspended from the party for being a disruptive force. He would eventually be ousted from the CCF in 1954. Young who had joined the youth group of the CCF in 1934 and had been its first vice president, had been an active trade unionist in Alberta and British Columbia.

Internal struggles such as these kept the Ginger Group – of which Angus was a member – on its toes. However, in the summer of 1936 Grace was glad to slacken her pace and enjoy this visit with her mother in Winnipeg:

> It is good to be here and quiet. I had a splendid visit [with family friends, Dr. and Mrs.Wallace] in Emerson but my cold and cough came back and I was pretty glad to get home where I could look after it. You see they have a water shortage in Emerson. No rain for months. So no baths nor much in the way of sanitary conveniences. And I feel so sorry for these people in small prairie towns who can get practically no fresh fruit or vegetables. We B.C. people are very fortunate.
>
> Another afternoon [the Wallaces] were giving a farewell bridge party to a departing teacher. I went on the strict understanding that I would not play. Imagine all our horror when we found one girl short and I had to fill in. I did very badly but fortunately did not prevent one girl from taking first prize – even though she was my partner for a while.
>
> [July 3] You needn't worry about Mother and me getting along. I can always get on swimmingly with any single member of my family. It's mobs that make the fur fly. We are enjoying ourselves greatly.

[July 6] Mother and I have just finished the supper dishes. We had as guests Mr. and Mrs. Thomas. Not knowing enough about your cotton to work up a decent row with him, I had to fall back on the political situation. However, it was really too hot to enjoy a scrap so I let him tell me about the books he has been reading this winter.

This morning Mother and I walked over to the Agnes Street Forum. The speaker was Marcus Hyman, MLA and now again ILP candidate. His subject: Betrayal of Youth. He is an excellent speaker and not afraid to face the consequences of his own logic. I was asked to say few words during the discussion period so decided to lay emphasis on the necessity for less revolutionary talk and more concrete results. I have been asked to speak for the West End CCYM tomorrow evening.

[July 7] Your last letter told me you missed me. I'm glad you do for I miss you too, dear. These times away from each other help us to keep very vividly the feeling that we belong to each other. Your love is the biggest thing in my life, dear. I think I've told you more than once the two things I love most about you are your strength and your gentleness. Now I daren't say more along that line lest you accuse me of being sentimental. Of course I am! And so are you.

In all the letters exchanged between Angus and Grace these seem to be only ones describing a week of, for Grace, at least, relative calm. It was a life that, in the words of Scotton, "was ordained by 'There'll be a meeting on Thursday, . . . 'You have to go to Winnipeg on Friday' . . . you have to do that for about forty years to understand what it does to your personality. There are many days when you come home and you don't want to talk to anybody, not even the cat."[55] It is likely that this contributed to the perception by some people that Grace wasn't a warm person although, in her private life, she fought to save her warm relations with Angus and with her relatives.

Angus, meantime, had begun the fight for the enfranchisement of Japanese Canadians in B.C. It was a fight which J.S. Woodsworth had begun in 1923, but in the current election, the racist laws of B.C. – which continued to deny the vote not only to the Japanese but also to Chinese, East Indians, and First Nations – were being used as a stick against the CCF by the Conservatives and Liberals who were uneasy about the rising strength of the west coast socialists.

In her book about her father Grace wrote that Angus "proposed a resolution that if there were groups to whom, because of racial or religious origins, Canada would not grant the franchise, they should be excluded from the country. This was not at all to the taste of those people who wanted to continue importing Orientals as a source of cheap labour."

Nor did Prime Minister William Lyon Mackenzie King relish publicity about the fact that one Canadian province had such glaring racial discrimination. "Bringing this blot squarely into the national and international spotlight instead of leaving it hidden from sight behind the Rockies was a major step toward getting it removed," as it was eventually in 1949, a process seriously impeded by the Second World War and the removal and internment of B.C.'s Japanese Canadians.

Now it was time to see how socialism worked in other countries and in September 1936 Grace and Angus visited Europe. They came back full of enthusiasm about what they had seen and learned, particularly about how it applied to life in the Scandinavian countries. For instance, in Finland they learned more about the co-operative movement and in Sweden they visited factories and mills. Both Grace and Angus kept diaries of the trip – some of Grace's entries resembled a travel brochure write-up, while Angus was fond of recording what they had eaten.

They were unable to get into Russia, and in Copenhagen, according to a diary entry by Angus, they refused to pay the price of admission to the zoo – one Kron – instead attending a movie, *Charlie Chan at the Circus* (price of admission unrecorded).

Later they travelled on to Switzerland where they saw Anthony Eden speak in Geneva at a League of Nations session.

Then, on leaving Germany, Grace recorded in her diary: "We drew a long breath of relief,"[56] following what she perceived as racism towards Jews, "Blacks," and Orientals.

In their hectic lives it was a respite, or at least a change of pace. Angus enjoyed being idle if ever he had the opportunity, to potter about in the garden and to read or to indulge his hobby of collecting china, something he had started as a boy. Too poor then to actually buy china, he collected broken pieces he found about the place, admiring their colour and their beauty. By the end of his life, the collection still wasn't large, chiefly on account of the distaste he and Grace shared for what we now call consumerism. It was said of Angus that he was the sort of careful spender who believed a cigarette should be smoked until the butt was so small that a pin would be needed to hold it to his mouth. Poverty in childhood is not easily forgotten.

On the other hand, it was never easy for Grace to take it easy. In an interview after Angus died, she told an interviewer that she was a workaholic and that often she had found it difficult to accommodate Angus's fondness for afternoon coffee and a chat. She knew how much it meant to him, and he meant enough to her that she never let on about her feelings of irritation. She added: "I don't think he ever guessed how difficult it was for me to have to stop whatever I was doing and sit around drinking coffee."

By 1937, five years into their marriage, the MacInnis's political life together was firmly established and so was their party. *The Winnipeg Free Press* commented on the party's progress at that time: "As a party the CCF is about four and a half years old. Its first national convention was held in Regina in 1933. Today the CCF has seven members in the House of Commons. It is the Official Opposition in the Saskatchewan House. It has members in the Legislatures of three provinces – seven in British Columbia, seven in Manitoba and one in Ontario. That is a showing which indicates that Socialist voters are yet a small minority of the Canadian public. Still, for less than five years' work, it is a record CCF leaders can view without dismay."

In November 1937 Grace was in B.C. helping with a by-election. Despite a year-round work schedule, she hadn't yet

come to recognize her worth in her own right. Writing form Victoria she said:

> I think that in my humble way I am assisting – which means *you* are because any other husband in the world would insist that I be on the spot to wash dishes, get meals, etc. for him.

Money, too, was a perennial source of worry – at Grace's urgent request Angus sent her $10, evidently much needed, and, as she admitted in another letter, so also was a cheque she received from London, Ontario, for $3.45, her return fare from London to Toronto on a recent visit.

But, before another year passed, Hitler would invade Czechoslovakia, and Angus would fume over Neville Chamberlain's passive reaction to Fascist aggression, while those in a position to read political signs worried over what they feared was the approach of another world conflict that would likely involve Canada once again.

Young Socialists Play Their Part

Right from the earliest days of the CCF, young people played a role in building the party and in preparing themselves as standard bearers of social democracy in Canada. Despite her demanding schedule, Grace MacInnis was among the CCF leaders who made time to take part in the formation of a strong youth wing.

On July 17, 1934, during the second annual CCF convention in Winnipeg, the Co-operative Commonwealth Youth Movement (CCYM) came into being in the West End Labour Hall. Bernard Webber, later MLA for Similkameen, B.C., and youngest member of that CCF caucus, was recording secretary. Tommy Douglas was elected as its first president.

CCYM members were recruited from the youth sections of the same mix of socialist, labour, and farm organizations which were represented at the CCF founding convention. Consequently, as the CCYM developed, it reflected the same blend of enthusiasm,

conflict, and feverish activity which characterized the beginnings of its political parent.

Coming together as it did at the height of the Great Depression, the CCYM offered unemployed youth a chance to combine low-cost recreation with the added incentive of the opportunity of changing the economic system for the better through political action.

Florence Riley, now living in Nanaimo, B.C., remembers the CCYM study groups Grace worked with in Vancouver. A typical activity was a group discussion based on a CCF pamphlet such as *Who Owns Canada?* Each member would be assigned a chapter to read, and, in turn, would then lead the weekly discussion. There was also a CCF camp on Gabriola Island, one of B.C.'s Gulf Islands. There the CCYM members combined work with the fun of camp life and also had a chance to meet some of the party's leaders who visited and gave lectures.

Similarly, in Ontario, where the New Youth Association of Canada joined the CCF in 1934, the CCYM's founding meeting took place later that year. As in the west, there were study groups and social activities in centres such as Windsor, St Catharines, Hamilton, Kirkland Lake, Peterborough, and at several units in Toronto. The Toronto members "soapboxed" at street-corner meetings, with hikes and picnics on weekends. Bill Grant, president of the Ontario CCYM from 1934-40, and his young wife Marg hosted a weekend summer camp on their property in southeastern Ontario for a number of years.

Grant was on the planning committee of the second national CCYM convention in 1938, held in Edmonton. It took place prior to the national conventions. At this convention, Grace was elected CCYM national president by acclamation. The upper age limit at the time was thirty and Grace was thirty-three, but for her sake, the limit was extended to thirty-five and rolled back again after her term. Grant remembers Grace with affection and looked forward to her visits: "She was very affable, she had a great wit," he said.[57]

CCYMers were active in assisting the entry of the Congress of Industrial Organizations (CIO) into Ontario despite the efforts

of Premier Mitchell Hepburn to keep them out. Labour unions in Canada at that time – as in the United States – were concerned about the Communist push for power in their ranks. This situation affected non-union members of the CCF who knew that if they leaned too hard on Communist members it would interfere with the unions' ability to organize, and they needed to develop strength if they were to be effective against Hepburn, whose government was opposed to their entry into Ontario.

In his memoir, *The Good Fight*, David Lewis cites the help given by CCYMers to Local 222 of the Auto Workers during the 1937 strike at General Motors in Oshawa. When Local 222 president C.H. (Charlie) Millard became CIO director for Canada, it had valuable consequences. It led to some leading CCYM activists being appointed to important responsibilities in several unions; among them were Murray Cotterill, Eamon Park, Fred Dowling, and Eileen Tallman (now Eileen Tallman Sufrin). The latter two became Chairman and Secretary of the CCF Trade Union Committee in Ontario during the late thirties.

During her term of office, Grace encountered many of the same problems in the CCYM as occupied Angus and herself in the CCF. Among these was Communist infiltration. This had already occurred in the Saskatchewan CCYM, where the CCF Provincial Council felt compelled to dissolve the CCYM and start over with a fresh set of officers because, as Carlyle King, then chair of the CCYM advisory committee in that province, reported, "the CCYM was on its way to becoming just another undercover arm of the Communist Party. People who remember the Canadian Youth Congress in the United Front days will not need to be told about the tactics of the [Communist Party] in the CCYM."

Grace was well aware of this from attending a 1940 conference of the Canadian Youth Congress, led by her cousin, Ken Woodsworth. At that time the CYC was following "the party line" of opposing Canada's military participation in the Second World War on the grounds of Russia's non-aggression pact with Germany, and Grace had to disassociate the CCYM from this stand.

Getting full support for the CCF position on the war had not been without its problems in Ontario, where CCYM national

secretary Eileen Tallman and others opposed risking young men's lives on pacifist grounds (as held by J.S. Woodsworth), or unless there was conscription of industrial wealth. J.S. was "determined to keep the CCF intact despite the crucial divisions evident in all parts of the country." He wrote to Tallman: "I am very much hoping that the young people in Toronto will not take any precipitate action . . . some of us are determined to be true to our convictions, and yet are very anxious . . . to hold our organization together."[58]

However, by the time of the CCYM national convention in 1940, controversy over the war was put aside, and the establishment of its national office at CCF headquarters in Ottawa led to a better network between provincial branches. Although Grace resigned as national CCYM president at this convention, she was appointed in 1944 to serve as a liaison between the CCF and its youth movement to prevent potential gaps in understanding between the two.

War on the Horizon, Struggles at Home

In the year 1938, the Depression dragged on and many Canadians were going to bed hungry. Others went to bed frightened about the possible outcome of Hitler's continued acts of aggression against Germany's neighbours and the threat these posed to world peace.

As Hitler marched into Czechoslovakia, Britain's prime minister, Neville Chamberlain, continued his policy of appeasement. On his return from a Munich meeting with Hitler, having "bought" Britain another year in which to prepare for the inevitable conflict, he uttered his now famous sentence about bringing "peace in our time."

Angus, who detested Fascists as much as he did Communists, complained bitterly about Chamberlain and disagreed with all those who, like his father-in-law, wished to maintain Canada's neutrality in face of what J.S. called "an imperialist war." Grace and Angus were also on opposite sides of the fence over this opinion and this caused some friction between them. Grace would ultimately change her point of view just before the outbreak of the Second World War when she sided with Angus and the majority of the CCF caucus against her father's pacifist stance.

En route by train in late September for a tour of the Maritimes, Angus was met by his in-laws when the train reached Winnipeg. The issue of a possible war came up, and in a letter to Grace soon after, Angus wrote:

> By the way, your father is adamant against giving Britain, France and Russia any aid in a war to save Czechos- lovakia . . . if he were a swearing man he would say that

"the war in Czechoslovakia is none of our damn business."
He told me it was an "Imperialist war" and that we
decided at the convention [two months previously] that
we would have nothing to do with such wars. I did not
have time to ask if it were imperialism for the Czechs to
defend their country from dismemberment and their people
from Hitler's concentration camps, but it was no use. He
would prefer to see what is left of democracy destroyed by
Hitler and Mussolini than to save it by what he calls a
balance of power group. I can see where you got your
distorted ideas on foreign affairs from. Well, perhaps I and
others are plumb crazy.

In fact, at the 1938 national convention, Grant MacNeil
moved a resolution which read: "If collective action should fail
and war break out, the CCF believes that our decision as to
participation must be based on the determination to keep Canada
out of any war whose purpose is really the defence of imperialist
interests; recognizing that in future, as in the past, an attempt will
be made to dress up imperialist wars in a guise acceptable to the
general public."

The following morning, Angus wrote:

The coach is filled almost entirely with old people – several
old people on their way to the Old Country. I was talking
to some of them and they do not feel in the least deterred
by the fear of war. "Huh, we have no fear," said an old lady
I was talking to last night. "England will look after that
maniac" – referring to Hitler. They are from Regina. The
husband retired and they are going back to England to get
away from the grasshoppers.

M.J. was with Angus on the train, and the next day he
wrote:

Coldwell and I had a very pleasant day yesterday . . . he
had wired ahead to [Elmer] Roper and [Bill] Irvine. Irvine
is making a tour of the Cariboo and so could not meet us.

We wanted to get their point of view on what should be contained in a CCF statement which will have to be made in case war breaks out. As you will remember the statement prepared by Coldwell and [Grant] MacNeil suggested that Canada's assistance be economic only. When we met [Stewart] Smith and [George] Weaver on Monday evening they took the position that if war breaks out it will be an "Imperialist war" which is of no concern to us and which we should oppose (with this point of view I presume you agree?) Well, Roper, on the other hand, considers we cannot stop at economic aid. So there we are and where are we?

From the *News Bulletin* this morning the situation does not look any better. I am still, however, of the opinion that war will be avoided at this moment. Perhaps the wish is father to the thought, but I cannot believe that even Hitler is so crazy that he will risk a major war to get something which he can have almost in its entirety by waiting a few days or weeks. Even if Hitler is so crazy as to take the risk I do not believe his General Staff is. . . .

My stand on questions are usually vindicated. Great Britain, France and Russia are now co-operating to stop fascist aggression. It is only just two years since I pointed out that was the only way in which fascist aggression could be stopped. Had it been adopted two years ago in the Spanish situation in all probability it would never have come about. I wonder if people will ever appreciate a clear thinker – ahem!

I thought this would be a romantic letter but it has developed into a dissertation on politics . . . no doubt, if you were here you would have been called a sap or a nit-wit long ere this [presumably for her pacifist views]. I have resolved not to call you these nasty names any more. We shall both have to try and think constructively so that we can act constructively. Constructive thinking will inevitably lead to constructive action. We shall then become positive instead of negative.

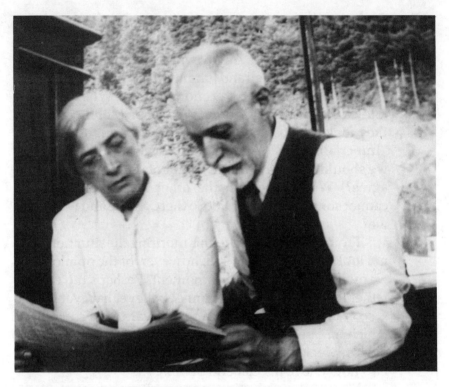

Lucy and James Woodsworth read the newspaper in August 1939, shortly before the outbreak of the Second World War.

Evidently Angus had also expressed his non-appeasement views to his mother-in-law, causing her distress. In a letter to Grace from Ottawa on the last day of September, he wrote:

> I am enclosing a little note which your mother put in my hand as we were parting – "Dear Angus: I have been thinking how little I have done or said in your hearing to let you know how I trust and admire – yes and love you. You are certainly making earnest with life – Mother."
>
> I suppose I hurt her by my policy of an eye for an eye and a tooth for a tooth. I am sorry if I hurt her. As you so well know there is no-one for whom I have a higher regard and admiration than I have for *our* mother. In my opinion she is indeed a woman among women.

The world breathes easier today because of the Munich meeting of the brigands. Chamberlain is willing to assure the peace of the world if it takes the last foot of Czechoslovakian soil. Good old Neville! Generous old Neville!

I hope Chamberlain will not take advantage of his brief popularity to call an election. I feel almost sure that there will be repercussions in France and Great Britain when the feeling of relief on having avoided war has worn off.

[A few days later, on the train to Glace Bay, N.S.] David [Lewis] was telling me that the people in Toronto are quite sore about the statement made in Victoria by [M.J.] Coldwell to the effect that "Canada would support the Mother Country in case of a war. " . . . It is the "Mother Country" part which they do not like. It is too bad that he made a statement at all. I know what he meant and it was not particularly different from what I thought in the matter. I hope it will blow over . . . I see the reaction to the Chamberlain peace policy is setting in already . . . the "peace" is a great betrayal but quite in line with Chamberlain's policy of aiding the fascists.

[En route to Toronto in November, on the way back from the Maritimes, Angus returned to the subject of pacifism.] We can never get anywhere either with foreign policy or with domestic policy until we stop thinking in absolute terms and think in terms of a changing world in which we must move towards the ideal along routes which may not always be in straight lines.

How this last sentiment seems to echo down the years!

Often throughout their years together Angus and Grace disagreed profoundly and vehemently, but without lasting rancour. Once Grace disagreed with Angus as they stood together on a public platform. His cheerful response was: "Well, the divorce courts are going to have a very interesting time in British Columbia when they have our petition for divorce, yours and

mine, up on grounds of incompatibility on foreign policy." Lucy would never have disagreed with J.S. in public but another generation brought its own degree of emancipation.

Despite the occasional bickering he and Grace indulged in, and what others have described as Angus's dour exterior, the MacInnises' correspondence continued to reflect an enduring love, great companionship, and mutual enjoyment of a good joke. Writing from Ottawa to Grace at home in Vancouver, Angus talked of a speech he had made on foreign policy:

> I think I made a fairly good job of it . . . Miss Macphail listened to all of it and she said she was proud of me. I think I told you that I sent her some yellow roses. One good turn deserves another. . . . Yes, I agree you are "sawed-off," but I do not agree that you are unimpressive. You are very good to look at and it is not just beauty . . .
>
> Love and kisses, Boy

> [In early June] Besides being busy with my work since you left I have been branching out a bit. Thursday, I took Miss Bell to dinner . . . after dinner she took me for a drive around the beauty spots of Ottawa . . . if it were not for the fact that so few of the group were in the House I would have made a night of it.
>
> When I came in Grant [MacNeil] said he had been hearing disquieting rumours about me. I said he might have been hearing rumours about me but they would not be disquieting rumours . . . I wish I had thought a little further ahead and had made a date with Miss B. for tonight. She is not as young as I like them, but at my time of life a reasonable amount of maturity is not an unmixed evil.
>
> I do wish we did not have our little quarrels. Do believe me dear, I love you, and in my quieter moments I know I am largely to blame for breaches of the peace between us. Living with you has been good for me and I am sure that taking the good with the bad that you have not been unduly unhappy since we have been married. But we

should have been much happier. And we can accomplish so much more when we are happy and content.

Grace and Angus were well known to have their political differences, at times heated, but it is unclear whether the conflict referred to here reflects disagreements of a more personal nature.

The CCF itself was firmly established, and at the convention that year in Edmonton it was reported that the party's membership numbered more than twenty thousand. In addition to the six CCF Members of Parliament, there were twenty-four provincial MLAs (seven in British Columbia, ten in Saskatchewan, and seven in Manitoba), and about twelve hundred members of municipal and rural councils and boards of education; several mayors and reeves were included in their number.

However, if the CCF was growing satisfactorily, the environment around it continued to be troubled both at home and abroad. On the home front another serious crisis occurred early in 1938 when a large number of destitute men moved into Vancouver following the closing of provincially administered relief project camps. Petitions made to both provincial and federal governments to re-open the camps met with a negative response. Writing to Grace from Ottawa, Angus spoke of the CCF's concern:

> The men are now in the sixteenth day of their sit-down strike. I am sure that both sides are getting on to the ragged edge, and if some solution is not arrived at shortly I would not be surprised if a blow-out took place. Grant [MacNeil] and I have decided to get a discussion on the subject on Monday . . . indeed, I do not know what to say. We have talked on every phase of the subject already.

Eventually, in mid-June, angry demonstrations and police arrests took place and the outcome could have been more serious without judicious intervention on the part of the authorities. These were tough times and the songs sung by CCFers and printed in their song sheets showed that. This one was sung to the tune of "My Bonnie Lies Over the Ocean."

> I'm spending my nights at the flop-house
> I'm spending my days on the street
> I'm looking for work and I find none,
> I wish I had something to eat.

CHORUS They give me a bowl of soo-oo-up
> Soo-up, soo-up
> They give me a bowl of soup.

> I spent twenty years in the factory
> I did everything I was told
> They said I was loyal and faithful
> Now even before I get old . . .[59]

Just how tough conditions were was described by Grace.

We came to another place, I have never forgotten this. As we drove up there a farmer was unhitching his horses, just walking skeletons, and I made some remark. The man who was with me said: 'Be careful, he feels terrible about it' . . . [the farmer's wife] went inside and got lunch for us. She had gone down into her root cellar and brought up a jar of Prairie chicken which was as if she were entertaining royalty. And you know I could hardly bring myself to eat it. I just felt like that story in the Bible where the man went and got the water and then it was so precious to the other man who was dying of thirst that he threw it on the ground, couldn't bear to drink it. Well, I knew better than to do that with the Prairie chicken, on the other hand I have never forgotten that. Nor have I forgotten the lines of washing I saw out there with the flour sacks doubling for winter underwear . . . and yet those people came through and they were vigorous about it. They seem to keep their hearts and minds active.

As we drove around those roads between meetings the farmer with me would say, "Now, in that house there is an old couple there, they're CCF, they have been CCF since the beginning." We'd go along – "In that house lives a man and his wife, he's all right but we've got to do a little

more work on her, we'd better call there." And every house that we came to they knew exactly how everybody was standing and they'd just work them like you'd weed a garden. That's how they got elected. Because it was good, hard work, and nothing but their bare hands really to work with, but they had dedication and devotion and belief.[60]

When Grace and Angus did find time to relax, they "used to love walking and very frequently on a weekend when we had a bit of time we could stroll around the streets in Ottawa and stroll into the places where they kept nice china, and Angus would fairly gloat over the idea of securing a piece of this china," a collection which Grace kept by her until she moved into a nursing home many years later because each piece reminded her of the happy times they had had.

That year's return tour to the Maritimes by Angus and David Lewis was successful for the party, and blessedly free of the snow and ice that marked Angus's previous visit. He came to know Lewis better and enjoyed his company and political support. Relations would not always be so happy between them; political considerations would lead to differences, and later on, to an unhappy incident over the chairmanship of the party which Lewis would later admit he regretted for the rest of his life.

In the three weeks in Nova Scotia the team organized local units of the CCF in nine towns. There were urgent calls as well for help in the formation of new clubs, although lack of time made this impossible. The Steel Workers told them they would follow the lead of the Mine Workers and affiliate as a body. On his return, Angus filed a report which said in part:

> A little more work in Nova Scotia and they will be ready for a provincial convention to work out a program and to set up a Provincial Council. It should be understood that the work has only been started. If the work we have done is to bear fruit that will be beneficial not only to the people of Nova Scotia but to the CCF cause right across Canada follow-up work must be commenced immediately.

The CCF in all other provinces must realize the organization in the Maritimes is of the utmost importance if we are to be successful in building a National movement.

The decision of the United Mine Workers to affiliate with the CCF for political purposes is the most significant thing that has happened in the political life of Canada for a long time. Here we have an old, experienced and strong industrial organization deciding that the time has arrived for it to begin to think and act politically as well as on the industrial field. It is also significant the UMW convention decided to affiliate with the CCF rather than form a provincial labour party. We can only conclude that the miners decided on affiliation with the CCF because they had watched the work of CCF representatives in the legislatures and in the federal parliament.

During the last week I visited a number of points in New Brunswick where we have some CCF members. The field in New Brunswick is also in need of workers and literature.

However, what this glowing account failed to mention was the ever-present Communist burr that pricked the smoother side of social democracy in its early years. In a letter from Moncton, New Brunswick, dated October 1, Angus wrote to Grace:

The people here are very confused. As you will know those we met yesterday and today are the leaders of the CCF here. Most of them do not know what the difference between the CCF and the [Communist Party] is, if any. When the leaders don't know, how can one expect understanding from the rank and file? I think the talks we had with them last night and today will do some good. They are well meaning, but their lack of understanding is amazing. They would be so much putty in the hands of well trained Communist organizers.

[Glace Bay, N.S., October 14] The local labour party here met last night and decided to dissolve . . . [David Lewis]

said the Communists were out in force – seven of them – and did everything they could to delay action. However, it was decided to dissolve the party and its members and make application for membership in the CCF clubs. One of the members present at the meeting came to tell me how well David handled the situation. He was amazed at his coolness and how cleverly he replied to the arguments of the Communists.

Another element in the maritime political mix was the Co-operative Movement. Angus and David Lewis met with two professors from the St. Francis Xavier Extension Department, A.B. MacDonald and A.S. MacIntyre:

> We ascertained from A.B. [MacDonald] that they were somewhat concerned that one result of the UMW taking up political action might be the loss of interest in the Co-operative Movement and its educational work. We assured him that was the last thing desired by the CCF and that we would make it quite clear at our meetings with them that the CCF was not something that was going to take the place of what they were doing now, but was in addition to the steps they had already taken to benefit themselves. I am more satisfied than ever I was that the Co-ops here are doing good work and that they are doing it in the right way. They are following the Scandinavian rather than the British method. Those who have come under the influence of the FX educational work can be detected without difficulty. They always stress the necessity of studying in groups in order to get a clear understanding of the subject. The work of the St. FX Extension Department has done much to mellow my hostility to the Roman Catholic Church. We must try to keep them with us.

As the year came to a close Grace and Angus were together on the eve of the new year – 1939 – a year which would see them united regarding Canada's commitment to involvement in the war, and, before too long, united in their lonely support of British Columbia's Japanese Canadians.

War Is Declared, Grace Becomes an MLA

One can only guess how members of the Woodsworth and MacInnis families felt as New Year's Day 1939 dawned. Although Grace's reactions aren't recorded, likely she was still struggling over her recent conversion to her husband's view that Hitler should be stopped and that the CCF support the government if it decided to enter a war against fascism.

J.S., however, remained steadfast in his belief that no war could be declared that he would support. Although respect for the other person's point of view was customary in the family, even when it concerned such a profound matter, for Grace especially the decision finally to disassociate herself from her father's pacifism must have been painful, placing her as it did between the opposing views of the two men she respected most.

It wasn't a case of siding with her husband against her father, in fact, an abiding memory of Donald C. MacDonald, one-time leader of Ontario's NDP, is of the "quiet smiling and whispering around the room when some topic would come up and Angus and Grace would be on opposing sides and really putting their case in the most vigorous fashion."[61] Grace's brother Bruce would agree: "Grace was not subservient to Angus at all, they were tied by love for each other, and work . . . they worked together as a team." Grace had been raised to form her opinions independently. As Bruce explained: "My father didn't propagandize or coerce us."[62]

Although Angus mostly avoided what would now be considered chauvinism, commonplace among husbands of that era, when it came to the operation of the family car, the tone of his letters adopted a distinctly more head-of-the-house approach:

> In regard to the operation of the car, be sure that you have plenty of oil and water in it, and also have the tires checked frequently. The pressure for the tires is 24 front and 26 to 28 rear wheels. If you are having three people in the back

seat make it 28. It would be a good plan to leave her at McKissocks for a check. The young fellow is reliable.

All of which Grace took in good part, recording in her diary: "We still regard each other's company as the supreme luxury."

In the summer of 1939 Angus attended the CCF conventions in Saskatchewan and Manitoba while Grace stayed home in Vancouver carrying out party work in British Columbia. Of the man who, not many years later, would succeed J.S. as leader of the party, Angus commented: "There is not the slightest doubt in my mind but that M.J. Coldwell is the best-liked man in Saskatchewan today."

In Winnipeg, on his way home to Vancouver, Angus wrote of J.S.'s failing health. Never robust, his thirty years of overwork in the cause of socialism had not helped. His health continued to deteriorate until May 1940, when he suffered a stroke, followed by a second in October 1941, when he retired from public life. J.S. never fully recovered and died in March 1942. Meanwhile Angus's own health was by no means good, and an attack of lumbago caused him considerable discomfort on the tour.

In August, Grace tried unsuccessfully for a nomination in Victoria. Angus, who read about it in *The Vancouver Province* as he toured the province en route home, commented by letter:

> Although I would like to see you accept a nomination somewhere, I was glad to see a local man in Victoria. I was somewhat surprised to see that Kenneth McAllister got it as his name had not been mentioned as far as I know. I am wondering what was the influence behind his nomination.

Angus and Grace had hardly caught their breath after his return, before Angus left again by train for Ottawa and the momentous days following the outbreak of the Second World War. In a letter written aboard the train on September 4 (the day after Britain had declared war on Germany), he wrote:

> I see the die has been cast and that we are in it again, I had a feeling right until Great Britain declared war that Chamberlain would back down. After giving everything

to the fascists during the last five years I could not see how they could fight now with the odds so terribly against them. May be it is a case of "Whom the Gods would destroy they first make mad." The British and French governments have certainly been mad since 1935.

Some forty members of the CCF National Council from across the country assembled in Ottawa to discuss the CCF's course of action following the outbreak of war against Germany. Lucy attended with J.S., and Agnes Macphail, part of the original Ginger Group, was a lone non-party visitor (member for the United Farmers of Ontario). Angus remarked at the time: "I believe we must have order in our internal affairs before we can have peace. Aggressor nations must be stopped by those nations who believe in international order."

On September 6 in the committee room of the Parliament Buildings, whose windows overlooked the Rideau River and the Gatineau Hills beyond, the atmosphere was tense; Prince Edward Island was the only part of the country not represented, and the National Council was bolstered on this occasion by provincial presidents and secretaries. J.S., pale of mien but calm of demeanour, opened the three-day session, outlining the reason for it. Although those present were well aware of how he would vote, there were other delegates who continued, even at this late hour, to wrestle with their consciences about how *they* would vote. Everyone present felt weighed down by the responsibility laid upon them, and awed by the magnitude of the decision whose outcome they would affect. They listened with respect and misgiving to the National President they revered as founder of their movement, as he made an eloquent plea for non-involvement in the war. No one doubted his sincerity, all admired the valour of his lonely stand, and, when he was done, the rest of the day passed in discussion. Hours later a six-man committee was struck to draft a statement of policy for the council's consideration. Its members included H.I.S. Borgford, Nova Scotia; Angus MacInnis and Herbert Gargrave, British Columbia; F.R. Scott, Quebec; George H. Williams, Saskatchewan; and David Lewis, National Secretary.

Before this motion was taken, J.S., supported by his old labour friend from Winnipeg, S.J. Farmer, moved "that this Council refuse to endorse any measure that will put Canada into the war." Following lengthy discussion, there was agreement – not unanimous – to refuse the motion at that time, but to have the committee proceed with the draft statement.

As Grace MacInnis recorded in her biography of her father, *J.S. Woodsworth: A Man to Remember:* "The story of the committee's work lives unforgettably in the minds of its members. One of them, Angus MacInnis, recalls that it was the steady and wise persistence of Frank Scott, later National Chairman of the movement, which made eventual agreement possible. For, like the rest of the delegates, indeed like the rest of the world at that time, the committee members were sorely divided and torn, even within themselves."

But finally they emerged with a policy statement, one which could only be a compromise among their differing viewpoints, a declaration that the CCF favoured Canada's participation in the war, but only to the extent of economic assistance. This limited support would subsequently be broadened considerably.

The following day was spent discussing the statement. For the pacifists the decision was simple, their minds were already made up. The others were faced with the dilemma of choosing between their traditional stance of opposing yet another war between rival imperialists, or that of embracing a principle that socialists should shoulder the responsibility of stopping aggression and preserving existing freedoms "as part of the painful process of building a world where law and order will be respected because they rest on a foundation of social justice and democratic control."

In the end the statement was approved in a vote of fifteen to seven – some delegates, because of transportation considerations, had left before the vote was taken. It was decided that M.J. Coldwell, National Chairman, would make the decision known to the House of Commons and the country.

The following day, Prime Minister Mackenzie King, rising to talk about the war, looked across the House and paid tribute to J.S. Woodsworth in a statement that was remarkable in view of the

known attitude of the CCF leader: "There are few men in this Parliament for whom, in some particulars, I have greater respect than the leader of the Co-operative Commonwealth Federation. I admire him, in my heart, because time and again he has had the courage to say what lay on his conscience, regardless of what the world might think of him. A man of that calibre is an ornament to any Parliament."[63]

J.S.with Lucy and two of his sons in the gallery, replied: "Tonight I find myself in a rather anomalous position. My own attitude to war is fairly well known to members of the House, and, I think, throughout the country . . . I could almost wish that [the Prime Minister] had not said what he did, because I am afraid that tonight I must disappoint him and disappoint some of my other friends in the House." He wound up a resounding speech in which he outlined his well-known reasons for the defence of pacifism and rejection of war as a solution to aggression with a quotation from James Russell Lowell, which in the words of his daughter Grace, "had long been one of J.S. Woodsworth's compass points":[64]

> Truth forever on the scaffold,
> Wrong forever on the throne,
> Yet that scaffold sways the future,
> And behind the dim unknown
> Standeth God within the shadow,
> Keeping watch above His own.

He concluded: "I do not care whether you think me an impossible idealist or a dangerous crank, I am going to take my place beside the children and the young people, because it is only as we adopt new policies that this world will be at all a livable place for our children who follow us. We laud the courage of those who go to the front; yes, I have boys of my own, and I hope they are not cowards, but if any one of those boys, not from cowardice but really through belief, is willing to take his stand on this matter and, if necessary, to face a concentration camp or a firing squad, I shall be more proud of that boy than if he enlisted for the war."[65]

The next day, September 9, writing to Grace, Angus said:

> J.S. spoke last night and he really made a fine speech. Of course, I felt it was not conclusive and it did not convince me. Perhaps I cannot be convinced. It was, however, a great speech and I am sure that it increased that respect in which he is held in the House. Coldwell put the case for the CCF today, but he did not seem to me to be as effective as I have heard him on occasion. However, it is very hard to please everybody.

That weekend Angus was in the House working on an editorial for the B.C. *Federationist* on the events of the week. He wrote:

> If Germany wins, that class will be greatly heartened. They will immediately become more aggressive and the unthinking mob will follow the lead of the one who can promise bread with the loudest voice. It will not be necessary for Hitler to invade Canada to impose fascism, thousands here have the idea in their hearts already.

The extent of conflict within CCF ranks at that time is illustrated in Angus's comments about Grant MacNeil:

> Grant is greatly worried. There is first his own memory of the last war and his horror of accepting the responsibility of putting another young fellow in the position where he will have to go through the same hell. I think it is a very real thing with Grant . . . [also] there is the fear of taking a stand which will be opposed to that of the CCF membership in [his constituency of] Vancouver North. If he takes one stand he will be repudiated by his constituency committee. If he takes another he will be repudiated by the people of the constituency who elected him in 1930. Taking it all in all, he is about as troubled a man as you could find. I have never known a time when one could justify suicide with more right than today. Everything is so chaotic.

Back on the coast, Grace must have grieved for her father, despite her own change of heart about the war, and doubtless wished she might have been in the House to hear him speak, but money was as scarce as ever, and train fares were expensive. Moreover, Grace, who always put duty first, would have felt bound first to carry out her provincial chores. Whatever her feelings, her letter to Angus following the National Council meeting focused on political rather than personal aspects of current events. In answer to her questions, Angus replied that "this is a straight fight as far as Britain and France are concerned, against fascism."

> I have no illusions on that point. When I posed the question to the Council members last week: "Are you wholly indifferent as to who should win this conflict, Germany, or Great Britain and France?" They all would rather that Great Britain and France would win. The next question was "Why?" Because, no matter how slim the chances of maintaining some democratic institutions after the war , we were more likely to keep something if the Allied powers won than if Germany won. These were the reasons that determined the action of the Council. These, of course, and the feeling that we were more likely to maintain the strength of our movement by taking this kind of action than if we said we had no interest whatever in the matter.
>
> You say you wish we had taken a position of solidarity with the International Labour Movement. I am convinced we have done that. The British Labour government is solidly against fascism at this time and so is the French. I am sure that if the workers of the other European countries were not afraid to speak that they would let it be known, in no uncertain terms, that they were hoping for a Hitler defeat. The workers in the U.S.A. are also on the side of the British and French, if not in the war.
>
> On the question of the "peace," when it comes, [M.J.] Coldwell, when he spoke, left no doubt in the minds of the members that the CCF firmly believes we should determine

now that when we are considering peace it will not be a peace of revenge. I think these are the main points you raised in your letter.

In 1940 Angus and Grace felt their constant separations keenly. There was a brief mention of finding an apartment in Ottawa together, although it came to nothing, perhaps because the following year Grace would finally win a seat in the B.C. Legislature, and this prevented her from committing herself to a move to the capital.

Her reluctance to join Angus likely marked a turning point in Grace's political life. Despite the couple's enduring affection for each other, and the pain of their frequent separations, Grace had, after all, grown up in a political family and knew it was a penalty she had to pay. That being said, Grace must also have felt that since her marriage she had more than served her apprenticeship on the political sidelines and it was time to move on. Although her first bid for a nomination had failed, she knew she had Angus's support for another try provincially so, with characteristic determination, Grace set about what is now called "networking," with, in her case, a whole lifetime of contacts to work with.

Arnold Webster, who at that time was active in Vancouver Burrard, approached Grace to ask whether she would run for the second half of the dual-seat constituency, in tandem with Grant MacNeil. Webster, a past president of the provincial organization, acted as her campaign manager.

Before launching her career as a politician, Grace went to Winnipeg to help her parents pack up their home. They had decided to retire to British Columbia's easier climate. Angus, back in Ottawa, wrote from the Bytown Inn in November, in a nostalgic mood:

> And then to the dear, old Bytown Inn ($2 a day). I have a room on the ground floor in the south end where we had our honeymoon. I do not think our first honeymoon was our happiest. We have had a number of lovely ones since 1932. I hope you will come down, I shall miss you.

[and two days later] I think I also detected in your letter a wish to come to Ottawa as soon as your father and mother are ready to leave Winnipeg. I hope you will come as I would like to have you here with me. As you say, we do mean a lot to each other and I imagine that, that being the case, it is best that we should be together. I think it is extremely hard to get apartments here now. I got the name of one woman who wanted to rent her apartment furnished. For: 1 living room, 1 bedroom – twin beds, bath with shower, kitchen, silver and linen, she wanted $100 a month. When she gave me the price I told her it was far more than we intended to pay.

Angus, who enjoyed teasing Grace about his "lady" friends, once quipped in a letter that, unlike a sailor with a wife in every port, he had a wife at home and a sweetheart in every port. Although he cheerfully described his meal and movie outings to Grace he added that his virtue was "of the essence." In a sense Grace was likely not surprised by her husband's enjoyment of women's company because, as her brother Charles reports, their father's partiality for good-looking young females was something of a family joke and resulted in J.S. becoming the butt of some good-humoured teasing. Lucy, for her part, always had absolute faith in her husband's morals on this and, indeed, on any other issue, and no doubt Grace took her cue from her mother's example.

By September Angus was setting out by CPR on a provincial tour as Grace began her campaign. Throughout her campaign he wrote – in a vein that many feminists today would likely consider politically incorrect or, at the very least patronizing – letters that reflected affection and a genuinely supportive attitude.

I am sorry I won't be home for your debut on Friday night. I hope it will be a great success. Be serious but not too serious. Aim to be constructive and positive rather than critical and denunciating. Be firm without being strident. A woman loses charm if she becomes pugnacious. I may appear to be setting you an impossible standard, but I love

you and also the cause in which we are both engaged. Besides you are young, you are at the beginning of what may be a very useful and interesting life. The best of luck, my love. Ask a few friends to the apartment to celebrate after the meeting.

When Angus received news of the meeting from Grace it was to hear that it had been poorly attended:

> It is too bad that meetings are so poorly attended. I think it especially unfortunate in Vancouver East. It was, of course, inevitable that Harold [Winch, provincial CCF leader] would have to go out, but arrangements should have been made for a more lively speaker. People just won't come out to hear the "understated" word these days.

> [ten days later] Take care of yourself and do not drive the car at night when you are tired. Make them get you transportation if they want to send you anywhere.

Grace won her seat and the party did well in that election, winning fourteen seats and two more in by-elections, giving the party twice as many seats as held previously. John Hart was the Liberal premier of B.C. Harold Winch remained leader of the province's CCFers, and his father Ernie was still a provincial member. (The early days of the party were distinctive for their political families.) Grace respected the younger Winch for his sharp mind and ability to react concisely, although she complained he did not always share the decision-making process fully. Instead, he would consult what Grace described as a small clique which included Grant MacNeil, Gretchen Steeves, and Colin Cameron, and expect everyone else to go along with the decision.

Letters from Angus illustrate the early days of Grace's career as a politician. For example, almost as soon as Grace took her seat in the Legislature, Angus was tutoring his wife in her new role as MLA. He wrote from his CNR coach, en route to Ottawa:

> The National convention is due in 1942, and we should be giving thought to selecting our delegates and preparing

for financing them now. As this year will be the 10th anniversary of the CCF we should be considering appropriate celebrations . . . if we busy ourselves with constructive activities we won't have the time for discussing damn fool things like the Theory of Revolution and underground activities. People who want to waste time at such things should be supplied with children's Indian outfits, complete with fringed leather pants, feathered hats, and wooden guns. . . . You are surely going to have your hands full. Avoid being governed in your attitudes by prejudice. Everyone has prejudices, but we must try and overcome them. However, prejudices are not always bad. In some instances they are protective. Be firm, but co-operative.

Lovingly Angus

Back in Ottawa three days later, lonesome and aware of how Grace's new commitment separated them as never before:

I wish you were here, but wishing will not bring you here this time. I do not think lovers in books have anything on you and me. We have, I think, experienced all the ecstasies of love. I believe I have anyway.

If you were here, we would be celebrating [your campaign victory]. . . . [J.S.] was in the House yesterday and got a great ovation [after his absence following his stroke]. . . .

So many people have congratulated me for you and have asked to convey their good wishes to you. . . . The Prime Minister sends his congratulations and so does Mr. MacKinnon, Minister of Trade and Commerce, Mr. Pulloitt, Mr. De Puis, Mr. Weir, Dr. Bruce, Mr. Mayhew, and many others.

[The following day] The expected has happened, J.S. has given way under the strain of the excitement of the past few days. When he was in the Buildings yesterday I noticed that he was much more feeble than usual. I was

worried and called the Carman home this morning. Mother spoke to me and she said they had to call in the doctor last night. The doctor, the same as he had after the stroke, ordered him to the hospital for a couple of weeks' rest. . . . This setback should at last make it clear to him that his trouble is not incapacity of his arm and leg, but the weakness of his general system.

This, of course, doubtless added to Grace's stress in her first days as an MLA. While pressure of work likely prevented her from brooding too often about her father, Angus's joking, but persistent reference to his dalliance with the ladies at this time may have proved something of a trial. Whether he was trying to console himself in his loneliness or simply making sure Grace didn't let her election go to her head is a matter of conjecture. In any event, her being in the limelight had some effect on him:

> I got the Baxter photo [of Grace] framed and [it is] hanging in my office. I took it around to show to the group before hanging it up. It is being greatly admired. I am very much afraid if I do not get back to the coast shortly and put you where you belong that your silly little head will be turned. I would not be surprised if I were soon to regret that I taught you to wear becoming clothes. From now on you are going to wear good Harris tweeds.

> [November 19] I am sending you the last issue of the *New Leader* which had your article on the election. I think it is very good. I hope you will not mind my saying so, but it seems to me that there is a sense – that may not be the right word – or feeling of maturity in the article that I have not noticed in your writing before. By the way, did not the Liberals get 21 seats and the Conservatives 12? In your article you said Liberals 20, Conservatives 13. . . .

> [Re strategy in B.C.] It seems to me that the CCF should be careful on two points:

> 1. Do not be manoeuvred into trying to form a government. I think that would be fatal.

2. Do not be manoeuvred into the position where you
 can be blamed for a new election. To avoid a new
 election you should be prepared to do almost anything
 except going into a union government. If [T.D.] Pattullo
 resigns and the Lt. Governor calls on Harold [Winch]
 to form a government he should refuse and advise
 Woodward to ask either [R.L.] Maitland or [John] Hart
 to form a government.

As Angus was riding home via the CPR on December 4 he
wrote to Grace that she "had been initiated into the mysteries,
complexities and futilities of parliamentary administration as
carried on by people who think of individual advancement rather
than in terms of social progress. Or, to put it another way, by
people who measure social progress by their own advancement."

In less than a week he and Grace would be reunited, the day
after Pearl Harbor and the Japanese attack on the U.S. fleet. On
December 7, Angus wrote from the MacDonald Hotel in
Edmonton:

The war is coming nearer to us. I suppose you were
shocked to hear the news. We listened to President
Roosevelt giving his message to Congress. I wonder if you
have noted any changes in the "temperature" on the coast.
I hope the people won't become hysterical and start
reprisals against inoffensive Canadian Japanese. So far the
radio and the press has been very reassuring.

Reassuring the news did not continue to be, and it would
not be long before Angus and Grace would be defending the
Japanese Canadians. Meantime, Angus wrote Grace: "I am looking
forward so much to seeing you again. We both must be wise and
make the most of our periods together because they are likely to
be more broken than in the past. It would be almost a miracle if we
would be able to continue together as we have been during the
past ten years. We never were short of things to talk about and the
experience of each during the past six weeks will give us almost
unlimited topics."

J.S. Woodsworth Dies – Political Life Goes On

On March 21, 1942, J.S. Woodsworth died, worn out by his lifelong struggle to spread socialism, his last months saddened by the war and his party's decision to support Canada's involvement in it. Grace was attending a CCF convention in Vancouver when the news came, ironically as local members of the party passed a resolution recommending a "Yes" vote in a plebiscite on conscription. Her personal opinion was that "the plebiscite was political trickery" on the part of Prime Minister Mackenzie King, however, a "Yes" vote prevailed because members believed a "No" vote would give a leg up to Quebec Fascists, who, Grace said, were working in co-operation with the Axis powers.

J.S. had remained national president of the CCF until the end, despite an offer to the delegates of the 1940 national convention to resign, an offer that was promptly and unanimously rejected.

At a memorial service for Woodsworth in Vancouver, William Irvine, who had been his first parliamentary colleague, said of his friend:

> He was genuine. He was never less than invariably more than he represented himself as being. He *was* what he seemed to be and he was that all the way through, everywhere and always. . . .
>
> It was his super sensitiveness to the touch of another's pain which made his soul a flaming passion of protest against injustice and drove his frail body into prodigious dynamic action. While his fellows were in want or pain,

Woodsworth suffered with them, when they were imprisoned he felt himself to be in chains.

He not only had courage of a physical kind, the courage to face a hostile crowd, to become a longshoreman, to go to prison. But he had that courage expressed in lines which he himself quoted: the courage "to go on forever and fail, and go on again," the courage which enabled him "to rest with half broken hope for a pillow at night."

J.S.'s eldest son, Charles Woodsworth, in a memoir about his father, wrote:

> It was with a sense of having shared magnificently in an undertaking ennobled by mutual friendship and deep understanding that we left the chapel and moved towards the final and dramatic rite in which, in a physical sense, Father took leave of us and we of him. At a dock not far from the chapel we boarded my boat . . . in which during his final illness he had enjoyed occasional short voyages into the surroundings of sea and mountain he loved.

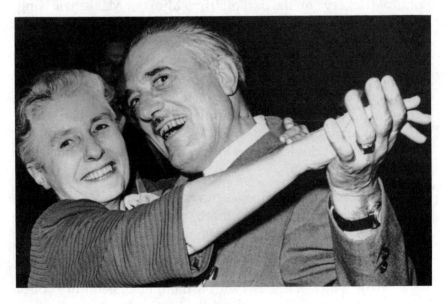

Grace enjoys a rare moment of leisure dancing with Harold Winch, leader of British Columbia's CCF when Grace was a provincial MLA. They are at Rio Hall, site of many party get-togethers.

The day was grey. Dark clouds rode the sky and a stiff breeze whipped up a choppy, rolling sea as we put forth into the waters off English Bay and the dark green mass of Stanley Park. It was a stormy day but the wind blew with a clean freshness, the clear, cold waves breaking into foaming white crests good to behold. It was a day which in many ways symbolized the turbulent, yet transparently honest and cleansing character of the man whose memory we were honouring.

As our little vessel tossed, bow-on, into the sea, with just sufficient power to keep headway, the urn containing father's ashes was brought to the after deck. There in the presence of his loved ones his ashes were committed to the winds and waves that know no bounds and exist for all.[66]

And his daughter Grace wrote:

In the immensity of sea and sky the launch rode at anchor while mother carried out his last wish . . . we saw that she held in her hand a few leaves of her shamrock plant, a growing slip from the love-token he had given her before they were married. She looked at the living green for a moment and then very slowly she let it drift into the waters.[67]

There is no record of Grace's personal grief, although she must have received some comfort from the praise and recognition given to her father by people of every persuasion from around the world. However, in the middle of a world war, there was little time for her to indulge her sadness, and, in any case, it was not in her nature. The CCF was working hard, firmly established with fourteen members, Grace herself having enjoyed a majority of twelve hundred votes in the election the previous year.

The party had come in on the slogan, "Victory abroad, security at home," and on policies calling for public ownership of war industries, democratic direction of the war effort, genuine collective bargaining, and social insurance. Profitable dollar patriotism was condemned. "The CCF contended that Nazism should

be opposed only with the full power of its opposite – democratic socialism," said the *B.C. Federationist*.[68]

Grace was a member of the social welfare and municipal committees of the British Columbia Legislature. Her work on social welfare issues received impetus shortly after the October election when it was reported in *The Vancouver Province*: "An announcement by Mr. Harold Winch at the CCF victory dinner told as plainly as well as words can tell anything why the CCF is a growing power in British Columbia and why its contingent in the new Legislature will have greater debating strength than either the Liberals or Conservatives. The CCF has been working at provincial problems and intends to continue its work."[69] Winch set up a number of committees to carry out the party's election platform.

The party itself was successful in its effort to set up a labour committee which, for the first time in Canada, enabled trade unionists to approach the Legislature directly.

Writing in *The Toronto Star* in May 1942 Eleanor Godfrey commented that "Grace MacInnis gives an odd impression of both quietness and vitality. She seems thoughtful and rather studious until she smiles when she suddenly seems very young [she was thirty-seven at the time] and full of eagerness as though everything around her is exciting and stimulating. This freshness and quick response are combined with a highly trained mind and a burning confidence in the eventual triumph of socialism.

"Although she dislikes and distrusts the word *gradualist*, she believes that, barring the unpredictable crises of a war world, social democracy can be won by what she chooses to think of as a 'pioneer movement,' that is, the political and social education of people on one hand and well directed mass action on the other."[70]

Only two months after Pearl Harbor, and less than six months after Grace's election to the Legislature, the federal government passed an Exclusion Order decreeing that British Columbia's Japanese (many of them Canadian by birth or through right of citizenship) must move a hundred or more miles inland from the west coast. Despite the conviction that gripped people both in and out of government at the time that the Japanese would

Angus and Grace share the dishwashing at home in Vancouver in 1941. This was their Christmas card. Angus promised before marriage that he and Grace would share housekeeping chores.

act as spies or saboteurs, not one single case of such behaviour was ever proved against them. Angus and Grace worked tirelessly and fearlessly against hostile opposition in their province and in the House of Commons to right, or at least to deflect the course of, something which both believed to be an intolerable injustice.

The friendship of many of the Japanese who came to their home in 1942 to bid goodbye before their enforced removal from the coastal area remained a constant throughout their lives. Conversely, they also made enemies who were ferocious in their condemnation of the MacInnises for the stand they took. A pamphlet the couple wrote, *Oriental Canadians – Outcasts or Citizens?* was a first step in their long fight on behalf of this minority.

In the summer of 1942, Grace was in Quebec during that province's CCF convention. Canadian Press reported that Grace complained that other political parties had called for union among the peoples of Canada, "but no-one has made any effort to bring

about the union. All across the Dominion, people are anxious for the problems of the times, yet various groups are divided. We must remove the hyphen separating them and the differences will melt away more quickly and more thoroughly . . . race and religion are not the enemies of the people of this province [Quebec], the real enemies are those who control the lives of the people, and this is all due to the present political system."[71]

Although no longer active in the CCYM, Grace always took a keen interest in education and training, and she continued to be consulted by its members. In the summer of 1942 her advice was asked about the possibility of the CCYM getting a study course, complete with questions, exams, and diplomas. She summed up her opinion by saying, "I shall try to steer their ambitions for the CCYM into less suicidal channels."[72]

In August she wrote to Angus from the coast:

> The 24 hours at the YMCA (CCYM) camp were very pleasant and introduced me to a group of people – most of them on the sunny side of 40 – who should be a valuable asset in getting advanced ideas across in many fields. The panel was quite a success – Bob MacKenzie, Bob MacMaster, Grace MacInnis – all good Scots! We discussed the role of co-operatives, (MacKenzie) in the church, MacMaster in labour, your humble servant, in the present-day world. The campfire following was reminiscent of Gabriola [site of another summer camp].
>
> In some ways, though, the two summer schools are poles apart. Here at the Y camp was a group wanting a *disciplined*, creative holiday. There was swimming and sport and fun, but also a keen interest in well-arranged intellectual sport. I really think we shall have to steer our CCF students into this camp, abandoning the other to the fresh air holiday crowd with the "Marxian" students to give a touch of snobbishness to it.

Along with a new self confidence born of her status as a politician, Grace seemed more willing, able really, to share her feelings in letters on a variety of subjects. One subject was

accommodation – in the early years, Grace (and Angus when he was home) shared living arrangements with his sister Ginnie and niece Violet.

> I've been turning over in my mind what we should do for living arrangements. Possibly in view of the uncertainty of things, the sanest thing would be to continue at the Montrose [an apartment building in which they lived in various apartments over the years] for the present at least. What I know for sure is that I'd like just you and me to be in whatever establishment we have this fall. Our time is bound to be so broken that I'd like for both of us to know we could come home to a quiet, orderly place with no-one else to plan for or live with. However, this may be just a sign of getting old on my part. And you have spoiled me for living with anyone else.
>
> Bruce [Grace's brother] left for Gibsons this morning. He will get some needful articles there and return to Vancouver in time to start work in the shipyards on Monday morning. He is to work there for a few weeks until they find a spot for his training and experience in the armed forces. Curious world, isn't it, where a teacher must leave his school and mount a scaffold to build ships while he waits to train as a soldier.
>
> [On the teacup collection] Not another cup until you get a house for us to display it in! I'm sure I've forgotten half the ones we have now and you have, too. But I like being married to a person crazy enough to live in the smashing, shattering 20th century and have a hobby like collecting china. While you live there will be optimism in the world, my dear! There's something really audacious about a hobby like that. Just daring the gods or devils to do their worst.

In a sense the war limited Grace's introduction to legislative life because its impact on every aspect of life narrowed the scope of government activity to dealing with a war-driven economy almost exclusively. Her years with the federal caucus and work on

a wide range of issues across the country likely left Grace feeling a little hemmed in by her latest position. Therefore she was excited when, in the spring of 1943, Dr. Cyril James invited her to become a member of the Sub-Committee on Post-War Problems of Women. Margaret McWilliams, the wife of Manitoba's lieutenant governor was chair of the committee.

Grace, unsure whether she should accept, wrote seeking Angus's advice. She didn't approve of the sub-committee's approach: they met only with personnel directors. "I would press to meet the women workers themselves, in unions if they are organized, wherever we could if they are not." In her usual methodical manner, she set out the pros and cons of her participation.

Pro
1. The chance to make contacts all across Canada with the opportunity of spreading our ideas.
2. Some recognition of the importance of the CCF in dealing with current problems.
3. Perhaps a chance to introduce new methods (i.e., meeting workers directly).
4. The opportunity to learn new work and new experience which might be of indirect value to our movement.

Con
1. The knowledge that the Council is controlled by people like Dr. James (academic) and Mrs. McWilliams (both able supporters of the *status quo*).
2. The fact that I would be the only CCFer on this particular sub-committee and might not be able to influence anything, while being associated with any wrong or foolish decisions they made.
3. The fact that I would probably have to travel standard and stay at good hotels – both of which seem to be well-nigh criminal practices in view of the living standards of the majority today.
4. The fact that my very acceptance of responsibility would prevent me in some measure from damning the Council and its works.

In the end, Grace decided to accept the appointment, and was able to look back on the committee's recommendations as basically sensible.

Before the trip, however, there was a flurry of correspondence:

> Your letter about springtime and Lover's Walk and the robin on the lawn was very lovely, dear. Had you not made such a success as a politician you would have made a good poet. . . .

> I've been lonely for you and I almost cried today when I read that you weren't coming home. But when you said you would like to meet me in Winnipeg I felt better, even though Winnipeg isn't nearly as beautiful as here. Perhaps, though, we can have a better time together – without CCFers or anyone else around.

> From the work you have been doing you must be very tired and we can just sleep and walk and talk and go to the odd show – and just relax in the manner of honeymooners the world over. [Grace and Angus nearly always referred to their times together as "honeymoons." Considering how seldom they were able to spend time together, it was hardly surprising.]

> From your last letter or two I begin to realize what a very imperious, selfish person I've been these years – or, perhaps, just how very unselfish and considerate you have been. Just *why* should my plans take precedence over *our* plans? If we're going to have any time at all together we shall have to *plan it together*.

Surely no letters written in wartime escaped the nitty-gritty of shortages, and Grace's were no exception.

> The business of expecting people to "grow their own" struck me yesterday in all its absurdity as I walked along those tenement fronts of the west end. It just can't be done. I'm really afraid for next winter. The shortages are severe enough now. . . .

The reason for wasting(!) an extra airmail stamp on this letter is that we observed that your ration book has all the coffee gone for April. We don't think we shall have enough to let you have your accustomed daily supply. *N.B. Please bring along your own coffee*!! Otherwise you won't be able to have any, and will have to watch Violet and me guzzling it.

Grace was due in Revelstoke in June 1943 to help out on the campaign trail of the eventually successful Vincent Segur. She travelled with Gretchen Steeves who, along with Laura Jamieson, was in the triumvirate of CCF women in the B.C. Legislature. Grace felt compassion for Gretchen during this trip because her only son, an RCAF pilot, had been killed. Grace's close friendship with Gretchen was to falter later over political differences, but the triumvirate was very much a feature of that wartime Legislature.

Around this time, Grace made her first radio broadcast, not that she was particularly happy with it, as she informed Angus.

Well, my radio recording is finished. It was quite a job – first the script, then censoring by Gretchen [Steeves] and Frank [McKenzie] with a re-write each time, then an hour's coaching in radio technique by a radio friend, then a visit to the Government censor (and he is a flirtatious old gentleman), and finally the recording itself. No, not finally. The final thing was the crushing blow of hearing my voice for the first time. Honestly, I never knew it was *that* bad or that I wheezed at the end of sentences like Billy King [William Lyon Mackenzie King, the prime minister].

More pressing problems needed attention in the summer of 1943 – cleaning Communist Party influence out of the unions and from within the CCF. In Toronto to help with the provincial campaign, Grace became increasingly irritated:

I got here today ahead of schedule . . . Saturday morning I phoned the CCF office and found them pleasantly vague and as disorganized as Ontario usually is during campaigns. Each one always runs his own in the best-approved

capitalist tradition. I could find no-one who appeared to be in command . . . everyone seems to be doing bits and pieces.

By the middle of August Grace was in Ottawa working on the Oriental pamphlet, and planning a draft to send to Angus. As she saw the situation, if the pamphlet was thoroughly comprehensive, mass circulation wouldn't be possible. Therefore it was important to produce something short enough to be widely read. Grace hoped it could be part of the national office series, with Dominion-wide distribution. Grace sent it off to Angus to do what he liked with, "as soon as your love for deliberate action will allow you to do it." Despite the frantic pace, Grace sometimes took a moment off for idle gossip and a brief giggle:

> I must tell you the story of how the Liberals tried to win the town of Humboldt. It seems that the town has the world's worst water – useful only for flushing toilets, according to M.J. [Coldwell] – provided you can get out of the toilet quickly enough! Well, a few days before the election, the Liberals began operations on some land and had water spouting out in various places. They informed the inhabitants of Humboldt that if the Liberals got a majority in the town, a new water supply would be provided. On the Sunday before the election they went around Humboldt with pails of water, knocking at doors: "Have you a pitcher, Madam? Here is a sample of your new water supply." (The first time, said M.J., that I ever knew the Liberals to bribe people with *water*.) Well, the Liberals did get a majority in the town itself – just 32 votes – and the CCFer who was announcing the results as they came in, pronounced enthusiastically: "Humboldt gets a new water supply."

Grace used her experience with the Dominion Reconstruction Committee to needle British Columbia's provincial government about women's post-war place in the work force. Following Premier John Hart's 1944 budget speech, her reaction was reported on March 2 in the *CCF News*. "Do we sit and wait for the avalanche

to overtake us?" She attacked the government's lack of planning for productive employment. "Anyone with a head knows that without the alternative of productive employment there will be thousands walking the streets. You can bury your heads in the warm sands of ignorance, but the cyclone of destruction will strike. Why not admit to our men in the armed forces that you are making no adequate plans for post-war employment?" She said the CCF wanted people trained and placed in the economy to earn their own living, so that social services could be cut to a minimum. Plans should be made, she said, for houses, clothing, food, and health services to replace the production of ships, guns, and materials of war. Throwing down the gauntlet to women on the other side of the Legislature, Grace said that "if the question of proper status (paying them the minimum wage, for example), and training for domestic workers was not brought up by the government, we on this side will see that it is brought up."

The *CCF News* commented: "Declaring herself to be 'no feminist,' but a citizen demanding quality for other citizens, Mrs. MacInnis devoted the bulk of her time to problems relating to the competition of women in the labour market. Citing census figures, and estimates from the Bureau of Trade and Industry in B.C., she established that the movement of women into industry in Canada was a long-term trend, not just a wartime, temporary condition. "One in every three industrial workers in Canada is now a woman. Estimates indicate that one in every five in B.C. is a woman. There were 600,000 Canadian women in industry at the opening of war, now the figure is 1,200,000."[73]

Speaking to an audience in Burrard riding in September 1944, Grace told them: "In the perfect post-war democracy women must have equality with men in the choice of occupation. This will only be possible with full employment which can come only through overall government planning and social control of the economy. About half the women now employed in industry want to stay. Single women earning their own living must have equality, and conditions for homemakers must be improved. Unless full employment is maintained," she pointed out, "part-time workers are a serious menace to the system."[74]

This 1944 picture of Grace during her four-year stint as a member of the British Columbia Legislature was taken before she was stricken with rheumatoid arthritis.

Working conditions for women were not Grace's only target. She told a West Vancouver meeting that the two "old-time parties" [the Liberals and Conservatives] had permitted payment of lower wages to Japanese to undercut all others; had allowed "big business" to bring the Japanese to B.C.; and had condoned the growth of race prejudice while refusing to deal with its cause, lack of "economic security."

Another issue Grace tackled was the restricted franchise. Writing in the *CCF News*, she said: "Mental and educational fitness has nothing to do with eligibility to vote in a Vancouver city election. To get on a Vancouver voters' list you must have property on the assessment role or you must be a tenant – not merely a roomer, boarder, or temporary occupant of rooms. Roomers pay rent but they can't vote. To vote for money bylaws your property must be of the assessed value of $300 or over. If you are a resident

here you may be interested in getting a new Nurse's Training School [proposed at that time] . . . but unless you have property worth $300 or over, you have nothing whatever to say about it."[75]

It was all part of keeping politics out of city hall, she said. "No wonder the Non-Partisans don't want CCF politics in city hall. It would mean planning and municipal ownership and the placing of human needs before property rights. But the people are waking up to the fact that it's high time Vancouver began to develop government of the people, by the people, and for the people."

Another milestone for the CCF took place in 1944 in Seattle when the nucleus of Washington's Co-operative Commonwealth Party (CCP) held its first public meeting. Grace was the main speaker. The *CCF News* reported that "memberships were taken and about $200 raised in cash and pledges to start statewide organization . . . applause greeted [Grace's] remark that the CCF regards everyone as a human being, regardless of race, creed or sex."

Nearly a hundred delegates attended the 1944 provincial CCF convention. Many of them were trade unionists – thirty-one affiliated with the Canadian Congress of Labour and twenty-nine with the All-Canadian Congress of Labour. The delegates endorsed a resolution following discussion of proposals made by these mainline labour bodies dealing with legislation for the post-war period. It included a twenty-nine-point action program. This followed months of behind-the-scenes plotting and planning and letters between Angus and Grace at this time give details of some of the machinations that went into bringing about a successful conclusion.

The CCF, which had been such a strong force during the war years, was defeated in the 1945 election by another coalition government, Grace being one of the defeated MLAs. She attributed her personal defeat to coalition forces, but she also believed that her championship of Japanese Canadians contributed to her rejection by the voters.

Part II, Chapter 10

The Japanese-Canadian Issue

When the Japanese attacked Pearl Harbor on December 7, 1941, there were, according to the census taken that year, 22,000 Japanese in British Columbia, 13,400 of whom had been born in Canada, and 2,400 more who were Canadians by right of citizenship.* The Japanese had started to come to the west coast towards the end of the nineteenth century – the first immigrant to arrive had been Manzo Nagano in 1877. They had found work as fishermen and as fruit and vegetable farmers in the Fraser Valley, others had found a variety of occupations including dress-making and running small corner stores.

The CCF's thinking on the subject of minorities was outlined in Section 12 of the Regina Manifesto. Under the heading "Freedom," was advocated "equal treatment before the law of all residents of Canada irrespective of race, nationality or religious or political beliefs." Such equality, as it pertained to the right to vote, had thus far been denied the Japanese of British Columbia. At the time Japan entered the Second World War on the side of the Axis powers, the only Japanese Canadians eligible to vote in B.C. were active servicemen. Without the right to vote the Japanese were effectively kept out of professions such as medicine and law which made citizenship a prerequisite for admission. Local business leaders in British Columbia saw the value of Japanese immigrants (and of Japanese born in Canada, whether or not they had citizenship status) simply as a useful source of cheap labour.

*The 1985 Price Waterhouse study puts the number of Japanese Canadians in British Columbia in B.C. in December 1941 at 23,000.

Angus fought hard in the House of Commons for their franchise long before Pearl Harbor. Outside the House, the CCF's championing of the vote ran up against such vulgarities as: "Look behind the solicitor for any CCF candidate, and you will see an Oriental leering over his shoulder with an eye on you and your daughter."[76] The war did not halt Angus's pursuit of this objective and, in a memorable speech in the House, he advocated that those of Japanese origin in Canada be granted "all the rights and privileges that I have, on the sole basis that they are human beings. To deny them one iota of the rights and privileges enjoyed by, I shall say, individuals of the race to which I belong, would be a denial of the brotherhood of man, a denial to fellow humans of rights and privileges which I enjoy for no better reason than that my race was here first. It would be an assertion on my part of the superior race theory, for the eradication of which from the minds of men our young men are dying all manner of deaths in every part of the world. This world can only be at peace when all its people are free and equal."[77] In fact, it would be 1949 before the Japanese were enfranchised.

In the meantime the fact that British Columbia's Japanese Canadians had no vote was just another hole in their armour against their white neighbours. Grace's brother Bruce pointed out that the hostility towards Japanese Canadians was also "economic persecution. The Japanese were very industrious fishermen. Whatever they did, they were frugal; they saved money to put into whatever it was – white people weren't as good at this, they were jealous. This led to their wanting to sabotage Japanese people."[78]

It is difficult now to put ourselves in the highly charged emotional space of those days. Many men and women who had lived peacefully alongside their Japanese neighbours – albeit often harbouring racist attitudes which, it should be remembered, were not then particularly perceived as politically incorrect – were suddenly caught up in the hysteria of the times. In the same way that many people in Britain expected German spies to drop from enemy planes over the countryside after the retreat from Dunkirk, many British Columbians truly feared that spies were aboard every Japanese fish boat sailing the coastal waters, or were

masquerading as fruit farmers in the lush fields along the Fraser Valley.

Angus was acutely aware of this hysteria and, as early as October 1940, more than a year before the Japanese attack on Pearl Harbor, had tried to head off the dangers inherent in it in an article in the *B.C. Federationist*. He reminded readers that the majority of Japanese in the province were Canadians by birth or naturalization, and that "Canadian-born Japanese are Canadians in every essential because of their education and associations."[79]

There was fear that Japan would attack the United States, using British Columbia as a corridor through which to travel. In Ottawa, federal members from B.C., in particular Ian Mackenzie, Tom Reid, and A.W. Neill, were influential in the federal government's decision of January 1942 to order all residents of Japanese descent to move from the west coast at least a hundred miles inland.

Angus and Grace from the outset opposed this edict, demonstrating, according to her brother Bruce, "their integrity by taking what looked to be the wrong side of the issue, which later showed they were the correct ones." Writing in the *B.C. Federationist* early in 1942, Angus commented:

> Mr. Burnett [a Liberal candidate] advocated dismissing all Japanese employed in British Columbia, replacing them by Canadians. Evidently it has not occurred to him that the "Japanese" he would deprive of their livelihood are not Japanese but Canadians, either by birth or by the laws of Canada . . . does he advocate using the taxpayers' money to keep them in idleness?
>
> At another meeting he condemned the CCF for passing resolutions favouring votes for Japanese and said they [the CCF] have "sold our birthright for a lousy bowl of rice." As Canadians of Oriental origin have not yet the right to vote it is clear the CCF have not made a sale. But sales have been made . . . the scrap iron, copper, pulp, and timber have been going to Japan with the knowledge and consent of the Liberal government in Ottawa and the Liberal government

at Victoria, and we haven't heard a peep from Burnett. Mr. Burnett's speeches indicate that he has a lot to learn.[80]

However, in the spring of 1942, even CCF members in British Columbia were divided on their attitudes toward local Japanese Canadians. According to David Lewis, as recorded by Ann Gomer Sunahara in her book *The Politics of Racism*: "Intellectually you would have to divide the CCF position [in British Columbia] into three: the position against the mishandling of the Japanese and their rights as Canadian citizens – that was Angus MacInnis's position, and that had the support of the majority of the CCF. The others were divided into two: the hysterical, which included strangely enough . . . the left-wing Marxists, and then there were the people who were afraid of the local situation,"[81] such as Harold Winch, then leader of the provincial CCF.

So it came about in March that the Japanese Canadians were rounded up, without the benefit of judicial procedure, and temporarily housed in Vancouver's Exhibition Grounds. (A two-acre park being created next door to the grounds and known as Momiji Gardens will both symbolize the wartime experience of the province's Japanese and celebrate the history of Japanese Canadians and their contribution to the Canadian mosaic.)

Despite the wish expressed at that time by a number of individuals that the round-up be conducted in a humane manner, the Japanese Canadians were treated much like animals and indeed were given space in stalls intended for animals. No mass protest ensued as the whole round-up took place so suddenly.

The inhumanity of the treatment meted out to Japanese Canadians was not to abate. Following their incarceration at the Exhibition Grounds, those who were not permitted to re-locate themselves outside the hundred-mile coastal limit were moved to various locations around the interior of the province. The internees often landed up in abandoned houses, many of them no more than wooden shacks in old mining towns. Icy winds blew between cracks in winter and the internees had to scrape the ice off interior walls. Those who worked were paid twenty-five cents an hour by

the B.C. Securities Commission established to supervise the evacuation. They were prohibited from owning radios or cameras – these might have been used for spying. Their fish boats were seized. An early plan to turn them over to whites was abandoned, instead they were auctioned off and their former owners given only a fraction of their worth. This was true for all the property of Japanese Canadians. In 1947 it was estimated that $11.5 million worth of Japanese-Canadian property had been disposed of for $5,373,317.64.

More than eleven thousand Japanese Canadians were interned in B.C.'s interior. Others were sent to sugar beet fields in Alberta and Manitoba. A few who went to Ontario as household maids and farm workers found that, on the whole, attitudes towards them were less hostile. "Often church groups got together to help in the work of trying to get justice done and also to help them in any way they knew," Grace said. "The church groups really took the initiative and helped them get acclimatized ... the Japanese Canadians had arrived at a stage of education and general way of living which was very comparable to middle-class people any place, or highly-skilled blue-collar people, and so they were received as such by the other people down east."[82]

Grace said Angus was like a watchdog in the House of Commons, "trying to get families reunited where they had been separated, in one case where a man's father was dying – trying to get permission for the son to go and visit the dying father – the son was in Ontario. He failed on that one, I think. But he did succeed in many ways to mitigate individual hardships and he never wearied of pointing out the injustices that were being done under this war situation. This was the reason he was later given an award by the Civil Liberties Union of the University of British Columbia – the 1955 Garnett Sedgewick Award for outstanding work in the field of civil liberties over a period of many years – and an honourary LL D, the first CCF person to receive one from a Canadian university."[83]

But during the war the MacInnises were often on the receiving end of a different sort of reception. Grace recalled many years later: "I remember going to one of the most hostile meetings I was

ever in out in the [Fraser] Valley. Out there, the farmers were very incensed about the Japanese Canadians and they had organized a big mass meeting in one of the towns . . . the chairman, who was supposed to be neutral, proved to be far from neutral . . . well, of course, it was a very hostile meeting and, of course, I was pretty aggressive there, I guess because I knew that was the only way to survive, but it was a nasty meeting. It was past the state of academic debate and I have always remembered that meeting as being one of the high points of nastiness."

According to Thomas Shoyama, now visiting professor at the University of Victoria's Centre for Pacific and Oriental Studies and formerly Deputy Finance Minister in the Trudeau government, all but one thousand of British Columbia's Japanese Canadians were affected by the evacuation order. At the time of this mass uprooting, Shoyama was editor/publisher of the *New Canadian*, which was allowed to continue because "its editorial line was to be 'loyal Canadians.'" However, he did move the paper to Kaslo while his parents, brother, and sister – the latter a graduate nurse – were moved out of the so-called hundred-mile protective zone to Kamloops in the interior. Shoyama feels that the MacInnises "on one hand were the voice of conscience and principle which they reinforced at least and, on the other, there was a voice for our defence which helped with morale amongst the Japanese Canadians themselves."[84] In other words, Angus and Grace were among the few who did what they could on behalf of this group. Despite the fact that their efforts met with little success, Japanese Canadians were aware of what they were trying to do, and it helped them to keep their spirits up in miserable circumstances.

The MacInnises worked hard to alleviate the wretched conditions of the uprooted Japanese Canadians, often with little success, however, the Japanese Canadians never forgot anything done in the line of kindness, and their attempts to help were acknowledged by a presentation of a power lawn mower to Angus when he retired and moved to a big house in Kerrisdale.

In retrospect, even though she still saw the process as despicable, Grace felt that the dispersal of Japanese Canadians across Canada gave them opportunities to influence the country's

affairs and establish themselves in its economy which they otherwise might not have had.

One of the earliest Japanese Canadians to claim citizenship when the franchise was finally granted in January 1949 was Katsuyori Murakami, then running a restaurant in Cardston, Alberta. His parents were already naturalized Canadian citizens. With another couple, Kumanosuke Okano and his bride Riyo, they had come from Japan to British Columbia in 1898. A daughter, Kimiko, born to the Okanos in 1904, was the first Japanese Canadian born in the fishing village of Steveston. Later she married Katsuyori Murakami.

Kimiko and Katsuyori bought and cleared seventeen acres on Salt Spring Island and, over the next nine years, they developed a successful berry farm, in addition to selling eggs from a five-thousand-chicken operation. They expected that the year 1942 would be a profitable one. Instead, according to the Murakamis' daughter K. Mary Kitagawa of Delta, B.C., "on March 17, 1942, an RCMP officer pushed my father onto the back of a pickup truck and took him away like a common criminal. Like a puff of smoke, he disappeared from our lives."[85] As she put it "the bomb that fell on Pearl Harbor shattered my parents' dream and plunged them into a life wrought with fear, uncertainty, and unspeakable hardship." The rest of the family was soon removed from Salt Spring as well. Their first destination was "the filthy livestock barns in Hastings Park. . . . there were no mattresses, just straw . . . poor food at the mess hall caused diarrhoea and food poisoning. Toilets were troughs previously used by animals."

In May, Mary Kitagawa's grandparents, who were with them, were sent to a sugar beet farm in Alberta. Her father, they found out, was living in a railway boxcar at Yellowhead Pass, working on the trans-Canada railway project. Along with her mother Kimiko and her four siblings, Mary was sent to Greenwood, B.C.

In July, Katsuyori Murakami joined his parents at Magrath, Alberta. The railway work was causing rapid deterioration of his health, and so he was moved to the sugar beet farms. In August, five months after the disruption of their lives, the rest of the family

was allowed to join him there. The sugar beet farmer provided them with a dirty, ten-foot-by-fifteen-foot shack. "In it was an unusable stove . . . the flies from the pig pen just ten feet away gave the illusion that the shack was painted black." In November, the family asked to be moved once again. The hard work and the harsh living conditions were having an adverse effect on Katsuyori's fragile health. They were sent to Slocan, B.C., accompanied by an RCMP officer. There they shared a large tent with three other families.

Another move followed in 1943, and this transient existence continued until 1946 when the family reluctantly returned to Magrath to work in the sugar beet fields. Twelve-year-old Mary stayed home minding her siblings, the youngest of whom was two years old, while each day Kimiko dragged herself back and forth to fields several miles away, limping because of an injured hip. "There was no hot bath," laments Mary, "to ease the pain nor to relieve them of their weariness."

By 1949 the family moved again, this time to Cardston to take over a restaurant their grandfather had started. Despite all the misery, somehow the Murakamis paid off debts and saved for a return to Salt Spring. All they had received for their confiscated (and looted) property was $500. The land was sold after the war to a returning veteran who refused to sell it back to them. They bought another farm and returned to Salt Spring in September 1954, on Kimiko's fiftieth birthday. Through hard work and determination the family has prospered, four of the children having attended university.

Katsuyori Murakami died in 1988, on March 16, one day short of the anniversary of his uprooting from the family farm in 1942, and six months before the Japanese-Canadian community achieved redress. Mary Kitagawa is saddened that "he was denied the joy of experiencing that happy occasion: the apology given by Prime Minister Brian Mulroney on behalf of the government of Canada and the symbolic monetary compensation of $21,000." But, she says, "by speaking out for others who are suffering injustices, we are also strengthening ourselves. We must never become silent victims again."

Well-known pacifist Mildred Fahrni, writing at the time in the *CCF News*, reported on the discomfort and overcrowding in the evacuation centres, such as that the Murakamis lived in. "Where old buildings are being used, families are crowded in close proximity sharing cooking and plumbing facilities, which are often inadequate. Where new huts have been erected, food for lean larders often miraculously appears grown amongst the rocks and roots and sand banks. This has made it possible for families to live more comfortably on their limited incomes . . . few have opportunities for outside work, and the margin of income they are allowed above their maintenance is so small as to discourage all but the most ambitious."[86]

Japanese Canadians were not only robbed of their property and belongings; the twenty-five hundred children of elementary school age moved to the interior were initially also cut off from the province's education system, if not completely, then certainly from anything comparable to that available to non-Japanese youngsters. Grace was amongst those who sought to redress the situation; she travelled to the interior to research the situation for herself. There were a number of concerned volunteers who went to help at the evacuation centres, some giving lessons to the children.

In Dorothy Steeves's biography of E.E. Winch, *The Compassionate Rebel*, she wrote: "The Minister of Education [H.G.T. Perry] was proposing an amendment to the School Act to prevent any child of Japanese origin attending a public school. They could go to separate schools only, if and when these were established by the federal government, which eventually came about."[87]

There was an attempt to solve the situation through correspondence courses. It was reported in *The Vancouver Province* that CCF members in the B.C. Legislature "protested the additional $8 charge levied on young evacuees in relocation centres for correspondence courses." What was described in the *CCF News* as a "free-for-all" was precipitated when the House was asked to approve a grant for correspondence courses.

"Mrs. Grace MacInnis (CCF, Vancouver Burrard) asked why Japanese Canadian youngsters were asked to pay $9 for a

correspondence course when the charge to other students is $1. The Education Minister, H.G.T. Perry, replied that they were evacuated by the Dominion Government and added that the problem of educating the children fell on the local school board." To CCF member (Vancouver Centre) W.W. Lefeaux's question whether the province had requested the Dominion to pay the $65 per student being paid to other provinces for the education of evacuee children, the Minister declared angrily, "Why talk about selling your birthright for a mess of potage? I would be selling the whole school system for $65 a kid."[88]

Among the Japanese throughout Canada were approximately seventy-five hundred children under eighteen, fifty-five hundred of them in B.C.'s interior. The Japanese, according to the report of a Royal Commission on Japanese Welfare, placed "great importance upon the education of their children, and this was one of their chief concerns at the time of evacuation."[89] Ultimately, after strenuous efforts on their behalf by the CCF and other supporters, the British Columbia Security Commission, between September 1942 and May 1943, set up a complete school system for the school-aged children in the housing centres in several settlements. The system was headed by two qualified Japanese-Canadian teachers, Miss H. Hyodo and Miss T. Hidaka, and 130 teachers were chosen from the best-educated young Japanese Canadians in the settlements. These were given an intensive but thorough teacher-training course in the summer of 1943 by a group of provincial normal school professors.

It was reported that "the fundamental weakness of the Commission schools is the lack of association of these Japanese-Canadian children with Canadian children of British and other racial origins." School clubs in debating, drama, public speaking, and choral singing were set up to help overcome this situation.

Approximately a thousand high-school students in the settlements were educated by Church Mission schools under trained Occidental teachers with the aid of provincial correspondence courses. The Commission assisted by providing accommodation, lighting, and heating, where possible. In the provinces east of the Rockies, two thousand Japanese children

went to regular public and high schools by arrangement with provincial authorities. Some Japanese Canadians in those provinces attended universities and colleges for academic and professional training.

Dispossession was only the beginning. Although in 1942 the Veterans Land Act had not yet become law, the Soldier Settlement Board, a similar First World War scheme, was still under the jurisdiction of Thomas Crerar, Minister of Mines and Resources. Federal MP Ian Mackenzie wrote to Crerar suggesting he get an order-in-council under the War Measures Act to enable the Soldier Settlement Board to buy the dispossessed farmland and hold it pending the passing of the Veterans Land Act. The farms were to be appraised and their former owners compensated accordingly. It was hoped sale of the land would discourage any post-war return by the Japanese. When this dastardly scheme passed it went largely unnoticed in the press's excitement over reporting the rout of Rommel's Afrika Corps.

Solicitors for the Japanese Property Owners' Association were confident that the dispossession order-in-council could be challenged, but this met with legal wrangling and procrastination that would go on for years and end in monstrous financial loss for the Japanese. In June 1947, *The Toronto Star* reported the case of Tokichi Takeuchi, a Canadian citizen. "He owned a house in Vancouver assessed at the time of evacuation at $2,500. For his livelihood he operated a rooming house in which he had an estimated investment of $2,500. All he received from the custodian for his home and rooming house fixtures and supplies was $1,675. This was not even as much as the assessed value of the house – an amount which often represents only 75 per cent of the real value," it was reported. The custodian sold the house for $1,500 and after deducting selling expenses of $200, turned the remaining $1,300 over to Mr. Takeuchi. He only received $175 for the rooming-house fixtures and supplies."[90]

There were other discriminatory acts. In 1944, following some fancy parliamentary footwork, the government succeeded in disenfranchising those B.C. Japanese who had previously been enfranchised: i.e., serving soldiers, then the only enfranchised

Japanese Canadians. Grace was furious. Writing to David Lewis in June she said, in part:

> This letter is being written entirely on my own though with the knowledge of Frank McKenzie [provincial secretary]. At long last we have been able to get some details about Bill 135 which is apparently going through its last stages in the Senate now. . . . I can hardly believe the evidence of CCF inaction.
>
> Here we have a bill whose purpose is to disenfranchise Japanese Canadians in all sections of the Dominion. In this province the CCF has been tenaciously fighting to wipe out discrimination . . . and we have been winning through, too . . . yet when Bill 135 comes up in the House of Commons there isn't a single word of protest from the CCF members. . . . Not only that: evidently Clarie Gillis, who was on the Franchise Committee that drafted Bill 135, expressed satisfaction over the general harmony existing in the Committee about the bill.
>
> I think I have said enough, David . . . British Columbia has gone through a lot on this matter for the sake of principle. Our CCF people are going to feel as I do that the National end of the movement has let us down and let us down badly. Angus [then in Australia] will be bitterly disappointed, because never in the world would he have allowed that bill to go through without the strongest possible kind of protest. . . . This legislation is of the same kind that Father spent the 1920s protesting against again and again. During the last war it was deportation legislation and Section 98. This time it is the franchise. But this time it will have to be repealed, too, no matter how long it takes. And the bitter thing is that there wasn't a word of protest while it was going through 2nd and 3rd readings in the House. Now the YWCA, the YMCA, the United Church . . . and many others are protesting. What about the CCF? Surely if the Civil Liberties League recognizes the need for protest, we should not be blind.[91]

Grace carried a good deal of clout in the party as a serving politician and as a member of a prestigious CCF family – and she was not above using it when she thought it was called for.

The war's end did not bring peace to Japanese Canadians. Dispossession, it transpired, turned out to be just a necessary step on the road to deportation, a goal of Ian Mackenzie's from the beginning, according to historians of the period.

There was an outburst of hatred by Progressive Conservative and Liberal members of the House, typified by Tom Reid, Liberal, of New Westminster, in what the *CCF News* described as "an incoherent attack on the CCF proposals to settle this problem in a democratic manner, by granting the franchise to all loyal Canadians regardless of racial descent."[92] Reid charged that "white" Canadians were buying farms on behalf of Japanese Canadians, and A.W. Neill, Independent member for Comox-Alberni, predicted, "There will be bloodshed if the Japanese return to B.C. It will be only a generation or two until the Japanese will overrun western Canada unless we do something about it."[93]

In the words of the *CCF News*, "After the heated chauvinisms of the Aryan-minded Members of Parliament, the voice of J.W. Burton (CCF Humboldt) came like a shower of rain at the end of a hot summer day. In the absence of Angus MacInnis, who recently left for Australia, the Saskatchewan member brought the debate to a close with a calm, reasoned appeal for tolerance to all racial groups in Canada."[94]

Nevertheless, just before Christmas 1945, an order-in-council decreed that "every person of sixteen years of age or over, other than a Canadian national, who is a national of Japan resident in Canada and who has, since the date of declaration of war by the Government of Canada against Japan, on December 8th, 1941, made a request for repatriation; or has been in detention in any place in virtue of an order made pursuant of the provisions of the Defence of Canada Regulations or of Order in Council P.C. 946, of the 5th day of February, 1943, as amended by P.C. 5637, of the 16th day of August, 1945, and was so detained as at midnight of September 1st, 1945; may be deported to Japan."[95] The same order applied to naturalized British subjects of Japanese descent sixteen

years or over resident in Canada who had requested repatriation provided that person had not revoked in writing such request prior to midnight of September 1, 1945. Natural-born British subjects of Japanese descent had until the minister had signed an order for deportation.

In addition, the wife and any children under sixteen of any person for whom the minister made an order for deportation to Japan could be included in the order and deported with that person.

There was provision for giving deportees, upon expulsion, $200, or topping up a shortfall, with the proviso that such sums be repaid. Personal possessions were to be sold or disposed of – goods undisposed of at the time of deportation were vested in the Custodian of Enemy Property to be sold at his discretion.

By way of rebuttal, the CCF put out a pamphlet – *Our Japanese Canadians: Citizens Not Exiles*, on the cover of which appeared a quotation from the Magna Carta: "No free man shall be taken or imprisoned or dispossessed or outlawed or banished or in any way injured – except by the legal judgement of his peers or by the law of the land."[96]

Kinzie Tanaka, a Canadian-born B.C. resident who had been sent to Lempiere, an Alberta road camp, during the relocation days, said at the time, "Japanese Canadians are loyal Canadians and want to remain in Canada. Yet, under the so-called voluntary repatriation scheme, many are facing deportation from the land of their birth. They were influenced into consenting to be repatriated by a fear of insecurity. Really, they want to stay in this country." Tanaka was then thirty and reunited with his mother and his brother George in Toronto. His mother's home in British Columbia had been sold for $700 to a buyer who later re-sold it for $2,000. Kinzie Tanaka founded the Japanese-Canadian Committee for Democracy whose one hundred members were not faced with deportation but were concerned about those who were. Ten thousand people were scheduled to be repatriated to Japan.

Terry Hidaka, supervisor of schools in the relocation centres, said that the department pictured repatriation to Japan in the most rosy hues, assuring the Japanese that they would find more

freedom and friendship than if they stayed in Canada. This was far from the truth. Arthur Hara of Vancouver, for example, who was fifteen when he was deported with his parents, found that his fellow students in Japan regarded him as an enemy; school in Japan was not at all a happy place for him.[97]

A poll conducted in 1944 showed that about half those who answered were in favour of the Japanese staying in Canada and being treated as citizens, albeit with some reservations about ensuring they were "loyal and good citizens," but nonetheless Mackenzie continued to press for deportation. In December of that year the federal government was forced to review its intentions when the United States passed legislation enabling its Japanese to return to the Pacific coast after the war. This didn't stop the relentless push in Canada against Japanese Canadians. They were now urged to repatriate on a voluntary basis or, alternatively, to move east of the Rockies. It was January 1947 before the government announced revocation of its orders-in-council ordering the deportation of Canadian citizens of Japanese origin, and a willingness to remedy the injustice caused through sale of Japanese property at less than fair market price. It would be decades before anything came of this.

According to a Globe and Mail article of January 1947, despite the federal government's action, in British Columbia the exclusion order was retained. This order prevented the 6,776 Japanese in B.C. from changing their place of residence without a permit from the Minister of Labour. The Japanese were also forbidden to engage in fishing activities in coastal waters.

Perhaps the first hesitant step towards redress can be traced to 1943, when the Japanese-Canadian Committee for Democracy was founded. After the war, in 1947, this committee was converted into the community's first national organization, the National Japanese-Canadian Citizens' Association (NJCCA), with chapters in Quebec, Ontario, Manitoba, Alberta, and British Columbia. Tom Shoyama reported that in 1947-48 the NJCCA had a "very brief discussion about the possibility of seeking redress," an idea quickly dismissed, "as being so remote as not to be worth fighting for."[98]

Remote it might have been, but the MacInnises always firmly supported the need for it. In an article published in March 1944 in *Reconciliation* (a publication that proclaimed itself to be "in the interests of the peace movement"), Angus expressed the opinion that Canada should follow the example of the United States which had already made a start in redressing the wrongs done to its Japanese residents. During the forty-year struggle for redress, Grace would speak on numerous occasions on behalf of Japanese Canadians. They knew they always had her unqualified support, and she came to number among them many friends.

Redress was on the minds of those in a CCF group in Toronto, the Co-operative Committee on Japanese Canadians, which announced in February 1947 that it had requested from the government information "concerning the machinery that they propose to set up to enable those who suffered losses to present their cases. Interested groups will have to give this matter a great deal of thought in order that we may assist the government to make amends for the injustices inflicted by the forced sale of property."[99]

In 1980 the National Association of Japanese Canadians (which had evolved from the NJCCA) set up a reparations committee to investigate the question of redress. Ironically, there was little public or media interest until 1983, when the congressional Commission on Wartime Relocation and Internment of Civilians in the United States, set up to assess the uprooting and incarceration of Japanese Americans, submitted its report, *Personal Justice Denied*. This report recommended a public apology and compensation of $20,000 for each uprooted Japanese American. When Canadian journalists began investigating the internment of Japanese Canadians they were surprised to learn that the violations and losses were even more severe this side of the border.

Early in 1983, the NAJC reparations committee, renamed the National Redress Committee and chaired by George Imai in Toronto, began advocating a redress package consisting of an acknowledgement of injustices and group compensation of $50 million for a community trust foundation. Individual compensation was not included in this position. Imai announced

his committee's proposal to *Toronto Star* reporter Joe Serge. Imai's revelation to the press coincided with the imminent departure of NAJC President Gordon Kadota to visit Japanese-Canadian centres across Canada to gather views on redress and to ask representatives to assist the NAJC to formulate a policy on this issue. When news spread that the issue of redress might be resolved without community input, many Japanese Canadians hitherto on the sidelines of community politics were drawn into the controversy. In a moment, the cause of a few became the issue of all. As a result, it was realized there was still a lot of work to be done before any consensus could be reached about compensation and the best way to seek it.

On the Labour Day weekend of 1983 at the NAJC conference convened by the National Redress Committee, there was heated debate, the upshot being the realization that more democratic means were needed to represent Japanese Canadians who were directly affected by the injustices of the 1940s. There was a leadership struggle between the NAJC president in Vancouver and the NRC chair in Toronto, one which, it was hoped, could be resolved at a meeting in Winnipeg. Art Miki, who had been active in the Japanese-Canadian community since 1977, with a background in education as a public-school principal, as well as extensive experience as a community leader in his hometown Winnipeg, was seen as the kind of leader who could bridge the divisions threatening to destroy the redress movement. Once he was elected president, he assumed chairmanship of the meeting, and almost immediately, three historic resolutions were passed that would remain the foundation of the redress movement until settlement in September 1988:

- The NAJC seeks acknowledgement from the Canadian government of the injustices committed against Japanese Canadians during and after World War II.
- Whereas the internment, exclusion and exiling of Japanese Canadians violated individual human rights and freedoms and destroyed the fabric of the community, the NAJC seeks redress in the form of monetary compensation.

- Moreover, the NAJC seeks review and amendment of the War Measures Act and relevant sections of the Charter of Rights and Freedoms so that no Canadian will ever again be subjected to the wrongs committed against Japanese Canadians during World War II.

The government released in March 1984 *Equality Now!* a brief containing recommendations to help visible minorities overcome the effects of racism and discrimination in Canada. One of these called for the government of Canada to:

- issue an official acknowledgement of the injustices inflicted on Japanese Canadians,
- undertake negotiations to redress these wrongs,
- review the War Measures Act to prevent recurrence of the injustices.[100]

It was at this point that Prime Minister Pierre Trudeau, in the words of Roy Miki and Cassandra Kabayashi in their book, *Justice in Our Time*, "hurled a massive insult at Japanese Canadians by flatly refusing to recognize the human rights value of redress." In a heated exchange with Opposition Leader Brian Mulroney, he stated:

> You're sick . . . if you're trying to take one wrong out of Canadian history and make great speeches about it and say that we are going to deal with this particular problem because there's a particular pressure group now.
>
> We could mount pressure groups across the country in many areas where there have been historic wrongs. I don't think it's the purpose of government to right the past . . . It cannot rewrite history. It is our purpose to be just in our time (*Vancouver Sun*, June 29, 1984).[101]

Charging that Trudeau was blinded by narrow-mindedness, Mulroney promised that a Conservative government would recognize the significance of redress.

> I feel very strongly that Canadian citizens whose rights were abused and violated and trampled upon indeed

should be compensated . . . if there was a Conservative government I assure you we would be compensating Japanese Canadians (*Globe and Mail*, May 16, 1984).[102]

Next the Minister of State for Multiculturalism, David Collenette, stated that the Trudeau government would not issue an official "acknowledgement," arguing that the actions of the government in the forties, although unjust, were legal under the powers of the War Measures Act. They would merely make a general statement of "regret," along with a token grant of $5 million for a proposed Canadian Foundation of Racial Justice to combat racism and assist its victims – but nothing would be provided directly for Japanese Canadians, or even the Japanese-Canadian community.

The government dismissed the call for a review of the War Measures Act, and assured Canadians that the new Charter of Rights and Freedoms was adequate to protect them against the injustices inflicted on Japanese Canadians. In fact it contained a major loophole: Section 33 allows the federal or provincial government to override the rights of individuals supposedly guaranteed by the Charter. Trudeau was correct in saying that the internment of the Japanese Canadians under the War Measures Act would have been illegal had the Charter of Rights existed then. What he failed to add, however, is that any government could still invoke Section 33 to override the equality rights under the Charter and intern individuals on the basis of ethnic ancestry.

Miki rejected Collenette's offer. There followed a period of conflict within Japanese-Canadian organizations and this held up progress. John Turner followed Trudeau as leader of the Liberal party and he promised to keep the matter of redress open. In 1984 a general election was called, and was won by the Progressive Conservatives.

In November of that year Miki submitted the NAJC's brief *Democracy Betrayed: The Case for Redress*,[103] and called on the government to acknowledge the injustices done. The following day the NAJC was greatly disappointed when Jack Murta, Minister of State for Multiculturalism, was quoted in the *Globe and Mail* as

saying: "The older Japanese Canadians, the ones who were actually involved in the uprooting, for the most part don't want compensation." According to Miki and Kobayashi in *Justice in Our Time*, "this theme would be played out for a number of years by the government in their attempt to discredit the NAJC as the legitimate voice of Japanese Canadians."

The next four years were a seemingly unending struggle. In December 1984 a joint press release from NAJC and the Ministry of Multiculturalism announced that negotiations would deal with the wording of an acknowledgement, civil rights protective legislation, and compensation to the Japanese Canadians interned.

In 1985 Murta reneged on his commitment to negotiate with the NAJC and refused compensation to the Japanese Canadians. Instead, he offered a token $6 million to "memorialize" their mistreatment. When the NAJC refused his offer, he threatened to act without their approval but backed down in the face of strong opposition. By August Otto Jelinek had replaced Murta as minister. The NAJC attempted to re-open negotiations as outlined in the December 1984 press release, whereupon Jelinek threatened to act unilaterally, but, as in Murta's day, strong opposition forced him to back down. The next year, 1986, Price Waterhouse Associates assessed income and property losses at not less than $443 million in 1986 dollars.

In February 1986 a testimonial dinner was held for Grace MacInnis, a fundraising event sponsored by the Greater Vancouver Japanese Canadian Citizen Association (JCCA) at Vancouver's Broadway Holiday Inn. Eighty-year-old Grace criticized Minister of Multiculturalism Otto Jelinek for his hard-line approach in negotiating with Japanese Canadians. "I think his best qualification to be a minister was that he was a wonderful skater. I can tell you right now, I think he's on thin ice," she said.

Thomas Berger, former B.C. Supreme Court justice, was the keynote speaker. In his address, he said "No nation can wash its hands of its own history." But, he said, redress should not come out of guilt. "I don't feel guilty. I was nine years old at the time . . . it's a question of accepting national responsibility." [104]

The Japanese Canadians gave the MacInnises (third and fourth from right) a dinner to recognize their championship of their cause during the Second World War. Angus was presented with a lawnmower and money. He declined the money, sending it to help survivors in Hiroshima and Nagasaki.

Perhaps this dinner brought memories to Grace of the dinner thrown by the Japanese ambassador sent to Canada after the war. It was huge, and, said Grace, people were "fairly falling over themselves to get invited." At a dinner held later to honour their dedicated work on behalf of Japanese Canadians, Grace and Angus were offered a trip to Japan. This had to be refused, reluctantly, on account of ill-health. A sum of money presented to Angus was given to those who had suffered in the attacks on Hiroshima and Nagasaki.

In May 1986 the NAJC submitted a comprehensive redress proposal to the federal government calling for the repeal of the War Measures Act and amendments to the Charter of Rights and Freedoms, official acknowledgement of injustices done, the creation of a human rights foundation, and compensation to Japanese Canadians. Jelinek refused to consider the redress proposal and ruled out negotiations with the NAJC.

In August that year David Crombie replaced Jelinek as multiculturalism minister. In 1987 he offered the NAJC a $12-million community fund. He ruled out direct compensation to and refused to negotiate with the NAJC.

By midsummer, talks had reached an impasse; the NAJC refused Crombie's "take it or leave it" redress offer and appealed to Prime Minister Mulroney to intervene personally. That fall the United States offered its estimated 66,000 Japanese-American survivors $20,000 each, plus a public education fund of $50 million.

In Canada, public support for the NAJC was mobilized through the formation of a National Coalition for Japanese-Canadian Redress with members from a broad spectrum of society, including writers Margaret Atwood, June Callwood, and Pierre Berton and former B.C. justice minister Tom Berger.

In October 1987 there was a rally in Toronto at which sixteen leaders of national ethnic organizations showed their support by signing a resolution urging the prime minister to negotiate a meaningful settlement with the NAJC. Finally, almost a year later, in September 1988, Brian Mulroney made a formal apology on behalf of the Canadian Parliament to Japanese Canadians and signed with NAJC President Art Miki the Japanese-Canadian Redress Agreement. Every Japanese Canadian who had lived through the war years in this country and who was still living, was entitled to $21,000.

Forty years had passed from the beginning of this sad and shameful chapter in Canadian history. Writing in the forward to Maryka Omatsu's book, *Bittersweet Passage: Redress and the Japanese-Canadian Experience*, former NDP leader Ed Broadbent wrote: "If there were few in the broader Canadian community who appeared with honour during this incident almost five decades ago, it is encouraging to read what can reasonably be described as a transformation in opinion by the 1980s. A small group under the leadership of Art Miki, who has appropriately been described as honest, stubborn, a consensus builder, first won a major battle within the Japanese-Canadian community and then went on in an imaginative and courageous struggle to mobilize public opinion."[105]

Angus MacInnis would have rejoiced that redress was finally made; certainly Grace did, although by this time she was not well enough to celebrate. No doubt the occasion took her back over forty years to 1945, when she had lost her seat as an MLA in the British Columbia provincial election partly on account of the strength of a coalition opposition, but also, she always believed, because of her wartime stand on behalf of the Japanese Canadians, a stand that she always took pride in.

Wes Fujiwara has said the redress movement "helped ease the feelings of shame." He was one of hundreds of Japanese Canadians who attended Homecoming '92, a three-day conference at Hotel Vancouver, and who took part in a discussion on the redress movement. He described the occasion as having taken a weight off his shoulders, "a huge weight that had been there for more than forty years."

At the time of the relocation Fujiwara was a medical student at the University of Toronto. He was warned by his sister, Muriel Kitagawa, who was working in Vancouver on the Japanese-Canadian newspaper: "This is just to warn you, don't you dare come back to B.C. no matter what happens, what reports you read in the papers, whatever details I tell you in letters. You stay out of this province. B.C. is hell."

Part II, Chapter 11

A War Ends, Conflict Continues

By the end of the war the fledgling CCF was taking shape. It had a research director, Lorne Ingle, and a publicity director, Donald C. MacDonald. In September 1946, together with National Secretary David Lewis, they moved into the party's first "real" office – it was on Metcalfe Street in Ottawa, and it was named Woodsworth House.

The first post-war convention was held in Regina. Two important policies came out of this convention. The first, a policy about women's equality, demonstrated that the CCF showed early leadership in this direction. The second was a policy demanding that civil servants be given the right to join unions and to bargain collectively. During this period a number of industrial strikes had occurred, all of them supported by the CCF.

In the fall of 1947 Angus left for New York to attend a session of the United Nations where he served on the political, security, and economic committees. His twenty-three letters to Grace from New York in about as many days revealed his fundamental shyness and lack of confidence in participating in a strange venue.

Used as he – and most CCFers – were to modest accommodation, Angus was impressed by his hotel room at the Biltmore on Madison Avenue. Thrift was not only a matter of necessity for most politicians of that period – $4,000 a year plus expenses was the salary for a federal member – it was also a matter of principle for Angus and Grace.

Angus wrote at that time that he did not believe that the then Soviet Union had any intention of making the U.N. work. He also wrote about his support, along with that of many others at the

U.N., for Lester Pearson to become chair of the Special Commission on Palestine. This was a position Pearson wanted, according to a letter written by Angus from New York, but his wish was thwarted by Mackenzie King who decided that Pearson must accompany him to London to attend the wedding of Princess Elizabeth and Prince Philip.

> I think Pearson should take the chairmanship of this Committee as I think it is very important to get a satisfactory settlement of the Palestine issue. If the United Nations could settle the Palestine question it would give it a much needed boost. I told Pearson that and I also told the Conference but Mackenzie King as usual will have his way.

Meanwhile Grace was driving herself as usual, in a pattern reminiscent of her father. Angus took her to task in an October letter, wishing she had come to New York where he would have made sure she got some rest:

> I am worried about your cold. Once a cold reaches your chest it hangs on for a long time. I do hope you will take care of yourself. Of course I know that any such hopes on my part are quite useless, because you won't take care of yourself as long as there is any talking to be done or people to be met. I am not, dear, being cross or complaining, I am merely stating a fact. In your letter of October 10, after telling me how bad your throat was you went on to tell me about your meeting and the good speech you made (which I don't doubt) and then the question period, the drive home, the coffee and cream puffs and other excellent edibles. Bed around 1 a.m. . . . not the way to cure a sore throat.

Grace had other concerns. Describing a visit with her great friend Laura Jamieson, a stalwart of the party, she wrote:

> Those present included Laura, Jessie Mendels [Winch], Gretchen [Steeves], Rod Young, Hilda Kristiansen, Colin

Cameron and myself . . . after Rod had left, we came to
foreign policy. Gretchen and Colin set to work to re-write
the statement we did at the last Council in Ottawa. I
realized there was no escape, took a deep breath and got
into controversy with Colin and Gretchen combined. They
were very fierce about the badness of the Americans (all
capitalists, of course) and the weakness of the Ottawa CCF
crowd for not standing up to the issue. Gretchen wants a
statement announcing to the world that Canada is taking
the lead in demanding that all troops get out of Berlin
immediately, that all bases on Canadian soil be abandoned
by the U.S. (including Newfoundland), that all the Geneva
trade agreements be scrapped forthwith, that all export of
fissionable material from Canada to the U.S. be scrapped
PDQ, etc.

I told them bluntly that I wasn't at all sure I would
support such an amendment, that to me the margin of
socialist survival was so narrow that I was not prepared to
pass any resolution which might give comfort to the
enemies of democratic socialism in Europe – and that I,
personally, had no doubt as to whether I would stand on
the side of Russian Communism or American Capitalism.

Well, the fat was in the fire, and for a good half hour we
went at it hot and heavy, the others listening and saying
nothing. Colin and Gretchen claimed to be perfectly neutral
as far as Communism and Capitalism were concerned, but
ended by accusing me of being so blinded by my hatred of
Communism that it outweighed my hatred of Capitalism.

I told them I considered Capitalism a waning force,
confined as it is pretty well to this continent and being
undermined by democrats here, but Communism was a
waxing force and hence, at the moment, far more dangerous.
They, of course, scoff at the idea of there being any hope of
getting the American people to resist the Fascism that is all
but supreme, in their opinion. Well, there's pretty deep
cleavage between our viewpoints, but – had you been a fly
on the wall – I think you might have felt I held my own

fairly well. I think it's no accident that Frank McKenzie and I were not re-elected to the National Council here. Gretchen gets her own way on foreign policy pretty much, because she's very positive on what she wants, and doesn't appear to count the cost of getting it – the cost to socialist forces.

In one of his letters home, Angus touched briefly on a nomination matter involving fellow MP Percy Wright. Angus had turned down the chairmanship of the caucus, whereupon Wright had been elected to the office by acclamation. It was not a matter of any consequence at the time, but three years later, in 1950, Wright would again take precedence over Angus in a nomination. On this occasion the outcome angered Grace, perhaps more than did anything else during the course of her political career; the hurt suffered by Angus in the process went deep and lasted for years.

Talking about the incident thirty years later, it is obvious that Grace still felt strongly about the subject. She told Peter Stursberg:

> Angus did meet just one great and bitter disappointment in his life, in his political life, and that was when, for the first time, the national federal convention met here in Vancouver in 1950, his own home city.
>
> Angus had for so many years been associated with the Council, and with the work on it. Way back, when it came to the Vice Chairmanship, Angus had been put forward as being a suitable person for it but the academic attitude prevailed, and they took Frank Scott – academic, plus geographic, because there is always the geographic to consider [when it comes to] British Columbia, until recent times. And so Angus willingly stepped aside to have Frank Scott in that position.
>
> Well then, the years went by until [the Council] met here in Vancouver for the first time in 1950, and they were choosing [a new Vice Chairman]. ... Without saying a word to Angus, [or] consulting Angus, and being very careful not to let it get to my ears, the higher command decided they wouldn't take Angus, that they would take

Percy Wright, a farmer from the Prairies. They thought it would make a better balance or something like that. . . . he was a good member and we remained good friends . . . but I did not like the manoeuvrings that were going on. David Lewis was the motivating force because David has always, as you know, known what was good for the party in David's mind.

And this was a bitter blow to Angus because Angus regarded it as treachery. . . . I had been going to run for [city] council again out here, I had been arranging publicity for the convention. As a matter of fact I'd not gone with Angus to Geneva . . . he got back just before [the convention].

I thought it was very unjust. . . . then Mr. Coldwell and other people came to me and they said: "Now look here, you've just got to decide whether this movement is more important to you, or your feelings about Angus" . . . and I suppose my own inclination was to stand by Angus, but Angus wouldn't have liked it on that ground because Angus was very like my father. He wasn't a self-advertiser at all, he would step aside if he felt there was a better qualified person to do a thing at the time, but he certainly felt keenly on this . . . and I don't think his relations with David Lewis were ever the same after that.[106]

In his autobiography, *The Good Fight*, which came out two years after this interview, David Lewis wrote:

There was another matter which caused distress, though it was not an issue of policy. . . . When Scott announced his decision to step down, MacInnis expressed his intention of running for the office, a most natural progression. However, when the National Council assembled in Vancouver, the prairie members, particularly [those] from Saskatchewan, insisted that since Scott was an urban easterner, his successor should be a western farmer. They decided to nominate Percy Wright, a farmer and a fine person from Saskatchewan, the province with a CCF government and

the strongest party organization. The conversations on the subject were, of course informal and private. Several other Council members, including Scott and myself, were canvassed and agreed. None of us, all friends of MacInnis, had enough sensitivity to appreciate the affront to his pride and self-respect which our decision entailed.

Since no-one wanted to defeat MacInnis in a contest, someone had to advise him of the decision to nominate Wright, in the hope he would withdraw his candidature. As everyone expected I carried out the unpleasant task, as I had done to many others during my fourteen years as national secretary.

MacInnis was too proud to be pushed aside; he ran, was defeated, and, for the first time since Calgary in 1932, was not a member of the National Council, because he refused to stand for any other office. I have never regretted anything as much as this hurt to MacInnis, for whom I had great affection as well as respect.[107]

At the 1952 National Convention, Percy Wright made what Grace described as "a simple, fine tribute" to Angus which she emphasized she had nothing to do with. It was followed by another from Lewis which backfired: Grace wrote to Angus: "David Lewis referred to you in introducing me. Indeed I was rather sore because he left the impression that I was at the head table because I was Angus MacInnis's wife. He said nothing about me being a National Executive member."

Charles Woodsworth later commented: "[Grace] resented David Lewis because David, too, knew precisely what he wanted but I think he was, in his mind, far more articulate as to how he would go about getting it in various ways. You see, Grace was essentially inflexible, and Lewis could see different ways of handling problems, and Grace felt her position and was menaced a bit by Lewis."[108]

Angus, like Grace, did not forget the hurt of his rejection. In a letter to Lorne Ingle in June 1954, he wrote:

I wish to thank the National Executive for the invitation [to be a speaker at the National Convention], but I feel that I

must decline. As you know, I have not been a member of the National Executive for some years. I am no one of any importance in the CCF. The 1950 Convention decided that, and I see no reason why the delegates at the 1954 Convention should be of a different mind.

Perhaps what happened at the Vancouver Convention has not the same significance for you as it has for me. Let me refresh your mind on what took place at that Convention.

Presentations were made to Frank Scott, David Lewis, and Sandy Nicholson in appreciation for their years of service to the movement. I was all in favour of the recognition which they received. For service which was longer in years and, I think, equal in quality, I got "the Order of the Boot." What hurt most, however, was not my defeat for National Chairman, but the fact that my defeat was organized. What hurt even more was that some of my supposed friends – if they did not assist with the planning – acquiesced in it.

Therefore, at this time, I think it would serve the best interests of all for me to remain in that obscurity to which the Convention of 1950, in the exercise of its democratic rights, so unceremoniously relegated me. [109]

There are those today who believe Angus's acerbic tongue and unflinching honesty may also have contributed to the decision of his peers in 1950, a year that bode him ill throughout. In that year he was operated on for colon cancer, successfully, but it took him a long time to recover. This placed additional stress on Grace, who filled in for her husband where she could; characteristically, she made no complaint but wrote concerned letters to Angus, urging him, now, to take care of himself.

The year 1950 was also the year the Korean War broke out. The CCF's official position, and Grace's, was to support the U.N. decision to uphold South Korea's claim to sovereignty against Communist North Korea.

The year 1952 brought Angus and Grace's twentieth wedding anniversary, Angus sent her golden roses, as he did on every

A few who were at the CCF's first convention in 1933 met again in 1956. Left to right: Frank McKenzie, Elmer Roper, Grace, Clarence Fines, and in front, M.J. Coldwell.

anniversary, with a note that said: "To my love of today and of long ago, every year you are more lovely to me." However, things on the provincial front were less rosy. In April, writing to Angus from the House of Commons, Grace spoke of troubles with the Social Fellowship, a disruptive group of Communist sympathizers banned by the provincial party. She feared they would try to "control the Provincial Convention . . . I wouldn't be surprised if they say very little at the next Provincial Council meeting, with the objective of apparently conforming to the ruling that the S.F. is out of bounds, and in order to keep as much favourable sentiment as possible within the movement."

The strategy proposed to combat this was to provoke the leaders – Rod Young, Colin Cameron, and George Weaver, who, it was thought, should be expelled.

In Grace's opinion:

> Gretchen is just as guilty but has martyr-like capacities which are more difficult to handle. If she could be left all

alone on the chilly heights, it might be just as useful. (I may be wrong in this). We're [Lorne Ingle and Donald C. MacDonald] wondering if it would be possible deliberately to get Colin to blow off at the coming Provincial Council meeting. (Tom Alsbury is the best irritator in this connection.) Failing this, we're wondering about exhuming some of Weaver's more glaring articles. As you know, under the B.C. Constitution, the Provincial Executive has power to expel. Whether or not it has willpower remains to be seen. It seems to me that if those three heads could be cut off before the Provincial Convention, there might be some hope of saving the situation.

Suppose this were done and one of the amputees (or more) appeared to the Provincial Council prior to the Convention. Suppose the appeal were sustained. This would be the spot for the Provincial Executive to make formal appeal to the National Secretary for help.

Kalmen Kaplansky, in 1957 Director of International Affairs of the CLC and a long-time member of the Quebec provincial CCF, commented on the perennial Communist problem within the early CCF. David Lewis "always saw both sides of the picture," Kaplansky said, explaining that sometimes this made him seem at odds with colleagues such as Grace, because, in Lewis's opinion, she saw only part of the picture. Kaplansky continued: "Lewis knew he must have an open party [in order] to allow discussion and have development responding to political realities. But, at the same time, he knew about the influence of the Communists boring from within . . . they [the CCF] could and did live with dissent, but it had to be open. They could not tolerate conspiracy."

Angus continued to be sidelined by ill health and, in 1952, sickness prevented him from attending the national convention held in Toronto. But Grace was there and was appointed to a sub-committee convened to revise the Regina Manifesto. It was decided to defer issuing this new policy statement until the 1954 convention. Grace outlined the reasoning behind this decision in a letter to Lorne Ingle:

As you are aware the Fellowship crowd have kept up their activities through many channels since the Fellowship was disbanded officially. In [Vancouver] Burrard, under the skilful leadership of two men who have been known as Trotskyites as far back as I can remember, they have carried on guerrilla warfare. Under Gladys Webster's leadership, we have been able to keep the upper hand, though at the price of turning each meeting into a dogfight.

As this Provincial Council meeting approached, it became more and more obvious that they would make a dead set against the new policy statement. Gretchen was very bitter against it, and had succeeded in winning over the Point Grey riding to her side – ordinarily and up to now a well-balanced crowd but with pacifist vulnerability. In various ridings they tried to amend the new policy statement by substituting a different preamble, by attacking any ideas which have come into the world since the turn of the century, etc.

All over the province there were ridings where there was so much hell-raising that the CCF members generally would have done anything for the sake of peace in the organization. . . . In addition to those anxious to defeat any modern ideas of democratic socialism, there was a whole crowd abjectly tied to the worship – yes, just that – of the Regina Manifesto as a holy, unalterable document. . . . Grant [MacNeil] and Jessie [Mendels] want a new statement and feel that in two years there might be some possibility of enough discussion and education to get it.

[Party Leader] Harold [Winch]'s reaction was disturbing to me and – I feel sure – to the rest. He said he had voted against postponement because he had felt bound to do so by our little group's thinking, but at a National Convention he would vigorously oppose a new statement because he felt that the Regina Manifesto, with certain very minor amendments, was what we should keep. The rest could and should be put into election programs. His

attitude was indistinguishable from that of his father [E.E. Winch] or from that of any orthodox churchgoer who hears that his favourite hymn is to be re-written or his credo altered.

Arnold [Webster] and I both pointed out that fact to him, but he is quite obviously in the orthodox camp that somehow identifies the Regina Manifesto with "socialism" and anything subsequent with falling from grace.

When the convention took place, daggers were out and machinations on all sides were cloaked in masterly fashion. A Mrs. Sophia Dixon of Saskatchewan, Grace wrote,

amended the very first foreign policy resolution in such a way that only confirmed pacifists could support her amendment. Result: a perfect situation for us. Colin, Gretchen and Co. (who are bidding for a Council seat tomorrow) had to oppose it, but dared not be too vigorous in opposition lest they support collective security.

The scene was perfect for a spirited defence of our position. I took advantage of it and except for the fact that I forgot about the microphone and, as a result, bellowed like a bull, it went over OK. . . . Colin and Gretchen were *not* amused. . . . the Ontario crowd are well aware of the B.C. situation.

When someone was to be interviewed for the press, it was decided that it be Laura [Jamieson] rather than Gretchen. When the CBC wanted an interview for News Roundup on the Trotsky business in B.C., it was I (and I added Laura) who was asked rather than Gretchen . . . pretty ruthless, but so is she.

In 1952 Grace was working on the biography of her father, *J.S. Woodsworth: A Man to Remember*, negotiating with publishers – she settled with Macmillan – and seeing a good deal of her family. The following May the edited manuscript for her book arrived by airmail.

I was agreeably surprised to find that there will not be a great deal to do – nothing like I thought. There have been

one or two major pieces of messing about over which I shall want to think carefully, but in the main, they have done nothing very radical – an encouraging thing to me, I can assure you, particularly when there is so much election work to do at the moment.

After publication, Grace's book won a special award from the University of British Columbia in the popular biography category.

It was while she was writing her father's biography that Grace suffered her first major attack of the rheumatoid arthritis which plagued her for the rest of her life. Her brother Ralph, a medical doctor, recalls: "She often had considerable pain in spite of various treatments and medications – Aspirin, gold therapy, cortisone, physiotherapy. The first attack involved various joints – hands, knees, shoulders, neck. At that time she had a great deal of difficulty even getting out of a chair. . . . As far as I am aware, she always managed to carry on whatever work she was doing."

She attended the CCYM banquet in 1952 where she, Thérèse Casgrain, and Donald C. MacDonald judged a public-speaking contest. "Later I went to Thérèse's room for a little chat. This is Pierre's birthday – her late husband – and she misses him sadly. Her children – with one exception – are opposed to her activities. She's a very able and charming person indeed. It was a real feat to run twenty-three candidates in the Quebec elections with a $200 deposit apiece – all of which was lost."

In 1953, Angus's riding, Vancouver South, was split in two, and for the next four years he represented Vancouver Kingsway. In the spring of that year Grace visited her sister Belva in Toronto. Belva was suffering from one of her recurring bouts of depression. Home in Vancouver, Angus passed the time playing a card game called Smear. Grace wrote:

I hope the family finances are being well kept up by your winnings at Smear. It isn't everyone who is married to a brilliant statesman *and* a card shark. I hope you don't take to spending the nights with a partner at Smear. You'd skin him completely, or perhaps "her."

Grace could sometimes be rather lofty about her other relatives, although, no matter what she said, she was the first to come to their aid whenever it was needed. By and large though, her work and her husband apparently fulfilled all her emotional needs.

> [Toronto] Now mother is coming down the creaking stairs and we'll be getting our lunch. I'm taking her to see *Brandy for the Parson*, a British comedy film – next best thing I hope to real brandy. I wonder if everyone needs to escape from living as much as Mother does – and as Belva thinks she does. I'm sure I'd rather have my typewriter and an interesting job of work than run around to shows – or wish I was running. But, of course, I like a break, too, in spite of having a husband that makes escape unnecessary most of the time – and impossible in any case. It's wonderful you're so fascinating, dear, but it's quite true.

By summer Grace was back on the coast, on the campaign trail in Kelowna where local cherry picking interfered with meeting attendance. Angus, meanwhile, was on the road with Tommy Douglas.

But by 1954 he was sick again, troubled by cankers in his mouth and a mysterious problem keeping him awake at night as his leg constantly moved involuntarily. Unable to attend the national convention in Edmonton in July, he heard from Grace that the same old political troubles continued:

> Lorne [Ingle] has no longer any illusions about the importance of keeping Colin [Cameron] off the Council. Indeed there is a good deal of thought being given to the mechanics. At the moment it is hoped to have David Lewis as chairman with Hazen Argue as vice chairman. The only problem is Hazen wants to run as chairman and may not stand as vice chairman. The general belief is that Colin will run for everything, beginning with chairman, and building up a sympathy vote as he goes along. I had a word with

Tommy [Douglas] and he, too, is well aware of the importance of allowing no beachhead to be established on the National Council.

[The following day] We've been ambling along on international affairs. Yours truly caused about the only excitement by protesting against the way in which the Resolutions Committee, in its difficulty about trying to crowd a dozen or two resolutions into one, had ruined a number of well-drafted ones and made a patchwork which had little sense and no drive. My own resolution being involved, Bert [Gargrave] and David [Lewis] from the platform tried to make fun of me. The upshot was that the convention decided they were not prepared to accept the Resolutions Committee version of the resolution (the one involving mine on the U.N.)* and sent the matter back to the committee for redrafting.

One of David's unlovely characteristics is the way he attempts to steamroller lesser minds from the platform. I think he'll be elected National Chairman, but it will be in spite of this bad handicap!

Mr. Coldwell is proving somewhat of a problem behind the scenes. He's keen on David's election and makes the error of declaring to some of Hazen Argue's backers that for anyone to vote for Argue means to show an anti-Semitic bias.

If he were wise he'd refuse to get involved. At the banquet Coldwell paid a glowing tribute to Angus MacInnis for his stand on the Oriental issue.

It was at this convention that Rod Young was finally expelled from the CCF. Young had been the federal member for Vancouver Centre from 1948 to 1949. Before that he had been the first Vice

*The resolution called for a positive, independent Canadian foreign policy to restore the UN to its original high objectives . . . a resolution based on the threat to world peace by the hydrogen bomb.

Grace and Angus attend a farewell party in 1955 for George and Jessie Mendels (left) on their move to California. Jessie had been Provincial Secretary and First Vice-President of the British Columbia CCF. Arnold Webster, party President, and his wife are at right. (Jessie Winch Mendels collection)

President of the CCF Youth Group. An active trade unionist and trouble maker, it was his wrangling and Communist views that led to his expulsion. He told the convention that he was proud to have people tell him he was a Communist, something that brought grief in its wake, undoing the careful work of the party in separating socialism from communism.

In February 1955 Angus attended the Garnett Sedgewick award dinner at the Ho Ho Café in Vancouver. Grace wrote from the House of Commons that she was glad that "at last you are getting a little recognition for the things you have done that matter most" – his championship of Japanese Canadians. Angus celebrated twenty-five years as a Member of Parliament that year and an anniversary banquet was held in his honour in October at Sunset Memorial Community Centre by the Vancouver East CCF Constituency Association.

In the middle of this busy year the MacInnises put their home on West 15th in Vancouver on the market. It sold for $14,900. It was a beautiful summer, and Angus reported Fahrenheit temperatures in the eighties, the peach trees loaded, and the apple trees also headed for a bumper crop.

Up in Ottawa, Grace was faced with a more sombre picture. The finances at the national office were once again "in a very precarious state – due to the Auto Workers being so much taken up with the strike and to the Ontario CCF being so busy with the election and to Saskatchewan's poor crop prospects."

Donald C. MacDonald, head of Ontario's CCF, was disappointed over the party's share of the vote in the election – down from about 19 per cent to 17 per cent. However, according to Grace, "he remained enthusiastic about prospects, though in a more sober fashion." In any event, MacDonald was heartened and amused by Grace's customary greeting of "Hello Mr. Ontario" or "Hello Mr. NDP."[110]

Angus headed for Ottawa shortly before the end of June 1956. This would be his last year as an MP before illness brought to an end his twenty-seven years in the House. The following month Grace took the train to Winnipeg to attend the convention. No longer was there a Woodsworth home in the city for her to stay at, but she put up with friends, attended the CCYM banquet, and came back to a bowl of fresh raspberries before turning in.

Two hundred delegates were expected at the convention and Grace, who knew how much Angus wished he could have been there, filled him in with all those she had met.

> I keep wondering how you and Ginnie [his sister] and the boys [sons of his niece] are faring. Perhaps you're sleeping a bit better this last night or two. I do hope so, dear, and I hope the swelling and inflammation in your legs have gone down. And I feel sorry for us in the CCF who can't have you with us at this Convention. Your vision and judgement are sorely needed. It was like you, Angus, to think of sending those boxes of raspberries with me on the train. How much I have learned about real living from you – the little things that add sweetness and spice to living.

The following day the new policy statement, i.e., the re-worked Regina Manifesto, was tackled.

The Council met at 9:30 this morning with the new policy statement the first item on the agenda. David [Lewis] introduced it and then Alex Macdonald rose to his feet and said the things – and more of them – that I had been saying at earlier considerations of the draft at the National Executive. Very effectively he pointed out that the draft lacked the new *moral* emphasis that must be made if we are to provide a new incentive for our membership and for the public.

He was followed by Frank McKenzie who took the same vein, without repetition, pointing it up by quotations from his actual statement which met favour at the B.C. convention just after Easter. Oh! I forgot! Even before Alex spoke, Clarence Fines got up and said the Saskatchewan caucus and economic experts had found the draft very inadequate – a hodge-podge of theory and practical mixed in such a way that part of it would date almost immediately while other parts would last. Following Frank, Lorne Ingle got up and defended the statement (as he and David were among the major drafters of it), and so did Ken Bryden.

Then yours truly arose and pointed out that the statement was: a) so long that few except the initiated would read it; b) so complicated and wooled up with academic language that it was hard to take; and c) arranged in such a way that the new ideas were buried pretty deep in it and the effect was a re-hash of the Regina Manifesto.

I urged that the new emphasis, as Frank and Alex had pointed out, must be on the *moral*, the *ethical*, and *egalitarian*. The fact that a re-hash of mere economics would not do had been proven by the way in which Social Credit had cabbaged the voters in B.C. and scared the CCF in Saskatchewan. I felt that the statement had too narrow a base for drafters – Ottawa, plus a little Montreal and Toronto. I ended up by moving that we add B.C. and Saskatchewan people, adjourn Council and put them to work with instructions to make a policy statement in two parts: a brief summary of principles and a longer section describing their application.

Everyone got "browned off," Grace said, working and re-working the statement, but persevered in the knowledge that if they couldn't come to an agreement, the convention would do so the following day. "These Ontario people have far too much faith in the *machinery* of organization," said Grace.

And so the hard work progressed, challenged by the regional differences that were, and would continue to be, the bane of political existence in Canada. The new policy was, indeed, accepted at this convention. However, Grace ended her letter on a cheerful note with the news that her friend Thérèse Casgrain had arrived with about eight or nine young and influential French-speaking people. Grace described them in a manner she intended to be appreciative, however, viewed in the light of current standards of "political correctness," the words she used might well bring down criticism upon her head today. As she put it: "They are much more like young people elsewhere than I have yet seen coming from Quebec. They seem to have a vigour and durability that makes it a pleasure and an adventure to talk to them."

Angus's retirement and the party's twenty-fifth anniversary would coincide in the following year – 1957. Grace found that she was increasingly needed at home to look after her husband, as Angus's health continued to deteriorate. Neither was her own health robust at this time; in fact, her arthritis called for several hours of complete rest daily. As a result, the couple became more or less isolated from the active role in political life that had been their focal point over several decades. For Angus the severance would be forever – a comeback was in the cards for Grace, although the swinging sixties would roll around before she could take advantage of it.

Part II, Chapter 12

Angus Retires

Five months before his seventy-third birthday in 1957, ill health finally forced Angus into permanent retirement from Parliament. He had held his seat, Vancouver South (later, after the riding redistribution of 1953, Vancouver Kingsway) continuously for twenty-seven years. On one occasion his majority was so healthy that *all* his opponents lost their deposits.

No more would the House listen to the "lean, grizzled Scot" deliver speeches in the "harsh voice, rasping and grating like a file at work on stern metal." Journalists at the time described him as "the sort of lovable rebel who doesn't much count odds, who 'goes down scornfully before many spears,' unwhining in defeat and never losing meanly." He himself said: "I'm proud to be a politician. Politics is of the greatest importance because it has to do with the lives of all of us. . . . I couldn't ask to work with a finer group of men than in the House of Commons."

He had sat on the National Executive from 1933 to 1950 and that year made the last of his journeys abroad as a politician, going to Geneva for the annual conference of the International Labour Organization, acting as an advisor to the Canadian government delegates. At the time of his retirement Angus was deputy leader of the CCF in the House, under party leader M.J. Coldwell.

Grace, writing to Lorne Ingle in the spring of 1957, said:

> [Angus] was forced to face the fact that he just couldn't make the trip [to Ottawa]. Perhaps as a result, in part, of the strain of the decision, he is now feeling very miserable again, though this bout of illness has not yet developed the

worst features – i.e., the cankers – that go along with this spring attack which seems a regular part of his trouble. If you should write, please don't refer to this particular bout of sickness as he hates to have me circulate the details.[111]

Grace herself was feeling dispirited, and in the same letter wrote:

As everywhere in Canada and in every type of forward-looking and community-minded organization, British Columbia is finding CCF work slow and difficult. The public is too much absorbed in working long hours to buy new major appliances on credit – or in watching TV for endless periods – or in getting the garden into shape – or in anything of a comfortable or comforting nature – to care about the leg work and brain work involved in a movement like ours. Result: the faithful and aging little band – among which all of us can be separately counted – tries to shoulder a somewhat thankless load. I must say, however, that the work we have been doing on our CBC free-time TV and radio committee this winter has been taxing and stimulating to those of us who have been working on the job.

Now was the time for Angus to enjoy pottering around his home, the painting presented him on the occasion of his twenty-fifth anniversary, his china collection, and working in the garden when he felt well enough. In the beginning Grace could not always be with him, but they continued to correspond, exchanging political gossip and sharing, still, words of tenderness.

Grace was busy working on a booklet celebrating the CCF's twenty-fifth anniversary with Morden Lazarus, a long-time member who had been editor of the *Ontario New Commonwealth* and an executive secretary of the Ontario CCF.

The following year, 1958, Grace became president of the B.C. CCF. In July, on the train to the convention in Montreal, with a stop-over in Ottawa to visit her mother, she wrote (perhaps with some awareness that she and Angus might not have much more time together):

I relished it [the *Vancouver Sun* Angus had sent her] greatly, particularly after making a first survey of the Convention resolutions. Anything that bunch in B.C. didn't think up, Saskatchewan did – though there is, by and large, a much higher percentage of horse sense in the Saskatchewan resolutions . . . it's wonderfully kind of you to actually encourage me to make this trip, dear. By letter I can tell you without being firmly contradicted! . . . I wish you had been in better health, for I know how you would have loved to come too. It's been wonderful [being] married to you – and your kindness and thoughtfulness only increase over the years.

[The following day]: Yesterday, after I had written to you, I saw two moose feeding beside the track and later a fair-sized black bear in the bush. Johnny and Billy [Angus's great-nephews] might have seen more game. Apart from a large crane in flight and numerous wild ducks with their broods on the ponds, I haven't seen any other wild creatures.

When Grace saw Lucy, by then in her eighties, she found her "a lot older, and much more forgetful, and harder of hearing. But her devotion to duty is almost fantastic in its solidity. She's crippled to quite an extent with arthritis – knee, back of her neck, etc., but her spirit is firm and calm."

In Montreal, Grace stayed with Frank Scott and his wife. She celebrated her birthday there on July 25; M.J. Coldwell happened to invite her to dinner and, on discovering what day it was, passed the news along to the Council members when they met, whereupon Tommy Douglas kissed her on both cheeks and all the members insisted on taking her out for coffee. They were joined by several others, including Thérèse Casgrain, who insisted she spend the night at her home. After a gin nightcap and tête-à-tête, the two of them eventually called it a night. "My fifty-third birthday was a real celebration," she wrote to Angus. As she left the convention, Hazen Argue said, with tears in his eyes, according to Grace, "If Angus ever feels he could send me advice, I'd love to hear from

him" . . . "Whether or not you know it," wrote Grace, "you've a great many good friends."

In 1960 Grace was in Winnipeg to attend initial discussions on a CCF-CLC merger. Some three hundred people were on hand representing ten provinces, with opening speeches by Claude Jodoin, head of the Canadian Labour Congress (CLC) and David Lewis.

In a general discussion which followed provincial reports, Grace wrote home:

> Saskatchewan revealed itself as solidly opposed to any CCF-CLC merger . . . Donald MacDonald and some Ontario trade unionists would, I believe, form a Labour party right here if they could do so.
>
> Quebec is much more content to go slow and feel out the ground. Alberta, alias Bill Irvine, welcomes Labour and says the farmers never invited him to speak to them. Most of the gathering seem to favour moving with caution, having regard to Saskatchewan's (and British Columbia's) provincial elections.
>
> I had lunch with David Lewis and Frank Scott and found them both pretty cautious. In general, I think the idea of having the gathering is working out all right.

Two days later, on August 30, Grace wrote that she could safely predict there would be a new party (the NDP).

> Through two workshop discussions, one yesterday, one the day before, it was quite evident the will to co-operate was there. Saskatchewan people may see no real reason for a new party. British Columbians may feel that in the short run any associations with the unions is a liability. Ontario may feel there is no need to wait for elections in either Saskatchewan or British Columbia before launching the new party. But I'm sure there's an overriding conviction that we must have the strength of the unions added to what we already have. And obviously the union leaders here, most of whom, I believe, are CCF members, share so thoroughly the philosophy of the rest of us, that the job is

A portrait of Angus and Grace MacInnis on their silver wedding. On every anniversary, Angus gave Grace a bouquet of yellow roses.

really one of fitting together the tough edges and making sure of good timing.

On the final day, Grace wrote, Gérard Picard of the Catholic Syndicates, speaking in French, commented that he knew Quebec was not a country and that he himself wanted to be a citizen of all Canada. "I took pains to give the whole gathering the sense of what he said," Grace wrote.

It was in 1960 that Grace and Angus attended in Regina their last convention together, coincidentally the party's final convention under the name Co-operative Commonwealth Federation. Two old stalwarts of the CCF, they still marvelled at the scenery outside their window, enjoying the train ride at a time when air travel was becoming all the rage.

Back in Vancouver, Angus frequently suffered from insomnia which made him ornery and often difficult to live with, however,

they struggled along. Grace's deep affection for him and her self control smoothed over the rough patches. With maturity she had overcome her earlier impatience and her penchant for cutting remarks.

It was hard going, especially after Angus had a fall, breaking a shoulder and a hip. Grace, too, had pushed her limits beyond endurance, and, before the year was out, she was bed-ridden. It meant she could not run as provincial president, and the following year she was unable to attend the founding convention of the New Democratic Party.

Even when Grace's pain was crippling, her first thought was always for Angus. She promised him that she would never allow him to be looked after in an institution. To add to her responsibilities, eighty-six-year-old Lucy was staying with them at their big house in Kerrisdale. The house itself was too big for them to care for in their state of health, yet Grace, advised to go to hospital herself, refused to leave Angus, and the two of them cared for each other as best they could. To control and relieve her arthritis, for three years doctors had Grace on a regimen which required her to sleep twelve hours every night and two every afternoon.

In 1963 Lucy was back in Cavan, on the farm where she grew up. On a visit Grace took pleasure in watching Ralph Staples, her brother-in-law, make maple syrup and attend to the beehives. In a letter home to Angus she joked about her mother now regarding Ralph "as a reincarnation of J.S. Woodsworth. Indeed she has said to me, 'He's more like Father than anyone in the younger generation!' Anything less like Father would be hard to imagine."

In the last letter that survives, written from Ottawa in the spring of 1963, a little less than a year before Angus died, Grace kept up her hopes that he might get better.

> If any part of you shows healing, it's a sign that your whole organism has the capacity for healing – at least in some measure. On the strength of your good reports about your legs, I've been thinking of trips to Capilano Canyon, up the Fraser Valley, and, of course, to Harrison! I'm sure we've

done Harrison [Hot Springs] many a time when you weren't in as good a shape as you are now.

Much love my dear Boy

Meanwhile, Grace grew stronger, although it took her four years "to crawl out," and just as she recovered, Angus died at home, on March 2, 1964, at the age of 79. They had been married thirty-two years.

Historian and columnist Alan Morley once wrote of Angus's defence of Japanese Canadians: "But every honest man in British Columbia should stand up and salute Angus MacInnis today. He is the first politician in B.C. within living memory to stand by an unpopular cause unflinchingly when he knew it would cost him votes and political support. . . . He has his own self respect and the respect of honourable men to gain by sticking to his guns." [112]

Liberal Minister of Northern Affairs Art Laing said, "The coin that can buy Angus MacInnis will never be minted," and British Columbia's Premier W.A.C. Bennett commented after Angus's death: "I am sure I express the feelings of all the people of B.C. regardless of party, that Angus MacInnis was an outstanding citizen for B.C. and Canada. He served the city of Vancouver well in Parliament for many years and he will be greatly missed." The provincial New Democratic leader at the time, Robert Strachan, said: "He has been my idol since I joined this party. He was an example to every elected member in absolute honesty and absolute integrity." In Ottawa, federal NDP leader Tommy Douglas said the death of Mr. MacInnis closed a long life of devoted service to the CCF and the NDP . . . "he was a valiant fighter for the oppressed and the underprivileged."

Harold Winch, who succeeded Angus in the provincial constituency of Vancouver East, was quoted as being almost in tears as he spoke of his old friend. "MacInnis was one of the most dedicated men I have ever met. I feel a great affinity to him not only because we believe the same philosophy, but also because I feel he made way for me to take his place in Parliament in 1953."

Finally Grace was free to lead a life in which career choices were truly hers. The price was high, loss of the one person she

loved most dearly, and the prospect of having to rebuild a political base eroded by her years at home nursing a sick husband. But her rheumatoid arthritis was in remission, and now, indeed, she was at last free to fulfil Angus's injunction to her many years before – to be "her own person."

The First Woman M.P. from British Columbia

Angus's funeral took place in March 1964. Held in Vancouver's Unitarian Church, it was attended by some four hundred people, many of whom were the Japanese Canadians he had championed during his lifetime. He was borne away to the strains of his favourite Scottish song, "Road to the Isles." Speaking at his funeral, Arnold Webster, who had been elected to Angus's old riding of Vancouver Kingsway, said: "to him, honesty was as natural as the graciousness of his own spirit."

Grace scattered Angus's ashes where they had loved to walk together, under the trees on a little trail in to Beaver Lake in Vancouver's Stanley Park. Her Aunt Mary, her father's sister, was staying with her, and further emotional support came in the form of letters from her mother, who wrote: "strength will come to you although we cannot explain it, and there is a reservoir found in the fact that you and your strong, brave companion have tried to be and do the best you knew. You have indeed 'made earnest with life' and you who remain will grow in strength." In another letter Lucy, referring to her own husband James, wrote: "What two great souls you and I have been given to walk beside through so many years."

Perhaps the most apt description of Angus had been made many years before by E.J. Garland, MP for Bow River, Alberta, who, on being asked where Angus had been born, replied: "Born! MacInnis wasn't born, he was quarried."

However, the private man whom Grace missed most, then and in the years ahead, was the one who had shared with her what she described as the "post mortems . . . we did everything separately, except the post mortems. When the meetings were over, we loved to get back, often we would be in two different directions, you see, on the same nigh . . . and we used to love to have a cup of cocoa or coffee and just discuss what we'd been through that evening. Well, I miss that tremendously now." [113]

Angus's death was one more unhappy event in a year that brought a series of misfortunes to the Woodsworth family, but the good news was that Grace's arthritis was in remission. It remained so for more than seven years, thus releasing her to become a federal politician.

Unlike Angus, who was able to relax, read detective stories, tend his roses, and enjoy pottering about, Grace's intense nature required more focus. That focus had always been politics; however, in the years of nursing Angus and being sick herself, she had lost the close contacts she had once enjoyed with party members and others. Therefore, first, in her usual practical and organized manner, she set about networking. Initially, she confined her political activity to campaigning on behalf of others. However, when ill health forced Arnold Webster, an old friend of the MacInnises, to resign Angus's old seat in Vancouver Kingsway, the NDP approached Grace to seek the nomination. She won by acclamation.

So it came to pass that in 1965, at age sixty, Grace finally became a Member of Parliament. She was also the first woman Member of Parliament elected from B.C. and the sixteenth woman to serve in Parliament following Agnes Macphail's political debut in 1921.

Since Angus's resignation in 1957, the Vancouver Kingsway seat had been held by three other MPs, two of them NDP members. During this time many newcomers had moved into the riding, the younger ones among them likely holding few clear memories of her husband and his fine political record. Not that Grace went along with those who accused her of riding on her husband's coat tails in Vancouver Kingsway. She knew her record could stand on

Although Grace stood alone as a female member for four of her years in Parliament, on this occasion she shared the stage with four other well-known women politicians as they looked out from the Rotunda of the House of Commons in Ottawa. *Left to right:* Flora MacDonald, Grace MacInnis, Jeanne Sauvé, Albanie Morin, and Monique Bégin.

its own merit; moreover she had a strong feeling that Angus would have wanted her to "inherit" his old riding.

To support this theory she continued to carry in her wallet as late as 1979 a slip of paper that Angus had handed her during a National Council meeting back in 1955. "I made a speech then," Grace said, "we were discussing the federal tax rental agreements that afternoon – between the federal and provincial [governments] . . . and Angus passed me this note, 'I am proud of you, best speech made this afternoon, the logical next member for Vancouver Kingsway.' Now he very seldom commended me for anything I said or did. I mean he just took it for granted and he didn't want me to get uppity, I guess I didn't have any danger of doing that. But there was never any talk about that before or

after . . . just this little note." Yet in the last weeks of Angus's life, according to Grace, he "quite frequently expressed the regret that he probably spoiled my life by marrying me because I hadn't been able to do those things I wanted to."[114]

How important then it must have been for her finally to emerge from the shadows of her illustrious father and husband. She moved into a place of memories, Room 639C in the Parliament Buildings, previously the office of first her father and then her husband. As she sat behind their desk for the first time, her thoughts must have gone back to that day, more than thirty years before, when she had first come to Ottawa as her father's unpaid secretary.

Perhaps the shamrock plant she kept in her office acted as a living link with her family's roots. Indeed, since for four years of her time in the House she was the only woman MP, it seems possible there were occasions when she privately called up the ghosts of her father, her husband, and her old friend Agnes Macphail to share her lonely vigil. Not that this would have been in character with this resolutely independent woman. It would have been contrary to her strongly held belief that a person, man or woman, should be judged on individual merit – and that socialism, not gender legislation, was the road to equality. Nevertheless, fate was kind to Grace; few women of her era could say they had lived among men who showed readiness – both before and after marriage – to give them full recognition as a person, free of gender bias.

Where others were concerned, Grace sometimes showed herself less than tolerant of those women who needed a "movement" to bolster their fight for an equal place in society. Like many people of strong character, she found it difficult to comprehend timidity. Her sister Belva, for instance, suffered for many years from emotional illness, and Grace sometimes showed irritation about her sister's need for support, although this never deterred her from going out of her way to help Belva, or, indeed, others, some far less close to her. All the same, occasionally she felt compelled to comment that her sister could do more about her difficulties herself, with perseverance.

When Grace took her seat in the House of Commons she was one of 20 NDP members in a Parliament of 131 Liberals under Lester Pearson, 97 Conservatives led by John Diefenbaker, 5 Créditistes, and 2 Independents. She described Pearson as "not very effective," although she recognized the part he had played (before she became a member) in ensuring that Canada finally had its own flag.

Always a strong and effective speaker, Grace soon espoused women's issues in ringing tones. Her emphasis was nearly always on poverty because, in her estimation, poverty was a major stumbling block for women, particularly as it generally went hand-in-hand with a poor education.

One of her first recommendations was wages for housewives, and this caused an uproar both in the House and in the newspapers. As would often be the case, her suggestion was ahead of its time, although, as she pointed out, it had existed in countries such as France for some time. Always one to hold a considered opinion, Grace's rationale not only took women into consideration, but it also included their husbands – she was an advocate of husbands and wives sharing child care, each working half a day.

Children's well-being was also a primary concern. Grace's personal view of women and socialism was family-based and remained so until the end of her life. Even in retirement, she continued to lament the fact that no satisfactory answer had been found, in her opinion, as to how children could adequately be cared for in families where both partners worked. Strongly as she believed in women's right to achieve wider goals in society, and in an education to make that possible, she never ceased to maintain that children needed the nurturing of two parents. Perhaps this was rooted in her own childhood when her father was so often absent, and she herself often was called upon to step in and look after her younger siblings.

Grace argued that it would be cheaper to have those mothers whose modest skills and education meant they only earned small salaries stay at home during their children's early years. She reasoned such women could ill afford day-care expenses and such costs would make their take-home pay hardly worth the effort.

One of the plants on Grace's desk in her parliamentary office is a cutting from the family shamrock, originally given to her mother by her father during their courtship.

However, later on she came to accept that many women wanted, as well as needed, to work outside the home. At this point, she took up the issue of affordable child care and fought for it tenaciously.

At the time of Grace's "pay for housewives" suggestion, Canadian Press, as reported in the *Toronto Star*, ran public reaction to Grace's proposal of pay for housewives under the headline: "Wives Spurn Honey-Money Plan." One woman called the concept "ethically wrong. It's like paying a farmer not to raise his crops." Some housewives said they didn't want to be civil servants, and others felt the wage would not be worth the tax boost they thought would follow it. "Maybe we wouldn't have to pay so much for broken homes and juvenile delinquency," suggested Mrs. A.A. Hope, while Mrs. Ronald Campbell said she didn't "see why we should pay them to stay [home]. I don't think a woman should have so many children that her husband can't support them." [115]

The *Ottawa Journal*, which conducted a survey on the subject, showed that the average Ottawa housewife would earn about

$144.34 for a seven-day week at the going rates. This is how they figured it: child care (twenty-four hours) $10; general maid work (one hour) $1; cooking (three hours) $3; laundry and heavy work (one and one-half hours) $1.50; chauffeuring (one hour) $1. That's $16.50 a day, plus 25 per cent for miscellaneous duties (washing the dog, going to home and school meetings, listening to her husband's jokes). So, at $20.62 for seven days, she'd have $144.34, before taxes.[116]

As an illustration of how these figures changed over the years, in May 1993 the *Toronto Star* quoted an article from the *Canadian Economic Observer* of June 1992, in which it said Statistics Canada analyst Chris Jackson estimated that in 1986, the cost of paying people to do housework at the going rate for each task would come to close to $200 billion, 39.3 per cent of Canada's gross domestic product that year. The *Star* went on to say that the replacement cost of housework for each woman – having some-one else do it – was $13,307. Andrew Harvey, director of the Time Use Research Centre at St. Mary's University in Halifax, topped up Jackson's 1986 figures for inflation in 1992 and found that the value of housework performed by a married woman with children, who did not work outside the home, was close to $30,000 a year.[117]

Grace was happy to be back in harness. Harold Winch remembered her eating in the Commons restaurant, a lunch of just an apple. She brought out a pocket knife and meticulously peeled the apple in a single piece, enjoying her own skill in doing so.

When two Liberal women members left the Commons in 1968 Grace stood alone among the men in the House. She had twenty-two NDP members sitting alongside her and a triumphant Pierre Elliott Trudeau leading the Liberals. To her chagrin, his mind was more on constitutional reform than on the economic rights of women, although this did not stop her hammering his party for the social reforms she wanted.

Grace felt at home in Parliament because she knew the building well, the halls, the galleries, the meeting rooms and offices. However, this was her first opportunity to sit as a member on the floor of the Chamber itself. Unlike many new members, Grace could hardly be called a rookie. She had served as secretary

of the caucus her father had presided over many years before, and she had worked in close collaboration with her late husband. She knew, and was on good terms with, the librarians and many of other key members of the staff of the House. And she was quite familiar with the labyrinth of rules and procedures which confuse and confound many new members and prevent their making the headway promised to their constituents during the election period.

The prime minister, Lester Pearson, welcomed her, as did Opposition Leader John Diefenbaker, though Grace must have winced a little as the latter added that he felt she "deserved special mention by reason of her association with her late husband and her late father."[118] No matter how well intentioned, these words were yet another reminder of the lifelong label she laboured under as the daughter and wife of two such prominent Socialist leaders. However, Grace was not one to be deflected from her main purpose; she knew she would put her own stamp on parliamentary life soon enough.

When Grace rose to make her maiden speech on January 24, 1966, she gave notice that her goal was to defend those millions of Canadians living in poverty – 23 per cent of the population according to the government's own figures. Broadening her approach and drawing more deeply on her basic Socialist philosophy as to the appropriate role of government, Grace emphasized that she spoke not for herself alone, but "as a member of the group in this corner who believe that the proper job of government is to help a community of people do for themselves collectively what they need to have done and what they are not able to do for themselves as individuals. In case anyone should think that is a radical definition of the job of government, let me hasten to assure them it is the one given by Abraham Lincoln about a hundred years ago. . . . We should realize that when we have one-quarter of the population living in poverty this calls for heroic measures and high priorities which so far have not been forthcoming from the government in any tangible way.[119]

Like many neophyte MPs, Grace drew on material from her own riding to bolster her case (after all, her speech would be reported and she would distribute copies there). She quoted from

a study carried out in the Greater Vancouver area about those living in poverty there. "As a group they characteristically display many severe problems – physical, social and economic – by and large they remain basically dependent during good economic conditions and bad, and tend to transmit their dependency to their children." She added that she had looked "in vain" through the Throne Speech "to find anything dealing with this major social concern."[120]

It was to be Grace's battle cry during her years in the House – to protect the poor, particularly women, to give them what she called a "fair deal," whether that took the form of consumer protection, better day care, job training, adequate and affordable housing, equitable pay, unemployment insurance, pensions, medicare, or maternity leave.

Grace was a slim, straight, handsome woman, with fine features, cropped grey hair, hazel eyes, and a warm and ready smile. Her voice was strong, clear, pleasant and well-articulated – it could be penetrating but was rarely shrill. She was never at a loss for an apt metaphor, and sometimes displayed a nimble wit. In short, whether in the House or out on the hustings, she was well able to hold her own. Armed with well-marshalled, well-researched arguments, Grace could never be intimidated as she doggedly pursued her course against opposition, apathy, or outright prejudice. She fought hard but always fairly, with a political savvy born of more than thirty years in the ranks.

During that first session she shared a seat with Ed Schreyer, later Canada's governor general. Grace found him to be a person who didn't welcome friendly chat or everyday small talk. "I had seat mates who were very much easier to share comments with . . . he was all attention to business."[121]

Another colleague was Stanley Knowles. " [He] was my great guide, philosopher, and friend all the time I was in Ottawa. You see, I consider Stanley one of the few people that I know of who was really appropriate, to use the modern term, to succeed my father because he was so very similar in outlook."[122]

It was almost inevitable that Grace, for half of her parliamentary years the lone woman in the House, would be

patronized occasionally. How surprised and gladdened she would have been to learn that in 1993 the NDP ran 113 women candidates – albeit, for the most part unsuccessfully – in the federal election under the leadership of Audrey McLaughlin, Canada's first woman leader of a federal party. Grace, and the women who preceded her in the House can take credit for their pioneer contributions to women's inclusion in government. However, that lay in the future. Grace, as she commented to someone who sympathized with her for being called a "sweet doll," was well able to deal with the patronizing remarks, having had plenty of experience. Once Ron Basford, member for Vancouver Centre and at the time Minister of Consumer and Corporate Affairs, told the House that he had "just had a most engaging invitation from the Honourable Member for Vancouver Kingsway to go tiptoeing through the supermarkets with her. I am not sure, with women's liberation, and one thing and another, who would supply the money, or whether it would be proper for me to supply the money." Grace replied that, of course, it would be Dutch treat![123]

During Grace's life in Parliament, issues arose and subsided and debate might be interrupted by another question or subject and further comment or discussion. Perhaps an emergency debate had to take place on some matter of urgent importance. Days, weeks, or sometimes months would go by before the original subject was re-visited. Grace's voice was but one echo coming to us from the daily din of Parliament. Her work, its achievements and setbacks, like that of her colleagues then and now, was but part of a broader picture. To define it fully would require an account of encyclopedic length. What follows, then, is an overview, illustrated here and there by the trenchant comments of a politician who learned her craft at the knee of an exceptional orator.

Because Grace could see that women from that time on would join the labour force in ever-increasing numbers, eventually she became a firm proponent of adequate and affordable day-care facilities. In 1970, women were 34 per cent of the labour force. By 1992 that figure had risen to 45 per cent. But the availability of day care has not kept pace with the growth of the female workforce; in fact, figures show that between 1974, when Grace retired, and

1991, the number of working mothers unable to find regulated day-care spaces increased by 800,000. "I am the first to declare," Grace stated in her day, "that women have the right to say whether or not they shall work in the home or outside it . . . by 1971, according to the Department of Labour, one married woman in every two . . . will work at paying jobs. . . . I feel that for these women we should be doing something to make sure their children will be adequately cared for. We should be building nursery schools . . . located right in or near the place of work."[124]

Although the pattern of family life was already changing by the time she entered Parliament, Grace continued to defend the more familiar structure and would never quite relinquish her belief in the virtues of a traditional family lifestyle. In many ways she was an old-fashioned woman, yet her issues were always up to date if not, on occasion, ahead of her time.

When Grace took up an issue she brought to its resolution the stubborn temperament for which she was known. It helped her persist where others might have given up. This facet of her character wasn't always easy to deal with, although it sometimes opened the way where more accommodation on her part would not have succeeded. Yvonne Cocke, former NDP provincial secretary in B.C. who later worked with Grace in Vancouver on the party's Honorary Life-Membership Committee, recalls: "She was very opinionated and really quite adamant when she made up her mind. Grace could be quite intransigent about her idea as to how things should progress. . . . She would wait out someone who disagreed with her until hell froze over if she decided that was the way to go."[125]

However, she also commanded unusual loyalty amongst her constituents and party workers because of the personal attention she gave them. Whenever she could, Grace spent time amongst them, and, when she was in Ottawa, they could count on prompt and careful answers to their letters. In fact, hand-written notes remain treasured possessions of many of those whom she represented.

The president of Grace's Vancouver Kingsway riding in the sixties, Carol Adams, who worked with her during two campaigns,

said it was impossible to say "No" to Grace. "There seemed to be a core group of people, no matter what Grace wanted, whether it was a meeting open to the public or organizing a campaign, who were very committed. . . . She had great leadership qualities and inspired people."[126]

Another friend, Muriel Michener, volunteer secretary in Grace's riding, recalls an evening in the 1958 federal election when John Diefenbaker made his sweep. In Vancouver, CCFers were gathered in Rio Hall on Kingsway.

> Grace and Angus were listening, grim-faced, to results on the radio. . . . Everyone was searching for some hope in late polls, and any other straws we could cling to. I was drawn into studying results for some time when I heard Grace's clear, strong voice calling me. She was smilingly shepherding a young couple toward me and introducing them. She said, "I've just discovered these people in the hall and they want to become members. Will you look after them?" She had left the wake at the radio and scouted around the hall, recruiting new members.
>
> This has always been the essence of Grace to me; that she could turn from a crushing defeat of all her life's hopes and start right in to re-build. She had indomitable courage.[127]

A Fair Deal for Consumers

During her years in Parliament, Grace sought to provide protection for consumers. She pushed for the establishment of a consumers' affairs department, called for a prices review board to control escalating prices, and worked with government on changes in labelling and packaging practices, although these were not legislated until after her retirement in 1974. For Grace, these reforms were important because of her belief that consumers had a right to fair marketing practices. It was always her objective to ensure that their income, however limited, could be spent to best advantage. To this end, Grace took on two of the most powerful corporate interests in the country – the food and the pharmaceutical industries. Named to the Joint Senate/Commons Committee empowered to make recommendations on controlling the cost of living, Grace watched as, despite her unflagging efforts, prices, particularly food prices, continued to escalate.

In Grace's day, many families managed on only one salary, generally the husband's. In 1967, thousands of Canadian husbands earned less than $3,000 a year, an amount inadequate for basic living requirements. Four years later, the high cost of food and shelter for poor families would prompt Grace – as NDP critic for consumer affairs – to tell an Ottawa reporter that the minister, Ron Basford, and the Consumer Association of Canada (CAC), of which she was a member, should be defining what it cost these families to live, and implementing a guaranteed income for them where necessary.

The next year, Grace, with acerbic wit, drew attention in the House to the fact that a nutrition survey had reported that the only

foods sold on the basis of their nutritional value were pet foods. She wondered whether, until food for humans was also classified by nutritional value, human beings should be reclassified to pets. Prompted by the fact that between April 1971 and April 1972 the cost of food had risen 7 1/2 per cent, Grace moved that the matter of food prices and profits be referred to a committee for a report, and that there be a public investigation of food prices.

A Food Prices Review Board was set up under the leadership of Beryl Plumptre to look into allegations such as Grace's that the consumer was being made to pay higher and higher prices for food while the profits of the large supermarket chains were skyrocketing. The NDP wasn't always happy with the actions of the board, however. As one frustrated consumer wrote to Grace in 1973: "Mrs. Plumptre's group could just as well be occupied knitting booties for teddy bears for all the good they are doing at present."[128] NDP leader David Lewis demanded Mrs. Plumptre's resignation following a report by the Food Prices Review Board which he blasted on four counts: it had "whitewashed" rising food costs; it had based its conclusions on unobjective sources; it had ignored 1973 corporate profit levels; and it had failed to devote any attention to the fundamental problem of monopoly power. While the board had its problems, it wasn't as completely ineffective as all that. It did, for example, influence prices of some commodities through marketing boards.

One in four Canadians, said Grace, lived below the poverty line. "One of these four Canadians gets welfare, the other three do not. Families on welfare across Canada, even if they are to spend an average of thirty cents per person per meal, must spend half their entire welfare allowance for food, clothing, shelter, utilities and fuel . . . do you think it is possible to get nutrition on thirty cents a meal?"[129] Grace saw the solution to the problem in broader terms: on the international level through agreements on such products as wheat, sugar, and meat; and on the domestic level by stabilization of agricultural production, based on the food needs of the Canadian people.

On the subject of putting nutritional and affordable meals on the tables of the poor, Grace asked Prime Minister Pierre

Trudeau whether the government, since it had helped corporations secure big tax cuts, intended to do anything about getting "proper food to those on low incomes." Trudeau dodged the question and countered that there had been "substantial personal tax cuts." Grace was not to be fobbed off and replied that she wanted to "ask him quite seriously, will it take food riots to get action from this government?"[130]

Her endeavours on behalf of consumers were often uphill work. Time and again during her nine years in the House Grace repeated the same questions, sometimes to an almost empty house. Unlike today's MPs who can sit in their offices and watch proceedings on their TV monitors, only putting in an appearance in the House when necessary, in Grace's day she was forced to rely on her colleagues keeping up to date by reading daily reports of proceedings in *Hansard* or via the less sophisticated media coverage of that period. In the final analysis, she could only prod things along. Rather than getting the job done, her role, and that of her party, was often restricted to keeping an issue before the House and, in that sense, greasing the legislative process.

Her method must have been successful. In November 1966, Ron Basford, then a co-chairman of the Special Joint Committee on Consumer Credit, paid her an early tribute when he said she "had made a useful contribution to the work of the Joint Committee on problems of consumer credit and factors contributing to recent changes in the cost of living . . . the NDP members contributing ably and energetically in the work of the Committee."[131]

A Department of Consumer Affairs

A month after Grace's introduction to the House in January 1966, she asked Prime Minister Lester Pearson what the government proposed to do about holding down the cost of living. Pearson's reply was brief and, in Grace's opinion, hardly inspiring. The government, the prime minister said, would go on "maintaining, as we have tried to maintain, good financial and economic policies."[132] When Opposition Leader John Diefenbaker asked the

prime minister about rising food prices, Grace, trying to interject over Speaker Lucien Lamoreux as he attempted to silence her, asked about creating a review board to monitor cost of living and price increases.

It would take more than the Speaker to silence Grace. Soon her consumer campaign had started in earnest. In May, she moved during the Private Members' Hour, "that in the opinion of this House the government should give consideration to the establishment of a Department of Consumer Affairs."[133]

Consumers themselves had provided her with a reason for her request by writing and phoning to say they were aware the price index had risen 3.1 per cent in the previous twelve months, the most notable increases affecting food, clothing, and rent – "the rock-bottom essentials of families" – and they wanted to know the reason why. In her motion, Grace pointed out that a consumer affairs department was not a new idea. For example, the NDP's Reid Scott (Danforth) had proposed it in 1964 and, the following year, it was raised by another NDP member, Robert Prittie of Burnaby-Richmond. Grace also quoted from the communication she had received from the Mayor of Espanola, in the prime minister's own riding of Algoma East, pointing out that large increases in the prices of goods and services over the past twelve months would seriously affect those living on fixed incomes and hourly wage earners whose contracts would not be negotiated within the immediate future. It called on the government to establish a prices review board.

A week earlier, she had told Prime Minister Pearson, when he introduced a measure to set up half a dozen new departments, that "one department that has been left out is probably more important than any one of the changes that have been made. . . . While bits of consumer legislation are in operation in several departments there is no single department charged with the responsibility of looking after the interests of consumers as a whole. The department is long overdue [and] while consumer legislation is [part of] our platform, we would love to have it stolen." Then, Grace said, they would get her party's support. That was, in due course, just what happened.

Grace goes shopping in the market in Vancouver's Chinatown. The government would surely hear about the 2.2 per cent rise in the cost of food announced by the headlines of the *Vancouver Sun* she carries.

Unfortunately, like almost all Private Members' Motions, Grace's motion on that occasion was "talked out." However, she issued a report on her speech in the House and called it *A Consumer's Bill of Rights* – not printed, she was at pains to point out on the title page, at public expense.

In November 1966, Grace moved for leave to introduce a bill to create a Department of Consumer Affairs, the purpose of which would be "protection of consumers throughout Canada . . . to bring all such matters within the jurisdiction of one ministry . . . to abolish certain nefarious selling practices such as trading stamps, 'cents off' gimmicks, and trinkets placed in packages, size designations such as 'jumbo,' 'giant,' and 'family,' and other practices detrimental to the interests of consumers."[134] The motion to introduce the bill was passed and the bill was approved on first reading for printing and distribution to members.

In June of 1967 the government began to discuss the need for a registrar general's department. Grace, quick to recognize this as an opportunity to promote her wish for a consumer affairs department, suggested that the registrar general's department might include a consumer branch; in fact, she even suggested renaming this new branch the Department of Consumer Affairs. There could be a problem, however. In her opinion, "to mix consumers and corporations in one department is simply the same as trying to have the lion and the lamb live peacefully together. This may happen in Utopia but in our society [the result would be] a happy situation from the lion's point of view."

At last, in November 1967, the bill to develop a Department of Consumer and Corporate Affairs was introduced by the government, and the department came into being just before Christmas, transformed from the Department of the Registrar General. Once again government was acting on the prompting of opposition members, in this case the NDP.

A Prices Review Board

The concept of a prices review board to monitor the rising cost of living was first introduced as an amendment in 1966 by NDP leader Tommy Douglas. Grace immediately took up the cudgels on behalf of this issue, but it was 1973 before the review board saw the light of day. A good deal of the credit for the fact that it did so must go to Grace and her well known "squeaky wheel" approach. Although she was successful, the reform she won did not always achieve the results she had in mind. Prices failed to remain at an acceptable level, and, according to Statistics Canada, between 1972 and 1974 the price of beef, for example, increased 36 per cent, of bread 37 per cent, of eggs 46 per cent, and of milk 23 per cent.

But Grace always proceeded on the assumption that reform was necessary, and acted positively on the premise that what seemed like a sensible strategy would work. Based on this criterion, a prices review board seemed a viable answer to rising food prices. Moreover, as poverty was the likely outcome of rising

prices amongst many Canadians, Grace was sure to be on her feet demanding that something be done. This was the case soon after idea of a review board was first introduced, when she told the House in March 1966:

> Items which have gone up in price are protein foods such as meat, fish, chicken, which are essential proteins for body building. It is the fresh fruit and fresh vegetables which Canada Food Rules list among the most important essentials for good diet . . . which have gone up in price . . . I have had letters from women across this country in various provinces pointing out in despair that the price of milk has gone up to such an extent they can no longer afford to buy it in reasonable quantities; the price of oranges and fresh fruits has risen until these things are completely out of the range of that quarter of our population which is living at the poverty level at the present time . . . yet the government is showing no disposition to do anything about this situation. . . . Are the honourable gentle-men on the treasury benches opposite going to wait for the Economic Council to report? If so, they are not heeding the warning of the Organization for Economic Co-operation and Development which issued a special report at the end of January about Canada, telling us we should do well to watch unnecessary price rises in this country and suggesting it might be well for this country to establish guidelines in this regard.[135]

She pointed out to the prime minister that the protests focused on some half-dozen specific complaints, soaring food prices heading the list. Other complaints listed were the inclusion of trinkets in soap boxes, and two loaves being sold at a cheaper price – the bread being stale. Consumers also complained that government had failed to prohibit grocery trading stamps. These were "awarded" to consumers according to the total of their check-out bill. The stamps could later be "traded" for items listed in a special retailer's catalogue, a scheme which consumers complained simply put up prices.

Finally, consumers vigorously protested the fact there had been no increase in old age pensions, veteran's pensions, or family allowances to help them cope with all the increased prices. Despite this barrage of complaints, Pearson's reply gave no indication that the government intended to take any action to control prices or increase the incomes of the poor.

In the early 1970s Grace sat on a committee which she had been instrumental in getting started – the Special Commons Committee on Trends in Food Prices. Its objectives were to concentrate on the monopoly of power in the food industry and to establish a prices review board with the authority both to stop price increases, and also to roll back prices deemed to be unreasonable. Predictably the business sector cried foul and resorted to describing the committee's work as farcical and a witch hunt. The mandate of the first prices review board recommended by the Special Commons Committee was considered to be too strong in the view of those representing the corporate sector, and even, much to Grace's chagrin, in the eyes of some of her NDP colleagues. She was immensely displeased with the outcome because, once again, she felt that although the review board proposal would be allowed to study prices and make recommendations, it would lack the "teeth" to freeze or lower them.

However, Grace kept up the pressure, announcing that, according to a recent survey by the Canadian Grocery Distributors Institute, public confidence in the grocery business had dropped from 48 per cent in 1966 to 24 per cent in 1971. She added fuel to her argument by announcing that the food chains now held over 50 per cent of the grocery market, having taken 2 per cent more from the independent retailers during the previous year – all of which she held to be contributing factors in rising food prices. Using the folksy approach she sometimes adopted, Grace said: "These increases in costs are beginning to interfere with the nutritional standard of people in this country. . . . A man who raises chickens once said that if a small chick's nutritional needs were neglected for even one day, the chick would be unable to recover that loss during its entire life. If that is true for chicks, what about children?"

In 1968 a Special House of Commons Committee headed by Liberal MP Mary Batten found that prices on the prairies were 26 per cent higher than the Canadian average. Grace placed the blame for these higher food prices on grocery oligopolies, in particular Safeway and Weston. She wanted to know what had happened to recommendations of the Consumer Credit Committee to the federal government, and the effect of extravagant advertising on this situation. Her badgering paid off. Within days John Turner, the Registrar General, announced that his department was giving priority to the problems of labelling, packaging, and bilingual labels. Grace complimented him for giving the most explicit description of the department goals to date. In the past, she admitted, she had referred to the department as a "toothless wonder." Now that it was looking into the combines investigation and retailing on the prairies, perhaps she could hope that it would also look into the cost of living.

Later that week Grace found it necessary to complain that, once again, the price of milk had gone up two cents a quart in Ontario. She demanded to know what the Department of Consumer and Corporate Affairs proposed to do about it. Turner's reply was hardly enlightening; he said that the government of Canada "has no constitutional authority to impose pervasive controls over the price of goods and services except in a national emergency."[136]

One of Grace's most famous forays into consumer protection occurred in the summer of 1969 when she took an ice cream bar into the House of Commons – strictly speaking, forbidden under parliamentary rules. Generally in earnest in the Commons, she sometimes used the element of shock to make a point, and if it brought a little fun into the proceedings at the same time so much the better.

The problem concerned certain ice cream bars manufactured by Woodland Dairy of Edmonton, which were one half-ounce less than the weight printed on the labels. As Grace put it, the fraudulent advertising was a small deal for Parliament, but a big deal for the mothers and children who bought the product. Following her complaint, the weights and measures office in Calgary promised

to see to it that future labelling would carry accurate information. Three months later the situation remained unresolved, short-weight ice cream bars were still being sold, and, Grace complained, the dairy went on piling up profits. Not surprisingly, this state of affairs wasn't good enough for consumers, or for Grace.

Three days later an outraged Grace rose to challenge the appointment to the Canadian Consumer Council by the Minister of Consumer and Corporate Affairs of A.J. Child, President of Burns Food Limited of Calgary – Woodland Dairy, the ice cream manufacturer, was a subsidiary of Burns.

In the summer of 1969 Grace blamed a continued and upward spiral in the cost of living on Ron Basford, Minister of Consumer and Corporate Affairs. In the process of building a departmental dynasty, she taunted, he had failed lamentably in other ways. She reminded him that the cost of food was up 4.2 per cent, housing 5.3 per cent, and transportation 5.2 per cent. Grace did not think anyone believed the farmers were to blame for the rising cost of meat. As she informed the House, they had actually received less money for their meat in 1966 than they had in 1949. She quoted the wire service: "When lambs go for about twenty-five cents a pound on the hoof in the Calgary livestock market and turn up in Safeway stores in the same city as lamb chops at $1.95 a pound, consumers are entitled to know why."[137] There was evidence that speculators were investing in cattle just before they went to market and "making a nice, speedy profit on the transaction." Gambling on food must stop, Grace said, and, using the analogy of unions who bargained for fair wages, she thought consumers should also have bargaining rights, in their case for fair prices at the check-out counter.

Grace, along with public and private consumer groups such as the CAC, monitored food prices on a regular basis. Until her final days in the House, she continued this monitoring. She wanted to know why prices rose and why the Food Prices Review Board failed to make its decisions stick. "The consumer is not stupid," she said. "He or she may be a little slow to catch on, but they are learning fast and will be quick to notice." If they were not, she would be quick to attract their attention and to demand action on the part of the government.

The Pharmaceutical Industry

The pharmaceutical industry was another priority for Grace. In keeping with her strong support for medicare, she believed consumers needed reliable information regarding drugs and protection from high prices. For instance, although she complained it did not go far enough, Grace supported an amendment to a bill respecting the Patent Act which would facilitate the granting of a compulsory licence at any time during the life of a drug patent to anyone who wished to manufacture a compound in Canada. She asked for an amendment to trademark and patent laws to grant manufacturing rights to non-patent holders as a means of lowering drug costs to the public. She also traced how an international cartel had boosted the price of a type of pill used for heart problems from $12 to $65.25 within a few weeks.

In 1969 Grace and the New Democratic Party supported a bill to allow generic drugs to be brought into Canada. This, Grace said, "would interject competition into the brand-name stranglehold of the big drug manufacturers." The government was urged by NDP member Max Saltsman to set up a crown corporation to manufacture and market at least some of the more important prescription drugs.

Once a consumer and corporate affairs department was in place, the NDP sought amendments to the bill for a prices review board to establish the very crown corporation Saltsman had recommended, empowered to manufacture, sell, distribute, and promote drugs offered for sale in Canada and to supervise advertising and promotions for them.

This issue is still with us. In 1993 Tories extended patent protection for pharmaceutical companies to twenty rather than seventeen years, a move that significantly affects prices. Estimates of this increase, presented to the House of Commons Legislative Committee in 1992, range from $550 million to $7 billion by the year 2000.

Grace also pointed at the time to evidence of large monopolies stockpiling drugs in order to control prices and advocated using the Combines Act to protect consumers.

She complained that the price of drugs was higher in Canada than anywhere else in the world. Some people with modest means and without the benefit of some type of drug plan, she said, were being forced to choose whether to pay for their medication or their food. She rejected the government's suggestion of giving a subsidy to the poorest users and instead recommended the setting up of an independent marketing agency – a crown corporation – to control prices.

Packaging and Labelling Legislation

Les Benjamin, the former NDP member for Regina-Lake Centre, worked with Grace and the Committee on Health, Welfare and Social Affairs on a bill designed to help consumers figure out the best buy among the confusing assortment of sizes and shapes and deceptive packaging. What they wanted was unit pricing, something we now take for granted. Les tells an amusing story about Grace's inventiveness when she wished to make a point. One morning Grace called Les for help in carrying two large cardboard cartons down to the committee's hearing room, and "when Grace asked you to do something like that, it was an order."

The boxes contained a variety of packaged consumer goods of different sizes: cardboard containers, ketchup bottles, canned food, detergents, and so on. A delegation of representatives for retailers' and manufacturers' organizations had been invited to appear before the committee to make representations. Grace laid out all these items on a table, and "went after these guys and said to them: 'All right, pretend you're a housewife in a supermarket with these items. Which one is the best buy for the price per ounce, the 19-ounce can? Why not the 15-ounce or the 20-ounce?' They flunked the test, and she accused them of confusing the consumer – and, as she had the press and TV on hand, it was every effective.

Unit pricing became one of Grace's ongoing issues. Without it, the NDP said at the time, there was no way to properly compare prices for the same product in containers of different sizes.

Moral Suasion Alone Won't Protect Prices

Shortly before the House recessed for Christmas in 1968, Ron Basford introduced a White Paper on Price Stability. It was quickly trounced by the Opposition's Robert Stanfield, followed immediately by Grace, who in the course of the next few days, kept up a stream of harassment on the subject. Among her many salvos was the fact that it had been two years since she had asked when the minister would establish a Senate Commons Committee on Price Stability, Income and Employment. The answer then had been, "after the Prices and Incomes Commission is established." In the meantime, profits of Algoma Steel of Sault Ste. Marie, for example, said Grace, had risen to $1.70 a share from $1.22 in 1967, but people's incomes had not been keeping pace.

Basford countered that he was in consultation with consumer groups as a preliminary to setting up a Prices and Incomes Commission. Grace, of course, preferred the inherent openness that a prices review board (with its mandate to publish recommendations) would provide. She quickly returned to the attack.

There had been a time, she said, when the masses had had no idea of what they were missing. However, modern communications had put an end to that sort of ignorance, and now the poor were all too aware of the chasm that divided them from the élite. "Advertisers have created the clear impression that this [affluence] is possible for everyone. The revolution of rising expectations can no longer be denied with impunity." In this connection, she talked about the migration westward of a mixed group of young people – students, trouble makers, "hippies," and those who had started looking for work in the Maritimes and travelled steadily across Canada unable to find it. In words that still apply, Grace recommended that government should employ

some of these young people in cleaning up pollution, re-forestation, cleaning roadsides, and removing diseased trees, saving youth *and* the environment in the process.

When the Prices and Incomes Commission was set up in 1969, its mandate empowered it to develop a formula with which to make price increases, but without a requirement to inform the government, instead perhaps conducting a review of such increases later on. This was quite different from the goal of a prices review board which would be empowered to ensure price increases were justified before they were made, and to make its recommendations known.

Naturally, Grace was not enthused about the Prices and Incomes Commission and told the House that in spite of "the minister's pride in his newly born brainchild, I fear that the long labour has provided a puny infant."[138] The sessions were to be held in private. "The achievement of price stability is not the private concern of the consumer and corporate affairs department. It is a public matter of the utmost importance," Grace declared.

There soon followed amendments to consumer and corporate affairs which resulted in the transfer to it of certain functions of the Standards Branch and the Food and Drug Directorate. At that time, the department consisted of three branches: consumer affairs, corporate affairs, and combines investigation. Needless to say, Grace expressed no surprise over the fact that the department protected corporate strength, and, she said, the combines branch appeared to have "a most insecure and secretive personality." In her opinion, the department needed to "overcome its schizophrenic personality," and learn to relate to and work directly with people. For example, consumers had been asked to direct their complaints to a box number. However, this was a fruitless exercise because they usually were not able to learn the results of any investigation into their complaints. Such findings were not open to public scrutiny. Grace asked for the removal of this confidentiality rule. She also wanted the Consumer Association of Canada (CAC) to hold meetings in various centres, at least one of which should be open to the public.

In February 1970 Grace made scathing comments about a

recent conference of business leaders held under the auspices of the Prices and Incomes Commission. It "has been heralded by the government," she said, "as a conference on price stability. We in this party, and many other people in the country, believe that it is a misnomer. It should more correctly have been called a conference on profit maintenance."[139] She went on to call for implementation of a complete income policy, not simply voluntary restraint, in which all forms of income should be included rather than targeting organized labour. In short, she said, the commission should abandon its piecemeal approach.

Federal Umbrella for the Co-Operative Movement

Grace saw the co-operative movement as another means of consumer self-help. Her brother-in-law Ralph Staples was a leader in the movement, and Grace learned much about it from him. She had first heard of the concept as a teenager at Gibson's Landing when her father rubbed one of the leading merchants the wrong way by investing in the local co-op store. Later on she and Angus learned more about the co-operative movement during their trip to the Scandinavian countries in the thirties. They were impressed, and when Angus was on his maritime visits he made a point of seeking out local co-op movement organizers and promised them that the CCF had no intention of eroding the co-operative influence and activities in that area.

However, in the early days of the CCF the situation between the two organizations tended to be confused. According to history professor Ian MacPherson, quoted in a collection of essays appearing in *Building the Co-operative Commonwealth**:[140]

> The close relationship between the social democratic and co-operative movements was based in part on strong ideological considerations. As the co-operative move-

ment emerged as a reaction to industrialism during the late nineteenth century, it was widely embraced by social democrats in Scandinavia, Great Britain, France, and Canada (where it was particularly strong amongst the farmers). Many social democrats believed that three kinds of institutions were essential for the advancement of working people. Trade unions would protect workers in the work place, labour parties would advance their cause in politics; and co-operatives would protect their interests in the market place. The Fabian tradition, so basic to the rise of the CCF, particularly endorsed this three-pronged support for the working classes.

The Regina Manifesto strongly endorsed co-operatives. However, it did not outline the role co-operatives would play in areas such as housing, credit, or health services, and, as a result, leaders in the co-operative movement regarded the Manifesto with some suspicion, maintaining, for example, that the movement should be in control of agricultural matters. By the late forties attempts were underway to rationalize the relationship.

In 1970 Grace supported a bill favourable to the co-operative movement that was, she said, fundamentally different from ordinary business concerns in that its motivation was co-operation, not competition. The bill was referred to the Standing Committee on Justice and Legal Affairs. Grace proposed instead that it be sent to the Standing Committee on Health, Welfare and Social Affairs, in the absence of a Consumer Affairs Committee.

During her time in Parliament Grace would continue to support the co-operative movement whenever the subject arose and, of course, since then the co-operative approach to organizing food stores, day care, and so on has caught on with many consumers.

Re-elected With a Clean Sweep

In the 1972 federal election Grace won again handily, taking every poll in her riding of Vancouver Kingsway, all her opponents losing their deposits. It was a repeat of Angus's clean sweep many years before.

A year had passed since she had caused quite an uproar upon entering the House wearing a stylish wig. It came as a shock to everyone, used as they were to her short, cropped hair, worn in the same severe style from the days of her girlhood. She had put the wig on, she said, because her own hair was getting thin. No doubt she also resented the time – and given the importance Grace placed on keeping costs down – the money spent at the hairdresser's. A headline at the time said: "MPs Wolf-Whistle at Lady Member's Wig."

Although her arthritis was creeping back, she gained some relief from pain through acupuncture treatments – a revolutionary procedure at the time. She had to return to more traditional treatments when the medical profession banned the procedure.

The year 1972 would be Grace's last as a lone woman in the House. On top of her many other commitments that year, she was involved with the Status of Women report. When Parliament re-opened the following year with a minority government, Grace was joined by four more women: Liberals Monique Bégin (St. Michel), Albanie Morin (Louis Hebert), and Jeanne Sauvé (Ahuntsic), and Conservative Flora MacDonald (Kingston and the Islands).

At the end of Grace's days in the house, despite the grinding years she had put in on behalf of the issues she believed were important, her concrete achievements could probably best be described as minor. The inspiration she gave to women who came after her, however, was considerable.

Part III, Chapter 15

The Issue of Birth Control

Despite her undisputed reputation as "a backroom politician *par excellence*," as the only female member of the House in 1968, Grace faced the challenge of her lifetime, especially as some of the subjects she chose to pursue – family planning and abortion, for example – met with embarrassed snickers on the part of her male colleagues. Grace explained: "The members mostly regarded me like one of themselves even though I was the only woman ... but whenever I would get on to my pet subjects of birth control, family planning, and abortion, they would become just like little boys in a washroom – you know, they'd get kind of nervous and raucous in every way they knew."

Nevertheless, reaction to the subject of birth control had moved forward from 1961 when it was reported in the *Vancouver Province* that "a bid to ease Canada's birth control laws was killed Friday in the Commons by Quebec Créditistes who called it 'a diabolical work' and 'straight from hell itself.' At the time Grace entered the House in 1965, contraception was a forbidden subject in Canada, and had been so for seventy-five years. Advising women on the subject was illegal, and prosecutions were not unknown. Personally, Grace felt that women who had sex and didn't want a child, yet failed to take precautions, were "immoral." Yet, in order for them to act responsibly, she realized, they needed free-flowing information that emphasized the responsibility of sex as well as providing information on what she called "the mechanics."

The emphasis on birth control came naturally to Grace considering her mother's work with sex education for local women in Winnipeg more than thirty years earlier. However, although Lucy gave her daughter basic sex information at an early age, she had stopped short of telling her about birth-control methods.

Despite the Roman Catholic church's edict against "artificial" birth control methods and the fact that it was illegal under the Criminal Code, when Grace took up the issue many women, including Catholic women, practised it. In 1967-68 sociologist Dr. J.E. Kantner conducted a survey among 976 Toronto women.[141] He found that 83 per cent of Protestant women and 63 per cent of Catholic women practised birth control. Of 79 women in the study who were neither Protestant nor Catholic, 76 per cent practised birth control. Consumers, kept ignorant because of government-imposed censorship on birth control information, were further frustrated by the unreliability of available contraceptives. Although today's situation is vastly improved, women are still unable to rely absolutely on a contraceptive's efficacy, and it is ironical, although perhaps not surprising, to find that the issue is still with us. In June 1993 the *Toronto Star* reported that Dr. Marion Powell, a leader in health care, told a local forum that Canadian women have a "limited choice" of birth control options and rank with those from India and Russia as being the only ones without access to the long-term contraceptive, depo provera.

In 1963, reported the Dominion Bureau of Statistics, there were 24,458 illegitimate births. Children fifteen years of age or less bore 707 of these babies. This strained child-caring agencies at a time when few young mothers of illegitimate children kept their babies. Children giving birth to children was abhorrent to Grace. Moreover, she insisted that since men contributed equally to the problem, they should be involved in the solution; in short, information on birth control and its social implications should be made available to male as well as female teenagers.

As an MP Grace served on the Health and Welfare Committee, and in 1968 she worked on a bill that had died in the previous session, composed of a wide range of amendments to the Criminal Code, including matters as diverse as firearms, drinking

and driving, lotteries, abortion, and birth control. Some Opposition members wanted this bill divided up by subject to get around having to vote on a package that included things they did not want to vote on, such as abortion and homosexual provisions. At the time, Grace was being "plied with appeals to take up the abortion debate,"[142] however, the family planners were terribly scared, she said, of her emphasizing abortion when members were trying to get birth control out of the Criminal Code, as they felt it would endanger the birth control issue.

The NDP was opposed to a split in the bill because it felt this would hold up its passage. In the end, the Omnibus Bill passed in March 1969, and with it the issue of birth control was removed from the Criminal Code, and dissemination of birth control information became legal.

Before that, said Grace, she often had to fight even to get the subject of contraceptives on to the Order Paper.

> The Speaker and the House got bored with listening to me holding forth on contraceptives of various kinds and the results in various cities, because I had to do research so I didn't say the same thing on each one . . . but I annoyed the pro-life people very much because I was always bugging the government to make public the information as to the effectiveness of the different contraceptive devices, beginning with the pill which was 98 per cent [effective] down to rhythm which was only 24 per cent effective. . . .
>
> I would keep harping on these things, you see. [I felt] the government ought to publicize the fact [that] while people have every right to use the rhythm method they [also] have every right to be told it would fail in three-quarters of the cases.[143]

She cited the case of a Quebec doctor who "scandalized not only the Catholics but a lot of others by saying that if a young girl came to him to ask for birth-control pills he would size her up, and if he figured she was the type of girl who, if she wasn't given birth control pills would come back and ask for an abortion, he would give her the pills."

As usual, Grace's concern about this issue was rooted in her concern about poverty. During a House debate in 1970 she reported that the Family Planning Federation of Canada – a forerunner of Planned Parenthood in Canada – said it had discovered that the practice of family planning declined rapidly from the top to the bottom of Canada's socio-economic ladder. "The poor," its report said, "are still having the babies, many of them unwanted babies." Grace commented:

> While some people may consider abortion a crime, the real crime is the birth of unwanted children, children who from the very moment of their birth are unwanted and condemned to wander in the world alone, uncared for and completely derelict from the beginning. What we want is more democracy in such matters; that is, the right for people on low incomes to have the knowledge and the means to plan and limit their families in the same way as those on higher incomes."[144]

Feminists today might find it difficult to understand that Grace's espousal of "women's" issues was generally rooted in socialism rather than feminism. For her, elimination of women's poverty through socialist legislation was a better way of winning equality than by polarizing their issues as "special interests." Then, as now, poverty only magnified women's difficulties when it came to issues such as birth control and abortion. Grace believed polarizing issues by gender in the end would not serve women well. What perhaps she failed to appreciate was that many women needed a "movement" to articulate and politicize their needs.

A political profile which compared Grace with Dorothy Gretchen Steeves, a colleague in the B.C. Legislature in the forties, described the MLAs respectively as guinea hen and peacock. "Socialism also came first for the 'guinea hen' of the British Columbia legislature. But like the 'peacock' [Gretchen Steeves], she forged new paths for women, advanced women's rights, and assisted feminist campaigns. But her political activities and choices, to an even greater extent perhaps, reflected a preference for socialist fellowship and goals and a flight from a really profound

identification with women's groups and women's causes." [145] On the whole, Grace preferred working in mixed groups and once commented: "The first thing any man or woman needs in the line of liberation is to be liberated from the notion that they are just a man or just a woman . . . there is something much better than being either and that's being a full human being." [146]

Nonetheless, she persistently upheld the rights of women, especially those from the working class; their access to birth control (or abortion clinics), better working conditions, better pay and employment opportunities, and better conditions for their children, including adequate day care.

When birth control was finally decriminalized in 1969 it was not, of course, the end of the story. Grace was constantly on her feet during each session of Parliament – asking, for example, for the release of scientific reports on contraception, and its effect on women users.

> Quite frankly I think the government is in a very vulnerable position in this regard. It is using taxpayers' money to get this sort of work done by scientists and others who have every interest in giving the facts to the public.
>
> The Status of Women Committee report recommends that birth control information be available to everyone, and recommends that the Department of National Health and Welfare should be prepared to offer birth control information free of charge to provincial and territorial authorities, organizations, associations and individuals, and to give financial assistance through health grants to train health and welfare workers in family planning. . . .
>
> I think it is better to deal with birth control measures than to wait until you have to deal with an abortion . . . if we could get adequate family planning information in Canada . . . we could reduce the average number of children per family. This would have a number of important results. It would reduce the burden of many families and enable them to achieve economic independence . . . [and] the very considerable cost to the state of supporting these additional children would be eliminated. [147]

In Grace's opinion, the furor surrounding the abortion issue might never have developed the way it did, had adequate knowledge and effective contraceptives been made readily available seventy-five years earlier when birth control was made illegal in Canada.

Another issue was the safety of contraceptives, especially oral ones, in regard to women's health. Once again it was uphill work, entailing endless research, unending prodding in the House, and, although Grace once remarked that members found birth control "a relief to talk about" compared with abortion, it took dogged persistence to inch her way forward.

Just how on target Grace's fight was for women living in poverty during the period she was an MP was reflected in a report of that period: between 1971 and 1986 the number of women living in poverty increased by 110.3 per cent while the number of men living in poverty increased by only 23.8 per cent. All of the increase in women's poverty, relative to men's poverty, occurred in the 1970s. This increasing poverty was described in 1978, after Grace's retirement from politics, as the "feminization of poverty." It was a term she would have related to, however, it would have saddened (though not surprised) her, to learn that today, the conditions causing poverty among women, which she fought so hard to alleviate, have regressed. A 1993 report from the National Action Committee on the Status of Women says that six of every ten single mothers are living in poverty; almost half of all single women over age sixty-five live in poverty; one-quarter of all working women earn less than $9,000 a year and more than half earn less than $20,000 a year.

A 1990 report prepared for the Canadian Advisory Council on the Status of Women included tables that demonstrated poverty between the years 1971-86, which reflect conditions that existed at the time Grace was in Parliament.

In this connection, poverty, the wellspring of Grace's work and often a major factor in the many areas of need she tried to alleviate, has continued to cripple many Canadians. The National Council of Welfare in its autumn 1992 report, *Poverty Profile 1980-90*, indicates the percentage of families who were poor in

1990 was 8.3 per cent, a figure that would have risen to 17.3 per cent without the earnings of wives.

According to Statistics Canada, using 1986 data as a base, in 1990 the average Canadian family spent 36.2 per cent of gross income on food, shelter, and clothing. However, this figure rose dramatically for low-income families. The percentage of income this group needed to pay for the necessities of life was 56.2 per cent.

Grace would be no more satisfied today than she was twenty years ago with the high cost of living experienced by Canadian families. Statistics Canada figures released in the fall of 1993 show that food accounts for 17.5 per cent of a family's after-tax expenditures; shelter takes another 19.8 per cent (although this is down from the 1986 figure of 22.4 per cent); and clothing has risen from 6.1 per cent to 7.7 per cent. Figures such as these were always part of Grace's rationale for family planning, need for which she believed was increasingly crucial not only in Canada, but also in countries whose economies are infinitely frailer.

The Issue of Abortion

Insofar as the law and abortion are concerned, Grace once remarked that it was necessary to go back as far as the end of the sixteenth century to find it mentioned in a legal context for the first time. Up to that point the Roman Catholic church had always had sanctions against abortion; now it imposed a prohibition under Canon law, with excommunication for women who disobeyed. In England, abortion before the child quickened in the womb – that is, before its first movements were felt – was permitted until 1803. This was based on a theological doctrine relating to the nascence of the soul, which supposedly entered the body of an unborn child at the moment of quickening. As the law stood in Canada in 1961 a child was regarded as "viable" from the beginning of the twenty-eighth week of pregnancy.

Grace always worked on the premise that abortion was a medical, not a moral issue, and should be decided by a woman

and her doctor. She argued that the growing demand for abortions could directly be linked to the fact that because birth control and abortion were in the Criminal Code for many years and birth control now no longer was, the public lacked information about the subject.

Officially the NDP had passed a resolution in favour of a pro-choice stance some time before the abortion issue came to the fore in the late sixties, but this didn't mean that all members were in agreement with that. Even among those who were, some were apprehensive as to how it might affect them in a future election should such a contentious issue be raised in the House. David Lewis was one of these and felt the matter was divisive; in fact, Grace chose a time when he was absent to introduce it to the House.

Because of factors such as these, Grace worked patiently with the all-male members of the NDP caucus to gain their support before actively taking up the issue in the House in the spring of 1967 in a private member's bill. This bill specified abortion as an option when "continuation of the pregnancy would involve serious risk to the life or grave injury to the health, either physical or mental, of the pregnant woman." Grace also added two other conditions: "there is a substantial risk of a defective child being born; or the pregnancy is the result of rape or incest." The word *health* was not officially defined at this time, but Grace's definition was in line with that of the World Health Organization: "health is a state of complete physical, mental and social well being and not merely the absence of disease and infirmity."

Under the chairmanship of Dr. Harry C. Harley, MP, the Health and Welfare Committee considered Grace's bill, along with two others, in the fall of 1967, and then received delegations and heard briefs. By March 1968 the committee had received 35 briefs, heard 93 witnesses and 49,174 people had signed letters or petitions, all opposed to any change. On the other hand, 252 private submissions and letters, some signed by as many as four people, supported change. The briefs, resolutions, and statements included those from seven churches, religious or ethical

associations; social work organizations or agencies; family planning and family planning research organizations; professionals, hospital associations, ad hoc groups, and private individuals. Of the churches, only the Roman Catholic church was totally opposed to abortion at that time. Its position was that should the medical choice be between saving the life of the baby or that of the mother, the child should be saved. Organizations were divided; some believed the decision was the mother's, others favoured Grace's proposal that an abortion could be carried out with the approval of two doctors when it endangered life or health or when rape, incest, or the possibility of birth defects were involved. Included in these points of view were those of 1,800 affiliated organizations, and the Canadian Labour Congress representing 1.5 million members, one in five of them female.

From the beginning, abortion was perceived by some to be in conflict with the sacred principle of the inviolability of human life, based on God's commandment to Moses: "Thou shalt not kill." If the life in the womb is deemed to be human life, then abortion is just as much murder before as after it is born. This tenet of belief, so straightforward for those who hold it, was the basic objection of many anti-choice forces. As well, many anti-choice believers disagree about the precise moment that human life can be said to begin to exist, and that extinguishing it is a crime.

There were rumours in December 1967 that the government intended to introduce amended legislation on abortion in spite of the fact that the Health and Welfare Committee was still working on recommendations for that purpose, as it had been assigned to do. The committee decided to present an interim report which recommended "that therapeutic abortion be allowed where pregnancy will seriously endanger the life or the health of the mother," and to continue its hearings on the subject, examining the experience of other countries.

Two days later the government introduced a bill which included an amendment legalizing therapeutic abortion where "the continuation of the pregnancy of such female person would or would be likely to endanger her life or health." Quebec had already decided not to enforce the abortion law. When amendments

to the Criminal Code were first introduced, according to Dr. Henry Morgentaler, a champion of women's right to choice and a pioneer of free-standing abortion clinics, "[Prime Minister] Trudeau had so much abuse heaped on him he was traumatized to the point where he didn't want to help us. It looked completely hopeless. At one time health minister Marc Lalonde had mentioned, as a trial balloon, that maybe the law needed to be changed. There was so much opposition that they just abandoned it."[148]

Grace had first met Morgentaler earlier that year when he presented a brief to the Health and Welfare Committee in the Parliament buildings on behalf of the Humanist Fellowship of Montreal. "It was a very revolutionary brief in the sense that it was the first time that a public organization proposed that abortion be made legal and decriminalized for the right of women." It was a two-and-one-half-hour brief, and afterwards questioners included Grace and fellow NDP committee member Stanley Knowles, both of whom "stood out for being in sympathy with our proposal," Morgentaler said. Grace's acquaintanceship with Morgentaler strengthened her commitment to improving abortion legislation. The trust and respect that developed between them, coupled with Morgentaler's unique and important place in the history of the pro-choice movement in Canada, influenced the course of legislation both inside and outside the House of Commons.

Before the amendment to the bill went through, abortion continued to be punishable by a long prison sentence. Grace put the case forcefully for poor women who, she said, had the right to a safe therapeutic abortion rather than "being butchered, mutilated, and tortured by quacks." She also denounced as hypocrites the men in the equation who, she said, "often get off scot-free." As Maureen Jessop Orton put it in her 1968 report to the Health and Welfare Committee entitled *Whatever Happened in Ottawa on the Way to an Amendment* ?: "I suppose reform at any age is a matter of people dragging their institutions behind them."[149]

The government-worded amendment in respect of abortion eventually went through in 1969. It supported the broader view of circumstances in which a woman could obtain an abortion. A Créditiste attempt to limit abortion only to women whose lives

were endangered was beaten, although it won the support of twenty-six Conservatives, two Liberals, and a New Democrat. Most importantly, however, even when the amendment passed, allowing it under specific conditions, abortion remained in the Criminal Code.

Grace was always shocked by "the continued concern of all these forces that are opposed to getting [abortion] out of the Code, carrying the concern for the fetus all the way from the moment of conception to the moment of birth, and their absolute lack of any concern whatsoever as to what happened to it after it was born. They didn't care what the family circumstances were, what the mother would have to go through . . . into what conditions that child would be born. All they cared about was getting that fetus born."[150] She particularly disliked the fact that abortions would come under provincial administration which, in turn, meant hospitals would decide the conditions surrounding any abortion undertaken by them. For instance, any hospital participating had to set up its own abortion board, although the medical personnel on it could not include the woman's own doctor. Should any hospital board oppose abortion, as many did, there was no requirement that it set up an abortion board unless it wished to do so. This system also meant that hospitals in country areas might very well not have the time or personnel to set up and operate a board.

There were attempts to add other drawbacks to the amendment, Grace said, such as making sure the board had a priest or a spiritual counsellor available, or a social worker. "Finally it got to the stage where some of us suggested they wanted to put everyone on there with the possible exception of the TV repairman. It was a very fierce debate, even at that time, but it went through."[151]

As a result of attitudes such as these, the forces opposed to abortion became fairly strong and very vocal, a situation that led to the organization of the pro-life movement which at first consisted mainly of Roman Catholics and members of fundamentalist Christian churches.

During her time in the House, Grace conducted polls amongst members which consistently showed that between 70 and 80 per cent wanted abortion taken out of the Criminal Code. The result of public opinion versus the law of the land, according to Grace, was that "if a woman has enough money she can get an abortion safely by going to the United States or Quebec or any place that permits it. Or if she lives, of course, in a big city."[152] Legal abortions at that time cost around $100 and illegal ones more than $300. Less than a year after the 1969 abortion amendment had passed, the Canadian Medical Association reported that women were still flying to Europe or going to back-alley clinics because some hospitals were not participating and abortion committees were not being set up quickly enough.

Grace was not to see abortion taken out of the Criminal Code while she was an MP. Indeed, it wasn't until 1988 that it was struck down as unconstitutional. Section 7 of the Constitution guarantees life and liberty to every person – in the case of abortion, this was denied some women either because they lived where no pro-choice doctor was available, or in a place that lacked a committee of adjudication, or where local hospitals did not perform abortions. A new bill was introduced in 1989. This replaced the committee which was empowered to allow or deny a woman's request for an abortion with a doctor. Under the new law, it was the doctor's responsibility to decide whether, in denying a woman's request for an abortion, her physical, mental or psychological health would be endangered. The new bill passed in the Commons and went to the Senate where there was a tie vote, and the law failed to pass. In effect, there has been no law on this issue since that time.[153]

Reliable statistics about abortion in the days when it was illegal are, not unnaturally, hard to come by. Figures for 1991 show that 23,343 clinical therapeutic abortions were performed in seven provinces, plus 1,439 legal abortions performed in American border states. In addition, there were 70,277 hospital-performed therapeutic abortions. This is a total of 95,059 abortions on Canadian women in 1991, an increase of 2.3 per cent over 1990.

The 1991 hospital-performed therapeutic abortion rates for the two territories and the provinces ranged from 1.2 abortions

per 100 live births for women residing in Prince Edward Island (where no hospital will allow abortion procedures) to 25.9 for the Yukon. More than half of all women receiving abortions were between twenty and twenty-nine years (19.8 per cent below the age of twenty), and 64.8 per cent were single. Another 12.4 per cent were separated, divorced, widowed, or living common-law.

Until she retired from politics in 1974, Grace kept on working at an abortion bill, introducing it for several years, one after the other:

> I pointed out that we live in a pluralistic society and consequently there should be freedom to decide on the part of a woman whether she would have an abortion or whether she wouldn't. And that was the only way we could do it . . . to amend the existing legislation; to make it possible for both sides of the controversy to have more conscience, because any other way meant that the minority would be forcing their will on the majority of people in this country.
>
> There was very little response in the House. As a matter of fact, the only group that I recall that was eager to speak on it was the Social Credit group (they're all French-speaking people from Quebec), and . . . invariably they got around to likening it to being on the road to Hitler's gas ovens, but in both big parties there was great reluctance to [discuss it] because it was a dicey subject, as it was with my own party . . .
>
> I think the feminist movement to a certain extent contributed to all this, because they always considered abortion as one of the subjects that should be discussed as being only of concern to women, about getting control of their own bodies. I used to say to them, "Well, look now, look at the House of Commons, it is pretty nearly 100 per cent male – how can you expect, when men don't know anything about this subject, having been precluded from discussions because they're strictly female meetings – to be suddenly confronted with something they know nothing

about, but they feel is as dangerous as a live bomb – how do you expect them to be supportive?" I never got an answer to that. . . .[154]

Over the past twenty-odd years, Henry Morgentaler opened clinics across the country and, undeterred when police shut them down, re-opened them, spending $1.5 million fighting for his right to do so in the courts. "At one time," Morgentaler said, "I invited Grace to the clinic so she could see for herself how an abortion can be done without an abortion committee and without the necessity of having it done in the hospital. It was very courageous of her to come to the clinic when it was basically illegal – it was in the Criminal Code – and be a witness to what could be construed as an illegal act. When she came to the clinic she joked around with the staff. She talked very freely with the woman and said it shouldn't be in the Criminal Code. . . . The woman, who already had several children and was in her thirties, was fine and left the clinic shortly after."

Talking of that experience in the House, Grace said the abortion she had witnessed in Morgentaler's clinic was:

> the truth about most abortions, and I wish it was better known. Those people who are keeping this truth shrouded in an emotional fog and who are using the ideas of the middle ages to prevent us from entering the twentieth century are not doing a service to the Canadian population. . . . The whole subject of abortion should not be treated as a criminal matter, but as the medical, personal and social matter which it is. . . . The only way to meet these requirements is to remove the subject of abortion completely from the Criminal Code and leave it to those directly concerned, namely, pregnant women, their doctors, and those members of the medical profession required.[155]

Morgentaler commented: "Grace didn't get much sympathy from the male Members. . . . She contributed to the [abortion] cause by putting it in front of the House of Commons when there were not many supporters, she was a most reliable and devoted supporter."

Hilda Thomas, for twelve years chair of Everywoman's Health Clinic in Vancouver, a clinic established in 1979 by a committee for the B.C. Coalition of Abortion Clinics, described Grace as "inspirational," and a "great speaker who put things in a straightforward, clear way," as she did during the 1969 debate:

> One feature of this debate which has alarmed, saddened, and, I may say, made me feel very indignant, is the attitude toward women which has been displayed by some honourable members. It is quite an unconscious attitude; I am not saying it is deliberate. It is an inborn, inbred, uneducated attitude. . . . I have read letters from people in despair, social workers, and pregnant women. These are not young girls who go out for an evening and get into trouble; they are women who have had three or four pregnancies, are in poor health and financial circumstances, often with an ill husband at home, and who do not know how they will raise their existing children physically, emotionally and financially . . . they do not want this situation to continue.[156]

Abortion is now permissible in Canada but that doesn't always mean that it is readily available. In 1973, four years after the abortion amendment had passed, women seeking abortions in different parts of the country continued to meet with insufficient facilities, or no facilities, or committees so loaded down with cases that they could not operate efficiently. In January 1993 it was reported that only in British Columbia is abortion available everywhere with the cost fully covered by the province in both hospitals and clinics. No abortions are performed in Prince Edward Island and about two hundred women leave the province annually to have abortions in Halifax. Other provinces all have either restricted services or are restricted because of partially funded programs.

Many people fought on the pro-choice side of the issue: raising money to support Dr. Morgentaler, taking part in marches, writing to newspapers, and working in the community to soften attitudes and support women who needed, or received abortions.

A well-known activist was Doris Anderson, whose involvement covered her period as editor of *Chatelaine* and later as president of the National Action Committee on the Status of Women (NAC), which worked hard in support of this cause.

In 1960 Anderson published an article on abortion in *Chatelaine* – a courageous action at that time although she describes the article as "cautious." It advocated that women support safe and legal abortions in the case of rape, incest, where there was a danger of a deformed fetus, and when the mother's life was in danger. There was an immediate (and highly critical) flood of mail which continued for two years. Anderson published some of the more extreme letters, which "kicked off public debate" and provided a forum for those who chose to respond on both sides of the issue. She received various threats, from cancelling subscriptions to the magazine to having her removed from her job.

In 1984, Anderson's name (along with those of other notable pro-choice supporters such as Margaret Laurence) appeared on a release mailed out by the Canadian Abortion Rights Action League (CARAL). Norma Scarborough, then CARAL's president, phoned to tell Anderson she had received death threats on behalf of those named in the release. Indeed, the threats were accompanied by the dates on which they were slated to be executed. Anderson's reaction was to advise that the police be notified and all the women concerned warned. Although nothing came of the threats, the incident was chilling and indicative of the passions evoked by the abortion issue.

Another pro-choice group was ARCAL (the Association for the Repeal of Canadian Abortion Laws). Its priority was an emphasis on contraception. In 1971 it was quoted as saying that 70 per cent of women who came for counselling were not using any means of contraception – bearing out Grace's contention that birth-control information must become widely available.

In May 1971, an assault on Canada's abortion legislation was mounted from Vancouver when twenty-five women set out in caravan for Ottawa. Among them was Grace's second cousin Ellen Woodsworth (daughter of Grace's cousin and erstwhile left-wing protagonist, Ken Woodsworth, with whom she had tangled

in 1940). They towed a coffin symbolizing the deaths of an estimated two thousand Canadian women each year from illegal abortions. Joined by other women's groups from across the country they planned to demonstrate on Parliament Hill on Mother's Day and to present the government with demands to remove abortion from the Criminal Code. Two letters from them to Prime Minister Trudeau had gone unanswered.

When these some three thousand women of all ages and from differing socio-economic backgrounds arrived on Parliament Hill, they were met on the steps by Grace MacInnis, a lone member there to support their caravan and to meet about 450 pro-life demonstrators seeking unsuccessfully to enter the Parliament buildings. Members of the Cross Canada Abortion Caravan were chilled by cold winds and blowing snow as they moved around under the Peace Tower chanting slogans, and the same winds blew on the demonstrators from the Ottawa-based Alliance for Life who marched around them, waving signs – "Every Abortion Kills a Child," "Population Control Yes, Abortion No."

The following day some of the women managed to get inside the House; the galleries were filled with supporters and some of the caravan members chained themselves to the seats. Ellen Woodsworth recalls: "It was an exciting time. When we went inside the House of Commons we dressed up and disguised ourselves. Some of the members inside provided us with passes. We hid chains in our purses. We would stand up and say 'Abortion is a right,' and the guards would rush over and put their hands over our mouths. As soon as they stopped one, another stood up in another part of the gallery. They couldn't do anything, we were chained, and they didn't have wire cutters."[157]

Their shouting brought parliamentary business to a standstill. Grace was absent on this occasion on an official visit to the maritimes and Trudeau and more than half the cabinet were in Saskatchewan. There was no response from the handful of members on hand. Although later Trudeau promised to introduce a bill to repeal abortion it turned out the promise was an empty one.

By November 1971 Grace was back at it with a motion on the floor of the House "that this House urges the government at an

early date to introduce legislation to remove abortion from the Criminal Code." She kept up the pressure all year, sometimes using what she called "the late show" at the end of the day's scheduled sitting, when members were allowed seven minutes to present their concern of the day.

Increasingly, pro-choice groups faced opposition from pro-life organizations such as the Alliance for Life, using tactics such as carrying placards showing a number of eighteen- to twenty-four-week-old fetuses lying dead in a hospital disposal bag. Grace once commented that pro-lifers reminded her of the Canadian history she learned as a child about battles between the Sioux and the voyageurs. The Sioux Indians used to hide themselves behind trees, individually, and they [would] whoop and holler as though there were a dozen people hidden. . . . That's the way these pro-life people impress me, whooping and hollering and making a big fuss . . . giving the impression that theirs is the 72 per cent, whereas the 72 per cent is pro-choice."[158]

In April 1973 Minister of Justice Otto Lang refused Grace's latest request for abortion to be removed from the Criminal Code and also tried to stifle debate in the House. Nonetheless, speaking in the House in June, Grace praised *Chatelaine* editor Doris Anderson, saying:

> the magazine *Chatelaine* has shown itself capable and courageous when it comes to leading modern crusades. Ten years before the present abortion legislation it was pressing for legalized abortion. It's still at it. In a signed editorial Doris Anderson refers to past events and to the 1969 legislation in these words: "But the law doesn't work. Some doctors won't have anything to do with helping a patient get an abortion. No Roman Catholic hospitals will perform abortion on the liberalized grounds, so in a town with only a Catholic hospital, women find it almost impossible to get an abortion. Many women still have to go to the back-street butchers or, if they can afford it, go out of the country to get abortions."
>
> She goes on – and I agree with her completely: "Let's make it clear right here that no-one is suggesting that birth

control is not preferable to abortion. Nor are we suggesting that anyone whose religious beliefs do not allow birth control or abortion is being pressured to go against her convictions in having or performing an abortion. But contraceptives sometimes fail. Ignorance and irresponsibility can't be legislated out of the human race. And birth control information in Canada has only legally been available since 1969 and it is only patchily available today."

"Other countries," Grace concluded, "are waging more vigorous campaigns of birth control and sex education than we are in order to create that assumption of personal responsibility."

Shortly before Grace retired in 1974, Laura Sabia, then chair of the National Action Committee on the Status of Women, wrote to the prime minister and Members of Parliament recommending the removal of abortion from the Criminal Code.

This is *not* abortion on demand. It is believing (a) that abortion, while a very complicated question, is basically a moral issue; (b) that a woman in consultation with a doctor should be considered capable of making a responsible decision when abortion is contemplated; (c) that the present law is unfair and unworkable; (d) that there is urgent necessity for Government action regarding counselling services and contraceptive clinics. This is *not* encouraging abortion. It *is* saying that the decision should be open to all on the same basis.

As her days as a parliamentarian wound down, Grace enjoyed more solidarity within her party on the subject of abortion. At the 1973 federal convention, she presented a resolution to organize a defence campaign for Dr. Morgentaler who faced charges for illegally performing abortions. She received unanimous endorsement for her resolution and later that year supported a Montreal Morgentaler Defence Committee.

Before Grace left the House, she was joined by a new ally, the just-elected NDP member for New Westminster, Stuart Leggatt,

later to become a judge. Together they attended a pro-choice rally in Ottawa and one on Parliament Hill. They were confronted by members of the Stop Morgentaler Committee. Grace told those assembled they had to fight not to be "driven into the dark ages where women were men's playthings and their property as well."

Grace did not win the war against prejudice in her fight for women's access to abortion, but her passionate commitment evoked this analytic assessment by NDP Dave Barrett, a former premier of British Columbia. "Grace was a socialist for humankind, not gender. Within humankind there were problems, problems for men, problems for women. It's the whole body politic, the whole social structure that she fought against." [159]

Grace Goes to Bat for Mothers

When she went to Ottawa as an MP initially, Grace didn't set out to champion women's issues above others; indeed her political interests – and her record – were always broader based and seldom limited by her regional or gender roots. This was no neophyte politician who arrived in Ottawa with little experience beyond her home province. Grace's family background and her political involvement both with her party across the country and in the House since her early twenties had widened her perspective significantly. In today's language Grace's attitude to reform would likely be described as "holistic." Although in her time the word hadn't yet come into vogue, it springs to mind when describing how she looked at issues, particularly those affecting women, whether they spent their days at home, in the workplace, or as pensioners.

However, once women's issues engaged her actively she brought to them a passionate commitment. In retrospect, they have become synonymous with the name of Grace MacInnis, and certainly she was ahead of her time in focusing on such issues as day care, maternity leave, and tax breaks for child-care expenses. Many of her legislative goals for women – and Grace would be quick to point out that her range of concerns also included those that were not gender specific – remain to be resolved today and form the major thrust of the feminist movement's agenda.

She brought to the struggle what Dave Barrett describes as her "tenacity, her wit, her charm, and her ferociousness. I don't want to say ferocious in a negative sense, but she was a champion and champions are ferocious."

Standing up for the underdog in 1968, Grace said:

> References have been made to the modern technology
> with which we live. I have a feeling we are up in a great DC-
> 9 or DC-8 airplane and that somehow the pilot's instruments
> are not working and he has lost contact with the ground.
> We are headed for no place in particular except in the
> general direction of the great peaks of the Rocky Mountains,
> and this is rough weather. The pilot is nonchalantly saying
> to us that our destiny is the just society. [Pierre Trudeau's
> name for what he hoped to bring about during his time as
> prime minister], but all of us have the very uncomfortable
> feeling that we are heading for the big peaks and that it is
> only a short ride to Kingdom Come.

Likely all Grace's male caucus colleagues, especially during
her four-year stint as the House's only woman member – thought
she was their best bet to debate women's issues and delegated her
to work on them in the House and as a member of the Health and
Welfare Committee. *Hansard* reports show that it took some effort
on Grace's part to get the government to table a progress report on
the recommendations of the Royal Commission on the Status of
Women, a blueprint for the goals and aspirations of countless
Canadian women. When this occurred in May 1972, it received a
mixed report card from the member for Vancouver Kingsway.

> When the report of the Royal Commission was tabled it
> provided Canadian women at once with a bible of their
> rights and a blueprint as to some of the ways in which
> action must be taken for them to reach the promised land
> of equality. What does this statement disclose? It discloses
> that there have been several measures of real substance
> achieved. . . .
> Some pious hopes have been expressed about how the
> government intends to encourage the appointment of
> more women to senior posts in the public service. However,
> apart from token positions where women have been so
> outstanding that they could not be ignored, these hopes

have not been anything more than expressed. . . . As for Family Income Security, we in this party have pointed out that it will take from one-third of our mothers even the little cheque they now receive. They will have to give it to those who are living in poverty because the government has not the courage to institute a fair tax system so as to obtain the necessary revenue from other sources. . . . I am afraid the government has laboured mightily in its mountain of red tape and given birth to a very small mouse indeed compared with what is necessary. . . . Women are grateful for what they have got but, like Oliver Twist, they intend to keep on asking for more.[160]

Although Grace was the first woman MP elected from British Columbia, she was not the first politician to seek reforms that benefited women. She was perhaps the first to try to put together a package that could meet women's needs through a series of legislative changes designed to empower them by providing the necessary tools to achieve equality as people, especially as working women and mothers. For instance, she was an early proponent not only of making life easier for working mothers by provision of child care, maternity benefits, and tax exemptions, but also of ensuring that all working women could expect equal pay and equal access to job training, promotion, and non-discriminatory hiring conditions.

Working as an opposition politician, she wasn't always successful in terms of pushing government to introduce and pass the reforms she sought, but, as a woman who raised awareness and the consciousness of men and women inside and outside Parliament about matters that particularly affected women, she stood out – and continues to stand out – as a role model.

Jean Scott, a former executive member of the Victoria Status of Women committee and, like Grace, a recipient of the Person's Award, remembers her with awe. "When Grace spoke, her rhetorical self just came billowing out and everyone stood by with their ears flapping. . . . There was nothing quiet or docile about that woman when she was fired up politically. . . . I think she would

have liked to have been the first female prime minister of Canada;
the very fact that she could rise to the heights of oratory made me
feel she was longing for something more." When former NDP
member Ian Waddell once asked Grace why she had never run for
the party leadership, she replied that no-one had ever asked her.

Tax Exemptions

Typical of the approach Grace took, one that was inclusive of both
women and men, was a speech she made in February 1968 about
the need for income-tax exemptions for day-care expenses. In
Grace's opinion, women had the same right to tax exemption for
child-care expenses as men had for business expenses.

In the nineties the NDP took issue with the Conservative
plan to spend millions on helicopters, pointing out the money
could better be spent on programs such as day care. Grace had
made the same point thirty years earlier when she said:

> We learned this afternoon of a reduction of some kind in
> the civil defence establishment. If we reduced civil defence
> costs a great deal more and used that money to cover child-
> care expenses I think we would gain something worthwhile
> in respect of civil defence.
>
> I suggest there is one great and growing group of
> people across this country who are being penalized. I refer
> to those who have been left as a single parent in a family
> and are the sole means of support for their families. . . . The
> people in these groups are all men and women who have
> been left in the position of having to undertake the
> maintenance of a home on their own. . . . I think we must
> come to grips with the question of whether the home is an
> important institution or whether we want to throw it in the
> ashcan. Today we give lip service to the home on Mother's
> Day. At other times we do not seem to care what happens
> to it. We seem to take it for granted that the home is some
> kind of air terminal from which planes take off one after

the other and leave the place for anyone who comes along . . . then we wonder about the increase in delinquency and the people who fall into the ways of the hippies, drug addicts, and so on. . . .

These single parents have a very difficult time getting along. . . . There is no provision by way of income-tax exemption for payments to babysitters or housekeepers. This is the situation whether it is a man or a woman who is involved. . . . Parents Without Partners in Toronto said some time ago that an estimated 30,000 single parents in Toronto would be affected by income tax deductions for babysitters and housekeepers. That was a year or two ago, so now the number would be greater.*

She then quoted from a letter from Parents Without Partners: "if the minister will allow me $50 to take John Doe, a client, to dinner to get his business surely he should allow a wife who hires a babysitter, because she has to work, the same consideration."

In November 1971 the government finally recognized the Opposition's call for income-tax exemptions in respect of the children of working parents. What Grace described as "a very small breakthrough in this important area" secured a tax break of $500 per child up to a maximum of four children ($2,000), or for two-thirds of the parents' earned income, whichever was the lesser. However, Grace protested, this allowance was "a very unrealistic figure." Five hundred dollars worked out to $10 per five-day week in a fifty-week year, or $2 a day. The actual minimum for which child care could be provided at that time was $15 a week which worked out to an annual figure of $750. In terms of the actual market figure, the cost began at $20 a week, or $1,000

* The National Action Committee on the Status of Women 1993 Review of the Situation of Women in Canada reports the average monthly fees for child care are $370-$777 for infants; $328-$578 for pre-schoolers and $165-$275 for school age children. In Toronto alone, 15,300 eligible children were on a waiting list for subsidies in April 1993. There are 800,000 more children with a working mother for whom there is no regulated child care space than there were in 1974, the year Grace retired from Parliament.

a year, and the Canadian Conference on Child Care had suggested that even $1,000 per year was a minimum starting figure, the real market price being considerably higher. All in all, Grace didn't think much of the allowance compared with "business executives and self-employed people [who] are permitted almost unlimited deductions for expenses incurred as a result of their occupation."

In reply, Parliamentary Secretary to the Minister of Finance, Patrick Mahoney, explained that the process by which figures such as those proposed were arrived at involved a combination of things that were fed into an assessment of what the revenue impact might be – in this instance, the estimated revenue reduction as a result of a child-care allowance was estimated to be about $50 million a year.

Freeing Women to Participate

One of the reasons that Grace early on earmarked day care as an essential service for women was her hope that some of them, as well as opting to work at a job, would become active in politics, working themselves for the reforms needed, even if only on a part-time basis.

In 1970 Grace told an interviewer: "Raising children is much more than just feeding them, it's setting social relationship patterns, and if the child doesn't get the right home development he's liable to end up with all kinds of troubles . . . *but*, if we were properly organized, you could have part of the day at home and part of the day when the child is in a real, proper day-care home and the mother could go out and take courses, or work, or go into politics on a local level, where she can attack problems that affect the family."

Before these women overcame the problem of finding child care, some of them were confronted with the fact that their education was inadequate for the requirements of the workforce. They needed training (or re-training) before they could apply for a job, and they needed financial assistance to support them in the interim.

In 1970 Grace moved to amend the Adult Occupational Training Act to provide that any woman who had been working solely as a homemaker should, under certain conditions, be classified as a member of the labour force and be eligible for acceptance under the Act on the same basis as a man, thus making it possible for her to secure living allowance while training, and, in this way, provide "additional womanpower services for Canada."

In this connection, Grace also had to fight to have women who had previously worked for three years "within the four walls of the family home looking after her husband, her children, and sometimes aged parents" defined as a member of the labour force, and therefore eligible for full "manpower" training. "I am sick and tired," she said, "of hearing people take it for granted that only the woman who goes out to sell ships, seals, and sealing wax is working." Manpower and immigration minister Allan MacEachen replied that declaring women who had, as Grace put it, been engaged for three years "in the labour of their homes" implied a major policy change, and this would be considered. The restriction was eventually removed late in December 1971.

The following year the report of the Royal Commission on the Status of Women was tabled and Bryce Mackasey, who had taken over as Minister of Manpower and Immigration, told the House that a bill to amend the Adult Occupational Training Act had received first reading. For the first time, it would provide an opportunity for women who had worked for one year at any time in their lives to receive training, as well as training allowances.

But this was not enough for Grace. Many women, she said, especially single mothers, couldn't take advantage of the training program because they couldn't afford the child-care expenses in order to leave their homes. Grace asked for an amendment on their behalf under which full-time household responsibility would be equivalent to participation in the labour force insofar as eligibility for training programs was concerned. There followed a long speech by Bryce Mackasey in which he acknowledged that Grace "had become synonymous with the battle against discrimination," however, he added, there were also men engaged at home

in domestic service – "more than we realize" – therefore Grace's amendment should be re-worded to read: "including a person engaged in domestic service at home whether or not such a person at any time has been a member of the labour force."[161]

Grace cheerfully acknowledged the correction:

> I wish to say right now that I find the minister's generosity very great. Not only is his generosity great, but his wisdom is much greater than mine because I infinitely prefer the word *person* in there rather than *woman*. But I did not know the minister was prepared to look far enough ahead to the point at which men would be doing household work on a large scale along with women, and that is exactly how it should be.[162]

The re-worded motion passed before the House rose.

Training for the unemployed and underemployed was a project initially raised by Ed Broadbent, NDP member for Oshawa-Whitby, and then pushed for by Grace. According to the Economic Council of Canada, Grace reported, the former were costing between $2 and $4 billion a year in unused human resources, yet late in 1971, five years after the manpower training scheme was first introduced, there were still no programs geared to women who wanted training for full or part-time work, especially in the fast-growing service industry.

Even after women overcame the hurdle of being prepared for, and finding work, they still faced the challenge of finding child care of a standard that was suitable and at a price that was affordable. Grace had been quick to pinpoint these difficulties. For example, in 1967, she had told the House, "about a quarter of all Canadian women with small children had husbands who earned less than $3,000 a year. Only the women who can afford *not* to work can afford to hire a good housekeeper. The person with little money who *has* to work is the one who really suffers. Consequently, Grace was quick to recognize that along with day-care places, subsidies were required for women who could not afford to pay the market price. As she told the House: "These great groups of women whom I have mentioned are faced with the choice of either

going out to work and leaving the children neglected or staying at home and facing a very thin type of life for their families." [163]

The combination of the problems facing mothers who needed (or wanted) to work outside the home in order that their families could survive, and Grace's own concerns about children's welfare in the conditions that prevailed, led her to suggest again, in November 1967, that a carrot be offered to women to help make it possible for them to stay home instead. She moved:

> That in the opinion of this House, as a measure to promote the development of family life in Canada and to prevent its erosion, where a mother chooses to make a full-time career of motherhood by remaining at home instead of taking gainful employment outside, the government should consider the advisability of providing such a mother with an allowance to enable her to fulfill this service to Canada. [164]

Grace explained that such a scheme in France operated whenever there was a single pay cheque in the family. It paid the mother at a rate slightly above the country's minimum wage for each of her children, the rate increasing with age to a cut-off point at age twenty, which could be extended in the case of the young person serving an apprenticeship. It was not an idea that went over well, Opposition members falling over themselves to give reasons why it wouldn't work, even managing to drag the issue of abortion into their arguments by saying Grace's motion and its defence of family values was at variance with her pro-choice stance. Financial support for the stay-at-home option was also supported at that time by the National Action Committee on the Status of Women (NAC).

In time, Grace came to accept the fact that many women were not only taking their careers seriously, but were also anxious to do what was necessary to get ahead. It became obvious that her concept of paid stay-at-home mothers no longer appealed to the women themselves. However, a generation later, one can hypothesize that mothers who opt to stay home and look after their families might very well welcome the possibility of their choice receiving financial and community recognition.

Statistics in 1967 bore out Grace's conclusions about the size of the day-care problem. The Women's Bureau of the Department of Labour reported there were 540,000 mothers of children under fourteen in the workforce (which involved more than 1 million children, 357,000 under school age. Less than 3,000 were in nurseries or day-care centres).

Later that year, in November, Grace reported to the House that the Royal Commission on the Status of Women said there should be 450,000 places in child-care centres provided "in the immediate future." The commission advocated the introduction of a Day-Care Act to provide federal-provincial funding for child care, and Grace considered this to be one of the report's most important recommendations. She recognized that women no longer perceived their choice to be either full-time homemakers or career women; in future, many of them wished to combine the two.

In March 1971 Grace told her male colleagues that their time had come to share with their wives the hands-on responsibilities of child care. Discussing recommendations on working mothers and day care set out in the report of the Royal Commission on the Status of Women, she told them: "in our society we are realizing that family foundations are not as solid as we would like them to be. . . . Today, the cold, hard truth is that we have reached that stage in society where child care and the life of the home will no longer be the sole responsibility of the mother or woman; they will be shared with the father and husband and with society. Those are the patterns that are emerging."

In June that year Grace tried to secure loans under the National Housing Act for the construction of day-care centres but Robert K. Andras, Minister Without Portfolio, managed to defer discussion on the excuse that such a move would call for legislative change.

In May 1972, during the tabling of a progress report on the Royal Commission of the Status of Women recommendations, Grace took the government to task on the subject of lack of day-care provision:

As far as the major recommendations of the Royal
Commission on the Status of Women are concerned, there
has been no action or only microscopic action taken to this
point. The major recommendation was for child-care
centres across the country. While this is obviously a shared
responsibility with the provinces and municipalities, the
federal government has a tremendous responsibility to
fulfill. The only mention of this matter in the statement
today is that under the LIP program [Local Initiatives
Program] the federal government has helped to establish
ninety day-care centres across the country. I would point
out, however, that the LIP program is due to end on the
31st of this month, and you know Mr. Speaker, what will
happen to most of these centres when the grant ends. My
other comment is that the Royal Commission said that
there is a need for 450,000 day-care places immediately. So
this is one big piece of unfinished business.

How far have we gone? Twenty years later, in 1992, Audrey
McLaughlin, leader of the New Democratic Party, was still pushing
for a national child-care system. "Children are our future. Invest-
ing in them is a positive and sure investment, with demonstrated
economic and human benefits. Their well-being must be at the top
of the political agenda if Canada is to continue flourishing as a
nation. The fight against child poverty requires a comprehensive
plan including improved child benefits . . . and decent child care."

The degree to which the stumbling block of adequate day-
care provision hasn't diminished over the years is born out in a
Vancouver Sun article of October 1993 which reported that only
about 330,000 regulated day-care spaces were available for the
more than three million children under twelve who needed them.
"For many families, child care is the second biggest expenditure,
next to the mortgage. Some families pay up to $12,000 a year," the
article said.

As Grace commented on another occasion during a debate
on family income security:

We cannot vote against this legislation, but I must say we
shall not vote for it with the degree of enthusiasm we

should like to show in connection with a program which purports to provide an increased measure of family security for children in this country.

It is a little like your feeling toward a leaky umbrella in a heavy rainstorm. You have to use it because it is the only protection available, but you sure wish you had an umbrella without holes, one which would really do the job.[165]

The following month, speaking to the same subject, she continued:

When I spoke on this bill at an earlier stage, I likened it to an umbrella that was full of holes ... now I find that the leaky umbrella, full of holes, has collapsed in a mass of metal ribs and torn cloth. It is completely useless to do the job. ... What about ensuring equality for women, as promised?[166]

Later in the same debate Grace raged against those who "crusade under the clichés of the just society" while pulling the rug from under that group of taxpayers that is hit the hardest by modifying the universality of family allowances.

A few years ago I tried without success to get the government to pass legislation to provide a salary to mothers who wanted to stay home and look after their young children ... and would the government do that? Oh no ... now it is going much further ... now, that family allowance cheque which has meant so much, and which has enabled mothers to buy small amenities for the family, is to be taken away from a great number of families. The government is not satisfied with insulting women; it is not satisfied with neglecting to do anything with the report of the Royal Commission; it is prepared to snatch away the only bit of money that is paid directly to women and which women have a right to expect. ... This is not a war on poverty that the government is conducting, it is a war on women, a war against the family.[167]

The concept of day care, now commonly accepted even if less than commonly implemented, in Grace's day was still relatively novel. So she had the daunting task of bringing her male colleagues on side, to convince them that working women were now a fact of life, and the day care they needed for their children was something for which government should take responsibility. Grace also pushed for legislation which she saw as going hand-in-hand with the provision of day-care facilities: proper standards to ensure children received adequate care, and training courses for day-care workers in order that they might meet these standards satisfactorily.

Although by 1970 funds were available through the Manpower Training Program to provincial departments of education that offered subjects as diverse as aircraft maintenance and baking, day-care training was not among the options offered to Manpower-sponsored students. In this connection, child care is still one of the lowest-paying jobs in Canada, even for those with experience or those who hold an Early Childhood Education diploma. The results of a recent study found that between 1984 and 1991 the average child-care wage (in real terms) fell by 4.5 per cent. Benefits are low, and unpaid overtime is not uncommon. As a result many child-care workers are living at or below the poverty line.

According to a 1992 study by the Canadian Child Day Care Federation, *Caring for a Living,* average hourly wages for all positions differ across the country, ranging from $7.73 per hour in Prince Edward Island to $11.80 in the Northwest Territories. Staff in municipal day-care centres, which operate in Ontario and Alberta, earn more; in Alberta, 26 per cent more than staff in non-profit centres, and, in Ontario, 29 per cent more than staff in non-profit centres and 33 per cent more than those in commercial centres.

By January 1973 federal expenditures on day-care services were forecast that year to reach $8 million; Grace wanted to know whether Minister of Health and Welfare Marc Lalonde intended to "take more vigorous steps to implement the full cost-sharing program of $400 million proposed by the report of the Royal

Commission on the Status of Women." Lalonde took evasive action, replying that it was "essentially a provincial responsibility currently under discussion with provincial welfare ministers on a consulting basis."

Maternity Leave

Many mothers, of course, have children after they have joined the workforce. When Grace was elected there was no legislation protecting their jobs while they were home looking after the new infants, and there was no government scheme to help them financially during this period.

After Grace had attended a conference on child care in Ottawa in 1967, she asked Minister of Labour J.R. Nicholson whether the government was proposing to introduce "maternity protection" for working mothers – protection did not mean the pill, Grace hastened to explain to her fellow members, but what are now called maternity benefits. Although the government replied it had the concept under review, it was evident that a good deal of prodding would be necessary before the matter could be moved forward from this preliminary stage. In fact, at the time the Speaker wondered "if that question is very urgent."

What Grace was after was ratification by the government of the International Labour Organization's maternity protection convention. This established the right of mothers to get maternity leave without losing their jobs and to collect cash and certain medical benefits provided out of public funds, or by means of a system of insurance. Nicholson informed the House that the ILO had not specified the methods by which its requirements should be ratified by implementing nations. As far as Canada was concerned, he said, the convention was deemed to be partly under federal authority and partly under provincial. He concluded by saying that the government was working towards making ratification possible.

Little legislation existed in Canada regarding maternity leave at that time, aside from some limited provisions in British

Columbia, New Brunswick, and in the private sector. In March 1968 Grace introduced a bill providing for maternity leave before and after childbirth for women who were employed "in any work, undertaking, or business within the legislative authority of the government of Canada." About one-quarter of the government's employees were women, and of these, 36 per cent were between the ages of twenty and thirty-four. Grace said the bill's provisions were in line with those of the ILO convention, and by adopting them it was hoped that the example set by the federal government "would encourage provincial legislatures to do likewise." The bill passed first reading.

In October 1970 Grace placed another bill on the Order Paper for second reading, with reference to the Standing Committee on Labour, Manpower and Immigration. This was an act respecting the employment of women in federal jurisdiction before and after childbirth. The government used a procedural wrangle to tie up any immediate action, and the upshot was that Grace was asked to "re-introduce the bill in such form as she feels would be acceptable under the rules," another time. Four days later Grace returned to the attack, moving that a woman's job remain open without loss of seniority until she returned to work after the birth of a child. At that time, women in the federal service were obliged to resign two months before the date their babies were due.

Liberal Jack Cullen of Sarnia-Lambton supported the bill, and suggested Grace bring her measure before the Justice and Legal Affairs Committee.

In April 1971, during the second reading of a bill providing amendments to the Canadian Labour Standards Code respecting hours of work, wages, vacations, and termination of employment, Grace complained that one shortcoming in the proposed legislation in respect of maternity leave was that an employee must be employed for twelve months in order to qualify for the seventeen weeks off. "As the employer will not be required to provide leave with pay, but merely unpaid leave of absence, it is hard to understand the need for such a requirement." It limited a woman's mobility in the work force, she said, and restricted her right to be in the workforce regardless of the biological function of

child-bearing. Her male colleagues sidestepped dealing pro-
ductively with the question by making what now would
unquestionably be described as sexist jokes about pregnancy.

In March 1972 Grace moved an amendment to a bill
respecting the benefit period during pregnancy. She introduced it
to rectify a provision of the Unemployment Insurance Act which
gave a woman a certain number of weeks before and after her
confinement when she was covered by unemployment insurance.
The amendment would allow for elasticity in choosing the number
of weeks before and after confinement. The motion was agreed to,
the bill was read for the first time, and went forward for printing.

A Tally on Day Care at the End of 1973

On December 17, 1973, Minister of Labour John Munro tabled the
publication *Status of Women 1973*, a review of the activities of the
government to improve the position of women in Canada. In
November 1972, he said, the International Labour Organization
Convention 100 concerning equal remuneration for men and
women workers for work of equal value had been ratified. The
Department of Manpower and Immigration was about to appoint
consultants in each regional office with specific responsibilities
for Manpower services to women. The government was continuing
financial support of women's voluntary associations, and other
departments had also made funds available to women's
organizations to assist them in promoting the status of women.
The Department of National Health and Welfare had established
a National Day-Care Information Centre within the Canada
Assistance Plan Directorate. The Canada Assistance Plan
regulations were amended to allow for expansion of financial
support to day care. Previously the provisions of the plan allowed
for the sharing in the cost to the provinces and municipalities of
such expenses as salaries, staff training, and research. With the
amendments, shareable expenses were expanded to include all
operational costs and, in some instances, equipment costs. Support
was also being provided under the Canada Assistance Plan to

family day-care services, that, day-care services provided in a home environment.

During the discussion that followed Grace, while welcoming developments announced, said:

> The Royal Commission report was tabled in September 1970. In March 1971, my colleague, the honourable member for Greenwood [Andrew Brewin], moved a motion on behalf of our party in which he detailed some of these important needs – the inclusion of housewives in the Canada and Quebec pension plans, the provision of maternity benefits under the Unemployment Insurance Act, the adoption of a national day-care act, the initiation of a family-planning program, certain amendments to the Criminal Code including the removal of abortion as an offence, and equal treatment of women in the public service. We now have maternity benefits, some grants to family-planning organizations and the beginning of fairer treatment for women in the public service. But the other major items are still practically untouched as far as legislation goes. The critical shortage of day-care facilities is an outstanding example of how little action has been taken. And the problems of women are growing with this neglect. . . .
>
> Speaking in Toronto, in an expansive and generous mood a few nights before his marriage, the prime minister expressed his concern about the need to take immediate steps to improve the status of women. With enthusiasm, he said he invited all Canadians to exhibit impatience with the government's rate of progress in this respect. Never did the prime minister issue an invitation which was more welcome to me and to Canadian women generally. Unfortunately, to date there has been all kinds of talk but far too little action on the status of women. It is time to exhibit our impatience in no uncertain way. This, women, inside and outside Parliament, have been doing ever since.[168]

Grace made valiant efforts on behalf of day care while she was in Parliament and although the problem continues to be a major one for working mothers, Grace at least legitimized the subject and cleared the way for ongoing negotiations.

Today, women child-care workers remain among the ten lowest-paid occupations, earning on average less than bartenders and service-station attendants. Only 12 per cent of children with working mothers are currently in regulated care. Sole-support mothers, 59 per cent of whom live below the poverty line, often cannot even afford to put their children in day care – the Daily Bread Food Bank in Toronto found that 22.4 per cent of them identified child-care costs as the reason they were not working.

Child-care workers, 98 per cent of whom are women, are subsidizing the child-care system through poor pay and lack of benefits. The result is high turnover of staff, the figure being highest in commercial centres where it sometimes reaches 30 per cent annually.

The outlook for day care in the 1990s remains unpromising. Day-care development gets pushed aside as a priority by governments that are troubled by continuing deficits. However, official attitudes have moved ahead from Grace's day; governments of most parties now at least pay lip service to the need for day care and generally include its development in their campaign promises. Too often, however, once in power their commitment to meeting these promises falters in the face of a fragile economy, leaving day-care advocates to continue their fight to reverse this situation.

Housing and Other Issues

Commenting on how Grace "operated" as a Member of Parliament, Dave Barrett called her "a model of propriety. That didn't mean she didn't have a hand in things. She had her own method of ensuring what she would like to happen. She had authority in the party, and she did not hesitate to use it. She taught us what fighting was all about; she taught us what being tough was all about. She taught us about being right but not being righteous."

Although many friends remember Grace as someone who had few interests outside politics, there were lighter moments in the life of a democratic socialist. Les Benjamin, former NDP member for Regina-Lake Centre, remembers an entertaining Christmas party when a take-off of Snow White and the Seven Dwarfs was staged by caucus members. One of Grace's lines read: "Mirror, mirror, on the wall, why do I look like bugger all?" Someone bet a bottle of scotch she would refuse to speak the line – but she did.[169]

She needed a few laughs when, day after day, she faced all the all-male Parliament of that time. Despite her protests to the contrary, *Hansard* reports reveal that Grace was the target of many sexist taunts. She was able to give as good as she got: There was the famous occasion during a debate on the status of women when Grace called the honourable members "MCPs." Asked by media members outside the House afterwards what MCP stood for, she replied with a straight face: "Members of the Canadian Parliament." "Not male chauvinist pigs?" the media wanted to know. Grace quipped: "You're the ones who are saying it." But it was a solitary role, played out without the comfort and back-up of today's women's movement and more enlightened attitudes.

At the time, however, Grace would undoubtedly have rejected overtly "feminist" support.

The attitudes Grace encountered in Parliament were not, of course, exclusive to members of opposition parties, despite the fact that, on the whole, the NDP shared Grace's objectives for women. But, given Grace's loyalty to her party, she seldom went on record about the pain individual members' sexist shortcomings may have caused her. When sexism occurred, she appears to have accepted it as a fact of life and worked around it, which might have meant ignoring it at the time but working to get her own way in a non-confrontational manner. Although such behaviour may surprise today's women, who are more assertive in their dealings with men, in Grace's day manipulative strategies continued to be the more effective route taken in the face of male dominance, whether in marriage or in a broader context. In retrospect, many of those who knew Grace believe the stress of standing alone was a contributory factor in the return of the rheumatoid arthritis that ultimately led to her retirement.

It was difficulties such as these, according to Cliff Scotton, a former national campaign director in four elections, that forced Grace to develop "a pretty tough skin . . . the men tried to trivialize her. She became strident because she was alone out there with her causes, [saying in effect] 'Is anyone listening?'"

Her experiences in the House also served to entrench the stubbornness that was a natural facet of her temperament. The late Harold Winch described her as "very controlling. In caucus especially, and at conventions, you'd have one whale of a time bringing her to another point of view."[170]

In her continuing fight against poverty and the way it often deprived those with low incomes of the necessities of life, Grace put strenuous effort into improving housing conditions, especially for families. In doing so, she was ahead of her time. Records show that at the time Canada lagged behind Europe in providing its citizens with affordable housing. For instance, a 1963 report by the Organization for Economic Co-operation and Development found that, out of fourteen western European and North American countries, Canadians spent the largest percentage of their incomes

on rent. Ten years later, Grace cited Britain and Europe as being far ahead in public housing. In Sweden, for example, assisted housing accounted at that time for 40 per cent of residential homes, according to Carleton University statistics.

During a debate on the increased cost of living in March 1966, soon after Grace had entered the House for her first session, she asked whether the government was so well paid that it did not understand the distress of the poor. She had her own opinions about the housing crisis, in particular about how government reacted to it, and, in October 1967, she told the House:

> To my mind the one thing this government lacks to deal with the housing crisis is the will to deal with it. I do not believe that money, materials or manpower are the essential ingredients which are lacking. The most necessary ingredient that is lacking is the will by this government to give housing the top priority that it ought to have.

Overall, during her years as an MP, Grace felt that this lack of will on the part of government was the single biggest factor preventing adequate solutions being found for the housing crisis, ahead even of government's tendency to give preference to expenditures such as defence over funding for housing initiatives.

The biggest organizational stumbling block Grace identified – one not overcome in her day – was the lack of a separate Ministry of Housing. She believed that only by having a ministry devoted solely to meeting housing needs – rather than the existing arrangement in which it was doubled up with another department – could the situation be resolved and adequate provision made to co-ordinate the efforts of private and public sectors.

Grace's persistence met with some success. On the whole, she raised awareness and sometimes the conscience of decision makers. She could take credit for some of the progress made in the field of public housing, especially for the elderly in her home town of Vancouver. She also promoted recreational facilities on public housing projects, and, in general, pushed government to address housing problems. But too often high interest rates, too-costly rents for low-income tenants, bureaucratic red tape, and lack of

co-operation between various levels of government and private developers prevented Grace from achieving the reforms she really wanted. Nevertheless, it was difficult to ignore her constant and well-informed pursuit of her housing goals. At the very least, she laid the groundwork for those who came after her.

Of course, her overall concern continued to be poverty, a condition which she said denied people's basic needs – food, clothing and shelter. She quoted a letter received from one of her constituents:

> If indeed you are not too far removed from us, why can you not understand that our problems are regarding, food, clothing and *shelter*, all things which go to make life worth while . . . we never get around to having because all our work, thought and care go into getting enough to eat and to wear and to educate our children.[171]

Later on the same day Grace underlined her point with a letter from New Brunswick, from a pensioner who wrote:

> The [federal] government granted a $10 a month raise in the Old Age Pension some time ago and all of us got our rent raised $10 a month immediately so you can see that raise did not go far.[172]

Poor housing conditions in the United States and its effect on behaviour among low-income youth disturbed Grace, and she used this example to urge government to improve housing for poor families in Canada. As she reminded Prime Minister Trudeau:

> It is true what the prime minister says: "We are looking at these bread and butter projects." What people need is not looking, but action. They need a prime minister who can see that there are needs of this kind, one does not have to be reminded by disorder in the streets that we need urban renewal and attention to urban problems. . . . We were told yesterday by the chairman of the Economic Council that if action is not taken to deal with poverty and these urban difficulties, we shall likely get disorder in Canada's streets along the lines of that experienced to the south. Does the prime minister look forward to a situation of this kind?

A pre-budget debate in September 1966 led Grace to demand the immediate introduction of a guaranteed annual income. This followed a ministry of finance decision to discontinue winter house-building incentives, hold back on increases for research grants, hold the line on old-age pensions, and postpone the start of the medicare project.

The government's determination to economize on projects that could help the poor did not deter Grace, and, in November 1966, she raised the question of recreational facilities in public-housing projects. She wanted an amendment to the National Housing Act for this purpose, saying that delinquency was a distinct possibility among children living in poverty without recreational facilities. However, she was told she would have to raise the matter again when this bill came before the House "in a matter of weeks." When debate on Housing Act amendments occurred one week later, Grace suggested the matter of housing had become such an important factor in the rising cost of living that it deserved a department of its own with a minister who could devote his time exclusively to it.

While welcoming some amendments respecting loans (such as for student housing projects), she quoted from a document prepared and presented earlier by the Canadian Labour Congress (CLC), saying that the National Housing Act had thus far failed significantly to help those with low incomes. The CLC believed it was a problem that could not adequately be met by the commercial sector and stressed the need for low-rental housing with rents geared to income to rescue poor people from sub-standard and cast-off accommodation. This group, according to Grace, included wage earners with low incomes, the elderly on small pensions, and those on social assistance.

Grace went after the Central Mortgage and Housing Corporation (CMHC) who, early that year had increased their rates from 6.25 to 6.75 per cent, a substantial increase for those with low incomes who wanted to purchase a house. It was said at that time that no family should consider spending more than two-and-one-half times its annual income on the purchase of a home.

"This means that a family with an annual income of $5,000 a year should pay no more than $12,500 for a house. Where in our cities can one get a house for $12,500?" Grace asked.

Regarding her push for recreational facilities, the government told Grace it was prepared to contribute one-third of the costs involved (shared with the provincial and municipal governments concerned), but the initiative must first come from the municipal level. One problem, she said, that hindered municipalities from making that necessary initial move was the cost of relocating the affected people – and the cost of new schools, points on which she urged the government to amend the National Housing Act. "I hope the minister will tell us whether there will be leeway under the amendments to provide new schools when municipalities request them as part of urban renewal."

Later that year a start was made on constructing recreational facilities at some Vancouver public-housing projects. Although, naturally, this was good news, the appropriate time for such installations in Grace's opinion was during a project's initial construction stage.

Another point Grace raised was the rental costs of public housing in her hometown of Vancouver. In her opinion, the current rents were acting as a disincentive for those on social assistance, in particular people who could eventually enter the workforce. The rents, in conjunction with other living costs, discouraged this group from getting off social assistance and back into the workforce. The tenants themselves had made some proposals on the subject: first, that wage earners living in public-housing projects be allowed a 15 per cent blanket deduction from gross earnings to cover compulsory deductions before assessing the amount of their rent; and second, that a basic exemption of $250 of casual earnings per year be allowed before calculation of rent, and that subsequent increases in rent be calculated on amounts of casual earnings over $250.

> I understand that the rental scale is fixed jointly by Central Mortgage and Housing Corporation and the provincial government. These people believe that policies with more

liberal incentives would assist more tenants to become permanently employed and help families who wish to move out to become established in the larger community, thus freeing space for other low income families and resulting, eventually, in more families working part-time or full-time as an alternative to social assistance, thereby saving taxpayers' money.[173]

In March 1967 the Conservatives accused the Minister of Labour J.R. Nicholson of believing his role in the housing crisis was that of "a benevolent banker." It was also suggested that the 12 per cent sales tax imposed on building materials and the 5 per cent provincial tax be eliminated, in particular on homes, in order to keep them priced attractively to purchasers.

What was needed, said Grace, was the type of housing survey that had been carried out in Vancouver, partially financed by Central Mortgage and Housing Corporation, which collected data on the types and number of housing starts needed in the city. She believed similar studies should be conducted in major cities across the country. Poor people, especially, needed such studies, because "the rich have decided that socialism is necessary in order that they may obtain CMHC loans and that the poor should be left to the tender mercies of free enterprise."[174] She quoted from a recent statement by Michael Wheeler of the Canadian Welfare Council saying there was no reliable data on the number of families enjoying home ownership at the cost of severely strained budgets. "This is a matter which, like so many other aspects of Canada's housing program, deserves more systematic attention."

In May 1967, Canada's centennial year, in the debate following the Speech from the Throne, Grace complained it was "a 5,500-word composition filled with pompous generalities. A vision of the promised land without a single road map to reach it." More particularly, she believed strongly that it was the primary responsibility of the federal government to provide housing, not the primary responsibility of the individual, "as the government claims, because today many individuals are quite helpless in so far as their housing needs are concerned." She added that the

speech, rather than outlining housing plans for the days ahead, had instead reviewed policies of the last few years, policies which had resulted in a shortage of at least twenty thousand homes in 1966. In short, to Grace, housing continued to be Canada's number-one problem.

In October 1967 Grace welcomed an Opposition motion that:

> This House asserts that the government by its failure to assign priorities to essential programs and to co-ordinate fiscal policy to ensure the carrying out of such programs, has directly contributed to the difficulty of providing adequate housing at reasonable cost; that its recent action with respect to the interest rate has worsened the condition of Canadians in the middle- and low-income brackets. And this House regrets the failure of the government to recognize the housing shortage as a major crisis requiring immediate and co-ordinated steps for its solution as clearly indicated by the recent report of the Economic Council of Canada.

According to Grace, not only were subsidized housing lists too long, but there was also the problem of municipal, provincial, and federal rules and regulations which, because they did not function properly, delayed necessary action. She demanded that the federal government take the initiative for an overall plan, adding that if it had been possible during the Second World War, surely it was equally possible now that a war on poverty had been proclaimed. To emphasize her point, Grace said the cost of putting such a plan into action was likely less than the cost of lives "blighted" by miserable homes, for example, those of native Indians whose living conditions she described as the worst imaginable. In a comment that could have appeared in yesterday's newspaper rather than nearly thirty years ago, Grace complained the money needed for housing was going into defence and deficit interest.

The following spring, during discussion of the Income Tax Act, Grace returned to the attack. Saying the cost of living had

risen 4 1/2 per cent over the previous twelve months and housing
starts were fifteen thousand behind the number deemed necessary
by the Economic Council, Grace said:

> Still looking at the housing picture, I point out that the
> minister [Mitchell Sharp, finance] said the increase in rents
> was undoubtedly due in part to higher property taxes, the
> higher cost of land, and increased interest rates. He also
> said, and I quote his words: "but perhaps it is also because
> in many places landlords are in a strong bargaining
> position." Why does the government not do something
> about ordinary people who find themselves in the hands
> of landlords who are in a strong bargaining position?

In her opinion, "this [Liberal] government, and I say it
seriously and advisedly, has mastered the art of reducing the
living standards of the common people to an extent no previous
government has been able to accomplish. Let that epitaph be
recorded, because something tells me it will not be long before this
government is buried underground and I hope this time it will be
for a long, long time."[175]

Debating the budget in November of 1968, Grace hoped
Canadians would be wise enough to tackle the housing problem
before it developed to the point it had in the United States, where
"the ghettoes rose higher and higher, grew thicker and thicker,
and the antagonisms mounted more and more. Today we are
doing through fear what we should have done through justice and
commonsense years ago." Incidentally, the housing policy in the
United States helped upper-middle-class home owners by allowing
them a tax deduction for mortgage interest payments.

Early the following year, following Paul Hellyer's task force
on housing, Grace wanted to know why it contained no proposals
to help the one million Canadians whose incomes were below
$5,500, but instead only proposed help for the upper-income
levels. In particular, "the decision to cold-storage public housing
and urban renewal" was "a shocking betrayal of those who
needed help most." To address her complaints, she advocated
rent supplements in line with rent controls and enforcement of
local housing controls.

In March, the Conservative Member for Pembina, F.J. Bigg, urged a continuation of the task force on housing, suggesting it was time to expand its consultative thrust beyond industry and government to include consumers, with a view to finding out from them directly their needs and how they thought these might be financed. Grace was in agreement. The task force, she said, was currently duplicating previous work. It was also disappointing because, in spite of coming up with good ideas, it had not formulated a specific policy and was targeting those who needed it least. In order to remedy the situation, first there needed to be a separate Ministry of Housing. "We have no business saddling a minister with the two portfolios of transport and housing," said Grace.

The previous minister, J.W. Pickersgill, had indicated that $500 million would be needed for public housing, but insufficient money had been allocated for the purpose. In Grace's opinion, banks and lending houses should invest a certain percentage for housing loans. As she commented, if $20 billion could be found for airports to accommodate jumbo jets, it should be possible to find $500 million for housing.

Minister of Transport Paul Hellyer, into whose bailiwick housing fell, defended his task force for its suggestions about alternatives. He said that housing was a concern of all thoughtful people. "As I listened to the end of the honourable lady's remarks I thought she was not too far from our thinking. Perhaps if she re-read the task force report she would find we are almost at one" – a reply with which Grace did not agree.

The following month, Hellyer resigned. Grace saw this as demonstrating the complete and total failure of the government to do anything about the housing crisis. What was at issue was Prime Minister Trudeau's assertion that there was not a housing crisis. As he put it: "Let them go to Bugaboo, or the West Indies, or some place else. There is no housing crisis in Canada." Grace observed: "There is none for the prime minister. There is none for most of us here in the House. . . . the housing crisis is basically a crisis of income." She also accused the prime minister of using "the constitution as a shield for inaction with regard to pressing problems at the federal level."

She criticized what she described as "the strange decision" of Hellyer to head the task force, something she said was without precedent among committees and commissions of this type. She could only interpret this unusual decision as a means of enabling him to "pigeonhole" the report's recommendations should they prove not to be to his liking. Although the Hellyer report stated that everyone had a right to clean, warm shelter, the task force had made a recommendation to shelve public housing. Expressing her disgust, Grace told the House, "good citizens cannot possibly be raised in some of the conditions we find in housing today – these fire traps and rat traps we have heard about in so many speeches."

Before the Christmas recess in 1969, Grace talked on a motion about the advisability of setting up a committee to look into urban development. She complained that by continually shifting responsibility for housing from department to department, the government was avoiding responsibilities for planning. "When the president of the Privy Council [Donald S. MacDonald] said he supported the need for dealing with urban affairs, it strikes me that he does so with a sympathy akin to the way the rope supports the condemned man."

For some time Grace had pressed for public housing for the elderly, a growing number of whom lived in her hometown of Vancouver. Her efforts and those of her colleagues paid off when, in 1969, with federal government assistance under the National Housing Act, 20,000 housing units for the elderly and those on low incomes came under construction. Early in 1970, Robert Andras, Minister without Portfolio, informed Grace this momentum would not only be maintained over the next twelve months, but would even be surpassed. Funds would be available to build 35,000 housing units; although Grace welcomed this good news, she reminded the government that in Toronto alone, some 15,000 applicants were on a waiting list for such accommodation.

She followed up with four questions on housing in the immediate future: whether the 35,000 units would have recreational facilities; whether a proposed new rental scale (i.e., rent geared to income) would be an improvement over the existing one; if the minister intended to consider a program for outright

grants to enable low-income home owners to improve their older homes; and why had the allocation for student housing decreased by 20 per cent?

Eric Kierans, Postmaster General and Minister of Communications, took issue with Grace, reminding her, on behalf of the minister in charge of housing, that nearly half the $854 million capital budget of Central Mortgage and Housing Corporation was earmarked for provision of housing for those on low incomes. Also, that the 35,000 housing units promised over the coming twelve-month period compared favourably with that of the previous twenty-year period when the total only amounted to 82,000 homes in all.

That February Grace pursued her objective of rent-geared-to-income. Robert Andras, Minister without Portfolio, supposed her question stemmed from an article in the *Globe and Mail* which he described as "quite romantic but not necessarily based on fact." However, Grace was not to be put off; equally, Andras was not about to answer her question.

An amendment to the National Housing Act was introduced in June 1973 by Oshawa-Whitby member Ed Broadbent, who later led the NDP. Its purpose was to permit CMHC to make loans of up to 100 per cent of the lending value of a rental housing project undertaken by a municipal agency. Unamended, the bill would provide 100 per cent loans to charitable non-profit housing operations and co-operative associations, but 95 per cent loans to municipal and provincial housing agencies, as well as to private developers of limited dividend projects. The amendment, Broadbent said, would put municipal agencies in a better position than private developers constructing limited dividend housing under Section 15 of the Act, which provided loans for low-rental housing projects. He considered it better than leaving funds solely in the hands of private developers, saying it could act as an incentive to municipalities that found it difficult to raise money for these types of developments.

Grace said that the amendment was one answer to the need for a massive program of public housing. She also believed the amendment could lead to the provision of the kind of housing that

would remove the stigma currently attached to it and to those who lived there.

Shortly before Grace retired in April 1974, she asked Ron Basford, who had become Minister of State for Urban Affairs, if he was going to announce plans for a large-scale program to provide rental accommodation for low- and moderate-income families. This followed a cutback in apartment construction in major urban centres. Basford replied his department was doing its best through the provisions of the National Housing Act. Grace replied that there was marked reluctance on the part of the building industry to use funds allocated for public housing, and she asked the minister to have government itself undertake construction as it had during the Second World War.

Basford, however, claimed that, on the contrary, the federal-provincial partnership was working well in most provinces, and not experiencing difficulty in finding people to build houses. Grace, for her part, was unable to accept the minister's statement in view of the many people who continued to find it difficult to get hold of rental accommodation.

Grace certainly put the problems of housing in perspective for the government of her day, demanding solutions and offering advice. But accommodation for low-income families in the nineties remains as much a priority need, being in short supply, especially in major urban centres. Rents, in relation to disposable income, have reached levels where some families must choose between buying food or paying rent; as a result, many of them must use food banks. Coupled with high levels of unemployment, we see the number of homeless on the streets of Canada's largest cities grow annually.

Insofar as women in particular are concerned, the availability of shelter and its cost remain a particularly pressing problem, especially among the growing number of sole-support mothers. In 1992, 16 per cent of all Canadian families were headed by a lone woman. In 1993 the National Action Committee on the Status of Women reported there were 61.9 per cent of sole-support mothers living below the poverty line. Their incomes had, in fact, decreased by $2,834 from two years previously. In addition, although

incomes of single, elderly women have increased slightly – up $375 to $16,929 in 1991 from the 1989 figure – their incomes remain too low for market-priced housing, particularly in larger centres, and thousands of them remain on long waiting lists for accommodation geared to income.

Pensions and Allowances

Shortly before she retired, Grace informed her constituents that she and her NDP colleagues were making good progress towards social security, especially in the area of pensions and allowances. She could pass along this good news, she said, because of the previous year's federal election results; her party had secured thirty-one seats, giving it a balance of power with Trudeau's Liberal government. Consequently, the NDP would be better able to force the government to increase old-age pensions and veterans' legislation, improve tax measures, pass new family-allowance legislation under which young people to age eighteen received $20 a month, and announce improvements to the Canada Pension Plan. "We have used the strength of the thirty-one NDP members to gain these additional measures of social security for Canadians from coast to coast," Grace wrote.

She and her colleagues did not always experience such satisfaction. For example, the 1970 Royal Commission on the Status of Women recommended that the Guaranteed Income Supplement be increased so that all recipients would have an annual income above the poverty line, something that has yet to be achieved. Yet the concept of a guaranteed income was one that reflected Grace's aspirations for society. She shied away from materialism for herself and for others and instead was more interested in the "quality of people." In 1980, well after she had retired, she told an interviewer that in future she hoped there would be a change from the then current view of the economy, one where success was measured by an ability to buy more and more things. In its place she envisaged a society in which "more people develop and grow in relationships with each other, and in

harmony with the community. We have to make ourselves over in our thinking."[176]

In January 1971, telling the government it "should stop stringing people along," and take effective steps to abolish poverty in Canada, she had introduced a private members' motion calling on the government to set up a guaranteed income system and to plan "productive resources so that the wealth created by modern technology might produce a much more equal standard of living for Canadians." Liberal members were quick to put her down, saying the eradication of poverty was impossible within a short period of time, and that she offered clichés instead of potential solutions to the problem of poverty.

One year earlier, in a newsletter to her constituents in Vancouver Kingsway, Grace had written:

> We made it clear that this piecemeal approach to business and then to labour and then, perhaps to other groups, just won't work. We have to have an overall prices and incomes policy with teeth. . . . Only on this basis can a workable and fair policy be made. . . . We have emphasized strongly the need for bringing up the substandard incomes of those on old-age pension and other low fixed incomes.[177]

She was frustrated because during that session of the thirty-ninth Parliament her party could get nothing done to raise old-age pensions, veterans' allowances, and family allowances. "We are told that nothing can happen until the White Paper on Social Security is ready." The government produced that long-awaited White Paper on the last day of November, 1970. According to Economic Council figures, that year, poverty for two persons began at $3,240. Under the new legislation an elderly couple would receive $3,060. Grace commented: "They'll still be living in poverty, no matter how the Christmas package is presented."

In December, the Liberal majority on the Commons Health and Welfare Committee, of which Grace was a member, defeated a bid by the Conservative opposition that would have prevented the government from freezing the basic old age security benefit at $80 a month. A bill to amend the Old Age Security Act that was

then before the Committee, allowed a cost of living adjustment of up to 2 per cent a year for needy pensioners who were entitled to the Guaranteed Income Supplement (GIS). However, the bill eliminated the escalator (cost-of-living adjustment) for pensioners who qualified only for the flat-rate benefit (i.e., were not entitled to GIS), thus freezing the universal basic pension at $80 a month from January 1, 1971. Conservatives and New Democrat MPs on the committee pressed to restore the escalator to the basic pension, but were beaten by an eight-to-five vote. The bill increased the supplement to single needy pensioners to a maximum of $55 a month and boosted the maximum for married pensioners to $95 a month from April 1 the following year. The basic pension was adjusted from $79.58 to $80 and frozen at that level. It was an early attempt on the part of government to erode universality, an attempt that angered Grace. She described it as "a nasty act of discrimination" against a large group of old-age pensioners.[178]

Cost-of-living escalator clauses remained in effect for those covered by the Canada Pension Plan, retired civil servants, members of the armed forces, and Members of Parliament. "What the government is doing is picking on a defenceless lot of people on old-age pensions and discriminating against them . . . the fact they have been getting the benefit of the escalator clause makes the blow all the harder to bear," said Grace.

Winnipeg NDP stalwart Stanley Knowles, the chief proponent of pension reform, Charles Gauthier, member for Roberval, and Grace continued to press for an adjustment to improve seniors' pensions. By March 1972, when Grace herself had been a pensioner for more than two years, she jumped into the debate on government legislation raising the basic pension from $82.88 to $100 a month. Supporting the bill, she couldn't resist pointing out that if the pension eventually hit $150 a month it would simply be following a tradition set in motion by her father in 1927 when he pushed the government to introduce the old-age pension in the first place.

Following this move, and while urging restraint on salaries and wages, the government introduced a bill one part of which provided MPs and senators with what a *Globe and Mail* editorial

described as "just about the sweetest pension plan that ever came down the pike." It was satisfactory, according to Grace, to all but a group of New Democrats led by Stanley Knowles. "I am proud to have been one of the group," she wrote in her newsletter, "and I hope to do likewise if and when the proposal comes down later this session to increase the salaries of Members of Parliament." In April 1971, she was one of 31 out of 264 MPs who voted against the pay raise.

Until the end of Grace's days in Parliament she remained dissatisfied with some aspects of the Canada Pension Plan. In November 1973 she wrote to Marc Lalonde, Minister of National Health and Welfare, complaining that the Canada Pension Plan discriminated against women – especially women at home who were non-contributors. The plan, earnings-related as already indicated, was instituted as a contributory social insurance program designed to provide a basic level of protection for individuals and families against the contingencies of retirement, disability, and death. As long as individuals met the eligibility requirements, both males and females who contributed received a retirement or disability pension based on their contributions. The lump-sum death payment was the same for widow or widower.

However, as Grace pointed out, in respect to payment of survivors' benefits, widowers were treated differently from widows. This decision followed discussion during the plan's formative stage and was based on the philosophy of providing a basic protection for all families when the main breadwinner of either sex was lost. Lalonde pointed out that in order to amend the plan, it would be necessary to have the support of two-thirds of the provinces having two-thirds of the affected population. In respect of benefits for non-contributory persons, said Lalonde, and in keeping with the quest for equality of the sexes, the matter would be added to future agendas – as it turned out, this was a far-reaching promise whose fulfillment has yet to come about.

Another form of pension that occupied Grace's time was the Family Income Security Plan – family allowances. Family allowances had first come into being in 1945 when they were universal

in nature, covering every child under the age of sixteen who had lived in Canada for one year. At that time there were four different rates according to the age of the child, ranging from $5 to $8 a month. These rates were subject to deductions according to the size of family: $1 for the fifth child, $2 a month for the sixth and seventh child, and $3 for the eighth and subsequent children. These reductions were removed in 1949. In 1964 a youth allowance of $10 was introduced for young people of sixteen and seventeen continuously attending school, except in Quebec which had introduced schooling allowances in 1961.

A revised plan in 1973 covered young people to age eighteen (there were more than 7 1/2 million of them at the time), for an average of $20 a month, with some provincial variations. The allowance was treated as taxable income.

Grace retired in 1974. Considering the party's efforts and the gains that were made while she was in Parliament, albeit indirectly, she might well be dismayed at the current claw-backs of family allowance from families whose incomes are deemed too high to merit full benefits.

Grace was always an MP who took her duties seriously, in every day at 9:00 a.m. and staying on three nights a week until after 10:00 p.m. to catch "the late show," when she could bring up something that hadn't been possible earlier. She had little free time, but when she did, she enjoyed reading biographies and books with a sociological content.

She was a serious person, but she did have a good sense of humour and fun. What amused her, however, was not perhaps typical of that which amused some of her more worldly Ottawa colleagues. She told a Toronto reporter a joke in 1974:

> There's this story of the old lady at the zoo. She pestered the attendant with questions about the hippopotamus and finally asked him if it was male or female. He replied: "Madam, that information could be of interest only to another hippopotamus.

The simplicity of this story reveals something of Grace's character. She once told *Toronto Star* columnist Lotta Dempsey, when asked what it felt like to be third party down on the political totem pole:

You always labour for what is your basic interest in life. Politics, and what this party stands for, are my life. It is satisfying to see so many ideas first put forward by the New Democratic Party later adopted by the Liberal or Conservative governments in power. The ideas are what count.[179]

Each day, for as long as her health held, she walked the mile to work from her apartment in mid-town Ottawa, having risen at 7:00 a.m. She attended most social functions on the Hill, but rarely entertained at home, although she said people were her hobby, especially young people who were never turned away when they asked for an interview.

In 1971 Grace, never one for self-glorification, tucked into one of her office files a photograph of herself taken along with such celebrities as writer Simone de Beauvoir, anthropologist Margaret Mead, feminist Betty Friedan, and world leaders Indira Gandhi of India and Golda Meir of Israel. The occasion was her inclusion by *Marie Claire* magazine of Paris in its nominations of the fifty most important women of her time.

Grace shows off the china collection at home in Vancouver in 1974, the year she retired from the House of Commons.

An Early Defender of Many Causes

Amongst the causes that Grace took up that touched upon everyone's lives was the environment. She was an early defender of its protection, and was among the first to advocate legislation which would ensure consumer goods measured up in this respect. For example, she fought hard for the removal of phosphates from laundry detergents.

Early in 1969 Grace welcomed a bill to replace the former hazardous substances bill. The new bill replaced the word *substances* with *products*, a change she welcomed because of its broader connotation. In fact it added to a list which had included chemicals, glues, household cleansers, bleaches, and polishes, new articles such as matches, flammable textiles, mechanical toys, electrical appliances, and dangerous lawn mowers. She only hoped the process of declaring products hazardous would be speeded up to give the minister power to take responsibility for adding new products himself, rather than having him pilot each addition through Parliament.

It was June 1969 when she first brought up pollution that affected bodies of water, on this occasion Placentia Bay, Newfoundland. However, the parliamentary secretary to the Ministry of Fisheries, Eugene Whelan, stalled her, saying the minister, Jack Davis, had not yet completed an on-the-spot review of the area.

Later on, Grace talked about the difficulties she had experienced "getting listened to about the environment in the House of Commons." To overcome this obstacle, she said, she talked about it at meetings all over the country. In a paper about the Athabasca tar sands in Alberta, she wrote:

> One of the great problems confronting us is the realization
> that all our natural resources are finite. Until we face up to
> this fact and plan to arrange our future accordingly, I am
> afraid the world will go from one crisis to another.[180]

If Grace's words fell on deaf ears it was not because her
powers of oratory could ever be called into question. Many years
before, the *CCF News*, reporting a speech she made to the B.C.
Legislature, described it as "vibrant and dynamic . . . [she] gave a
staccato speech whose delivery had the government benches
fogged in the smoke of the revolutionary battle."[181]

Early in 1970 Grace was named to the Standing Committee
on National Resources and Public Works which was mandated to
study the Canada Water Act. She was soon pushing the
government to legislate for federal national standards that would
apply to the entire country rather than, as previously, only to
specific geographical areas.

At the end of January 1970 she placed a private members'
bill on the Order Paper to ban phosphates from detergents by the
beginning of 1972. She promoted a phosphate-free detergent
formula developed by Dr. Philip Jones of the University of
Toronto, suggesting that a crown corporation be set up to market
it at cost. Always a believer in letter-writing campaigns, Grace
encouraged people to write to the federal Minister of Energy,
Mines and Resources, John James Greene, urging him to follow
through on his promise to ban phosphates by 1972. In her opinion,
letter campaigns were always a good antidote to the lobby
presentations that could be expected from industry
representatives. Between mid-January and the end of February
1970 some 413 letters, briefs, and other documents protesting
phosphates were received by the minister.

Her tactics paid off and, in the spring of 1971, new sections
of the Canada Water Act were presented to the committee,
reducing the permitted content of phosphates in detergents to 20
per cent and by the fall of 1972, following a good deal of badgering
on Grace's part, the ban was complete.

But it was a fierce fight, and one that Grace waged throughout most of 1970, starting off in January by firing salvos in all directions from her seat in Parliament:

> What is the hold-up in banning these detergents? . . . It is because of companies such as Lever Brothers, Colgate-Palmolive-Peet, and the Proctor and Gamble Company of Canada Limited . . . these companies point out that it is going to take a long time to develop a replacement, although they must be aware that in Sweden there has been a replacement for some time which is working very well . . . it is interesting to note that the Vice President of the Electric Reduction Company, the firm that manufactures all phosphates for detergents in Canada, the same company that has been pumping pollution into Placentia Bay, killing the fish and taking away the livelihood of Newfoundland fishermen, also happens to be the Chancellor of Toronto University and the president of the Science Council of Canada.[182]

In June, Grace introduced an amendment to a sub-section of an act to provide for the management of the water resources of Canada reading: " [it is recommended that there should be] labelling on containers of cleaning agents and water conditioners, listing percentages contained therein of phosphates or other prescribed nutrients." As Grace explained it to the House: "Consumers ought to know what are the ingredients in the different products they buy. No matter whether we talk about fruit juices, meat, or any other product, we are learning that it is a good idea to list the ingredients." The government, although open to the concept, was not about to accept the motion immediately.

In the same vein, in December Grace asked whether the Food and Drug Directorate was developing regulations for infant-feeding formulas which would specify the essential nutrients, similar to those recently set by the U.S. Food and Drug Administration. This time she received an affirmative answer from John Munro, Minister of National Health and Welfare.

Eileen Sufrin, a friend and long-time party worker, with Grace in November 1982. Although retired from politics, Grace was still a busy backroom worker.

The year 1971 marked royal assent being given to legislation creating a Department of Environment – the minister was Jack Davis and the department was combined with fisheries. The following year R. Harding of Kootenay West tabled a motion calling for the establishment of an Environmental Council of Canada. On the same day, Grace told the House that Canada had to face the twin problems of world population and world pollution:

> Canada is one of the world's few remaining treasure houses of natural resources and we are beginning to discover that other countries are beginning to realize this fact. They have used up their own treasures, their own natural resources, to quite an extent. We in our province are very aware that other countries have found the way to our door and are beginning to take from our shores our treasures, our minerals, our wood, and other commodities. We are afraid that our water power and other resources

may be taken away entirely. This may be good from the standpoint of international trade, but from the standpoint of planning a future for those who will come after us we must make sure that we do not destroy in the short run our whole heritage and the possibility of a good environment for those who follow us.[183]

Eugene Whelan, who later became Minister of Agriculture, would have none of this and commented: "If one were to read the record one would find that many of the statements made about pollution are exaggerated, unfounded, or even fabricated,"[184] but NDP members repudiated his statements.

Oil spills, still a source of environmental concern, were debated in June 1972 following an incident at White Rock, B.C., when oil spilled from the Cherry Point refinery. Ron Basford, Minister of State for Urban Affairs, attempted to quieten strenuous complaints from British Columbia's NDP members, telling the House about the recent installation at Vancouver, Victoria, and Prince Rupert of devices known as slick-lickers. These consisted of 2,000-foot inshore booms in support of which available sources of sorbants had been located. Despite such steps and stringent legislation, Basford had to admit that Canada was limited in dealing with potential spills occurring in American international waters or on the high seas. Grace replied tartly:

> The Minister of State for Urban Affairs has given a performance as smooth as silk. In this case it needed to be very smooth indeed. He has papered over the cracks in the record of the government, practically turning himself into an oil-slick licker in order to show his anxiety and to cover up the long months of neglect when the government turned a deaf ear to the pleas from this side of the House for something to be done in order to avoid a disaster such as has taken place at Cherry Point.[185]

In a statement that sounds curiously up-to-date, Grace said what was really needed was altogether to prevent oil tankers coming down the Pacific coast of British Columbia. She realized

that this would call for some backbone on the part of negotiators in their dealings with the United States. This was the year when the Liberals had won the federal election with a minority. The New Democratic Party, under the leadership of David Lewis, had won thirty-one seats and considerable power.

In the almost twenty years since Grace retired from the House, the issue of our environment has increased significantly in profile. Of course, she would still be on her feet protesting about inadequate protection measures, but she would be heartened to see a will to make progress, and overall a better awareness that something must be done to save the environment for our children and grandchildren.

A Broader Scope

As indicated earlier, the scope of Grace's work as a parliamentarian was infinitely broader than is recorded here. However, undoubtedly Grace's work on behalf of women stands out above other issues she worked on, and it is what she is best remembered for.

Despite the fact that Grace modestly described her achievements as an MP merely as "opening doors" and opening people's minds to change, in reality her legacy is more concrete. Not only did she put before Parliament women's right to, and need for, fair and equal treatment at work and at home at a time when to do so showed both courage and vision, but the zeal she brought to the struggle also illuminated it for future generations. Although never a feminist herself, Grace's work on women's issues has made her a role model for the movement's activists. Likely she would not be surprised about this turn of events; however, given the overall breadth of her parliamentary endeavours, in the long run it is fair to say she would also wish to be remembered for paving the way for future reforms that continue to be needed by that other half of humankind – men.

The importance of reformers like Grace for those who come after them can be measured by the example they set and how this

Grace and her youngest brother Howard unveil the plaque at "Applewoood," their father's birthplace.

serves to inspire and empower the next generation to take up their causes and build on them. Reformers' causes, including Grace's, tend not to go away. The issues of day care, birth-control education, choice in the matter of abortion, equality in the workplace, and pension rights; all of these remain to be fully resolved and continue to simmer (and sometimes boil) on the front burner of activist groups.

In this connection, poverty, the wellspring of Grace's work and often a major factor in the many areas of need she tried to alleviate, has continued to cripple many Canadians. The National Council of Welfare in its autumn 1992 report, *Poverty Profile 1980-1990*, indicates that the percentage of families who were poor in 1990 was 8.3 per cent, a figure that would have risen to 17.3 per cent without the earnings of wives. According to Statistics Canada, using 1986 data as a base, in 1990 the average Canadian family spent 36.2 per cent of gross income on food, shelter, and clothing. This percentage rose dramatically for low-income families. The percentage of gross income this group needed to pay for the necessities of life was 56.2 per cent.

Grace would be no more satisfied today than she was twenty years ago with the high cost of living experienced by

Canadian families. Statistics Canada figures released in the fall of 1993 show that food accounts for 17.5 per cent of the family's after-tax expenditures; shelter takes another 19.8 per cent (although this is down from the 1986 figure of 22.4 per cent); and clothing has risen from 6.1 per cent to 7.7 per cent.

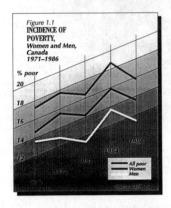

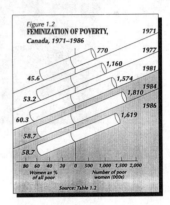

TABLE 1.2: Poverty by Sex, Canada, Selected Years, 1971–1986

	1971		1977		1981		1984		1986		Increase
	(000s)	%	(000s)	%	(000s)	%	(000s)	%	(000s)	%	1971–86
Both Sexes											
All poor	1,690		2,180		2,611		3,086		2,758		63.2%
Incidence		14.6		15.1		14.1		16.1		13.9	
Women											
All poor	770		1,160		1,574		1,810		1,619		110.3%
Incidence *		16.9		18.0		16.6		18.4		16.0	
Distribution (% of all poor)		45.6		53.2		60.3		58.7		58.7	
Men											
All poor	920		1,030		1,037		1,276		1,139		23.8%
Incidence		13.3		12.9		11.4		13.6		11.7	
Distribution (% of all poor)		54.4		46.8		39.7		41.3		41.3	

Note: 1971 data uses 1969 LICO (low income cut-offs) base; 1977 to 1986 data uses 1978 LICO base. Numbers may not add up due to rounding.

Source: Tabulations by Analytical Services, Health and Welfare Canada and Statistics Canada on Statistics Canada, Survey of Consumer Finances, Public Use Micro-data Tape: Incomes of Individuals.

1990 Women and Labour Market Poverty by Morley Gunderson and Leon Masznski. Prepared for the Canadian Advisory Council on the Status of Women.

Anyone interested in reform, and in seeing how it's done, can look at Grace's personal papers in the Special Collections Library at the University of British Columbia in Vancouver. Manuscripts archivist, George Brandak, says the collection was so well organized when handed over to the archives, it required little rearranging. This neatness was very much part of Grace's image, whether in the way she dressed or, in general, her methodical approach to life. Indeed, no one could ever accuse Grace of sloppiness. For instance, not a note of hers survives in public archives or in the homes of friends and relatives that isn't written in her unfailingly neat hand. Her speeches in Parliament denoted meticulous research, and, if anything, she was tidy to a fault. Towards the end of her life, when she lived in a nursing home, visitors would receive a quick reprimand if they moved something or failed to replace it in *exactly* the same spot.

On one occasion, she chided her parliamentary colleagues for appearing in the House dressed more informally than she considered proper, yet she is on record for defending the long-haired look that was so popular among men in the sixties and early seventies.

The range of topics on which Grace spoke ranged from the Company of Young Canadians through combines to women retaining their maiden names on passports, the railways and the needs of the physically disadvantaged, prison reform and bettering conditions for native people. She railed against the War Measures Act (and against Prime Minister Pierre Trudeau) and, predictably, was a vocal opponent of the war in Viet Nam. She was a staunch supporter of medicare.

But women's issues surfaced early in her career as an MP. In fact, scarcely two months had gone by from her introduction to the House when, in March of 1966, she complained about the manner in which women's names were reflected in lists of committee members – namely, stuck amongst the "Messrs." without any attempt to define their female status by identifying them by the respective modes of address commonly used at that time – Miss or Mrs.

As a member of a minority group in this House my question concerns the privileges of this minority. . . . You will notice . . . within the all-embracing framework of the word *Messrs.* are listed the committee members. . . . I know, Mr. Speaker, that the presence of women in this House this past while may have been accidental and we hope their presence will not recur in that particular form. But I do suggest that women have been members of this House long enough now to be considered as lady members on committee listings [and not] as though they were something accidental and perhaps not likely to recur . . . I suggest that women . . . be considered as lady members of committees instead of having their names put in the list haphazardly like raisins in a pudding, as though to signify they are less than full members.[186]

Though to modern female ears it may sound strange to *want* to be referred to as "Miss" or "Mrs." rather than being listed among the male members "like raisins in a pudding," Grace always knew what it was to be a person, and she made sure that others did as well.

Part III, Chapter 19

A Woman to Remember

In 1974, the year Grace retired from the House of Commons, she was made an Officer of the Order of Canada, although the investiture at Rideau Hall in Ottawa did not take place until the following October.

Her retirement year was earmarked by many honours. Three of them, honorary LL.D.s from Canadian universities, were among a total of eight similar honorary doctorates she received during her lifetime.* In May 1974 she received a doctorate from the University of Notre Dame in Nelson, B.C.; in June from Laurentian University in Sudbury, Ontario; and, in November, from the University of Toronto. In October 1974 she was given a testimonial from the University Women's Club in Vancouver, and in December she became the first woman "Freeman" of the City of Vancouver.

Other ways in which Grace's work was recognized included an honorary membership in the Vancouver District Public Housing Tenants' Association in January 1975, and, in May 1982, she received the Canadian Labour Congress Award for Outstanding Service to Humanity. In October 1985 she received the Human Relations Award from the Canadian Council of Christians and Jews "for outstanding contribution in promoting understanding and co-operation among the people of Canada."

*May 1971 – Brock University, St. Catharines, Ontario
May 1972 – Simon Fraser University, Burnaby, B.C.
June 1973 – Trent University, Peterborough, Ontario
November 1975 – University of Manitoba, Winnipeg
June 1977 – University of British Columbia, Vancouver

In 1986 she received the Distinguished Pioneer's Award as part of Vancouver's centennial celebrations – among ninety-nine others who were similarly recognized were old comrades such as Harold Winch, Daisy Webster, and Mildred Fahrni, who had spoken the eulogy at J.S. Woodsworth's funeral. That year, too, she was given a testimonial dinner by the Japanese Canadian Citizens Association of Greater Vancouver where she was reunited with many old friends including Hidi Shimizu, who she knew well in relocation days. The Honourable Thomas Berger was the keynote speaker, and when Grace rose to speak it was to reproach the current government for its attitude to the Japanese-Canadian redress issue.

Finally, in October 1990, B.C.'s Lieutenant Governor David Lam came to Totem Lodge in Sechelt, the home where Grace spent her last years, to present her with the Order of British Columbia. Friends say this award meant a lot to Grace. Although born in Manitoba, she had always regarded British Columbia as home because of all the memories it held for her, memories that dated from the time the Woodsworth family first arrived in Gibson's Landing when she was still a young teenager, through her life with her husband Angus, and eventually through her own career as an MLA and then an MP.

On the downside, following Grace's retirement, the arthritis which had driven her from office increasingly threatened to hamper her movements. But ever stubborn, she refused to let it get the better of her. The dynamic politician refused to leave the stage; she would struggle on to platforms, her voice as strong as ever, her socialist message undiminished. As she told former Vancouver East NDP MP Margaret Mitchell: "I work fine from the neck up."

A reflection remains of Grace's thoughts at this time when she wrote:

> I love this country because it is my home and my roots run deep. I share it with a tremendous variety of others from all over the globe. As we learn to work together, to share our untold treasure of hand and mind and spirit, Canada can truly become a land of heart's desire. But that means

learning to accept individual responsibility for change. Are we ready to learn?[187]

Grace was always ready to learn, even if it was how to live with pain. Her brother-in-law and cousin Ralph Staples, wrote in his 1978 diary about Grace and how he helped her cope:

> Grace was rather uncertain on her feet and one day I asked her how she would get into the tub for her daily shower. She said: "Oh, I put one hand on the toilet tank, the other on the taps and step over." One day she was away all afternoon for routine tests and I drove downtown and bought a very sturdy two-foot length of railing to bolt on to the side of the tub. I knew if I asked Grace she wouldn't want to be bothered. But I had it on securely when she got home and, on a careful testing, she was greatly pleased.[188]

Until February 1987, Grace remained in her apartment in the South Granville area of Vancouver's west side. According to Yvonne Cocke, who, as project director, worked with Grace on the board of the J.S. Woodsworth Endowment Fund at Simon Fraser University, she was fascinated with the new devices she acquired during this period and the freedom they gave her to remain independent in her home. The Arthritis Association supplied her with a number of gadgets for reaching things, including a favourite with which she could turn on the stove. Anything which made it possible for her not to ask for help was fine with her.

Despite her frailties, Grace continued to drive her car – "long past the time when she was a safe driver," according to Yvonne Cocke. In fact, Grace kept on driving until one day she started to parallel park and physically was unable to complete the operation. Much to her disgust she was forced to ask for help – and, finally, to admit that she must give up her car.

But she remained active in behind-the-scenes activities of the NDP, getting rides from friends or in vehicles for the disabled. At home, she was surrounded by books and mementos, and one of her great interests was overseeing the Lucy L. Woodsworth Fund for Children, which provided at that time $10,000 a year in

help for Vancouver's school children on the city's east side. She told a local reporter: "The fund is my true link with the living, and I'd be utterly lost without it."

Lucy had died in 1976 at St. Vincent's Hospital in Ottawa, at the age of 102. During Grace's years in Ottawa she had often visited her mother on weekends, wheeling her out from the nursing home. Lucy died in the arms of her eldest son, Charles, on his return from South Africa where he had served as ambassador. For ten years or so, Lucy had not recognized anyone. As Grace commented: "there wasn't any grief possible. She was 102, and she had received good care, we had always kept in touch with frequent visiting. . . . there were no regrets."[189]

At Lucy's request, her ashes were buried in the old cemetery near her childhood home in Cavan, Ontario. Grace's rheumatism prevented her from attending the ceremony. Neither was she able to attend in 1983 the memorial service held for her sister Belva at their father's childhood home, Applewood, in the Toronto suburb of Etobicoke.

Over the years, her mother had spoken to Grace about the grief she felt over children born into low-income families, "perfect little bodies and the potential they have, and how it's just like someone taking an iron clamp around a bud, so that it could never open." When Grace received a legacy from her mother, she decided to add some of her savings to it and start the fund named for her mother that could help poor children enjoy some of the things they had missed. From the beginning, NDP colleague Margaret Mitchell helped Grace with this project.

In 1975, before her mother's death, Grace took a luxury cruise, a present to herself, the first and only one she ever made. "I had missed a lot of trips because of Angus's illness and my own stubbornness, wanting to see through whatever it was I was doing at the time . . . I guess you could call me a workaholic but I'd rather do [that] than anything else."[190] She voyaged for two months around the rim of the Pacific aboard a Norwegian cruise ship.

Grace may not have been in her seat in the Commons any longer but she continued to be a public presence. To a cross-Canada abortion rally she sent a message: "As long as Dr.

Morgentaler is held in prison, we are not free." She acted as moderator-chair for a week-long Brandon University United Nations seminar. She accepted a nomination as honorary chair of the Canadian Arthritis and Rheumatism Society (CARS), an organization she had reason to appreciate on her own behalf.

On a more active political note, in 1975 Grace was criticized by the B.C. Federation of Labour for publicly supporting NDP Premier Dave Barrett in his last year in office for his action in legislating back to work 60,000 striking workers from different unions.

From 1966 Grace had sponsored a Korean boy through the Save the Children Fund and, in 1979, she transferred the sponsorship to a young Jamaican girl. Despite the fact that over the years her relations with her nieces and nephews had gladdened her heart, her choice was to champion young people in general rather than to undertake the commitment implicit in parenthood. Grace had not wanted a child, although, had one arrived she said, she would have cared for it. But she always believed that children needed two parents on hand, something rarely possible for her or Angus with their heavy political schedules.

When Ian Waddell won the NDP nomination in 1979 to run against Liberal Simma Holt in Grace's old constituency of Vancouver Kingsway, Grace remained neutral insofar as not actually giving him public support, although she helped with the campaign. Waddell won the seat and held it until the Liberal sweep in the 1993 federal election. Later, Grace backed Waddell when he ran (unsuccessfully) for the party's leadership. During Waddell's campaign, a picture appeared in a Holt election pamphlet that showed Grace with Simma, and bore the title "Simma Holt and Friends." This brought a swift and stinging letter from Grace, writing from her hospital bed, charging "unscrupulous trickery."

Waddell recalls with some amusement how much Grace, never one to indulge in luxuries, enjoyed some fine meals with him at Vancouver's better restaurants. He also recalled one memorable occasion when Grace, retired, came to Ottawa and attended the House, sitting in the gallery. She had won the

Person's Award that year and was in Ottawa to attend the investiture. This award was established by the governor general to mark the fiftieth anniversary of the victory of an appeal by seven Canadian women to the Privy Council in England. They were declared to be "persons" and thus eligible to sit in the Senate. While she was in the gallery Waddell read to the House Angus's comments on Japanese Canadians. "I could see the MPs listening because it sounded modern – about tolerance and so on. [But] the speech also talked about Orientals [with] words no longer in common use, so I said: "Mr. Speaker, those weren't my words, those were the words of Angus MacInnis who once told me that when [he and his wife] stood up for the Japanese Canadians, it was like standing up against a tidal wave of public opinion."

"What I learned from Grace," Waddell said, "was a living connection with the history of the NDP; some good practical advice, how to get through things when I was just starting out, to be careful here, but not to be afraid to take a stand and to remember the connection with the [Socialist] movement – so I tell people they are part of a movement."[191]

Meanwhile Grace's arthritis became increasingly crippling, without the benefit of any further remissions. She had a right knee replacement in 1979, a left knee replacement in January 1980, and a right hip replacement in October that year. She remained as alert as ever and determined to fulfill public commitments whenever possible. With a crowd of eighteen hundred in 1983, Grace had attended the fiftieth anniversary dinner of the CCF's founding convention. This was held in Regina during the NDP's annual convention. In 1985 she went to Ottawa to take part in the NDP caucus celebrating the coming into force of the equality provisions of the Canadian constitution – provisions for which she had worked so hard when in Parliament.

By 1987 friends and family were worried about Grace's safety living alone in her Vancouver apartment. She had had one or two falls and, more than the pain, she was frustrated and humiliated by her increasing dependence on outside help. Finally, she was persuaded to move to Shorncliffe Lodge, a nursing home in Sechelt on the Sunshine Coast near her brothers Ralph and Bruce and their families.

As she had all her life, Grace faced the inevitable, if not with equanimity, then with grace and courage. As long as she could have visitors to keep her abreast of her lifelong interests, she felt connected, albeit not as closely as she wished.

Never one for possessions, Grace took little with her from her Vancouver apartment when she moved to Shorncliffe. A battered old wooden filing cabinet and a desk were possessions she chose to keep, memories from the active life as a socialist pioneer which had begun so dramatically almost seventy years earlier in the hiding place a few miles away at Gibson's Landing. She was "home" near the "magical place" of her childhood, and as for the rest of her possessions, she gave most of them away, except for those letters which she and Angus had exchanged. Angus's precious collection of china went to close friends and relatives, her papers went to the archives, along with family photographs dating back to a picture of a three-year-old Grace sitting with her father on the steps of their Winnipeg home. Even her wigs were given away.

What she took with her was difficult enough to fit into her nursing-home room, but Grace was determined, and so relatives struggled to fit what remained of her "office" into its latest resting place, a reminder for this patrician woman of the days when she was a founding member of a party that gained grudging recognition in the House of Commons.

At Shorncliffe, Grace had a private room, and, with an electric wheelchair, at first she was able to get around enough to accompany friends on outings and to visit with others at the nursing home. In the beginning, her optimistic nature led her to hope against hope that perhaps her health might improve, and she would be able to resume a more independent life. However, it was not to be, and Grace was forced to face the fact that she was now too weak to care for herself to the extent required by her current nursing home.

So in March 1989 Grace moved across town to Totem Lodge, an extended care facility of St. Mary's Hospital. Though her family supported her through this period, Grace was severely upset, faced as she was with complete loss of the independence

that was so important to her. But she rallied and made the emotional adjustment, accepting the situation in the same spirit as years ago she had made the best of the constant uprootings of her childhood. Although she tried to make friends in her new surroundings, it wasn't easy. At Shorncliffe she had enjoyed the companionship of fellow residents, but at the Lodge many were too ill, mentally or physically, to socialize with her. But, as she once said philosophically: "There's always the telephone. I've got lots of friends on the end of that line, so I'm never lonely."

Grace could still read, and, as always, maintained a keen interest in news and politics. However on June 11, 1991, she suffered a severe stroke. She died on July 10, two weeks short of her eighty-sixth birthday. A memorial service was held for her on July 17 at the Unitarian Church in Vancouver – Rev. Sue Spencer acted as minister, and a eulogy was given by Harold Winch. Words were also spoken in her honour by Margaret Mitchell:

> Grace MacInnis represented all that is best in a politician and an MP. She was an outstanding Canadian who spoke French and had a sensitivity to all regions. She practised democratic socialism in practical ways – speaking eloquently about bread and butter issues that affected people's lives and encouraging people to organize and take collective action to solve problems and work for change.
>
> She had clear goals as a Socialist, a deep respect for people, and a dogged determination to fight for what she believed was right. She didn't hesitate to speak her mind, as the prime minister of the day discovered.
>
> She was a defender of the poor and elderly, supported women and labour in struggles and continued her husband Angus's fight for redress for Japanese Canadians.
>
> I knew Grace best on the front lines of community action in the seventies. She encouraged public-housing tenants and mothers on welfare to organize and fight for their rights to child care, jobs, decent housing, and to have a say in decisions that affected their lives. . . .

Grace had a rare ability and strength to accept debilitative disease with great courage and dignity and to go on from there. . . . as Audrey McLaughlin said, women across Canada continue to consider Grace MacInnis as their role model. . . .

The last time I saw Grace was when I drove Stanley Knowles to visit her in Sechelt. They had a grand reunion, recalling fifty years of friendship, and Grace was as sharp as ever. Stanley told me on the phone "she was always working for a better world for all of us, but especially for young people."

Art Miki, then president of the National Association of Japanese Canadians, wrote her family at the time of the memorial service:

As a member of the B.C. Legislature and a Member of Parliament in the House of Commons, Grace developed a strong reputation as a fighter for social equality and justice. During the Second World War Grace and her late husband, Angus, spoke against the government's treatment of Canadians of Japanese ancestry who were interned and had their properties confiscated. A strong supporter of Japanese redress, Grace attended rallies and meetings during the 1980s despite her ailing health and celebrated with us the redress settlement of September 22, 1988.

Former Premier of B.C. Dave Barrett talked of Grace in context with the Socialists of her time:

They were not self-pushing saints, not self-flagellating saints, not in the sense of depriving themselves psychologically or anything like that. These people were joyous in their work, these people had a mission in life, these people took very seriously the conditions of the world as they saw it and felt morally and ethically bound to commit themselves to redeem the world on a path they had chosen, and the path was pure. It was a lot purer than

in the very complicated world of today. It was a pure path, these were pure people, they were as pure as you can get. There's such a fixation around today that they've overcome a drug habit, they've overcome an alcohol problem, and it's hard for us to understand that there were some people in the world who were quite firmly established psychologically, who did establish one-on-one relationships of sincerity and true partnership. We're surprised by that considering the nature of hedonistic society we live in. You are talking to an elderly gentleman of sixty-three who has not seen the likes of these people since. These were, plainly put, very decent people.

Her brother Bruce felt Grace was very like their father, "right was right, no half way between. If this was the correct thing, we'll lay it on the line and fight our hardest for that. She was not going to do a lot of compromising, or saying things people liked to hear. I liked that about her; she was a hard fighter and a clean fighter."

Grace MacInnis at work in her office at the House of Commons. Cartoon drawings of her father adorn the walls of the office where he had sat before her.

Ex-MP Les Benjamin talked of Grace, the woman parliamentarian. "By word and deed and example, she showed that women could do almost anything, that there was a place for them in Parliament, and she did it without fanfare." Yvonne Cocke agreed: "Grace was one of the few women that I've ever known that did not lose favour with the "radical feminists" in our party. I've never been able to figure it out because she didn't bow to any group of people, she was her own person ... possibly it was the causes she espoused, she was espousing the causes when nobody else was."

One-time member of the CCF National Council, Kalmen Kaplanski, saw Grace as the one "who tended to the torch, and made sure the fire would not be extinguished in times when it flickered. She had this loyalty to the continuity of the movement, of the philosophy. . . . While preserving the legacy of J.S., her father, she showed the personal courage and strong conviction to adjust that legacy to the changing times, changing demands, changing problems. . . . It was a tremendous contribution."

Vancouver Sun columnist Denny Boyd wrote about the impact Grace had made on him the last time he saw her in 1985 when she was seventy-nine years old.

> She gave me her hand. It was like holding a small silk bag of marbles. The arthritis that bedevilled so much of her life had twisted her hands and the knuckles were terribly swollen. Her frail body was bent and gnarled, like a tiny bonsai pine.
>
> But there was a glow about her, in her and around her. It radiated upwards in a beatific smile at the six feet and six inches of MLA Emery Barnes who hovered over her. . . .
>
> She got up from her chair, and it hurt to see how difficult the act of walking was. But she put aside her cane, leaned on the lectern and – without notes – delivered a thundering ten-minute ideological wall-shaker that wrenched two standing ovations from the crowd of 400.

It was Grace's brother Ralph who suggested to her the name of her book about her father – *J.S. Woodsworth: A Man to Remember*. For the many people whose lives she touched, her family and fellow CCFers and NDPers, and for women today who benefit from the work she did on issues that affect their lives, she lives on as a woman to remember.

Backnotes

PART 1

Chapter 1
1. Grace MacInnis, *J.S. Woodsworth: A Man to Remember* (Toronto: The Macmillan Company of Canada Limited, 1953).
2. *Ibid*
3. *Ibid*
4. *Ibid*
5. *Ibid*
6. *Ibid*
7. *Ibid*
8. *Ibid*
9. *Ibid*
10. *Ibid*
11. *Ibid*
12. Interview with Bruce Woodsworth, Halfmoon Bay, B.C. 1992.

Chapter 2
13. *A Prophet at Home*, an intimate memoir of the late J.S. Woodsworth, MP, by Charles Woodsworth.
14. Interview with Charles Woodsworth, Ottawa, 1992.
15. *A Prophet at Home*
16. *Ibid*
17. Interview with Bruce Woodsworth
18. Interview with Dr. Ralph Woodsworth, Gibsons, B.C., 1992
19. Grace MacInnis papers, Special Collections Library, University of British Columbia.
20. *Ibid*
21. *Ibid*
22. *Ibid*
23. *Ibid*

Chapter 3
24. *J.S Woodsworth: A Man to Remember*
25. Grace MacInnis papers, U.B.C.
26. Interview with Charles Woodsworth
27. Interview with Kathleen Inglis Godwin, Nanaimo, B.C., 1992
28. Grace MacInnis papers, U.B.C.
29. *J.S. Woodsworth: A Man to Remember*

30. *Ibid*
31. Grace MacInnis papers, U.B.C.
32. Kenneth McNaught, *A Prophet in Politics: A Biography of J.S. Woodsworth* (University of Toronto Press, 1959).
33. *J.S. Woodsworth: A Man to Remember*
34. *Ibid*

Chapter 4
35. *A Prophet at Home*
36. *Ibid*
37. Grace MacInnis papers, U.B.C.
38. *Ibid*
39. Interview with Charles Woodsworth
40. Interview with Bruce Woodsworth
41. Anthony Mardiros, *The Life of a Prairie Radical: William Irvine* (Toronto: James Lorimer & Company, Publishers, 1979).
42. Taped interview with Grace MacInnis by Peter Stursberg, in the Grace MacInnis papers, U.B.C.

PART II

Chapter 5
The letters exchanged between Grace and Angus MacInnis during their courtship and marriage that appear in Part II were made available by the Woodsworth family.

Chapter 6
43. Letter to Grace Woodsworth from her mother, Lucy Woodsworth, made available by the Woodsworth family.
44. The *B.C. Federationist*: National Archives of Canada.
45. Taped interview with Grace MacInnis, Vancouver Community College, Langara Campus, 1973.
46. Interview by Peter Stursberg, Grace MacInnis papers, U.B.C.
47. Interview with Grace MacInnis, Vancouver Community College
48. Interview by Peter Stursberg, Grace MacInnis papers, U.B.C.
49. *Ibid*
50. *Ibid*
51. David Lewis, *The Good Fight: Political Memoirs 1909 - 1958* (Toronto: Macmillan of Canada, 1981)
52. From *Canadian Socialism* by Alan Whitehorn. Reprinted by permission, Oxford University Press, Canada.

Chapter 7
53. Interview with Bruce Woodsworth
54. Interview with Cliff Scotton, Nanaimo, B.C., 1992.
55. *Ibid*
56. Grace MacInnis papers, U.B.C.
57. Interview with Bill Grant, Peterborough, Ontario, 1992
58. National Archives of Canada

Chapter 8
59. National Archives of Canada
60. Interview by Peter Stursberg, Grace MacInnis papers, U.B.C.
61. Interview with Donald C. MacDonald, Toronto, 1993.
62. Interview with Bruce Woodsworth
63. *J.S. Woodsworth: A Man to Remember*
64. *Ibid*
65. *Ibid*

Chapter 9
66. *J.S. Woodsworth: A Man to Remember*
67. Grace MacInnis papers, U.B.C.
68. National Archives of Canada
69. *Ibid*
70. *Ibid*
71. *Ibid*
72. *Ibid*
73. *Ibid*
74. *Ibid*
75. *Ibid*

Chapter 10
76. Ken Adachi, *The Enemy That Never Was: A History of the Japanese Canadians* (Toronto: McClelland & Stewart, Inc. 1967).
77. National Archives of Canada
78. Interview with Bruce Woodsworth
79. National Archives of Canada
80. *Ibid*
81. Ann Gomer Sunahara, *The Politics of Racism* (Toronto: James Lorimer & Co. Publishers, 1981).
82. Interview by Peter Stursberg, Grace MacInnis papers, U.B.C.
83. *Ibid*
84. Interview with Thomas Shoyama, Toronto, 1993.
85. Extracts from a speech by K. Mary Kitagawa, Delta, B.C., 1993.

86. National Archives of Canada
87. Dorothy G. Steeves, *The Compassionate Rebel: Ernest E. Winch and His Times* (Vancouver: Boag Foundation, printed by the Evergreen Press, 1960).
88. National Archives of Canada
89. *Ibid*
90. *Ibid*
91. *Ibid*
92. *Ibid*
93. *Ibid*
94. *Ibid*
95. *Ibid*
96. *Ibid*
97. Interview with Arthur Hara, Vancouver, 1992.
98. National Archives of Canada
99. *Ibid*
100. Roy Miki and Cassandra Kobayashi, *Justice in Our Time: The Japanese Canadian Redress Settlement* (Vancouver: Talonbooks, 1991).
101. *Ibid*
102. *Ibid*
103. National Association of Japanese Canadians, *Democracy Betrayed — a submission to the Government of Canada on the violation of rights and freedoms of Japanese Canadians during and after World War II* (1984).
104. National Archives of Canada
105. Maryka Omatsu, *Bittersweet Passage: Redress and the Japanese Canadian Experience* (Toronto: Between the Lines, 1992).

Chapter 11
106. Interview by Peter Stursberg, Grace MacInnis papers, U.B.C.
107. *The Good Fight*
108. Interview with Charles Woodsworth
109. Angus MacInnis papers, Special Collections Library, University of British Columbia.
110. Interview with Donald C. MacDonald

Chapter 12
111. Grace MacInnis papers, U.B.C.
112. *Ibid*

PART III

Chapter 13
113. Interview by Peter Stursberg, in the Grace MacInnis papers, U.B.C.
114. *Ibid*
115. *Toronto Star* library
116. National Archives of Canada
117. *Toronto Star* library

Chapter 14
118. University of Toronto, Robarts Library: House of Commons Debates
 (*Hansard*), Jan. 20, 1966, p. 49
119. *Ibid*, Jan 24, 1966, p. 167
120. *Ibid*, p. 168
121. Interview by Peter Stursberg, Grace MacInnis papers, U.B.C.
122. *Ibid*
123. *Hansard*, Dec. 16, 1970, p. 2,133
124. *Ibid*, Jan. 26, 1966, p. 170
125. Interview with Yvonne Cocke, Vancouver, 1992.
126. Interview with Carol Adams, Sechelt, B.C., 1992.
127. Letter from Muriel Michener, Sooke, B.C., 1992.
128. Grace MacInnis papers, U.B.C.
129. *Hansard*, March 19, 1973, p, 2,378
130. *Ibid*, July 10, 1973, p. 5,451
131. Grace MacInnis papers, U.B.C.
132. *Hansard*, Feb. 1, 1966, p. 497
133. *Ibid*, May 25, 1966, p. 5,525
134. *Ibid*, May 9, 1966, p. 4,904
135. *Ibid*, March 10, 1966, p. 2,538
136. *Ibid*, March 21, 1968, p. 7,883
137. *Ibid*, June 16, 1969, p. 10,167
138. *Ibid*, May 20, 1969, p. 8,822–23
139. *Ibid*, Feb. 12, 1970, p. 3,548
140. Reproduced with the permission of the Canadian Plains Research
 Centre, University of Regina.

Chapter 15
141. Canadian Abortion Rights Action League (CARAL)
142. Interview by Peter Stursberg, Grace MacInnis papers, U.B.C.
143. *Ibid*
144. *Ibid*

145. Essay by Susan Walsh: "The Peacock and the Guinea Hen," included in *Not Just Pin Money*, by Barbara Latham and Roberta Pazdro: Camosun College, Victoria.
146. Interview by Peter Stursberg, Grace MacInnis papers, U.B.C.
147. *Ibid*
148. Interview with Dr. Henry Morgentaler
149. CARAL
150. *The Struggle for Choice*, video production, *c.* 1987, Nancy Nicol
151. Interview by Peter Stursberg, Grace MacInnis papers, U.B.C.

152. *Ibid*
153. CARAL
154. Interview by Peter Stursberg, Grace MacInnis papers, U.B.C.
155. *The Struggle for Choice*
156. *Hansard*, May 9, 1969, p. 8,528
157. Interview with Ellen Woodsworth, Vancouver, 1993.
158. Interview with Dave Barrett, Ottawa, 1993.

Chapter 16
160. *Hansard*, May 4, 1972, p. 1,885
161. *Ibid*, June 23, 1972, p. 3,467
163. *Ibid*, Nov. 8, 1967, p. 4,056–57
164. *Ibid*
165. *Ibid*, March 27, 1972, p. 1,169
166. *Ibid*, April 20, 1972, p. 1,183–84
167. *Ibid*, April 20, 1972, p. 1,486
168. *Ibid*, Dec. 17, 1973, p. 8,781

Chapter 17
169. Interview with Les Benjamin, Ottawa, 1993.
170. Interview with Harold Winch, White Rock, B.C., 1992.
171. Grace MacInnis papers, U.B.C.
172. *Ibid*
173. *Hansard*, Nov. 15, 1966, p. 9,934
174. *Ibid*, March 22, 1967, p. 1,4379-80
175. *Ibid*, March 8, 1968, p. 7,434
176. Taped interview with Grace MacInnis provided by Frank Snowsell.
178. *Hansard*, March 27, 1972, p. 1,171
179. *Toronto Star* library

Chapter 18
180. Grace MacInnis papers, U.B.C.
181. National Archives of Canada
182. *Hansard*, Jan. 15, 1977, p. 2,436
183. *Ibid*, March 21, 1972, p. 1,024
184. *Ibid*, March 21, 1972, p. 1,026
185. *Ibid*, June 9, 1972, p. 3,019
186. *Ibid*, March 18, 1966, p. 2,857

Chapter 19
187. Grace MacInnis papers, U.B.C.
188. Entry from diary of Ralph Staples, provided by his son Peter, Peterborough, Ontario.
189. Interview by Peter Stursberg, Grace MacInnis papers, U.B.C.
190. *Ibid*
191. Interview with Ian Waddell, Vancouver, 1992.

Bibliography

Adachi, Ken. *The Enemy That Never Was*. Toronto: McClelland & Stewart Inc. 1979.

Caplan, Gerald L. *The Dilemma of Canadian Socialism: The CCF in Ontario*. Toronto: McClelland & Stewart Inc., 1973.

Gunderson, Morley and Leon Muszynski with Jennifer Leck. *Women and Labour Market Poverty*. Ottawa: Canadian Advisory Council on the Status of Women, 1990.

Heaps, Leo, ed. *Our Canada: The Story of the New Democratic Party Yesterday, Today and Tomorrow*. Toronto. James Lorimer & Company, Publishers, 1991

Horowitz, Gad. *Canadian Labour in Politics*. Toronto: University of Toronto Press, 1968.

Lewis, David. *The Good Fight: Political Memoirs 1909–1958*. Toronto: Macmillan of Canada, 1981.

MacDonald, Donald C. . *The Happy Warrior: Political Memoirs*. Markham: Fitzhenry & Whiteside, 1988.

MacPherson, Ian. "The CCF and the Co-operative Movement in the Douglas Years: An Uneasy Alliance" included in *Building the Co-operative Commonwealth Essays on the Democratic Socialist Tradition in Canada*. Edited by J. William Brennan, Regina: University of Regina, Canadian Plains Research Centre, 1985.

MacInnis, Grace. *J.S. Woodsworth: A Man to Remember*. Toronto: The Macmillan Company of Canada Limited, 1953.

Mardiros, Anthony. *William Irvine: The Life of a Prairie Rebel*. Toronto: James Lorimer & Company, Publishers, 1979.

McNaught, Kenneth. *A Prophet in Politics: A Biography of J.S. Woodsworth*. Toronto: University of Toronto Press, 1959.

Miki, Roy and Cassandra Kobayashi. *Justice in Our Time: The Japanese Canadian Redress Settlement*: Vancouver: Talonboks, 1991.

Omatsu, Maryka. *Bittersweet Passage: Redress and the Japanese Canadian Experience*. Toronto: Between the Lines, 1992

Pennington, Doris. *Agnes Macphail: Reformer*. Toronto: Simon & Pierre, 1989–1990.

Shackleton, Doris French. *Tommy Douglas*. Toronto: McClelland and Stewart Inc., 1975.

Steeves, Dorothy G. *The Compassionate Rebel: Ernest E. Winch and his Times*. Vancouver: Boag Foundation, printed and bound by Evergreen Press Limited, 1960.

Stewart, Margaret and Doris French. *Ask No Quarter: A Biography of Agnes Macphail*. Toronto: Longmans, Green and Company, 1959.

Sunahara, Ann Gomer. *The Politics of Racism: The Uprooting of Japanese Canadians During the Second World War*. Toronto: James Lorimer & Company, Publishers, 1981.

Webster, Daisy. *Growth of the NDP in BC, 1900–1970: 81 Political Biographies*. Vancouver: Broadway Publishers.

Whitehorn, Alan. *Essays on the CCF–NDP Canadian Socialism*. Toronto: Oxford University Press, 1992.

Young, Walter D. *The Anatomy of a Party: The National CCF 1932 – 1961*. Toronto: University of Toronto Press, 1969.

Tapes

Interview with Grace MacInnis, October 1973, Vancouver Community College, Langara Campus

Interviews with Grace MacInnis by: 1) Ann Scotton and 2) Peter Stursberg, University of British Columbia, Special Collections Division, Grace MacInnis papers.

Other Sources

Simpson, Bernard. *The Role of Harold Winch in the CCF and British Columbia Politics 1933–1953*. Submitted to Allan Boag Foundation

Pamphlet: 1986 Fraser Valley Committee for Sexuality

The Struggle for Choice (videoproduction script) c. 1987. Producer/director Nancy Nicol.

Orton, Maureen Jessop. Survey and analysis briefs submitted to the Federal Standing Committee on Health and Welfare 1967–1968 re: *Proposed Amendment to the Criminal Code Relating to Abortion*. 2nd Session, 27th Parliament (contained in Minutes of Proceedings and Evidence, Vol. 1–24). Toronto: released by CARAL.

Statistics Canada (released June 1993): *Thereapeutic Abortion in Canada 1991*.

Review of the Situation of Women in Canada, 1993. For National Action Committee on the Status of Women.

Price Waterhouse, Vancouver, 1985. A study conducted on the *Economic Losses of Japanese Canadians After 1941*. Winnipeg: The National Association of Japanese Canadians.

Greater Vancouver Japanese Canadian Citizens Association Redress Committee. *Justice in Our Time: Redress for Japanese Canadians*. Produced for the National Association of Japanese Canadians.

The National Association of Japanese Canadians. Brief presented to the Government of Canada: *Canadian Democracy Betrayed: The Case for Redress*, c. 1984.

Walsh, Susan. "The Peacock and the Guinea Hen," included in *Not Just Pin Money*. Barbara Latham and Roberta Pazdro, Camsun College, Victoria.

Kitagawa, K. Mary. From a speech on the *Japanese Canadian Issue*, Delta, B.C.

Woodsworth, Charles. *A Prophet at Home: An Intimate Memoir of the Late J.S. Woodsworth, M.P.*

Woodsworth, Bruce. Biographical sketch of Lucy Lillian Woodworth.

Letters

Tom Barnett, former NDP MP, Campbell River

Joy Hodges, NDP party worker, Peterborough

Camille Mather, former British Columbia MLA, Vancouver

Bus and Louise Phillips, personal friends of Grace MacInnis, Vancouver
Ralph Staples, co-operative movement leader (letter given by son Peter Staples), Peterborough
Correspondence between Grace Woodsworth MacInnis and Angus MacInnis during their courtship and marriage 1931–1959, including some letters from Lucy Woodworth, with kind permission of Glenn Woodsworth, executor of Grace MacInnis's estate

Interviews

Carol Adams Kozy, former president of Vancouver Kingsway riding, Sechelt
Dave Barrett, former NDP MP and Premier of British Columbia, Ottawa
Les Benjamin, former NDP MP, Ottawa
Rosemary Brown, Chair, Ontario Human Rights Commission, Toronto
George and Barbara Cadbury, family planning activists, Oakville
Yvonne Cocke, former British Columbia president of the NDP, Vancouver

Hilda Davey, volunteer worker, Sechelt

Irma Douglas, Ottawa

Bill Grant, former Ontario president CCYM, Peterborough

Hon. Herb Gray (Liberal) House Leader and Solicitor General, Ottawa

Arthur Hara, Chair, Japanese Canadian Scholarship Committee, Vancouver

Nora Hill, Gibsons

Margaret Hobbs, Victoria

Kathleen Inglis Godwin, Nanaimo

Kalmen Kaplansky, International Affairs Director, CLC, Ottawa

Hilda Kristiansen, Chair CCF/NDP Women's Group, Vancouver

Donald C. MacDonald, former Ontario NDP leader, Toronto

Frank McKenzie, Vancouver

Ruth Milward, Vancouver

Margaret Mitchell, former NDP MP, Ottawa

Muriel Michener, Sooke

Dr. Henry Morgentaler, Toronto

Jean Scott, former secretary BC Federation of Labour, Chilliwack

Cliff Scotton, former member of the NDP Federal Council, Nanaimo

Thomas Shoyama, Japanese Canadian redress activist, Victoria

Professor Veronica Strong-Boag, Women's Studies, University of British Columbia, Vancouver

Hilda Thomas, former Chair, Everywoman's Health Clinic, Vancouver

Ian Waddell, former NDP MP, Vancouver

Daisy Webster, Vancouver

Harold Winch, former leader British Columbia CCF, White Rock

Bruce Woodsworth, Halfmoon Bay

Charles Woodsworth, Chelsea

Ellen Woodsworth, Vancouver

Ralph Woodsworth, Gibsons

Photographs
From albums in the Grace MacInnis papers, Special Collections Library, University of British Columbia – includes the Karsh Photograph.

Jessie Winch's collection

Bruce Woodsworth's collection.

Index

A

abortion 237, 239, 241, 244, 246, 247, 248, 249, 253, 255, 273, 301
 abortion clinics 241
 abortion on demand 255
 legal abortions 248
 pro-choice 252, 254
 pro-life 239, 254
 therapeutic abortions 248
Adams, Carol 217
Adult Occupational Training Act 263
Agnes Street Forum 111
agricultural matters 220, 234
Ahuntsic 235
Alberta 84, 92, 99, 110, 161, 171, 202, 269, 295
Algoma East 222
Algoma Steel 231
All-Canadian Congress of Labour 156
Alliance for Life 253, 254
Allied powers 136
Alsbury, Tom 189
American capitalism 183
Americans 183
Anderson, Doris 252, 254, 266, 285, 286
Applewood 308
ARCAL (Association for the Repeal of Canadian Abortion Laws) 252
Argue, Hazen 193, 194, 201
Arthritis Association 307
Athabasca tar sands 295
Atwood, Margaret 178
Australia 169
Auto Workers 196
Axis powers 143, 157

B

B.C. Coalition of Abortion Clinics 251
B.C. Federation of Labour 309
B.C. *Federationist* 35, 135, 146, 159
B.C. Legislature 85, 91, 137, 152, 165, 240, 296, 313
B.C. Securities Commission 161
Barnes, Emery 315
Barrett, Dave 256, 257, 275, 309, 313
Basford, Ron 216, 219, 221, 228, 231, 287, 299
Batten, Mary 227
Beauvoir, Simone de 293
Bégin, Monique 235
Bell, Miss 124
Benjamin, Les 230, 275, 315
Bennett, Premier W.A.C. 205

Bennett, Prime Minister, R.B. 68
Bennett Relief Act 71
Berger, Thomas 178, 306
Berlin 183
Berton, Pierre 178
Bethune, Norman 108
Bigg, F.J. 284
Bill 135 168
birth control 78, 237, 238, 241, 242, 254, 255
 birth-control education 301
 birth-control pills 239
 rhythm method 239
Bloody Saturday 37, 38
Broadbent, Ed 178, 264, 286
Borgford, H.I.S. 132
Bow River, Alberta 207
Boyd, Denny 315
Brandak, George 303
Brandon University 309
Brewin, Andrew 273
British Columbia 24, 43, 53, 96, 97, 97, 98, 98, 101, 104, 105, 110, 112, 113, 113, 125, 139, 141, 146, 153, 157, 157, 159, 160, 163, 168, 171, 179, 184, 191, 197, 200, 201, 202, 205, 208, 217, 251, 256, 259, 270,
British Columbia Security Commission 166
British Labour government 136
Broadway Holiday Inn 176
Bruce, Dr. 140
Bryden, Ken 197
Burnaby-Richmond 222
Burns Food Limited 228
Burquitlam 84
Burrard 154
Burton, J.W. 169
Bytown Inn 91, 137

C

CAC 228
Calgary 46, 84, 85, 87, 96, 108, 186, 227, 228
Calgary Conference 85, 86, 87, 94
Callwood, June 178
Cameron, Colin 139, 182, 188, 193
Campbell, Mrs. Ronald 212
Canada 36, 68, 69, 108, 112, 114, 116, 120, 127, 128, 135, 147, 150, 154, 157, 159, 170, 171, 172, 178, 183, 198, 200, 203, 205, 211, 223, 225, 227, 229, 231, 234, 237, 242, 243, 246, 251, 255, 260, 265, 267, 269, 270, 272, 273, 276, 278, 281, 284, 292, 297, 298

Canada Assistance Plan Directorate 272
Canada Food Rules 225
Canada Pension Plan 290, 291
Canada Pension Plan. 288, 291
Canada Through CCF Glasses 109
Canada Water Act 296
Canada Water Act. 296
Canadian Abortion Rights Action League (CARAL) 252
Canadian Advisory Council on the Status of Women 242
Canadian Arthritis and Rheumatism Society (CARS) 309
Canadian Brotherhood of Railway Employees (CBRE) 85
Canadian Child Day Care Federation 269
Canadian Conference of Charities and Corrections 14
Canadian Conference on Child Care 262
Canadian Congress of Labour 156
Canadian Consumer Council 228
Canadian Council of Christians and Jews 305
Canadian Economic Observer 213
Canadian Foundation of Racial Justice 175
Canadian Grocery Distributors Institute 226
Canadian Labour Congress 70, 202, 245, 279, 305
Canadian Labour Party 85
Canadian Labour Standards Code 271
Canadian Medical Association 248
Canadian Press 147, 212
Canadian Socialism 101
Canadian Welfare Council 281
Canadian Welfare League 14, 15, 22
Canadian Youth Congress 116
Canon law 243
Capilano Canyon 204
capitalism 109, 183
Cardston 163, 164
Cariboo 120
Carman 141
Casgrain, Thérèse 192, 198, 201
Catholic Syndicates 203
Catholic women 238
Catholics 239
Cavan 28, 59, 61, 204, 308
CBC 191, 200
CCF 33, 34, 52, 53, 59, 85, 91, 92, 94, 95, 96, 97, 98, 100, 101, 103, 107, 108, 109, 110, 112, 113, 114, 115, 116, 119, 120, 121, 125, 126, 127, 128, 129, 130, 131, 133, 134, 135, 140, 141, 143, 145, 146, 147, 148, 150, 152, 154, 156, 159, 160, 165, 166, 168, 170, 172, 181, 183, 185, 187, 189, 190, 194, 196, 197, 199, 200, 202, 203, 205, 233, 234, 310
CCF-NDP Constituion
 B.C. Constitution 189

Regina Manifesto, Section 12, 157
 Section 33 175
 Section 7 248
 Section 98 168
CCF-NDP Conventions
 1934 Convention, 114
 1938 national convention 120
 1944 provincial CCF convention 156
 1950 Convention 187
 1954 convention 189
 B.C. convention 197
 National Convention 110, 139, 186, 189, 190
 National Executive 186, 197, 199
 national federal convention 184
 Provincial Convention 188
 Vancouver Convention 187
CCF National Council 132
CCF News 153, 154, 155, 156, 165, 169, 296
CCF Provincial Council 116
CCF Trade Union Committee 116
CCF-CLC merger . 202
CCYM Co-operative Commonwealth Youth Movement 107, 111, 114, 115, 116, 117, 148, 192, 196
Chamberlain, Neville 114, 119, 123, 131
Charter of Rights and Freedoms 174, 175, 177
Chatelaine 252, 254
Cherry Point refinery 299
Child, A.J. 228
Child, Marquis 109
child care 211, 213, 257, 259, 262, 263, 267, 270,
 child-care workers 274
Citizens' Committee of One Thousand 36, 37
Civil Liberties Union of the University of British Columbia 161, 168
civil servants 181, 212
CMHC 286
Consumer's Bill of Rights 223
Co-operative Commonwealth Federation 3, 50, 54, 85, 99, 134, 203
co-operative movement 109, 148, 112, 129, 233
coal miners 71
Yvonne Cocke 217, 307, 315
Cold War 109
Coldwell, M.J. 100, 103, 120, 123, 131, 133, 136, 153, 185, 194, 199, 201
Colgate-Palmolive-Peet 297
Collenette, David 175
Columbia University 49
Combines Act 230
Commission on Wartime Relocation and Internment of 172
Committee on Health, Welfare and Social Affairs 230

communism 67, 72, 98, 109, 109, 116, 116, 119, 128, 128, 129, 152, 183, 187, 188, 189, 189, 195,
Comox-Alberni 169
Company of Young Canadians 303 .
Congress of Industrial Organizations (CIO) 115
conscription 143
Consumer Affairs Committee 224, 234
Consumer Association of Canada (CAC) 219, 232
Consumer Credit Committee 227
consumers 219, 221, 222, 224, 225, 297
contraceptives 239, 242, 255
Coote, Robert 66
Copenhagen 112
corporal punishment 29
Cotterill, Murray 116
CPR 138, 142
Créditiste 211, 246
Crerar, Thomas 167
Criminal Code 36, 238, 244, 246, 247, 248, 250, 253, 254, 255, 273
 Section 98 36
Crombie, David 178
Cross Canada Abortion Caravan 253
Cullen, Jack 271
Custodian of Enemy Property 170
Czechoslovakia 114, 119

D
Daily Bread Food Bank 274
Danforth 222
Davis, Jack 295, 298
day-care 217, 262, 264, 266, 267, 269, 273, 274
Day-Care Act 266
De Puis, Mr. 140
Defence of Canada Regulations 169
Delta, B.C 163
democracy 120, 240
Democracy Betrayed: The Case for Redress 175
democratic socialism 183, 190
Dempsey, Lotta 292
Depression 54, 63, 75, 84, 100, 119
Diefenbaker, John 211, 214, 218, 221
Director of International Affairs of the CLC 189
Disraeli, Benjamin 73
Distinguished Pioneer's Award 306
Dixon, Fred 37, 38
Dixon, Mrs. Sophia 191
Dominion Bureau of Statistics 238
Dominion Government 166
 Department of Consumer and Corporate Affairs 221, 222, 223, 224, 227
 Department of Environment 298
 Department of Labour 217

Department of Manpower and Immigration 272
Department of National Health and Welfare 241, 272
Department of the Registrar General 224
Dominion Labour Party, 85
Dominion Reconstruction Committee 153
Douglas, Tommy 100, 103, 114, 193, 194, 201, 205, 224
Dowling, Fred 116
Dunkirk 158
Dunrobin 49

E
Early Childhood Education 269
East Indians 112
Economic Council 225, 264, 278, 282, 283, 289
Eden, Anthony 112
Edinburgh University 49
Edmonton 99, 115, 125, 142, 193, 227
education 21, 148, 211, 262
Edward VIII 108
Electric Reduction Company 297
England 120, 243
environment 300
Environmental Council of Canada 298
equality 154, 258, 259
 equality in the workplace 301
 Equality Now! 174
 equitable pay 215
Estevan 71, 72
Etobicoke 308
Europe 112, 183, 276
Everywoman's Health Clinic 251
Exclusion Order 146, 171

F
Fabian tradition 234
Fahrni, Mildred 165, 306
family allowances 226, 268, 289, 291
Family Income Security Plan 259, 291
family life 265
family planning 237, 273
Family Planning Federation of Canada 240
Farmer, S.J. 133
fascism 114, 119, 121, 123, 130, 135, 136
federal caucus 149
Federated Labour Party 35, 44
feminist 21, 96, 154, 240, 249, 257, 276, 293, 300
feminization of poverty 242
Fenstein, John 99
Fines, Clarence 197
Finland 112
First Nations 112
First World War 28, 30, 34, 167
fiscal policy 282
fixed income 289

Food and Drug Directorate 232, 297
Food Prices Review Board 220, 228
foreign policy 124, 191
Fort Rouge Labour Hall 72
France 119, 121, 136, 211, 234, 265
Franchise Committee 168
Fraser Valley 157, 162, 204
Free Trade 73
French 136
Friedan, Betty 293
Fujiwara, Wes 179

G
Gabriola Island 115, 148
Gandhi, Indira 293
Gardiner, Bob 99
Gargrave, Herbert 132, 194
Garland, E.J. 94, 207
Garnett Sedgewick Award 161
Gatineau Hills 132
Gauthier, Charles 290
General Motors 116
Geneva 112, 183, 185, 199
Germany 113, 116, 119, 131, 132, 135, 136
Gibson's Landing (Gibsons) 25, 27, 30, 31, 32, 33, 34, 38, 39, 41, 43, 44, 78, 149, 233, 311
Gillis, Clarie 168
Ginger Group 54, 84, 110, 132
Glace Bay, N.S 123, 128
Globe and Mail 75, 171, 175, 286, 290
Godfrey, Eleanor 146
Godwin, Kathleen Inglis 30, 18
Grant, Bill 115
Grant, Mary 115
Great Britain 67, 119, 121, 131, 136, 158, 234, 277
Greater Vancouver 215
Greene, John James 296
Greenwood, B.C 163, 273
Guaranteed Income Supplement (GIS) 288, 289, 290
Gulf Islands (B.C.) 115

H
Halifax 251
Halpenny, Dr. J. 14
Hamilton 115
Hansard 221, 258, 275
Hara, Arthur 171
Harding, R. 298
Harley, Dr. Harry C. 244
Harrison 204
Hart, John 139
Hart, Premier John 142, 153
Harvey, Andrew 213
Hastings Park. 163

Health and Welfare Committee 238, 244, 245, 246, 258
Heaps, Mr. 70
Hellyer, Paul 283, 284, 285
Hepburn, Premier Mitchell 116
Hidaka, Terry 166, 170
Hill, Nora 29
Hiroshima 177
Hitler 54, 114, 119, 120, 121, 130, 135, 136, 249
Holt, Simma 309
Hope, Mrs. A.A. 212
Hotel Vancouver 179
House of Commons 30, 46, 48, 73, 87, 113, 133, 147, 158, 161, 168, 188, 195, 199, 211, 213, 227, 237, 246, 249, 249, 250, 253, 253, 255, 258, 263, 264, 277, 282, 285, 295, 300, 305, 308, 311, 313,
 Commons Health and Welfare Committee, 289
housing 215, 280, 282, 284, 286
 homeless 287
 Housing Act 279
 housing shortage 282, 284
 housing units 285
 affordable housing 276, 286
 Central Mortgage and Housing Corporation (CMHC) 279, 280, 281, 286
 task force on housing 284
Human Relations Award 305
Humanist Fellowship of Montreal 246
Humboldt 153
Hyman, MLA Marcus 111
Hyodo, Miss H. 166

I
illegal abortions 253
ILO convention 271
ILP 111
Imai, George 172
immigration 14, 22
Immigration Act 36
Imperial Tobacco Company of Canada Ltd 108
imperialism 120
Imperialist war 120, 121
imperialist war 119
imperialists 133
Income Tax Act, 282
income-tax 261
Independent Labour Party 53
Independent Labour Party of Manitoba 46
Independents 211
India 238
industrialism 14
Ingle, Lorne 181, 186, 189, 193, 197
Inglis, Kathleen 30, 31, 40, 44

International Affairs Director 70
International Labour Movement 136
International Labour Organization 272, 199, 270
international trade 299
Inverness 92
Ivens, Mr. 70
Irvine, William 46, 87, 99, 143, 120, 202
Ivens, Rev. William 35, 37, 44

J
J.S. Woodsworth Endowment Fund 307
J.S. Woodsworth: A Man to Remember 133, 191, 316
Jackson, Chris 213
James, Dr. Cyril 150
Jamieson, Laura 152, 182, 191
Japanese 112, 142, 146, 155, 157, 159, 160, 167
Canadian-born Japanese 159, 173, 306
Co-operative Committee on Japanese Canadians 172
Greater Vancouver Japanese Canadian Citizen Association 176
Japanese Americans 172, 178
Japanese Canadian Citizens Association 306
Japanese Canadians 69, 104, 112, 129, 142, 156, 157, 158, 160, 161, 162, 165, 166, 167, 168, 169, 170, 171, 172, 173, 174, 175, 176, 177, 178, 179, 195, 205, 207, 310, 312
Japanese-Canadian Committee for Democracy 170, 171
Japanese-Canadian community 164, 175, 178
Japanese-Canadian Redress Agreement. 178
Japanese Property Owners' Association 167
National Association of Japanese Canadians 172, 313
National Coalition for Japanese-Canadian Redress 178
National Japanese-Canadian Citizens' Association 171
National Redress Committee 172, 173
redress 164, 165, 171, 172, 173, 174, 175, 176, 177, 179, 306, 313
Royal Commission on Japanese Welfare 166
Jelinek, Otto 176, 177
Jews 113
Jodoin, Claude 202
Joint Committee 221
Joint Senate/Commons Committee 219
Jones, Dr. Philip 296

Jungle Tales Retold 108
Justice
Canadian Foundation of Racial Justice 175
Justice and Legal Affairs Committee. 271
Standing Committee on Justice and Legal Affairs 234
Justice in Our Time 176
Juvenile Court 13

K
Kabayashi, Cassandra 174
Kadota, Gordon 173
Kamloops 61, 162
Kantner, Dr. J.E. 238
Kaplanski, Kalmen 70, 189, 315
Kaslo 162
Kelowna 64, 193
Kerrisdale 162, 204
Kierans, Eric 286
King, Carlyle 116
King, Prime Minister William Lyon Mackenzie 46, 112, 133, 143, 152, 182
Kingston and the Islands 235
Kirkland Lake 102, 115
Kitagawa, K. Mary 163, 164
Kitagawa, Muriel 179
Kitsilano 43, 44
Knowles, Stanley 215, 246, 290, 291, 313
Kootenay West 298
Korean War 187
Kristiansen, Hilda 182

L
La Congrégation de Notre Dame 48
Labour Church 44
labour force 216
Labour Party 85, 91, 128, 202
Labour, Progressive 54
labour unions 116
Laing, Art 205
Lalonde, Marc 246, 269, 291
Lam, David 306
Lamoreux, Lucien 222
landlords 283
Lang, Otto 254
Latham, Mrs. G. 99
Laurentian University 305
Laurence, Margaret 252
League for Social Reconstruction (LSR) 84, 99
League of Nations 112
Lefeaux, W.W. 166
Leggatt, Stuart 255
Legislative Assembly, Manitoba 99
Lempiere 170
Lever Brothers 297
Lewis, David 100, 107, 116, 123, 127, 128, 129,

132, 160, 168, 181, 185, 186, 187, 189, 193, 194, 197, 202, 220, 244, 300
Liberals 54, 87, 112, 139, 141, 146, 153, 155, 159, 159, 169, 175, 211, 213, 227, 235, 247, 283, 288, 289, 293, 300, 309
Lincoln, Abraham 214
Local Initiatives Program 267
lotteries 239
Louis, Hebert 235
Lowell, James Russell 134
Lucas, Mrs. Louise 99
Lucy L. Woodsworth Fund for Children 307

M
MacDonald, A.B. 129
Macdonald, Alex 197
MacDonald, Donald C. 130, 181, 189, 192, 196, 202
MacDonald, Donald S. 285
MacDonald, Flora 235
MacEachen, Allan 263
MacInnis, Angus 3, 10, 19, 21, 29, 53, 54, 55, 56, 57, 59, 60, 63, 64, 67, 68, 70, 71, 75, 76, 77, 80, 84, 85, 87, 90, 94, 98, 99, 105, 111, 119, 122, 127, 129, 131, 132, 133, 135, 136, 137, 142, 156, 158, 159, 160, 161, 162, 168, 169, 177, 179, 181, 184, 185, 186, 187, 192, 193, 195, 196, 198, 199, 201, 203, 208, 218, 306, 309, 310, 312, 313
 Ginnie 149, 196
 Violet. 149
MacIntyre, A.S. 129
Mackasey, Bryce 263
McKenzie, Frank 197
Mackenzie, Ian 159, 167, 169
MacKenzie, Bob 148
MacKinnon, Mr., Minister of Trade and Commerce 140
MacMaster, Bob 148
MacNeil, Grant 120, 121, 124, 125, 135, 137, 139, 190
Macphail, Agnes 46, 66, 124, 132, 208, 210
MacPherson, Ian 233
Magrath, Alberta 163, 164
Mahoney, Patrick 262
Maitland, R.L. 142
Malliardville 72
Manitoba 36, 43, 113, 125, 131, 161, 171, 306
 Manitoba Free Press 23
Manpower Training Program 269, 271
Marie, Clair 293
Maritimes 119, 123, 127, 128, 129, 231, 253
Marxian socialists 96, 97, 148, 160
maternity 215, 259, 270, 273,
Mayhew, Mr. 140
McAllister, Kenneth 131
McDougall Church 44

McGill University, 22, 99
McKenzie, Frank 152, 168, 184
McLaughlin, Audrey 216, 267, 313
McWilliams, Margaret 150
Mead, Margaret 293
medicare 215, 229, 279, 303
Meighen, Arthur 46
Meir, Golda 293
Mendels, Jessie Winch 182, 190
Mentz, Walter 99
Metal Trades Council 37
Methodism 2, 3, 9, 28, 32, 44
 All People's Mission 10, 11
 British Columbia Conference 32
 Church Mission schools 166
 Manitoba Conference 9, 32
 Methodist Conference 7, 35, 45
Michener, Muriel 218
Miki, Art 173, 178, 313
Miki, Roy 174, 175
Millard, C.H. (Charlie) 116
Morrison, Miss 65
Mitchell, Margaret 70, 306, 308, 312
Momiji Gardens 160
Moncton 128
Montreal 197, 201
Montreal Morgentaler Defence Committee 255
Montrose 149
Moren, Miss 89
Morgentaler, Dr. Henry 246, 250, 251, 255, 309
Morin, Albanie 235
Morley, Alan 205
Mosher, A.R. 99
Mulroney, Brian 164, 174, 178
Munich 119, 123
Munro, John 272, 297
Murakami, Katsuyori, 163, 164
Murta, Jack 175, 176
Mussolini, Benito 120

N
Nagano, Manzo 157
Nagasaki 177
NAJC 172, 173, 175, 176, 177, 178
Nanaimo 10, 115
National Action Committee on the Status of Women 242, 252, 255, 265, 287
National Council of Welfare 242, 301
national day-care act 273
National Day-Care Information Centre 272
National Housing Act 266, 279, 280, 285, 286, 287
National Redress Committee 172, 173
Nazism 145

NDP 52,59,91,106,108,130,202,205,208,211,
 213, 216, 217, 219, 220, 221, 222, 224, 226,
 229, 230, 239, 244, 246, 260, 276, 286, 288,
 299, 307, 309, 310
Neill, A.W. 159, 169
Nelson, B.C 305
New Brunswick 92, 128, 271, 278
New Democratic Party 46, 204, 229, 247, 267,
 290, 291, 293, 300
New Westminster 169, 255
New York 181
New Youth Association of Canada 115
Newfoundland 183
News Bulletin 121
Nicholson, J.R. 270, 281
Nicholson, Sandy 187
Northwest Territories 269
Nova Scotia 92, 127

O
Okano, Kumanosuke 163
Old Age Pension 215, 226, 273, 290, 278, 288,
 289, 290, 291, 301
Schreiner, Olive 77
Omatsu, Maryka 178
Ontario 113, 115, 116, 161, 171, 191, 196, 202,
 227, 269
Ontario CCF 196, 200
Order of British Columbia 306
Order of Canada 305
Order Paper 239, 271, 296
Organization for Economic Co-operation and
 Develop 225, 276
Oriental Canadians - Outcasts or Citizens? 147
Orton, Maureen Jessop 246
Oshawa-Whitby 264, 286
Ottawa 46, 48, 52, 53, 57, 59, 66, 70, 80, 81, 91,
 92, 94, 99, 103, 107, 117, 124, 125, 131, 138,
 140, 153, 159, 183, 196, 197, 199, 200, 204,
 205, 210, 212, 215, 217, 219, 252, 253, 256,
 257, 270, 292, 293, 305, 310
Ottawa Journal, 212
Ottawa Normal School 48

P
pacifism 29, 34, 48, 117, 119, 123, 130, 133, 134,
 165, 191
Packaging and Labelling Legislation 230
Palestine 182
Parents Without Partners 261
Paris 50, 293
Park, Eamon 116
Parliament 48, 54, 68, 70, 84, 92, 134, 199, 208,
 211, 213, 217, 219, 235, 241, 242, 246, 259,
 273, 275, 276, 289, 291, 292, 295, 303
Parliament Hill 54
Pastor Newbottle 14

Patent Act 229
Pattullo, T.D. 142
pay for housewives 212
Pearl Harbor 142, 146, 157, 158, 159, 163
Pearson, Lester 182, 211, 214, 221, 222, 226
Pembina 284
pension 215, 226, 289,290, 291, 301
pension plans 273
pensioners 290
Perry, H.G.T. 165, 166
Personal Justice Denied. 172
Person's Award 259, 310
Peterborough 60, 70, 115
pharmaceutical companies 229
Picard, Gérard 203
Pickersgill, J.W. 284
Placentia Bay, Nfld. 295, 297
Plumptre, Beryl 220
Point Grey 190
pollution 297
Port Hope 60
post-war democracy 154
Postmaster General 286
poverty 113, 211, 214, 220, 240, 242, 268, 287,
 289
Poverty Profile 242, 301
Powell, Dr. Marion 238
Prairies 75, 86, 185
Price Spreads and Mass Buying 108
price stability 233
Price Waterhouse Associates 176
Prices and Incomes Commission 231, 232,
 221, 233
Prices Review Board 224
Priestly, Norman 99
Prince Edward Island 10, 53, 132, 249, 251,
 269
Prince Philip 182
Prince Rupert 299
Princess Elizabeth 182
prison reform 303
Prittie, Robert 222
Privy Council 285, 310
Proctor and Gamble Company of Canada
 Limited 297
Pregressive Conservatives 54, 87, 112, 141,
 146, 155, 169, 174, 175, 211, 247, 260, 281,
 289, 290, 293
Protestant women 238
Provincial Council 127, 188, 189, 190
Provincial Executive 189
Pulloitt, Mr 140

Q
Quebec 91, 108, 148, 171, 192, 198, 202, 203,
 239, 245, 248, 249, 273, 292

Quebec Fascists 143
Quebec provincial CCF 189
Queen, John 99

R
RCMP 40, 163, 164
redress 164, 165, 171, 172, 173, 174, 175, 176, 177, 179, 306, 313
Regina 99, 107, 113, 120, 181, 203, 310
Regina Manifesto 86, 99, 100, 101, 109, 189, 190, 191, 196, 197, 234
Regina-Lake Centre 230, 275
Registrar General 227
Reid, Tom 159, 169
Resolutions Committee 194
Revelstoke 8, 9, 152
Rideau Hall 305
Rideau River 132
Riley, Florence 115
Rio Hall 218
Roberval 290
Robson Commission 36
Roman Catholic 129, 238, 243, 245, 247, 254
Roosevelt, President 142
Roper, Elmer 120
Royal Alexandria Hotel 38
Royal Commission on the Status of Women 258, 263, 266, 269, 288
Friends of the Soviet Union 66
Russia 34, 89, 112, 116, 119, 121, 238
Russian Communism 183
Russian Revolution 36

S
Sabia, Laura 255
Safeway and Weston 227
Salt Spring Island 163, 164
Saltsman, Max 229
Sarnia-Lambton 271
Saskatchewan 71, 99, 101, 125, 131, 169, 185, 196, 197, 201, 202, 253
Saskatchewan caucus 197
Saskatchewan CCYM 116
Saskatchewan House 113
Sault Ste. Marie 231
Sauvé, Jeanne 235
Scarborough, Norma 252
School Act 165
Schreyer, Ed 215
Science Council of Canada 297
Scott, Frank 99, 132, 133, 184, 185, 187, 199, 201, 202
Scott, Jean 259
Scott, Reid 222
Scotton, Cliff 105, 109, 111, 276
Seattle 72, 156

Sechelt 306, 310
Second World War 48, 50, 69, 109, 112, 116, 119, 131, 157, 174, 282, 287, 313
Sedgewick, Garnett 195
Segur, Vincent 152
Senate 248, 310
Senate Commons Committee on Price Stability, Income 231
Serge, Joe 173
sex education 238, 255
sexism 276
Sharp, Mitchell 283
Shetland Isles 46
Shimizu, Hidi 306
Shorncliffe Lodge 310, 311
Shoyama, Thomas 162, 171
Similkameen 114
Simon Fraser University 307
Slocan, B.C. 164
Smart, Russel 107
Smith, Stewart 121
Social Credit Party 103, 197, 249
social democracy 35, 146, 233
Social Fellowship 188
socialism 1, 3, 10, 40, 70, 98, 101, 112, 113, 114, 131, 133, 146, 184, 91, 211, 214, 240, 256, 275, 306, 310, 312, 313
Socialist Fellowship 110
Socialist Party of B.C. 96, 97
Socialist Party of Canada 85
Soldier Settlement Board 167
Sorbonne 49, 52
South Africa 308
South Granville 307
South Korea 187
Southeast Grey 99
Soviet Union 181
Spanish Civil War 108
Special Commission on Palestine 182
Special Joint Committee on Consumer Credit 221
St Catharines 115
St. Francis Xavier Extension Department 129
St. Mary's Hospital 311
St. Mary's University 213
St. Vincent's Hospital 308
Standards Branch 232
Standing Committee on Health, Welfare and Social A 234
Standing Committee on Justice and Legal Affairs 234
Standing Committee on Labour 271
Standing Committee on National Resources 296
Stanfield, Robert 231
Stanley Park 207

Staples, Maureen 70
Staples, Peter 28
Staples, Ralph 204, 233, 307
Staples, Lucy 2
Statistics Canada 213, 224, 243, 266, 301, 302
Status of Women 235, 241, 252, 272
Steeves, Dorothy Gretchen 139, 152, 165, 182, 183, 188, 190, 191, 240
Stevens, H.H. 108
Steveston 163
Stop Morgentaler Committee 256
Strachan, Robert 205
Street Railwaymen's Union 53
Strong-Boag, Professor Veronica 21
Stubbs, Judge Lewis St. George 80, 81, 91
Stursberg, Peter 184
Sub-Committee on Post-War Problems of Women 150
Sudbury 305
Sunahara , Ann Gomer 160
Sunset Memorial Community Centre 195
Sweden 109, 112, 277, 297
Switzerland 112

T
Takeuchi, Tokichi 167
Tallman, Eileen 116, 117
Tanaka, Kinzie , 170
tariffs 67, 73
technology 289
Thomas, Hilda 251
Time Use Research Centre 213
Timmins 102
Tories 229
Toronto 102, 115, 117, 123, 152, 172, 178, 189, 192, 193, 197, 238, 261, 274
Toronto Star, 146, 167, 173, 212, 213, 238, 292
Totem Lodge 306, 311
trade union 110, 146, 156, 202
Trotsky 190, 191
Trudeau, Pierre Elliot 174, 175, 213, 220, 246, 253, 258, 278, 284, 288, 303
Turner, John 175, 227

U
U.S. Food and Drug Administration 297
UMW convention 128
Underhill, Frank 99
unemployment insurance 215
Unemployment Insurance Act 272, 273
Unitarian Church 46
United Church 168
United Farmers of Alberta 84, 99
United Farmers of Canda 99
United Farmers of Ontario 132
United Nations 181, 182, 187, 194
United States 68, 116, 159, 171, 172, 178, 248, 278, 283, 300

University of British Columbia 44, 49, 192, 303
University of Manitoba 48, 49
University of Notre Dame 305
University of Toronto 99, 179, 296, 297, 305
University Women's Club 305
urban development 285

V
Vancouver 33, 34, 43, 54, 61, 63, 64, 66, 71, 81, 86, 89, 98, 99, 115, 125, 131, 143, 149, 155, 156, 171, 173, 184, 185, 195, 203, 205, 217, 218, 251, 252, 277, 280, 281, 285, 299, 305, 307, 308, 311
Vancouver Burrard 137, 165
Vancouver Centre 166, 194, 216
Vancouver District Public Housing Tenants' Associa 305
Vancouver East 139
Vancouver East CCF Constituency Association. 195
Vancouver Island 10
Vancouver Kingsway 46, 53, 192, 199, 207, 208, 209, 216, 217, 235, 258, 289, 309
Vancouver North 135
Vancouver South 53, 192, 199
Vancouver Trades and Labour Council 33
Vancouver] Burrard 190
Vancouver Exhibition Grounds 160
Vancouver Province 131, 146, 165, 237
Vancouver Sun 68, 89, 174, 201, 267, 315
Verdun 91
veterans 167, 226, 289
Veterans Land Act 167
Victoria 114, 131, 299
Viet Nam 303

W
Waddell, Ian 260, 309, 310
Wallace, Dr. and Mrs. 110
War Measures Act 167, 174, 175, 177, 303
Washington's Co-operative Commonwealth Party (CCP) 156
Weaver, George 121, 188
Webber, Bernard 91, 114
Webster, Arnold 137, 191, 207, 208
Webster, Daisy 306
Webster, Gladys 190
Wesley College 49
West Indies 284
West Vancouver 155
Western Labour News. 37
Wheeler, Michael 281
Whelan, Eugene 295, 299
White Paper on Price Stability 231
White Paper on Social Security 289
White Rock, B.C 299
Whitehorn, Alan 101

Who Owns Canada? 115
Williams, George H. 99, 132
Winch, E.E. 33, 96, 139, 191
Winch, Harold 34, 139, 142, 146, 160, 190, 205, 213, 276, 306, 312
Windsor 115
West End Labour Hall 114
Winnipeg 1, 3, 7, 24, 27, 35, 39, 43, 44, 48, 49, 59, 61, 63, 64, 68, 69, 71, 75, 80, 87, 91, 105, 110, 111, 119, 131, 133, 137, 138, 151, 173, 196, 202, 238, 311
 Centre 46
 North Centre 10, 12, 68
 South Centre 48
 Winnipeg Strike 86
 Winnipeg Trades and Labour Council 13
 Winnipeg's Labour Church 35
 Winnipeg Free Press 13, 23, 113
women 211, 287, 300, 304
 Woman and Labour 77
 Woman's Rights 78
 Women's Bureau of the Department of Labour 266
 Women's International League for Peace and Freedom 45
Woodland Dairy 227, 228
Woodsworth family 13, 14, 15, 17, 18, 19, 23, 24, 29, 31, 32, 33, 35, 36, 37, 38, 41, 43, 44, 45, 46, 48, 49, 51, 69, 71, 85, 130
 Aunt Mary 207
 Belva 6, 9, 30, 44, 48, 50, 70, 83, 192, 193, 210, 308
 Bruce 6, 14, 15, 18, 29, 39, 49, 52, 74, 105, 130, 149, 158, 159, 314
 Charles 6, 15, 17, 18, 29, 31, 39, 41, 43, 48, 50, 71, 74, 91, 108, 138, 144, 186, 308
 Ellen Woodsworth 252, 253
 Grace 1, 3, 6, 7, 8, 10, 11, 14, 15, 17, 18, 19, 20, 21, 22, 24, 27, 30, 33, 35, 40, 44, 46, 47, 48, 49, 50, 52, 54, 56, 57, 59, 61, 62, 63, 64, 67, 70, 71, 75, 77, 80, 84, 87, 90, 94, 105, 111, 113, 116, 129, 131, 133, 135, 137, 142, 146, 148, 152, 153, 154, 156, 159, 162, 172, 176, 177, 179, 181, 184, 186, 187, 189, 192, 196, 198, 200, 201, 204, 208, 213, 217, 218, 219, 222, 224, 226, 228, 230, 231, 232, 233, 234, 237, 241, 244, 248, 250, 253, 257, 259, 263, 264, 267, 268, 269, 272, 273, 274, 275, 276, 278, 282, 284, 285, 286, 289, 290, 292, 295, 300, 306, 307, 308, 312
 Howard 6, 15, 18, 30, 48, 49, 74
 Harold 23
 James 1, 3, 5, 7, 8, 18, 20, 24, 31, 33, 39, 40, 48, 54, 59, 69, 87, 98, 99, 103, 112, 117, 119, 124, 130, 131, 132, 133, 134, 135. 138, 143, 204, 207, 306
 as longshoreman 120, 139
 Ken 116, 252
 Lucy 1, 3, 5, 8, 15, 18, 19, 20, 22, 23, 24, 28, 30, 31, 32, 33, 34, 38, 39, 45, 48, 49, 50, 52, 59, 63, 110, 111, 69, 124, 132, 134, 138, 141, 193, 201, 204, 207, 238, 308
 Mary 39
 Ralph 19, 29, 49, 60, 770, 74, 192, 310, 316
 Ruth 6
World Health Organization 244
Wright, Percy 184, 185, 186

Y
Yellowhead Pass, 163
YMCA 148, 168
Young, Rod 110, 182, 188, 194
Yukon 249
YWCA 168